Brassaï

Brassaï

The Monograph

Edited by Alain Sayag and Annick Lionel-Marie

With contributions by

Jean-Jacques Aillagon

Brassaï

Gilberte Brassaï

Roger Grenier

Henry Miller

Jacques Prévert

Werner Spies

A BULFINCH PRESS BOOK

Little, Brown and Company

Boston • New York • London

Contents

Acknowledgments

Profound thanks are due to Mme Gilberte Brassaï for the painstaking assistance and unstinting encouragement that she has given to the realization of this project. Her resolve to promote and proclaim Brassaï's work has provided constant stimulation and support.

Thanks are also due to all the members of the Commission Nationale pour la Photographie in France, and especially to Mme Agnès de Gouvion-Saint-Cyr, Inspecteur Général pour la Photographie.

A further debt of gratitude is owed to many others who have kindly contributed to the project with their advice and loans:

Stuart Alexander
Jean-Pierre Angremy, President of the Bibliothèque Nationale de France
Philippe Arbaizar, Curator in charge of the 20th-century photographic collections, Département des Estampes et de la Photographie, Bibliothèque Nationale de France
Anne Baldassari, Curator of Archives and Information, Musée Picasso
Laure Beaumont-Maillet, Director of the Département des Estampes et de la Photographie, Bibliothèque Nationale de France
Laurence Camous, Curator, Research Library of the Musée National d'Art Moderne, and also: Agnès de Bretagne, Francine Delaigle, Marina Garcia, Jean-Pierre Piton, Annalisa Rimmaudo
Henri Coudoux, Librarian, Maison Européenne de la Photographie
Manfred Heiting
Jean-Luc Monterosso, Director of the Maison Européenne de la Photographie
Élisabeth Perolini
Gérard Régnier, Director of the Musée Picasso
Françoise Reynaud, Curator in charge of the photographic collections, Musée Carnavalet
Jean-Pierre Marcie-Rivière, President of the Association des Amis du Centre Georges-Pompidou
Jean-Pierre Samoyault, Conservateur Général du Patrimoine, Administrateur Général du Mobilier National et des Manufactures des Gobelins, de Beauvais et de la Savonnerie
Yoshi Takata
Katherine C. Ware, Curator, The J. Paul Getty Museum

Thanks finally to Harouth Bezdjian and Vahid Hamidi, Lucia Daniel, Carole Hubert, Séverine Laurent and Anne-Laure Dalloz, as well as to the photographic laboratory of the Centre Pompidou.

Preface

The programming of exhibitions at the Centre Pompidou in Paris reflects the three main thrusts of the establishment's cultural policy: bringing contemporary art in all its forms to a wider public; exploring the effects of major cultural transformations as we enter the twenty-first century; and, of course, providing a large and ever-expanding public with the information necessary for an appreciation and understanding of the art of the twentieth century at its closing moments.

As a museum of modern and contemporary art embracing the plastic arts, architecture and design, an exhibition space for the permanent collections and also a centre for study and research, France's Musée National d'Art Moderne plays a leading role in the promotion of these objectives. Its collections, housed in the Centre Pompidou, number some fifty thousand items. Photography is well represented, as can be seen from the catalogue of the collection for the years 1905 to 1948, which was published in 1997. The collection's breadth is the result both of a vigorous acquisitions policy and of the good fortune of benefiting from a number of major donations and legacies. The Brassaï Collection, for example, which until recently amounted to some three hundred items, has now been greatly enhanced by the addition of more than two hundred original photographic prints, drawings, sculptures and documents deposited with the museum by Gilberte Brassaï, the artist's widow.

The Brassaï exhibition with which the Centre Pompidou marked the centenary of the photographer's birth in 1999 was the first proper retrospective of this artist's unique and eclectic body of work. Its aim was to represent the globality of Brassaï's wide-ranging activities as photographer, draughtsman, sculptor, writer – as well as privileged witness to the artistic activity of his day. It was one of a major series of one-man shows devoted to leading twentieth-century artists mounted by the Centre Pompidou as part of its systematic promotion of the collections of the Musée National d'Art Moderne. The retrospective also demonstrated the increasing emphasis on photographic and video images in the programming of the Centre Pompidou.

I would like to thank the Centre Culturel Français and its director Charles de Croisset for their participation in a project which I am delighted to say has aroused worldwide interest, taking the exhibition on to England, Japan and Italy after completing its run at the Centre Pompidou.

JEAN-JACQUES AILLAGON
President of the Centre National d'Art et
de Culture Georges-Pompidou, Paris

Brassaï: the darkness and the quarry

Of all the forces of nature there is one whose power has been recognized throughout time to be totally mysterious and totally involved with man: and that force is the night.... It wears curlers studded with sparks, and where the smoke clouds have died away, men have climbed up to those gliding stars.

LOUIS ARAGON,
Le Paysan de Paris, 1926

In Aragon's nocturnal ramblings, the city of arcades, Les Halles and Haussmann's ruthless surgery becomes the world capital of poetry and dreams. Walter Benjamin discovered in it the form and structure of a new critique. When Brassaï arrived there in 1924, he loved to lose himself in its streets, wandering about 'aimlessly, except for the aim of perpetual exploration'. Having arrived from his native Transylvania as a journalist, he quite soon traded his pen for a camera, and began to track the shady figures of the Paris *quartiers*. His images are redolent of waiting and conspiracy. Thugs from the slums, whores on the Place d'Italie, hanging about in the dim light of a street lamp. His figures have the stature and weight of colossi. A surrealist when he chooses, Brassaï's true love is reality. This penchant led him one day to Picasso. It was an accident that must have been meant, and it made Brassaï the accredited photographer of Picasso's sculptures, the most material and tactile element of his work. And to what else but Brassaï's predilection for the concrete, physical world can we ascribe his passion for graffiti, designs wrested only with a supreme struggle from the most 'rugged' reality? Graffiti, forms scratched rather than drawn, are manifestations of an ambiguous kind of art that exploits the charms of darkness the better to lure its quarry.

The stalking never ceases, even if the quarry changes. The work is protean, overflowing into other worlds: drawing, sculpture, even cinema.

That this wealth of material is here made accessible to all we owe to the generosity of Madame Gilberte Brassaï. I would like to express my gratitude to her, personally and on behalf of all the many visitors to the Centre Pompidou. By depositing with us the major part of Brassaï's works and archives, guiding us at every step with her comprehensive knowledge, she has made a remarkable contribution to the recognition of Brassaï's genius. Let this be our way of saying thank you.

WERNER SPIES
Director of the Musée National
d'Art Moderne, Paris

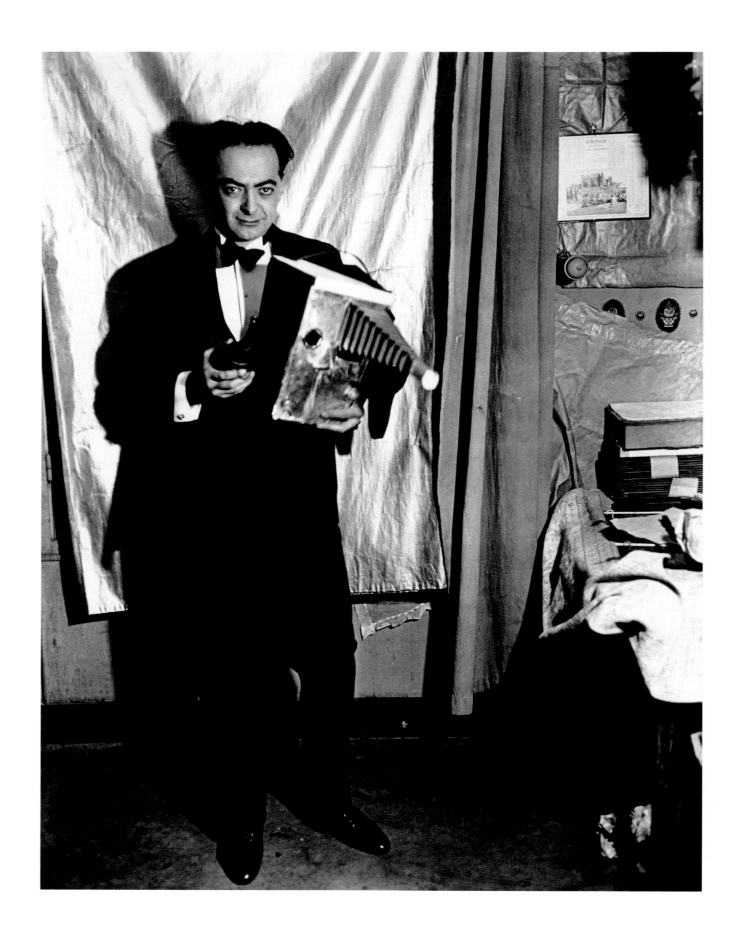

Self-Portrait as Society Photographer for a Costume Ball, c. 1932–34

The expression of authenticity Alain Sayag

The meaning of art is not authenticity ...
but the expression of authenticity.

BRASSAÏ

In the days of the Tang dynasty (AD 618–906), a Japanese monk was
returning home from China with a precious statue of Kuanyin.[1] Legend
has it that a fierce storm blew up, obliging him to seek shelter on one of
the 1,339 islands situated in the China Sea off Ningbo.[2] Was the hurricane
perhaps a sign that Kuanyin did not want to leave Chinese territory?
The monk believed that it was, and decided to abandon his journey. He
founded a temple which, in time, became wealthy and famous. Although
the island of Putuo Shan was repeatedly ravaged by wars, pirates and
typhoons, the temple was always rebuilt. The crowds of pilgrims have
subsequently been succeeded by tourists, attracted more by the beauty
of the place than by the Bodhisattva's virtues, but Western travellers
who venture this far remain a rarity. The inn where they stay bears the
evocative name 'Hamlet of Rest'[3] and offers the pretentious, fusty luxury
that was typical of China in the early 1970s. In the lobby, instead of the
somewhat fanciful view of the Great Wall or the Temple of Heaven that is
more or less obligatory in those places reserved for 'foreign guests only',
there is an overview of the island and its holy sites, instantly recognizable
to anyone who has spent even a few hours exploring their shady, paved
walkways. Here are the pool covered with lotus flowers, straddled by a
humpback bridge, the 'hundred-step beach' and the 'thousand-step beach',
the belvederes and pavilions, the convoluted silhouettes of the steep rocky
crags, the forests with their lingering drifts of mist. A whole repertory
of profoundly symbolic forms, clichéd from overuse, acquires here an
astonishing evocative power. The artist who painted this panel a few
years ago, using broad brush-strokes in the traditional Chinese style, has
somehow managed to invest the symbolic artificiality of the forms with
a far more powerful sense of poetry than was ever achieved by the banal
photographic images in the tourist brochure presented to visitors. It might
be said that this anonymous painting, in which 'everything is imagined
but nothing invented', poses much the same problem for us as do the
photographs of Brassaï. For was it not by the use of re-creation and
reconstruction that he too achieved his greatest truth to life?

It is not a gratuitous comparison. In Chinese painting, the absence of
any horizon or vanishing point, the juxtaposition of different zones of
space and the use of a codified graphic vocabulary all combine to create
a space that looks entirely artificial. And yet this language of symbols is
more evocative than any literal photographic reproduction. Is this not
also the key to the fascination held for us by Brassaï's 'Paris after Dark'
and 'Secret Paris'? In taking a 'hackneyed subject you might believe was
threadbare with use'[4] – the big city at night, with its lights and its low life
– and making of it an image at once stereotypical and freshly minted,

1. Kuanyin is a Bodhisattva who has taken the
form of a woman's body. As the incarnation of
'benevolent compassion', she intercedes to plead
forgiveness for human weaknesses in comparison
with the perfection of the Buddha.

2. Ningbo, approximately 150 kilometres (95
miles) south of Shanghai, was one of the five ports
opened up for foreign trade by the Treaty of
Nanking in 1842. Long regarded as one of the
most beautiful cities in the Chinese Empire, it has
been undergoing extensive rebuilding since the
early 1990s, which has deprived it of all its ancient
charm.

3. Xi Lei Xiao Zhuang.

4. Émile Henriot, 'Photos de Paris', *Le Temps*,
30 January 1933.

combining material fidelity with fantastical transposition, Brassaï is, supremely, Baudelaire's painter of 'modern life' who 'draws out the eternal from the transitory'.[5] (As though it were impossible to invent a strong, timeless image that was not first rooted in a substratum of ephemeral and purely circumstantial popular imagery.)

Perhaps this is also one of the reasons for Brassaï's ambiguous relationship with the Surrealists? Parallels have frequently been drawn between his work and the products of Surrealism. André Breton was particularly keen to 'annex' him as one of their own, asking him 'in the course of a conversation or in a letter written in that precise and tiny hand of his, with green ink on blue paper'[6] to come and see him in the Rue Fontaine or at the Café Cyrano on the Place Blanche, where the members of the group used to meet. In fact, Brassaï's principal contribution to Surrealism was probably the body of work he did for *Minotaure*, although it would be a fallacy to assume from this that he was an active participant in the group, for the two editors of the review, Albert Skira and Tériade, were adept at steering an independent course and evading the tyrannical edicts issued by André Breton. Brassaï's contributions to the pages of *Minotaure* were quite substantial. The twelve issues of the review published between 1933 and 1939 included something like one hundred and fifty of Brassaï's pictures. Brassaï himself always denied he ever belonged to the Surrealist group, and denounced their intolerance on many occasions. He could not stand the authoritarian aspects of Breton's personality. In a note in *Picasso & Co.*, he referred to Breton's way of behaving like an 'inquisitorial seer' and his propensity for drawing up 'secret files … intrusions into the private lives of his companions in the movement'.[7] But Brassaï, a man who had enlisted in the ranks of the Red Army of Béla Kun,[8] could not help but feel nostalgia for the excitement of those early days, when he had loved 'this fever of discovery away from the beaten paths of art and science, this curiosity to prospect for new veins of ore, this mental electricity which constantly charged through the little office at *Minotaure*, where André Breton flicked his whip at the mind'.[9] But by 1933 he found the Surrealist revolution a noticeably tamer affair, its ranks thinned by successive purges. He always regarded his identification with Surrealism as being due to a 'misunderstanding'. 'People thought my photographs were "Surrealist" because they showed a ghostly, unreal Paris, shrouded in fog and darkness. And yet, the surrealism of my pictures was only reality made more eerie by my way of seeing. I never sought to express anything but reality itself, than which there is nothing more surreal.'[10]

What interested him, in fact, was a form of literal realism rooted in the naturalism of nineteenth-century paintings and novels. Photography was for him, above all, a means of 'losing oneself in order to stick more closely to reality and achieve a likeness that represents some sort of absolute, that being one of the central preoccupations of the modern age'.[11] This concern for objectivity, for 'fidelity to the subject' – the need to free oneself from Romantic subjectivity also noted by Walter Benjamin with reference to the disappearance of the 'aura' surrounding the object – this

5. Charles Baudelaire, 'Le peintre de la vie moderne', *Charles Baudelaire critique d'art*, Armand Colin, Paris, 1965, p. 452.

6. Brassaï, *Picasso & Co.*, Thames & Hudson, London, 1967, p. 15. (Original French edition: *Conversations avec Picasso*, Gallimard, Paris, 1964.)

7. *Ibid.*, p. 11.

8. In the autumn of 1919, Brassaï enlisted as a military telephonist and took part in the offensive against the Romanian army. The Allied intervention led to the defeat of the Hungarian revolutionaries, and Brassaï was held prisoner by the Romanians for 'a few weeks in appalling conditions'. It was his father who found out where he was and obtained his release, by which time he was greatly weakened by the dysentery he had contracted during his imprisonment. (Biographical note, manuscript, Gilberte Brassaï Archives.)

9. Brassaï, *Picasso & Co.*, op. cit., p. 15.

10. Interview with Brassaï by France Bequette, *Culture et Communication*, no. 27, May 1980.

11. Brassaï, 'La photographie n'est pas un art?', *Le Figaro littéraire*, 21 October 1950.

concern nevertheless went hand in hand, in Brassaï, with a concern to isolate from the apparent chaos of things and the confusions of the real world an element of universality that was permanent and fixed. For him, the image functioned much more like a mental construct, or invented idea, than any sort of '*objet trouvé*'. Hence the liberties he would take with the composition of certain scenes; hence too his search for new visual systems, like the 'objects on a large scale' and the graffiti.

In the many accounts of his activities he has left us, Brassaï tells us quite matter-of-factly how he would often 'stage-manage' the images he photographed. He mentions, for example, that the flower-seller's customer in *Paris after Dark* (US title *Paris by Night*) was a friend of his[12] and the lover on the bench his regular stand-in Frank Dobo.[13] There are numerous other examples. With the images of cat-burglars or of 'rape', we can perfectly well see why such stage-management was necessary, but the reasons are less clear in the case of the famous pictures 'At Suzy's', for example. Their apparent candour, reinforced by the astonishingly natural behaviour of the girls and the madam, would make the presence of a real client seem eminently plausible. In fact, for legal and moral reasons, the latter role was played by a stand-in, 'Kiss', who was then Brassaï's right-hand man. There was another consideration. Brassaï's technique did not readily lend itself to improvisation. He used cumbersome equipment that required a fairly lengthy exposure, and therefore a tripod, and he frequently employed a magnesium flash that was anything but inconspicuous. This was not the *modus operandi* for a 'decisive moment' or '*image à la sauvette*', to use the term associated with Henri Cartier-Bresson. It required a reconstruction of reality, in the process of which the image acquired a symbolic significance. Brassaï placed in Picasso's mouth a justification for 'likeness' he could well have used for himself: 'An artist should observe nature but never confuse it with painting. It is only translatable into painting by signs. But such signs are not invented. To arrive at the sign, you have to concentrate hard on the resemblance. To me, surreality is nothing, and has never been anything but this profound resemblance, something deeper than the forms and the colours in which objects present themselves.'[14]

Photography is 'giving things the chance to express themselves'; what matters is 'that noble desire for objectivity and faithfulness to the object, that necessity to eliminate the self and achieve a likeness that represents some sort of absolute'.[15] A photograph cannot change its nature; manipulate it how one may, it will never be anything other than a transcription of the world in black and white in two-dimensional space. To 'become a definitive image', it must respect the immutable rules of art: 'equilibrium between the real thing and the form … the classic equilibrium,' he stresses, 'for my aim is to create something striking and fresh out of what is ordinary and everyday'.[16]

This desire to use photography purely as an instrument for the 'expression of authenticity' comes up against the problem of fidelity, and the fear of betraying that authenticity. It is this that obliges him to 're-create and reinvent'.[17]

12. Madame Gilberte Brassaï tells us this was the niece of Madame D.-B. (see note 60, p. 164).

13. According to Anne Wilkes Tucker, in *Brassaï: The Eye of Paris*, Museum of Fine Arts, Houston, 1999, p. 43.

14. Brassaï, *Picasso & Co.*, op. cit., pp. 162–63.

15. Brassaï, 'La photographie n'est pas un art?, *op. cit.*

16. Text written by Brassaï for Edward Steichen, for the exhibition held at the Museum of Modern Art, New York, 10 December 1951. Gilberte Brassaï Archives.

17. Brassaï, *Paroles en l'air*, Jean-Claude Simoën, Paris, 1977, p. 22.

Of course, the darkness is his best ally, and Brassaï consciously uses the effects it makes possible: the main subject is illuminated, emphasizing the way it is positioned off-centre, often right at the edge of the picture to render it more dynamic. Space is suggested by the distribution of lighter and darker masses within the shot, with certain areas completely blanked off. Brassaï obtains effects so simple that they seem like a straightforward reflection of reality. They are rendered more powerful by confining the human figure, when present, within the pool of light: the bright flash produced by the tramline polishers, the glow of the baker's oven and of the cesspool cleaners' pump, the halo of a gaslamp. The isolation of the human figure, in pictures that are predominantly made up of deep tones of black, becomes a metaphor for the situation of modern man in the urban world.

Another way in which Brassaï took liberties with the photographic image was in regarding it as no more than raw material waiting to be reconstructed by the photographer in the privacy of his darkroom, in a process analogous to that employed by the 'selective ear of the writer', who retains all the bits that are poetic, original or witty, but allows 'the stream of bland, incoherent words to ebb away and disappear without trace'.[18] If you examine the finished plates and compare them with the original proofs, there are many indications of the changes Brassaï made – and we know that he exercised complete control over the printing process, never allowing anyone else to print his negatives: 'A negative means nothing for my kind of photographer', he said. 'It's the artist's print that counts.'[19]

Thus we can be clear not only that 'his lighting is completely independent of the subject matter', lighting being 'to the photographer what style is to the writer',[20] but also that he did a great deal of his 'inventing' at the negative stage. He would often crop his shots to try out different formats, taking up to three different prints from the same negative. In the famous picture of the two toughs from Big Albert's gang, it was not until he was in the darkroom that he realized that the pair of figures, one cut off by the edge of the frame, was actually far more arresting and powerful than the trio on which he had originally trained his lens. Similarly, if you examine his contact prints, you realize that in 1932, when he was backstage at the Folies-Bergère or on the banks of the Canal de l'Ourcq with Prévert, he invented a sort of panoramic collage that opened up the restricted field of vision offered by his camera, not only giving the effect of a wider shot, but transforming the whole concept of what a photograph could be. He also brought a new dimension to the snapshot by compiling sequences of shots, thus anticipating a fashion of the sixties. *The Balloon Seller*, *The Fruit and Vegetable Seller* and *The Lovers' Tiff* are short stories in their own right, with all the charm and spontaneity of his *Histoire de Marie*.[21]

But why, given his stated aversion, or at least mild disdain, for photography, did he resign himself in the early thirties to becoming a practitioner and actually making it his profession?

The first – if not the principal – reason was economic. Although in the late twenties, as he told his parents, his position as a freelance journalist

18. *Ibid.*

19. Brassaï, undated typescript, Gilberte Brassaï Archives.

20. Brassaï, conference at The Massachusetts Institute of Technology, Boston, 13 May 1977. Gilberte Brassaï Archives.

21. Among the many unpublished projects in Brassaï's papers was a file in which he had collected these various sequences.

'Juan-les-Pins' at the Folies-Bergère,
1932

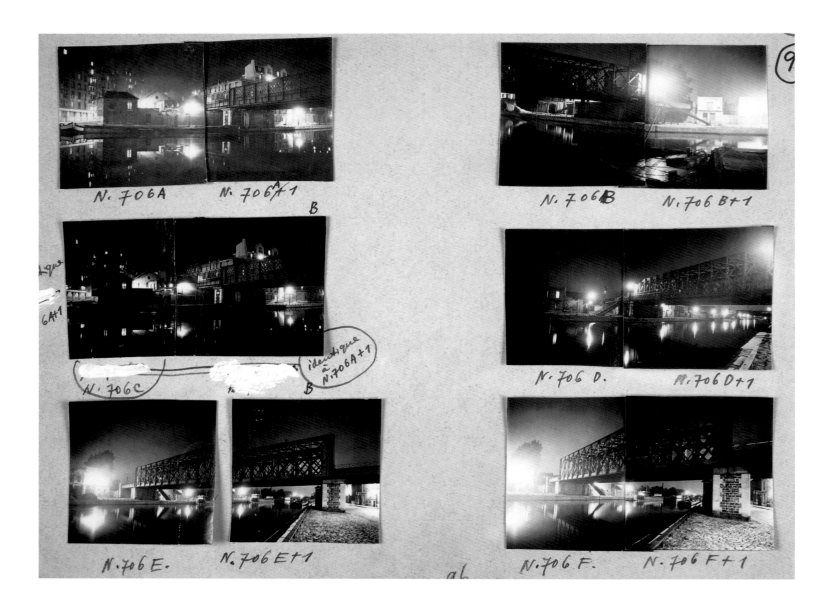

The Canal de l'Ourcq, Seen from the Quai de l'Oise and from the Quai de la Marne, undated

had at last become more stable, the global financial crisis shattered whatever fragile equilibrium he had achieved. Early in 1929, he became a regular correspondent for the *Münchner Illustrierte Presse* and the *Kölnische Illustrierte Zeitung*. He was being paid ten times more for an article than when he had started out ten years earlier, and could congratulate himself on earning five or six thousand francs a month. A few months later, when he made a list of the German periodicals to which he contributed, he came up with no less than six titles. His articles were, in addition, beginning to be picked up by the French press. *L'Illustration*, of course, but also *Vu*, which in 1928, under the editorship of Lucien Vogel, had adapted for a French readership the new journalistic formula of photojournalism. In response to this new market, Brassaï set out to supply a finished product, made up of texts accompanied by pictures he had researched himself.[22] In the early twenties, he had said he found it easy to earn quite large sums of money, and at one point even toyed with the idea of becoming the correspondent for a 'leading photographic agency'.[23] But

22. For example, in a letter of 3 September 1924, he asks for a 'pretty photograph of the ruins' at Földvar castle, to accompany an article on the Teutonic order.

23. Brassaï, *Elöhívás: Levelek (1920–1940)* [Letters to My Parents], Kriterion, Bucharest, 1980.

in the early thirties, the effects of the world crisis unleashed by the Wall Street crash began to be felt in Germany, and Brassaï noted that he could not hope to achieve the same income in the future. 'I too am affected by the crisis in Germany…. Fortunately, I was prepared for this eventuality. I shall try to earn my living here in France.'[24]

Thus it came about quite naturally that he began to offer a complete journalistic 'package'. Sometimes he would submit his own drawings, which frequently took the form of caricatures,[25] or otherwise pictures he had 'commissioned' from photographers who worked for him.[26] But there were a number of pressures on him to supply these photographs himself. Financially and materially, it would make his life much easier. But he was dubious about the major investment it would require: 'When my financial situation improves, I shall buy a camera and take my own photos.'[27]

In July 1931, he realized he ought no longer 'to count on Germany'[28] but needed to look for other sources of income in France: portrait drawing might be one – he felt he had everything it took for 'social' success – but photography was another, since he now possessed 'the curious and hitherto unsuspected mechanisms of the profession'.[29]

Photography was beginning to take up an ever-increasing proportion of Brassaï's time. He equipped himself with a professional camera at the end of 1929 or the beginning of 1930,[30] installed a darkroom with an enlarger in a room in his hotel in January, and began to show people the pictures he had produced: the hairdresser Antoine (photographed by Man Ray for *Vu* at around this time) professed himself enchanted, as too was Oskar Kokoschka who 'praised me to all and sundry and sent me clients'.[31] Tériade reported on them very favourably and (as Brassaï wrote to his parents) 'encouraged me to exhibit my work as soon as possible'.[32]

A few months later, Charles Peignot, editor of *Arts et Métiers Graphiques*, agreed to publish the photographs of 'Paris after Dark' in book form, with a foreword by Paul Morand.

Brassaï spoke on many occasions of the way his nights spent exploring Paris had impelled him to take up photography. All one can say is that, if that was the case, it happened in a very controlled and regulated fashion. Brassaï started relatively slowly: he may have taken his first pictures in late 1929 or early 1930, but it was not until a year, or even a year and a half, later that he met Lucien Vogel, and then Charles Peignot, and showed them the hundred or so images of Paris by night that he had assembled. And yet he worked quite quickly, for we know that, between that first meeting in mid-October 1931 and the early days of November, he produced another twenty or so photographs. With no date on the contact sheets, and the dates on the back of the pictures being, as is so often the case, not wholly reliable, if we want to reconstruct Brassaï's working methods, we have no choice but to rely on conjecture, based on the evidence of the negatives, whatever their state of preservation.

What, then, do we learn if we examine the sixty or so images that make up *Paris after Dark*? We recognize their great economy. It is as though most of the time he already knew beforehand the image he wanted. More than a quarter of them were single exposures, another

24. *Ibid.*, letter of 24 January 1931.

25. See Brassaï, *Elöhívás, op. cit.*, letter of 11 March 1930; also 2 March 1926 and 4 December 1929.

26. In his letter dated 27 January 1925 (Brassaï, *Elöhívás, op. cit.*) he speaks of two young women photographers who worked for him. Anne Wilkes Tucker (in *Brassaï: The Eye of Paris, op. cit.*) identifies one as Ergy Landau, while the other may have been Nora Dumas. Tucker also mentions the name Rogi André. However, there is no firm evidence to substantiate her identifications.

27. Brassaï, *Elöhívás, op. cit.*, letter of 28 February 1929.

28. *Ibid.*, letter of 27 July 1931.

29. *Ibid.*, letter of 4 December 1929.

30. It might have been in the last month of 1929, since, in a letter of 4 December of that year (Brassaï, *Elöhívás, op. cit.*), he wrote that he was thinking of buying a Leica. On 11 March 1930, he said he had done some photography in the preceding weeks. In a letter of 24 January 1931, he congratulated himself on mastering 'the art of photography' and on having got together the necessary equipment. Finally, it should be noted that Plate 57 of *Paris after Dark* shows the illuminations on the Eiffel Tower that took place at the end of 1929.

31. Brassaï, *Elöhívás, op. cit.*, letter of 27 July 1931.

32. *Ibid.*, letter of 18 September 1931.

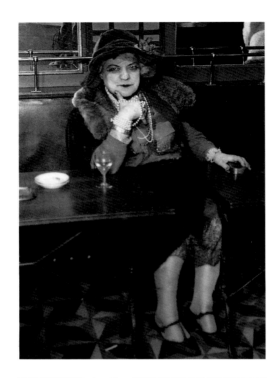

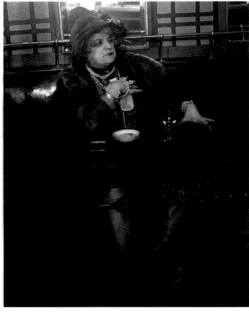

La Môme Bijou, Bar de la Lune, 1932
Above: in *The Secret Paris of the 30's*
Below: in *Paris after Dark*

33. Colin Westerbeck, quoted by Kim Sichel in *Brassaï, Paris le jour, Paris la nuit*, Musée Carnavalet, Paris, 1998, p. 24.

34. *Ibid.*

35. 'La vraie folle de Chaillot', *Point de vue*, 3 January 1946.

quarter took two exposures, and the remainder never more than three. Given that the work was spread out over several months, and that he was able to take twenty-four unexposed plates with him every night, such self-restraint is remarkable. Even for major pictures, he never took more than three exposures, whether it was the statue of Marshal Ney, immortalized on the spot where he died, or La Môme Bijou – 'Little Miss Jewel' – encountered one evening in a Montmartre bar. The number of negatives increases only where he is working on a 'theme', such as the bakery, or the cesspool cleaners. For the most part, the variations are minimal: a slight sideways shift in the field of vision, giving more prominence to some element of the image (the hotel sign on the Avenue de l'Observatoire, for example), or a widening of the shot – although even these were things that could as easily be adjusted in the printing.

Yet we should not conclude from this, like the American critic Colin Westerbeck, that there is some overall law that explains the work's progression. You simply cannot say that 'generally speaking, Brassaï's later prints capture the subject at closer range and in a more direct manner'.[33] The example he gives, the portrait of La Môme Bijou in *The Secret Paris of the 30's*, as compared with the picture of her published in *Paris after Dark*, makes absolutely no sense, since these are prints from different negatives. In 1976, when *The Secret Paris of the 30's* was published, Brassaï no longer had access to the negatives of *Paris after Dark*, which had remained in the publisher's archives (they were discovered by Kim Sichel only in 1984), and he used the two negatives he had left. The first image in *The Secret Paris of the 30's* is not dissimilar, in terms of composition, to that of *Paris after Dark* – one of the differences being that Bijou looks straight at the photographer and has abandoned her original haughty air. The portrait of her that appears two pages further on is taken from the third negative, as an examination of the contact sheet clearly shows. The shot has been cropped in such a way as to place the emphasis on the hands, which have become the central feature of the image. At the same time, the subject acquires monumentality from the flat expanse of the table in the foreground, with its ashtray, wine glass and empty saucers (see opposite). We certainly cannot say that 'the composition is not as powerful as the compositions that capture the atmosphere from the middle distance.'[34] On the contrary. What we see, once again, is how Brassaï manipulated his photographic material. Never mind the care with which the negative was composed, it was subsequently modified and altered to make it embody the artist's vision, and acquire the timeless and exemplary quality that enabled it to function as a symbol – a process that was particularly successful in this case, since we know that, when Giraudoux's *Madwoman of Chaillot* was staged in 1945, 'it was Brassaï's Môme Bijou who was believed to be its inspiration'.[35]

Brassaï may be thought disingenuous in his explicit refusal to practise photography as an art form, but he took hold of photography in the way that only an artist can. His choice was partly a question of circumstances, something imposed upon him rather than deliberately sought. Brassaï himself makes that point frequently. As we have seen, these circumstances

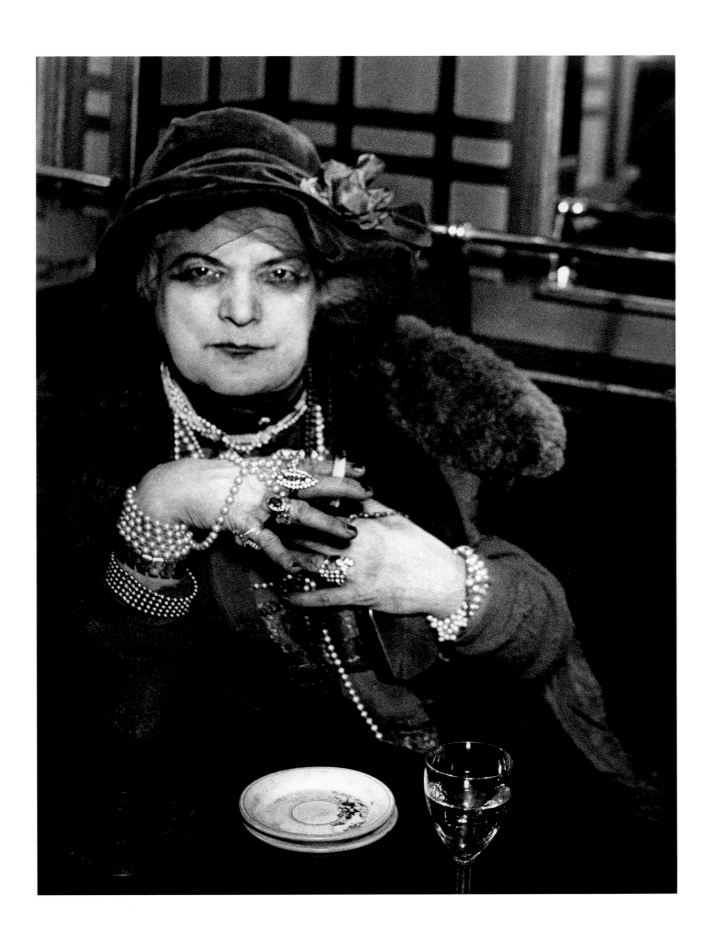

La Môme Bijou, Bar de la Lune, 1932

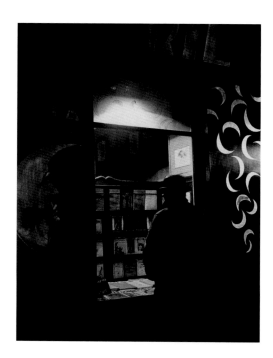

The Librairie de la Lune,
c. 1934

36. Brassaï, *Elöhívás, op. cit.*, letter of 13 December 1925.

37. *Ibid.*, letter of 2 December 1921.

38. Most notably by Bill Brandt, with the publication in 1938 of *A Night in London.*

39. Waverley L. Root, 'Brassaï Makes Photo Record of Nocturnal Paris', *Chicago Daily Tribune*, 13 March 1933.

40. Brassaï, undated typescript, Gilberte Brassaï Archives.

41. Christian Bouqueret, *Des années folles aux années noires, la nouvelle vision photographique en France, 1920–1940*, Marval, Paris, 1997, p. 159.

42. Biographical note, manuscript, Gilberte Brassaï Archives.

were in large part financial – in 1929, photographs seemed to him more marketable than his drawings – but they were also social. He was put off by what he regarded as the wildly exaggerated behaviour of 'the artistic hordes with all the ostentatious attributes of genius … wide-brimmed hat, cravat, hairstyle worthy of Samson, funereal shirt, one takes a thorough dislike to anything that might imply membership of that tribe'.[36] More fundamentally, it was the challenge of mastering a new technique that was his principal motivation. In Berlin, in December 1921, he declared: 'One year was enough to build up sufficient resources to last a lifetime', adding, very proudly, 'creativity depends henceforth on inspiration only'.[37] He was later to congratulate himself on being the first to have mastered night photography, and to have used it to create a 'historic' body of work.

Yet the success of this first publication did not bring him the sort of income he had expected, or the commissions he had hoped for: none of the books that had been discussed in principle – 'Paris of the Streets', for example – ever saw the light of day. That realization later caused him a certain bitterness: he lost access to his own negatives during his lifetime, he had to stand by and watch the formula being exploited by others,[38] and he had to endure the sight of Paul Morand's name plastered all over the cover, as though he were the real author of the book and not merely of the foreword.

The review in the *Chicago Daily Tribune* noted that 'the name of Paul Morand, who contributes to this book eight pages of more or less routine text' appeared in large letters, while Brassaï's name was given only in very small type, although his '60 photographs are the raison d'être of the book'.[39] Thirty years later, in December 1966, Brassaï wrote in his diary that he regretted Charles Peignot had never felt the necessity to introduce him to Paul Morand, whom he respected, and credited 'with having, of all the young writers, discovered a style of his own that was quick, economical and brimming with wit, perfectly suited to the pace of the modern way of life'.[40]

These disappointments and setbacks forced him to seek out a new clientele among the ranks of the popular, and less popular, illustrated magazines that proliferated at the time, and which were in the market for original and 'titillating' illustrations. In the catalogue for the exhibition that opened at the Museum of Fine Arts in Houston in December 1998, the organizer, Anne Wilkes Tucker, includes a list of these publications, the titles wonderfully evocative of the saucy, shady aspects of 'gay Paree' that have always thrilled puritan America: *Allô Paris, Paris-Magazine, Ici Paris, Paris-Sex-Appeal, Vive Paris, Scandale, Séduction, Pour lire à deux, Détective.*

The biggest of these, *Paris-Magazine*, with a readership, if we are to believe Christian Bouqueret,[41] of approaching 150,000, was owned, like *L'Illustration*, by an individual called Vidal. A native of Tahiti, he was also the proprietor, according to Brassaï, of several newspapers, a condom factory, a 'bookshop', and a 'factory making fine lingerie', an 'empire' he ran by telephone without ever leaving his office. Neither a drinker nor a smoker, he led an ascetic life. He was at the time Brassaï's best customer.[42] The shop, for which Brassaï did a series of photographs, traded under the

The Black Corset, 1934

Bonnard, Le Cannet,
October 1946

43. In 1940, according to Romi, there were a dozen or more 'houses of ill repute' identified by this sign (Romi, *Maisons closes*, privately printed, [Paris?], 1952; Michel Trinckvel, Geneva, 1979, vol. 2, p. 181).

44. Brassaï took a number of photographs of lingerie, which may have been intended for the shop's illustrated catalogue, published in 1934.

45. This volume was intended to be in the same format as *Paris after Dark*, as a similar fee was discussed. Pierre Mac Orlan was approached and agreed to write the foreword, after Colette turned it down on the grounds that the subject matter was 'too shocking'. (Biographical note, typescript, Gilberte Brassaï Archives.)

46. At the end of 1935, Brassaï told his parents the project had fallen through because the publisher had insufficient funds (*Elöhívás, op. cit.*, letter of 17 October 1935).

47 Brassaï, *Elöhívás, op. cit.*, letter of 17 October 1935.

48. Brassaï, 'Les choses parlent', *Les Nouvelles littéraires*, 18 March 1965.

49. Robert Graves, who collaborated with Brassaï on an article about Majorca for *Harper's Bazaar* (September 1954), was the author of *Goodbye to All That*, one of the most moving accounts written by a soldier who had served in the First World War.

50. *Séville en fête*, with a preface by Henry de Montherlant and text by Dominique Aubier, Éditions Neuf, Paris, 1954.

51. To quote an expression attributed by Anne Wilkes Tucker to Pierre Gassmann, who used it of Henri Cartier-Bresson (Anne Wilkes Tucker, *Brassaï: The Eye of Paris, op. cit.*, p. 39).

sign of the Moon,[43] and appears to have concentrated on mail-order lingerie and specialist items such as whips, masks and 'studded metal shackles'.[44]

The association ended badly. Although Vidal signed an agreement in August 1932 for the publication of a book on the subject of 'Intimate Paris',[45] he allowed the project to drift for two years[46] before finally publishing a 48-page volume called *Voluptés de Paris*, in which Brassaï apparently did not figure, and which he never included in his list of publications.

At about this time, Brassaï fulfilled his first commission for the American magazine *Harper's Bazaar*: a picture of a couple in evening dress on the steps of the Paris Opéra.[47] It was the start of a twenty-year relationship with the magazine, which ended only with the departure of Carmel Snow and Alexey Brodovitch from the editorial board.

Despite his relative freedom to choose his own subjects for *Harper's*, Brassaï's output was variable, reflecting a fluctuating level of interest. Not all his pictures had that same 'whiff of reality ... the same keynote of truthfulness and authenticity'.[48] Along with many portraits of painters (from Pierre Bonnard and Georges Braque to Bernard Buffet and Pierre Soulages), writers (such as Thomas Mann and Robert Graves),[49] musicians (Edgar Varèse and Olivier Messiaen) and architects (Le Corbusier), he also produced what were in effect documentary reports on subjects as various as the Hospices de Beaune, the Seville Feria (July 1950), midnight mass at Les Baux in Provence (December 1951), the 'monsters' of Bomarzo (January 1953), Constantinople and the Golden Horn (September 1953), the Mouton-Rothschild estates (February 1954) and the Brittany of the Bigouden (March 1955). Back in 1950, Spain was still the same primitive country whose baroque exoticism had attracted the French Romantics a century before. Brassaï's pictures of Spain, collected together in a book of 1954,[50] mark a probably inevitable development in his photographic style. Even if they still show the same concern for an honest relationship with 'things', invention and re-creation no longer have any place. This is the art of the 'pickpocket',[51] which by then had come to dominate the world photographic scene. An aesthetic utterly unsuited to Brassaï's genius, it nevertheless generated a few remarkable images, anticipating the best work of the rising generation of young photographers, such as the Englishman Tony Ray-Jones and the American Lee Friedlander. In their way, these are as indicative of his independence of spirit and responsiveness to contemporary trends as was the eclecticism of the book edited by Robert Delpire in 1952, which embraced all the facets of his artistic activity: drawing, sculpture and photography. Even his writing was represented by the moving 'Souvenirs de mon enfance' (Memories of My Childhood).

Brassaï always recoiled from anything that could be called news photography. When, like all Parisians, he succumbed to the emotion of the historic occasion and trained his camera through the small window of the bathroom at 81, Rue du Faubourg-Saint-Jacques down on to the leading tanks of Leclerc's division which, at five thirty a.m., began the liberation

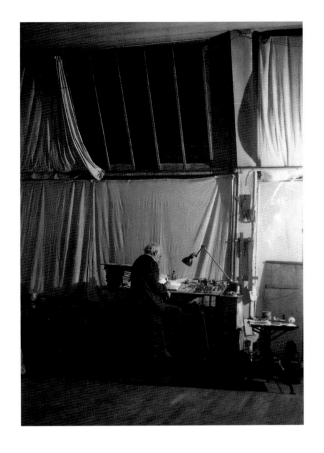

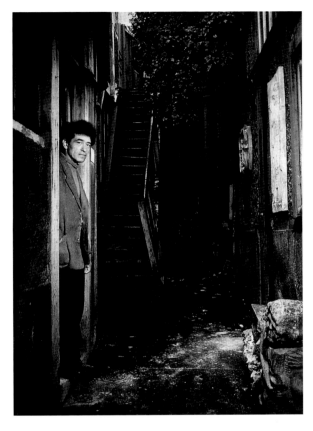

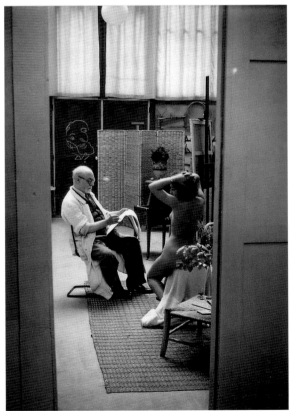

Braque, 1946

Matisse, 1939

Giacometti, January 1948

Bonnard's Studio, Le Cannet, October 1946

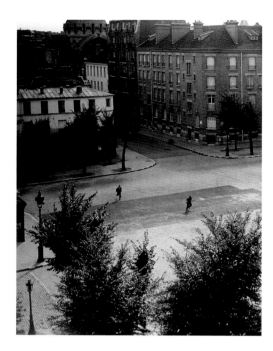

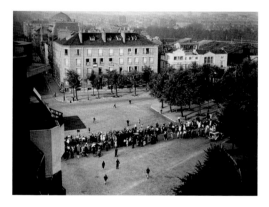

*Intersection of the Boulevard Saint-Jacques
and the Rue du Faubourg-Saint-Jacques,
25 August 1944, about six a.m.*

*The First Units of the Bilotte Group,
25 August 1944*

52. Nor was he any better suited to the army as a
profession. Although he did his military service in
the Austro-Hungarian cavalry, at Hermannstadt
(Sibiu) in 1917, he did not take part in the
offensive on the Isonzo, in October 1917, because
of a wound 'contracted while playing football'. By
the time he rejoined his regiment, the Austrian
front was on the verge of collapse. (Biographical
note, typescript, Gilberte Brassaï Archives.)

53. Brassaï, 'Du mur des cavernes au mur d'usine',
Minotaure, no. 3–4, December 1933. See p. 292.

54. Brassaï, *Graffiti*, Flammarion, Paris, 1993, p. 7.

55. *Ibid.*, p. 145.

56. Brassaï, 'Images latentes', *L'Intransigeant*,
15 November 1932.

of the capital, he nearly paid for it with his life. He was mistaken for a concealed sniper and a few bullets were launched off in his direction, one of which broke the mirror above his head. It was enough to persuade him, if persuasion were needed, that this was not the profession for him.[52]

Photography was, in Brassaï's view, a means of exploring what was fundamental in human activity. That in turn led him to take an interest in an ephemeral and underrated form of expression that went back to the earliest days of mankind: graffiti. 'These abbreviated signs are none other than the origins of writing, these animals, monsters, demons, heroes, phallic deities are the elements of mythology, no less.' As a photographer, he responded to 'their mute appeal'[53] by recording them for posterity, before all memory of them was lost. As he pored over the signs scored into the crumbling plaster of Parisian walls, Brassaï was following in the tradition of Restif de La Bretonne, who used to engrave signs on the parapets of the Île Saint-Louis which he subsequently copied down and published in his book of *Inscriptions*.

Over a period of something approaching thirty years, Brassaï built up a collection of these inscriptions, sometimes watching to see how they were altered over time. He used to record their locations in small notebooks. His purpose in all this was to decipher an underlying meaning, and in his book on the subject he proposed the following classification. 'The world of graffiti sums up the whole of life: birth, love and death. Birth: the image of man, spelt out and identified for the first time; love in both its aspects: carnal and sentimental; death: decomposition, annihilation and adventure. Animism is omnipresent, conjuring up not only warriors, heroes and animals but also devils, sorcerers, fairies, phallic deities, monsters.'[54]

These signs, created out of the very substance of the wall, its cracks and scars, damp patches, unevenness and pitting, offered an early intimation of the type of Art Brut that was to be practised later by such painters as Jean Dubuffet and Antoni Tàpies. The favourable reception given to his graffiti photographs encouraged Brassaï in his belief that what mattered in art was not the artist but the work itself. The work of art 'stands alone and naked, like a conscript in front of a recruiting board, and it should be allowed to be its own judge. The way it was generated, its genealogy, the ambition or intention that inspired it, none of these has anything to do with its value, and can neither enhance nor reduce it, justify nor destroy it.'[55]

Yet Brassaï could not be content with what he called the 'honest industry of images'.[56] In mid-1937, it was his opinion that photography had 'brought me out of the shadows' and 'given me the momentum I needed' and he could envisage the time when he might even make 'a clean break' with photography.[57]

He was pulled in so many directions: drawing, sculpture, writing. He passionately wanted 'to preserve the amateur's freshness of vision, coupling it every time with the knowledge and awareness of the professional … it is in this inconsistency that its consistency lies'.[58]

Of drawing, Brassaï said, 'I have always practised it.'[59] He studied under János Máttis Teutsch at the Academy of Fine Arts in Budapest, then at the Akademische Hochschule in Berlin. By the end of 1921, he felt that a year

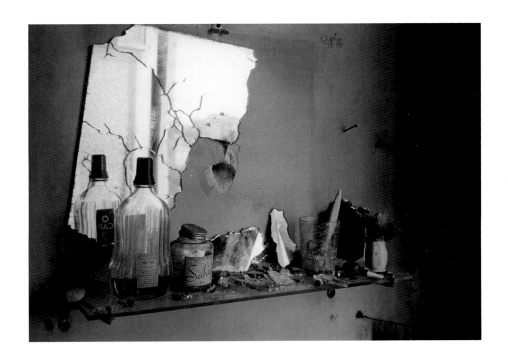

The Bathroom Mirror, 25 August 1944

57. Brassaï, 'Cahier jaune' (journal), entry for 27 June 1937. See p. 172.

58. Brassaï, 'Incohérence et plénitude', typescript dated 4 April 1960, Gilberte Brassaï Archives.

59. Viviane Berger, 'Brassaï par Brassaï', *Jardin des arts*, Paris, no. 209, 27 March 1972.

60. Brassaï, *Elöhívás, op. cit.*, letter of 2 December 1921.

61. Brassaï, *Picasso & Co., op. cit.*, p. 131.

62. *Ibid.*

63. Brassaï, typescript, April 1960, Gilberte Brassaï Archives.

64. *Le Monde*, 18 March 1960.

65. *France Observateur*, 24 March 1960.

had been long enough for him to acquire an adequate mastery of pictorial technique.[60]

The few drawings that survive from this apprentice period reveal a rather individual talent, although the style of his nudes has echoes of the prevailing Expressionism. He wielded pencil and rubber with considerable energy, seeming to concentrate all his attention on the lines of force running through the human body, whose 'monumentality' he succeeded in capturing very well.

A few years later, in 1933, Brassaï began to develop a more fluid style, reliant on a slender curving line. But, he explains, it was not until 1943, at his friend Picasso's insistence, that he took up drawing again: 'Without his persuasion, I would probably never have gone back to it.'[61] Certainly his output was considerable during the years 1944 and 1945.

The exhibition held at the Galerie Renou et Colle in May 1945 could easily have been a turning-point. Picasso had acted as his intermediary with the gallery owner; Jacques Prévert wrote an introductory poem for the album published by Pierre Tisné; André Dunoyer de Segonzac and Jean Cassou were enthusiastic. But Brassaï never really persevered with drawing, preferring to go back to the activity that was most definitely not his 'second profession', photography.[62]

'Doubtless it doesn't add up to a coherent body of work, as the heavyweight critics like to put it',[63] he remarked when he repeated the experiment some fifteen years later at the Galerie du Pont Royal, this time incorporating sculpture as well. The reviews were mixed. 'His drawings, whatever their highly subjective distortions, are rather passionless exercises', wrote *Le Monde*'s reviewer.[64] Generally they preferred his sculpted pebbles, which were 'more subtle and more appealing'.[65] The point they all made was his concern to lay bare underlying rhythms and

articulations 'in a series of synthetic gestures'.[66] Brassaï was later to compare himself with the 'plunderer of beauty of all kinds, a thief who, with a click of the shutter, a slow polishing of the stone, a carefully drawn line, captures the thing that has enthralled him'.[67] He notes that, as the impact of the pebbles was 'neither visual nor auditory, but tactile, the only way to express it was through sculpture'.[68]

The governing imperative was always the same. 'You need to remove all the excess fat from the image, say what you have to say as clearly as possible, be decisive as to where you avert and where you direct your eye',[69] in much the same way as the anonymous graffiti artist adds a line to emphasize the figure that has emerged from the cracks and pitting of a wall. Using this method, the majority of the pebbles tended to metamorphose into women, with each one, smoothed and eroded by the sea, suggesting 'the swell of the belly, the gentle dip of the back, the curve of the hips, the fullness of the rump, the rise of the breasts and the line of the thighs'.[70] One can only admire the extraordinary stylistic homogeneity of these nudes. Drawings, sculptures and photographs all exhibit the same 'reduction to essentials',[71] which in consequence emphasizes 'the body's swelling contours, volcanoes of alabaster skin, stony rumps, granite breasts … all those fleshy protuberances, all those joints and hollows and spurs, heights and depths, slopes and inclines, curves and plenitudes'.[72]

What you pick up from these works is the sense of a powerful, brooding fascination with the mysteries of the female body, something that might seem a long way removed from the approach to photography Brassaï himself recommended. Yet there is still that same desire to extract from transitory forms an image of universal significance, the same desire to create an accurate likeness (accurate because rooted in reality) within a vision of reality achieved in a spirit of total self-effacement, in which 'without any intervention on the author's part, the character appears in his true light'.[73]

This obsessive quest for 'likeness' has a twofold provenance, the one literary, that of the solitary walker, going back to Restif de La Bretonne's *Les Nuits de Paris*; the other pictorial, that of the chronicler of social reality, from Debucourt and Saint-Aubin to Constantin Guys, Gavarni, Eugène Lami and the unhappy Octave Tassaert, and even Robert Doisneau.

Long familiar to historians of Paris is the figure of Restif de La Bretonne's Monsieur Nicolas, wrapped in his cape and with the air of an owl. Every night he would watch the merry-go-round of girls and clients under the arcades of the Palais-Royal and then, being unsatisfied by this spectacle, slip noiselessly into their apartments to observe how 'they outraged nature by indulging their bizarre desires'.[74]

The pictorial tradition in question is the painting of manners, which exists alongside the major genre of history painting. According to Baudelaire, it was of 'particular beauty, circumstantial beauty', portraying 'life's trivia … the day-to-day metamorphosis of the external world' at a speed 'that demands an equal rapidity of execution on the part of the artist'.[75]

66. *Combat*, 31 March 1960.

67. Brassaï, typescript, 4 April 1960, Gilberte Brassaï Archives.

68. Brassaï, undated typescript, Gilberte Brassaï Archives.

69. Brassaï, typescript, 10 December 1951, Gilberte Brassaï Archives.

70. Brassaï, 'Sculptures latentes', typescript, 1968, p. 2, Gilberte Brassaï Archives. See also p. 200.

71. R. Charmet, *Le Nouveau Journal*, 16 March 1968.

72. Brassaï, 'Ciels postiches', typescript, 1933, Gilberte Brassaï Archives.

73. Brassaï, typescript, 22 July 1971, Gilberte Brassaï Archives.

74. Ned Rival, *Restif de La Bretonne*, Perrin, Paris, 1982, p. 107.

75. C. Baudelaire, 'Le peintre de la vie moderne', *op. cit.*, p. 440.

How can we fail to see in this, if not an actual manifesto statement, then at least a recognition of the fact that the old days were over: a thumbnail sketch in the margin of a sale catalogue done by Gabriel de Saint-Aubin, a drawing in lithographic pencil by Gavarni or Guys, was now superseded by the infinitely rapid reaction time and indiscreet eye of the camera. But is speed synonymous with fidelity? Brassaï comments that the work of these painters of manners is not without its literary dimension, that an artist like Guys 'is an "occasional" painter, with all the literary connotations that term implies'. The painter of modern life could not escape such 'connotations': 'observer, idler, philosopher, call him what you will…. Sometimes he is a poet, or, in subtler vein, more like a novelist or moralist.'[76]

To describe Brassaï as a moralist is perhaps inadvisable, given that today the word tends to be used in a rather pejorative sense. Brassaï a moralizer, a critic of moral depravity? Surely not. But keen to portray life in its own light, certainly. In 1952 he wrote, concerning *L'Histoire de Marie*, 'I wanted to portray life in its true light. All I was concerned with was creating not just a likeness, but a complete likeness.'[77] 'My difficulties were in a sense all one: giving form to the ramblings of Marie, which had none…. The meaning of art is not authenticity, it seems to me, but the expression of authenticity. Thus, truthfulness alone offers no justification or excuse. As the object is quite simply inimitable, it is always a matter of finding the only interpretation of it that is valid in another language. Moreover, it is precisely the difficulty of being faithful to the object, and the fear of betraying it (for every literal translation is a betrayal) that forces us to re-create or reinvent it. It can take us far, the obsessive pursuit of a likeness (whatever people may think of that today), much farther than the imagination or free invention.'[78]

Brassaï a moralist? Certainly, at least in the sense that the word is used to describe Montaigne, Pascal or La Rochefoucauld, men who studied 'human manners, human nature and the human condition'.[79] He is also a moralist in the modern sense, for what makes his observations so acute is their intimate combination of 'the transitory, the fleeting, the contingent, the eternal and the immutable'.[80]

76. *Ibid.*, p. 443.

77. Brassaï, typescript, 18 February 1952, Gilberte Brassaï Archives.

78. *Ibid.*

79. Petit Robert dictionary, Paris, 1967.

80. C. Baudelaire, 'Le peintre de la vie moderne', *op. cit.*, p. 452.

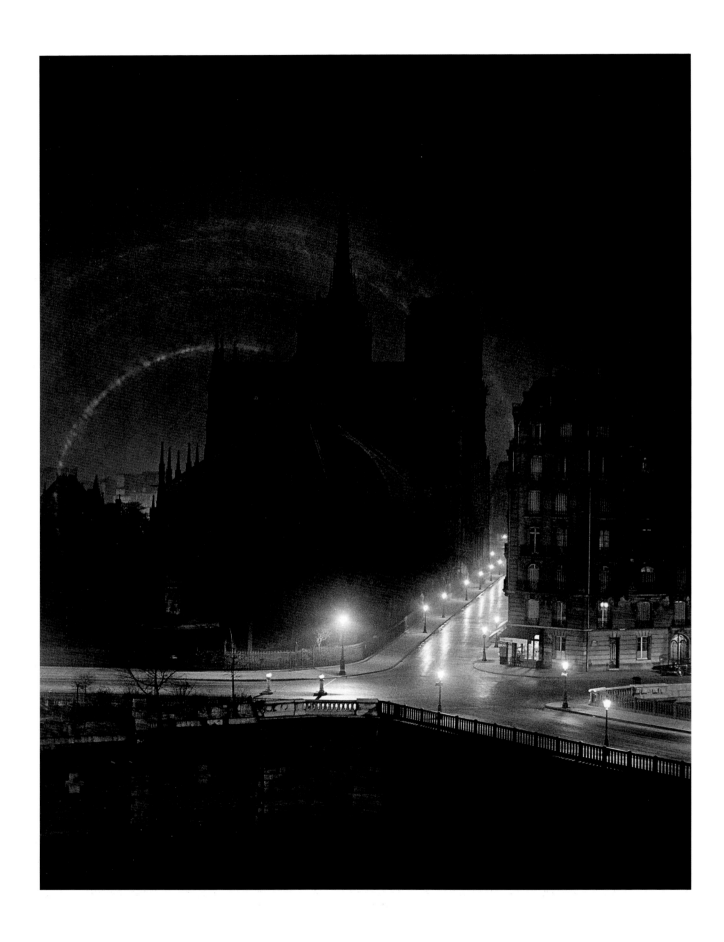

Notre-Dame, c. 1930–32

1932 **Paris after dark**

From the images of *Paris after Dark* to those of *The Secret Paris of the 30's*

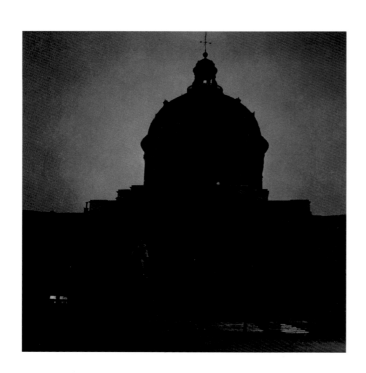

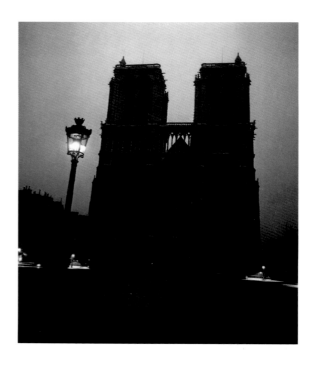

The Institut de France, 1939

Notre-Dame, 1939

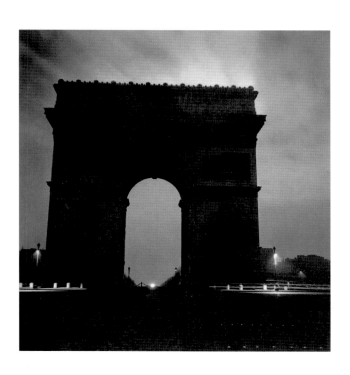

The Arc de Triomphe, 1939

Saint-Germain-des-Prés, 1939

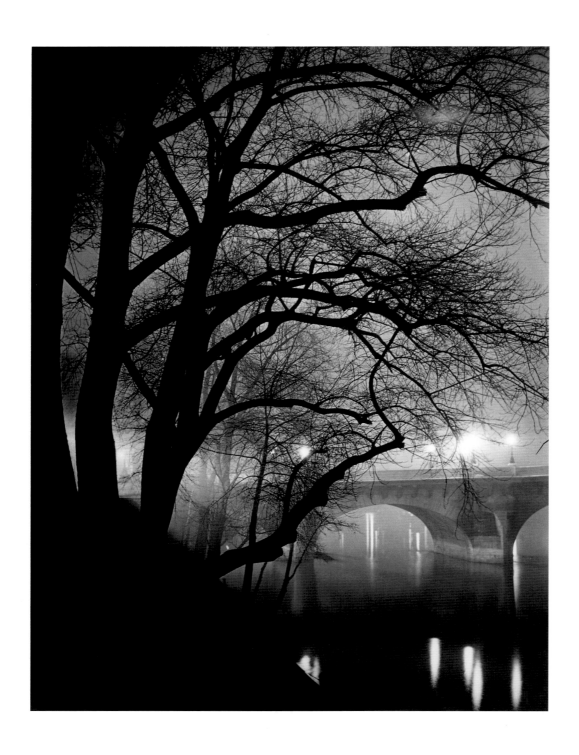

The Pont-Neuf, c. 1932

The Quai de Conti, c. 1930–32

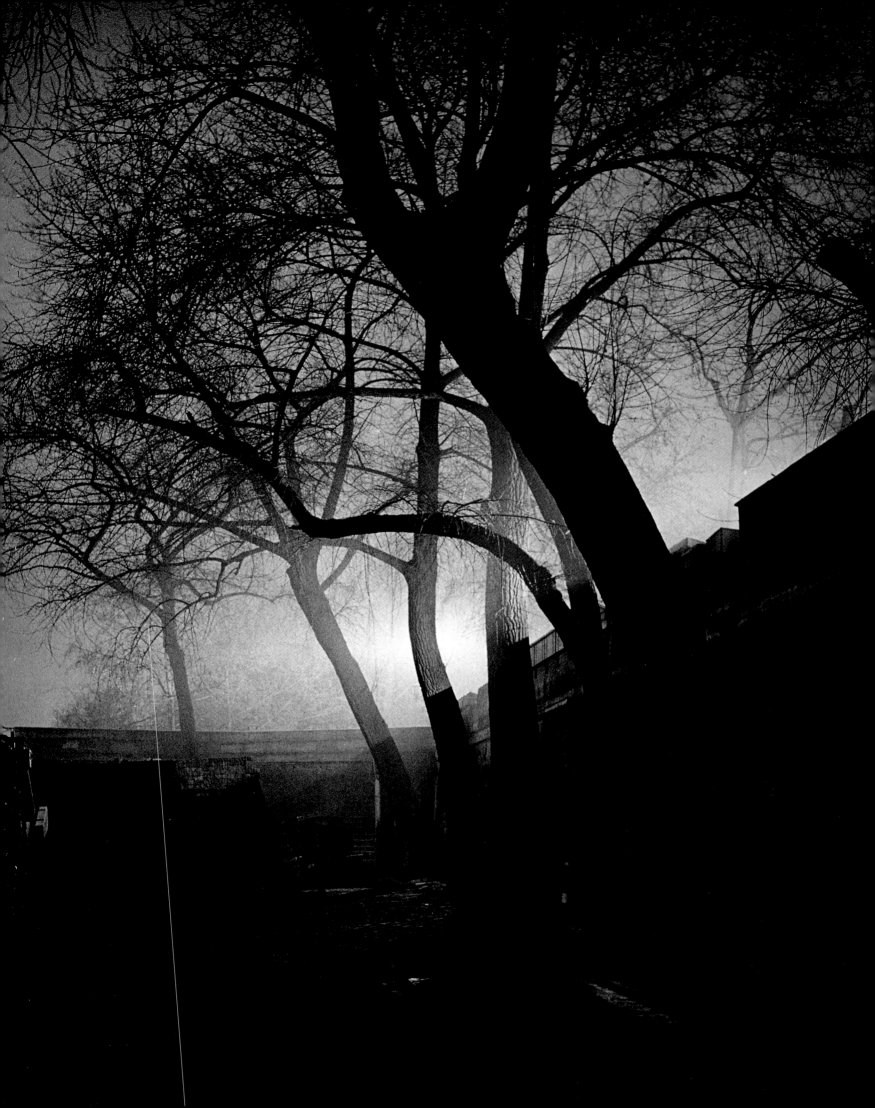

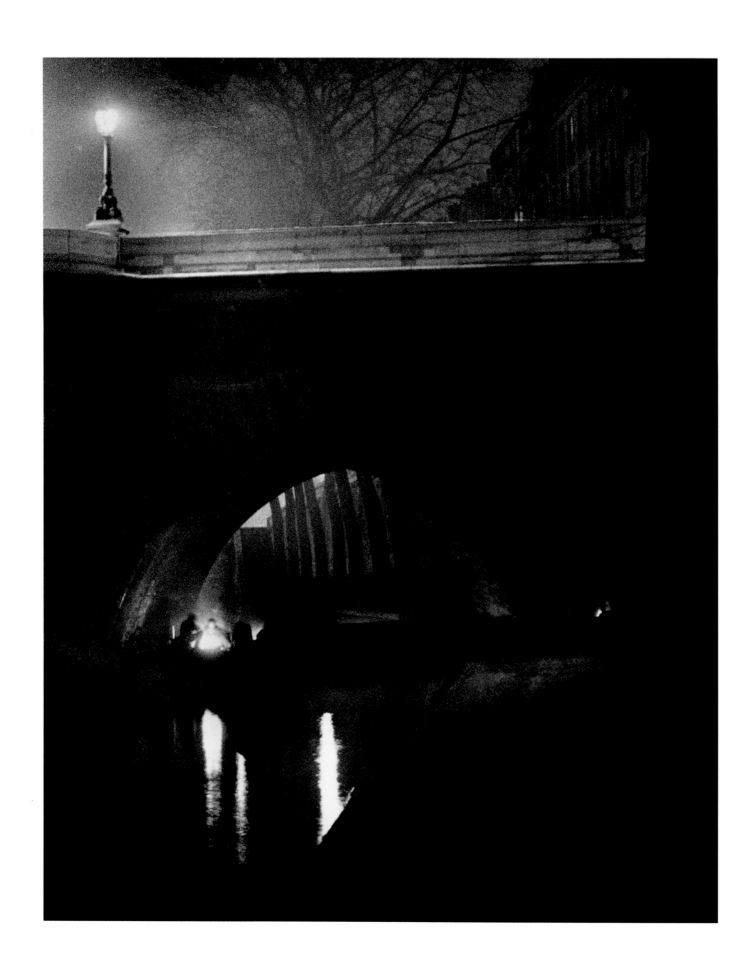

The Pont-Neuf, c. 1930–32

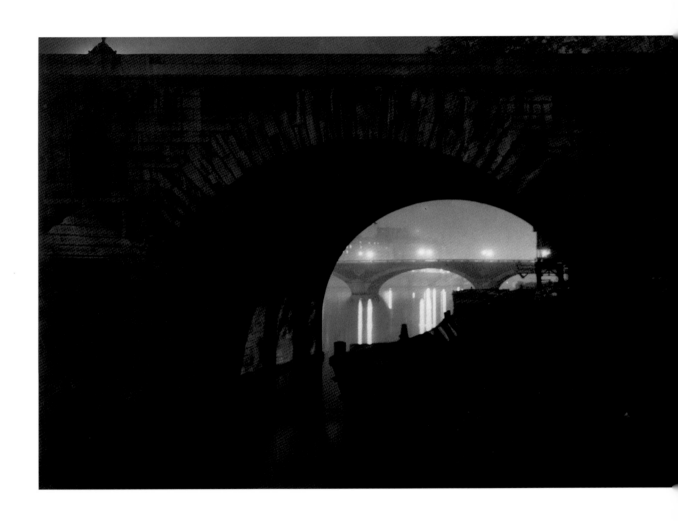

The Pont Marie, c. 1931–32

The Pont-Neuf in the Fog, c. 1934–35

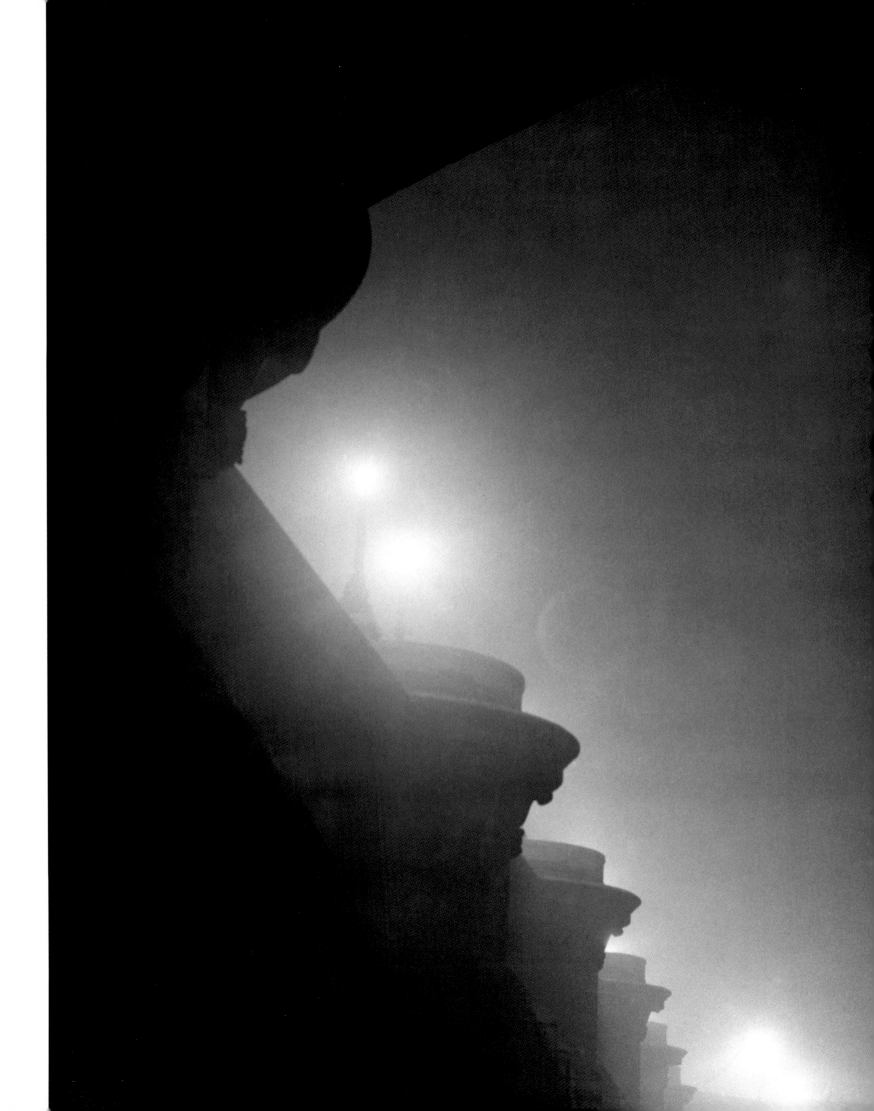

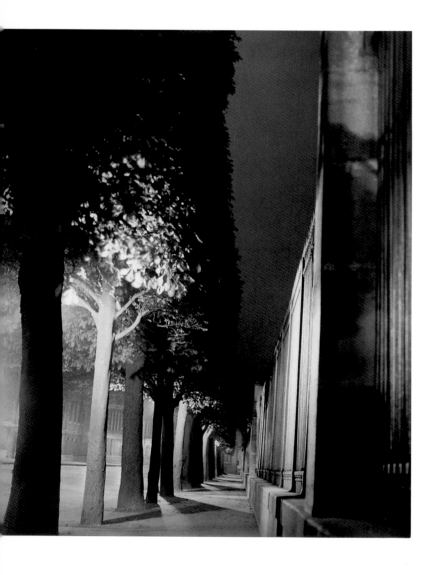

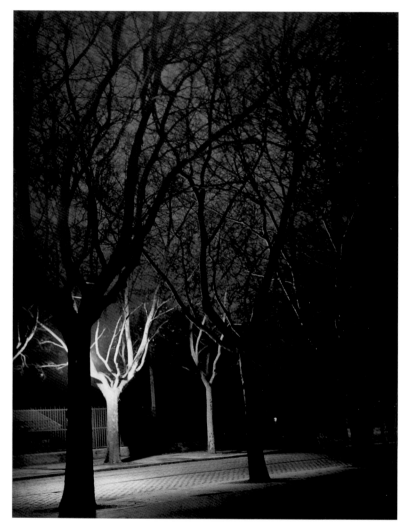

*The Edge of the Jardin du Luxembourg
on the Rue Auguste-Comte, c.* 1931

The Quai de Bercy, c. 1932

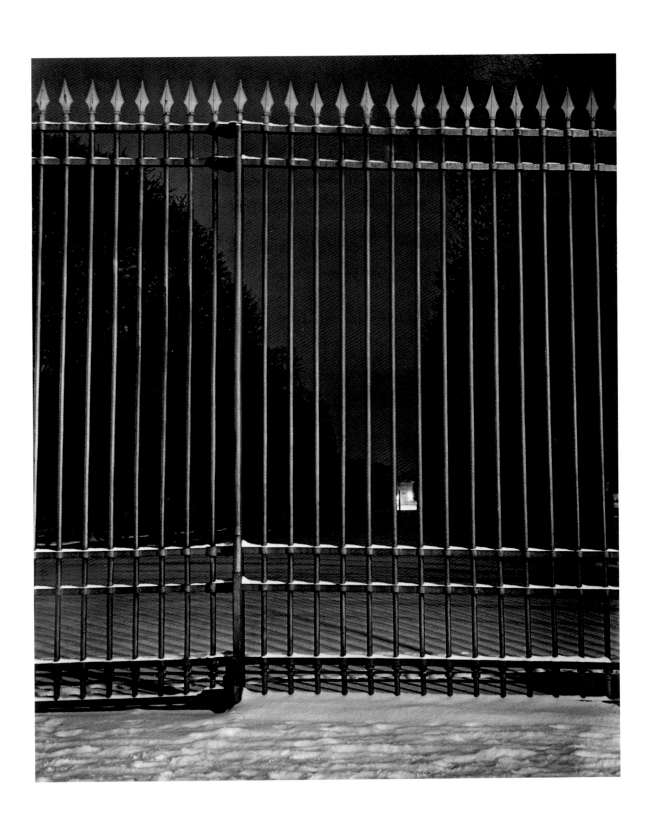

The Jardin du Luxembourg, c. 1935–38

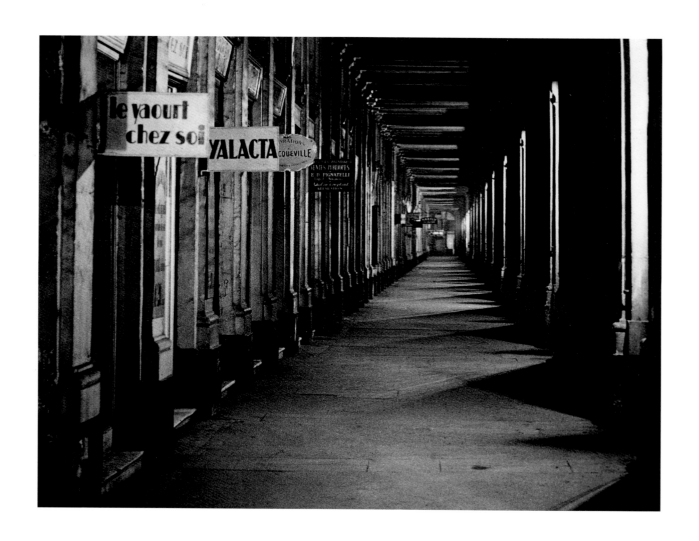

The Passage du Palais-Royal, 1932

The Viaduc d'Auteuil, 1932

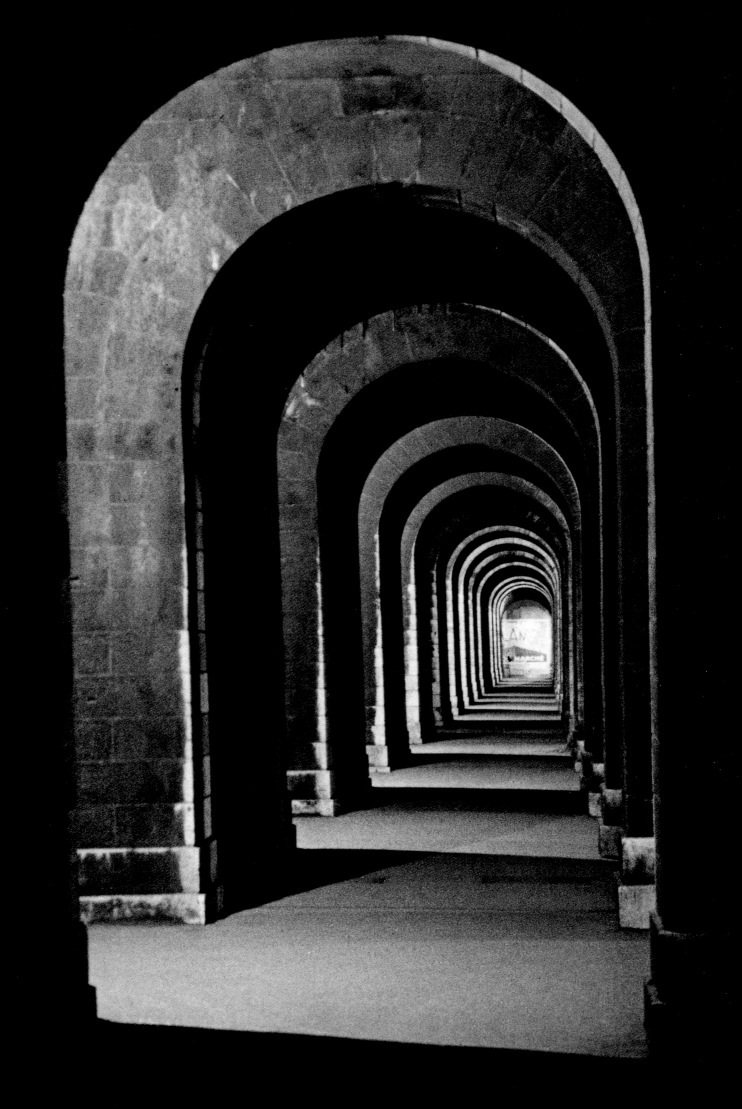

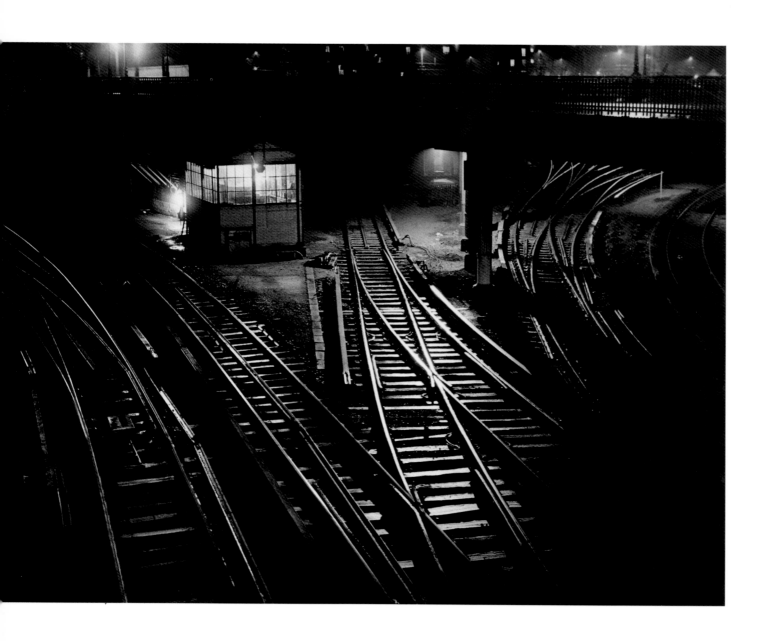

The Gare Saint-Lazare, c. 1932–33

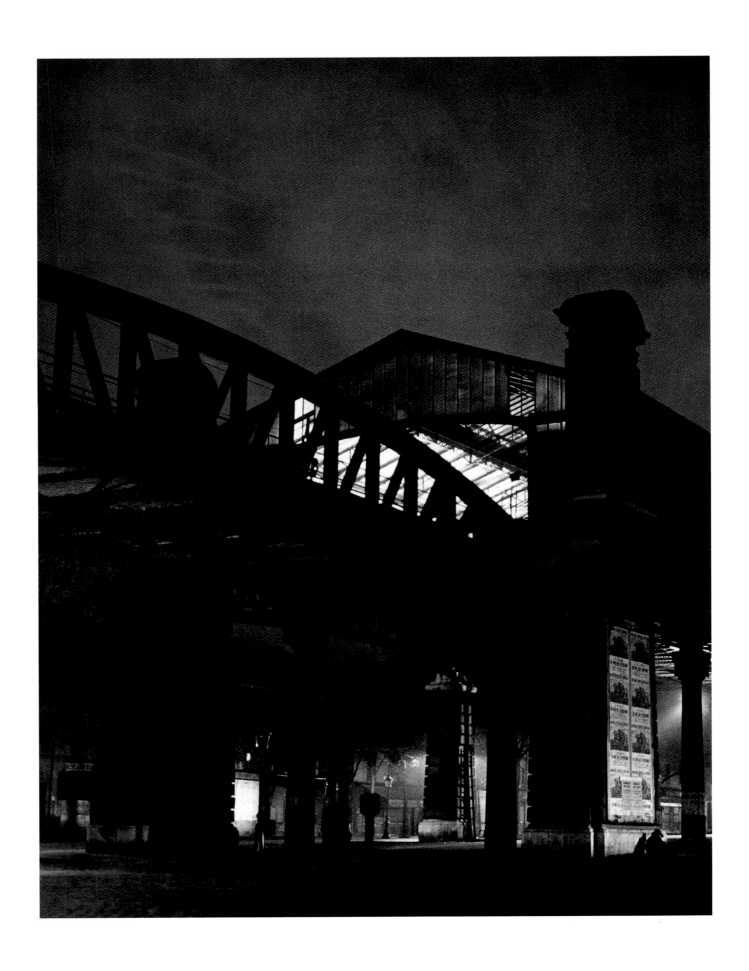

Glacière Metro Station, c. 1930–32

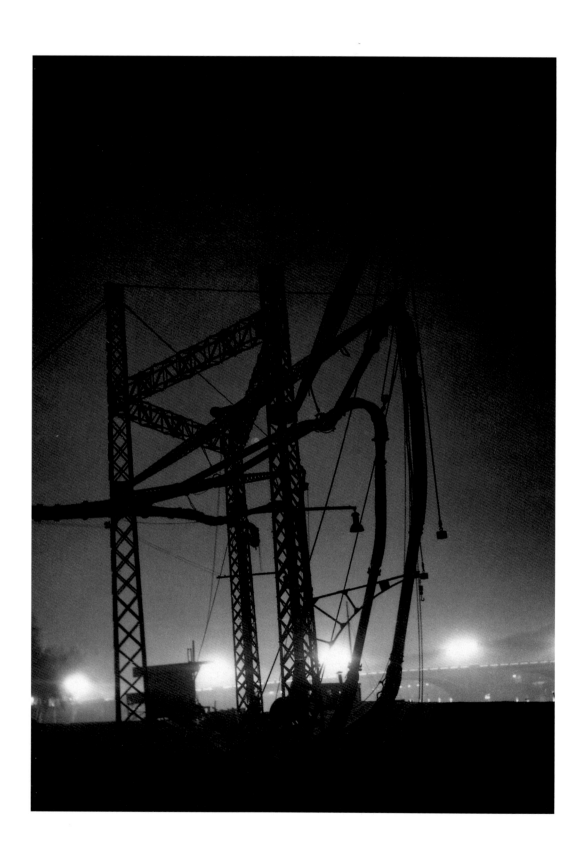

The Grands Moulins de Paris, Quai de la Gare, c. 1932–33

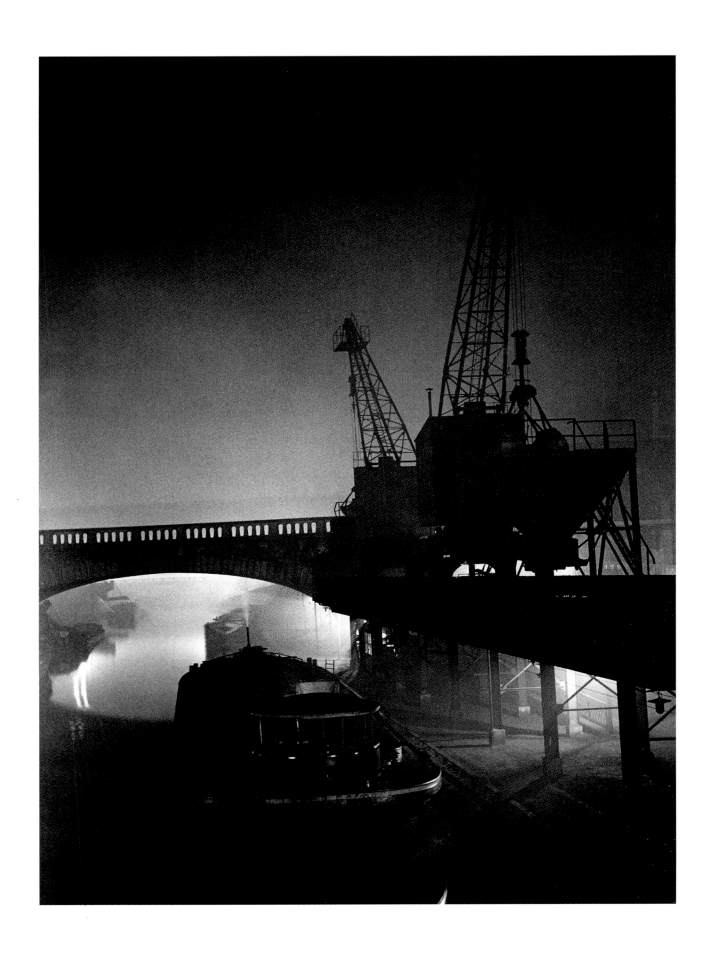

The Canal Saint-Denis, c. 1930–32

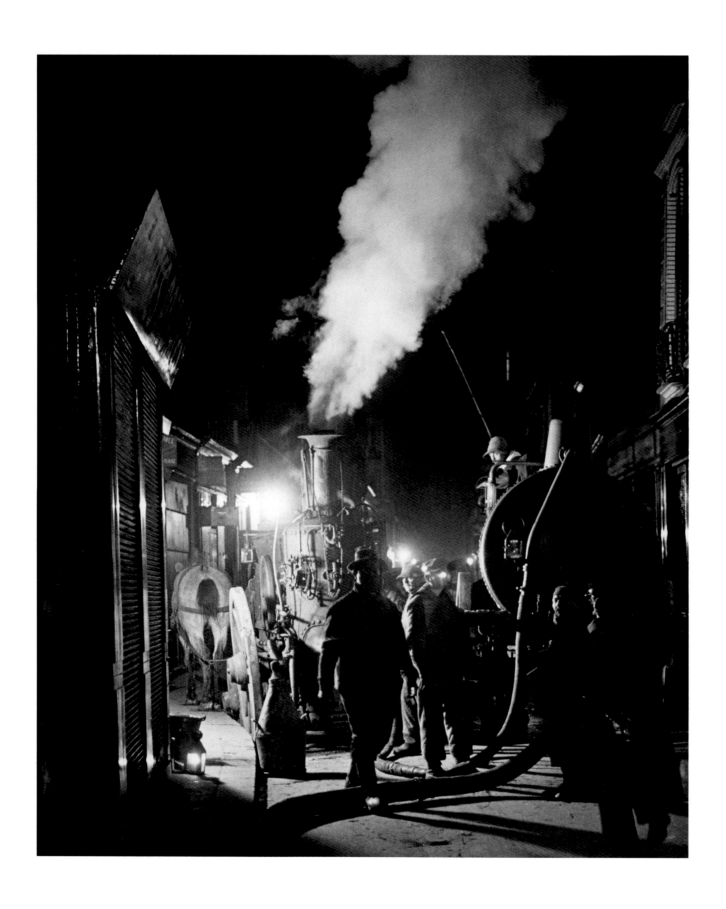

The Cesspool Cleaners and Their Pump, Rue Rambuteau, c. 1931

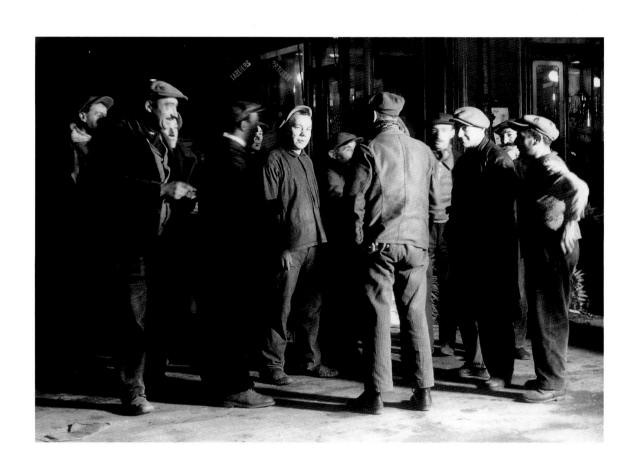

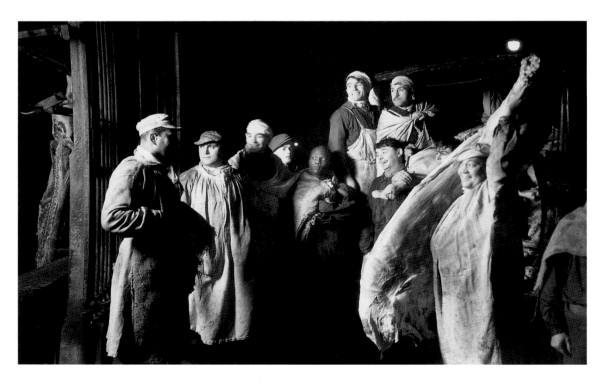

Unemployed Workers at Les Halles, c. 1932

Market Porters at Les Halles, c. 1935

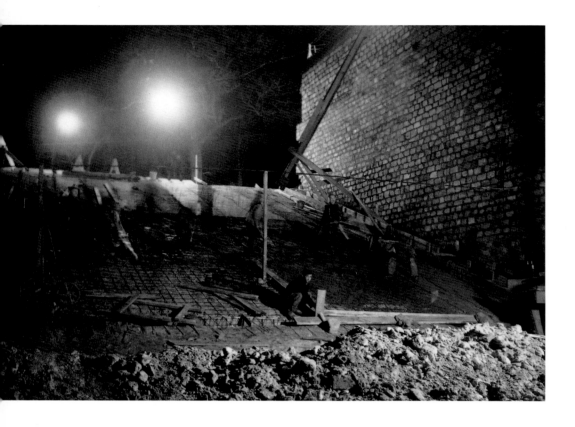

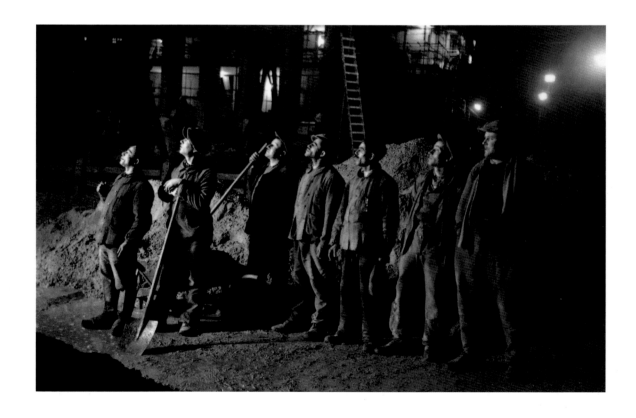

Building Site, Paris, c. 1932

The Baker, c. 1930–32

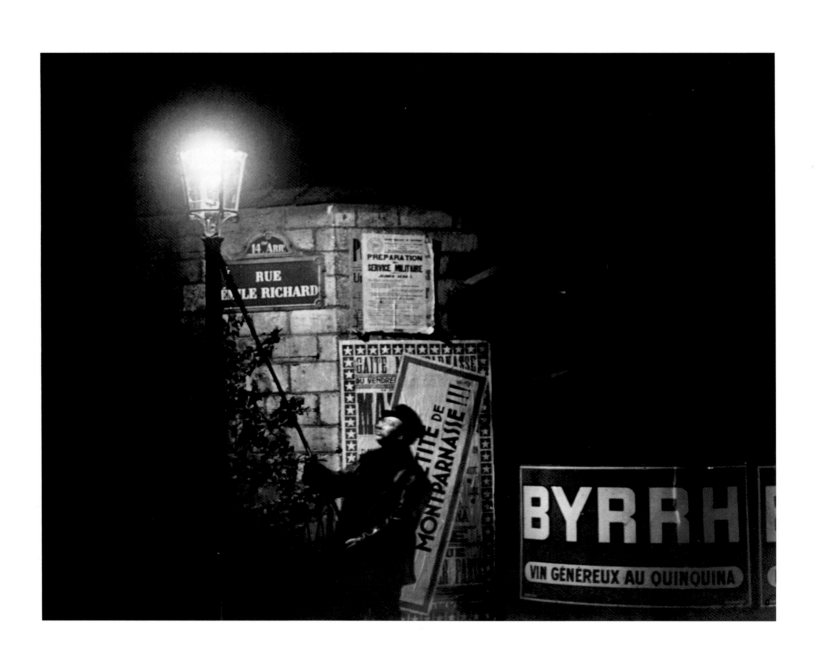

Lamplighter at the Corner of the Rue Émile-Richard and the Boulevard Edgar-Quinet, c. 1931

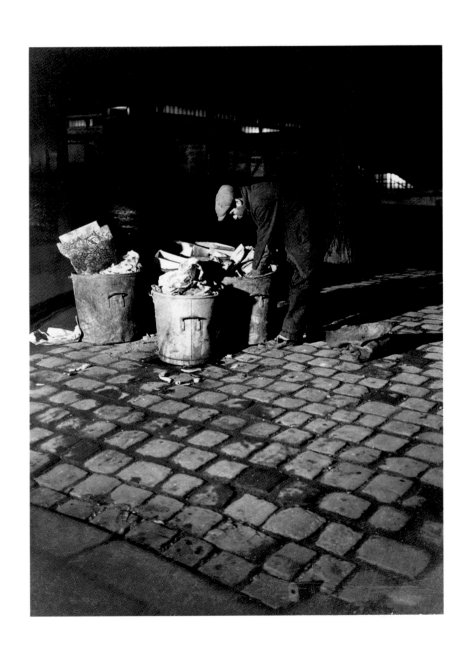

The Rag-picker, c. 1931–32

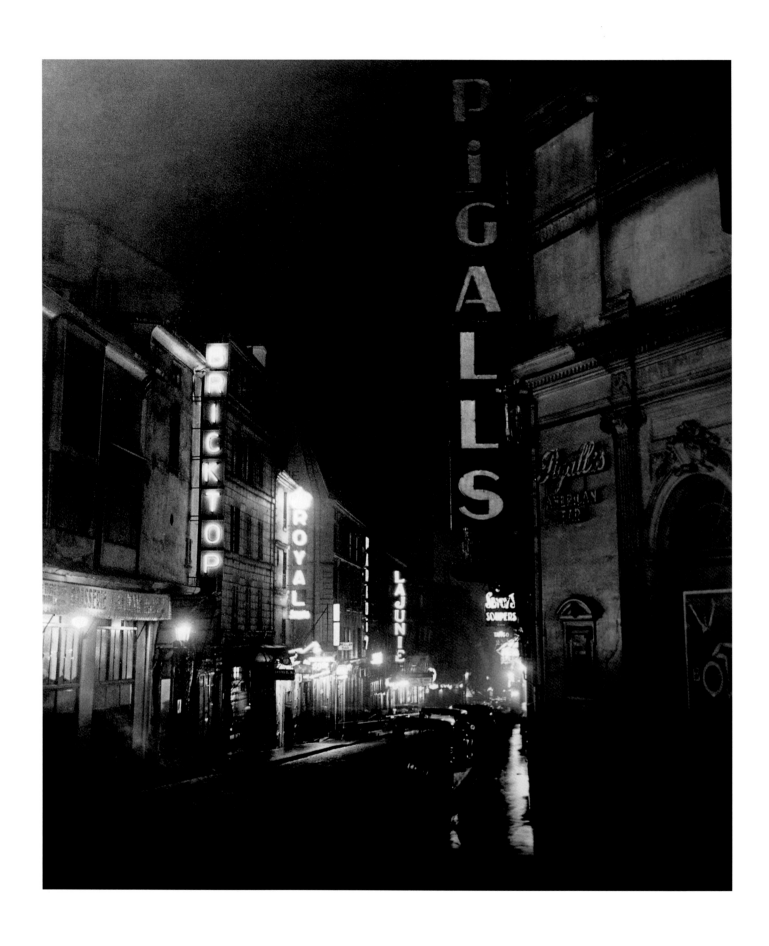

Pigall's American Bar, c. 1930–32

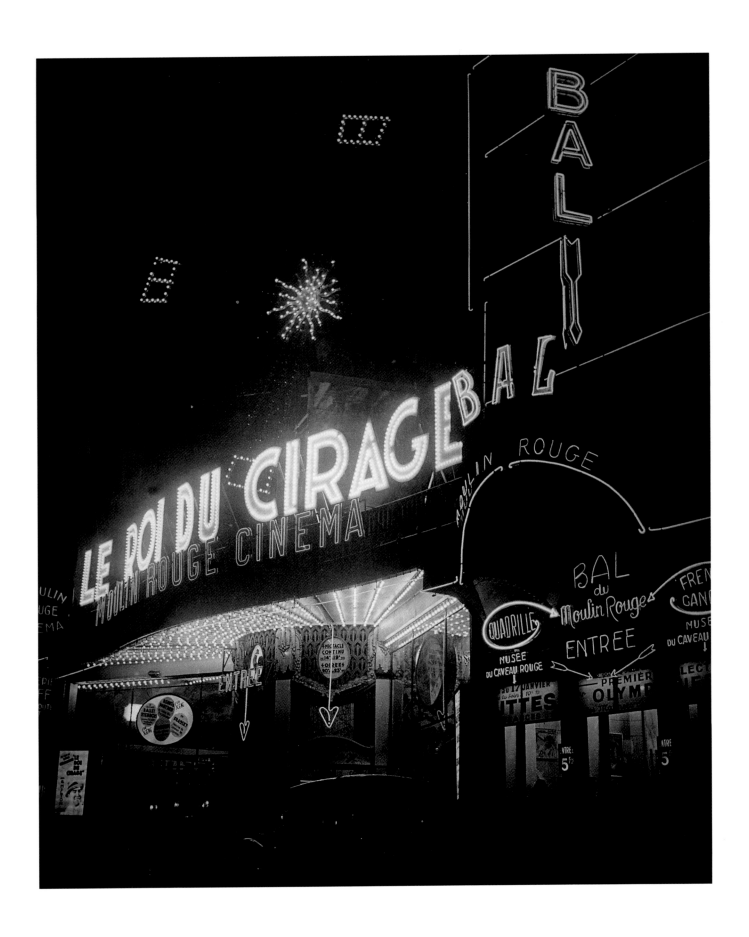

Bal du Moulin Rouge, c. 1930–34

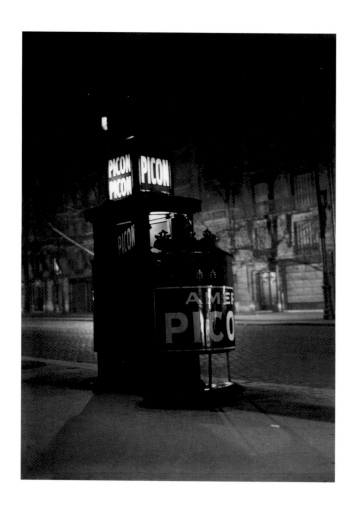

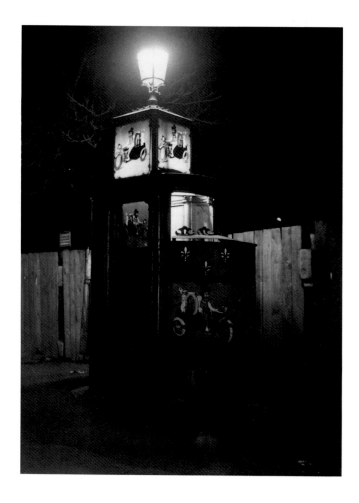

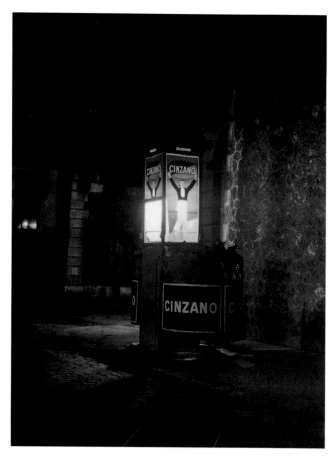

Public Urinals, c. 1932

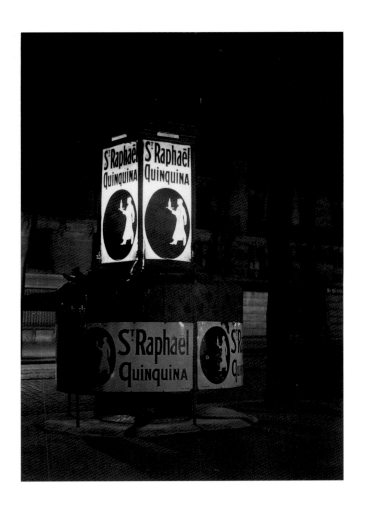

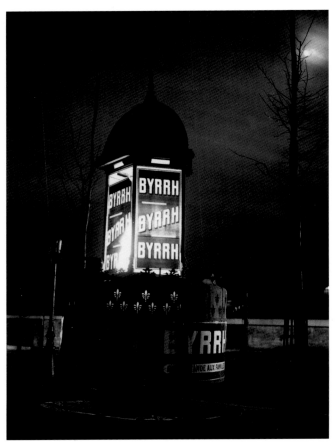

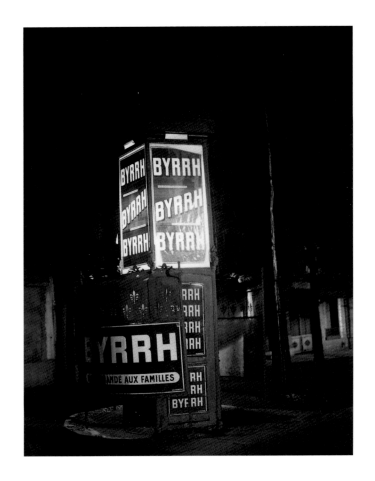

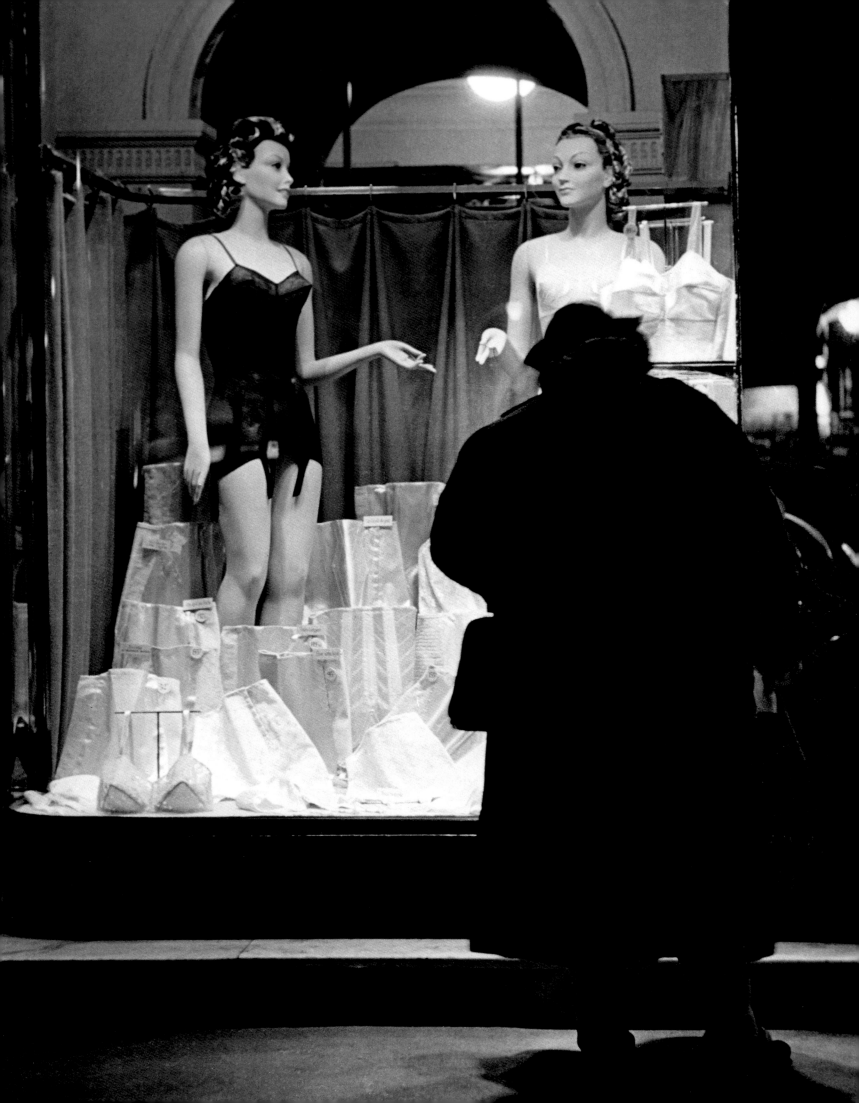

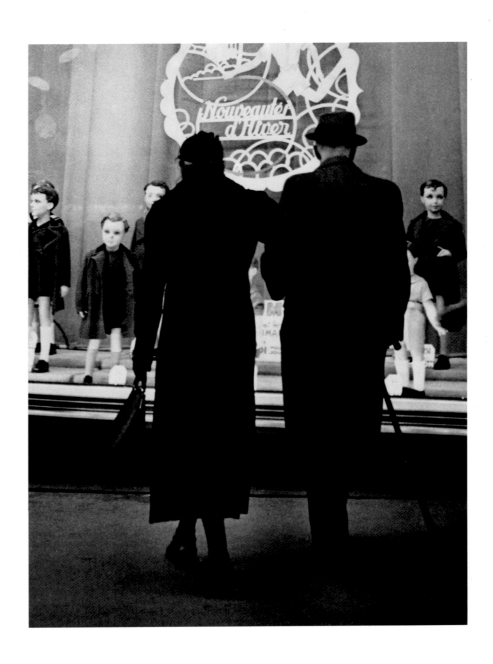

On the Grands Boulevards, c. 1934 Tom's Childrenswear, c. 1934

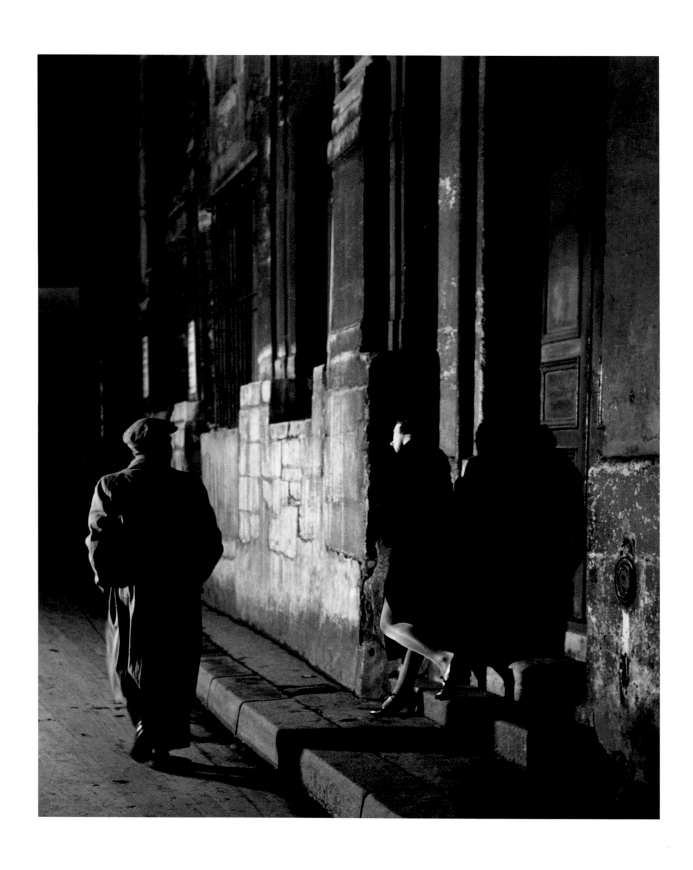

The Pick-up, near Les Halles, c. 1932

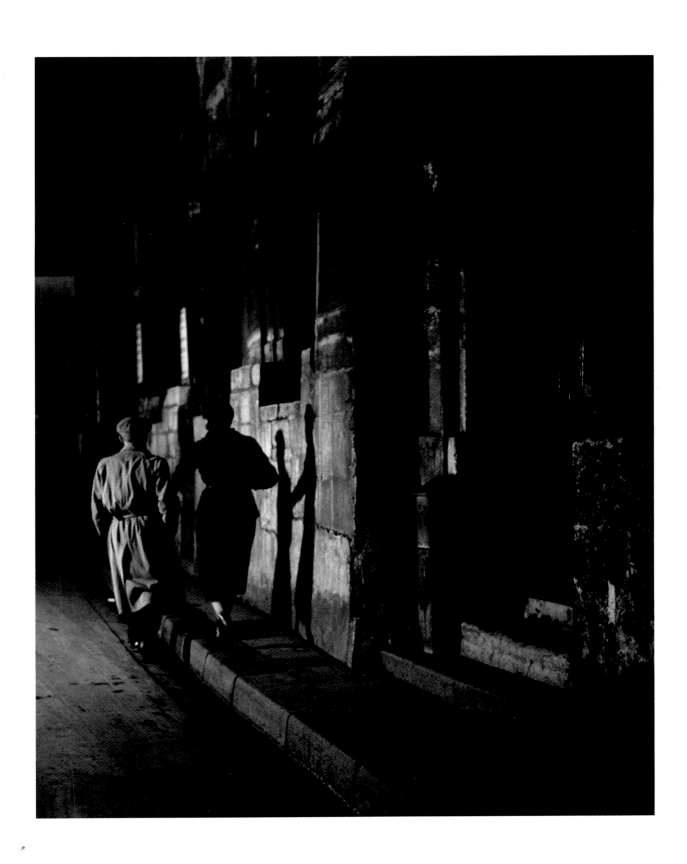

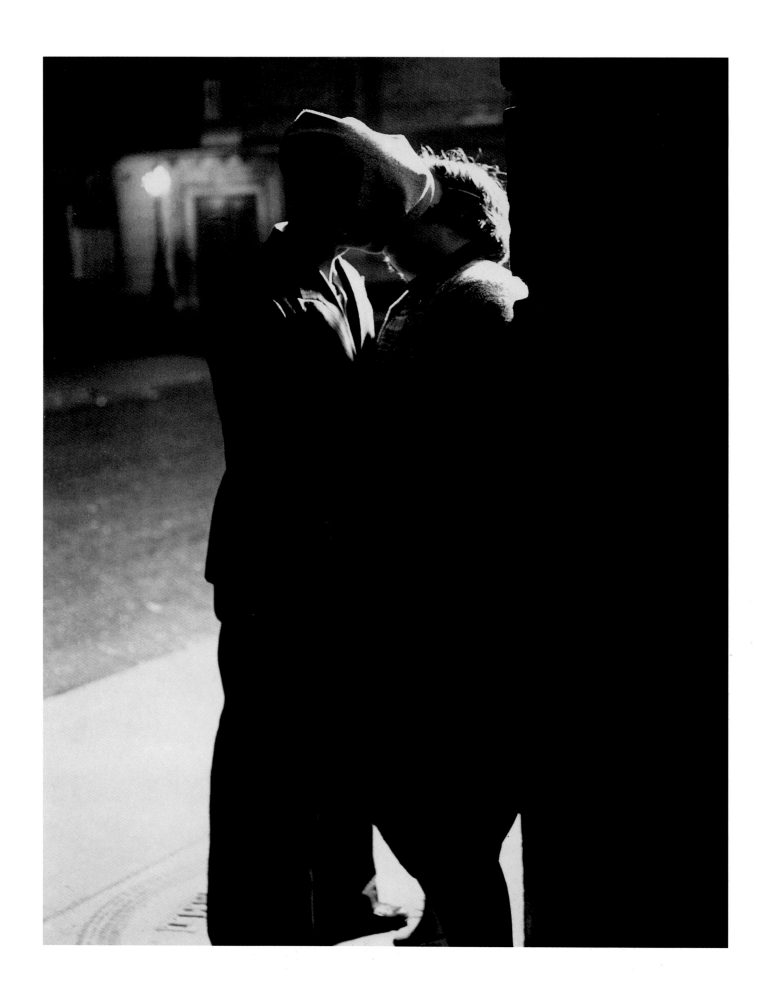

Near the Place d'Italie, c. 1932

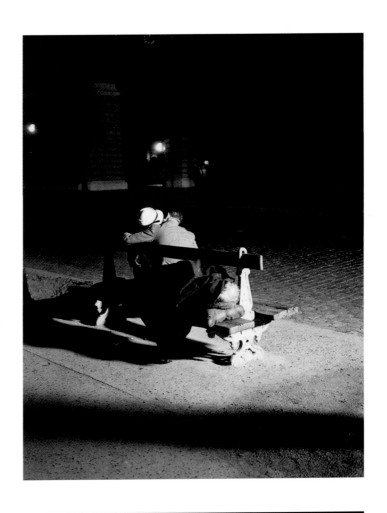

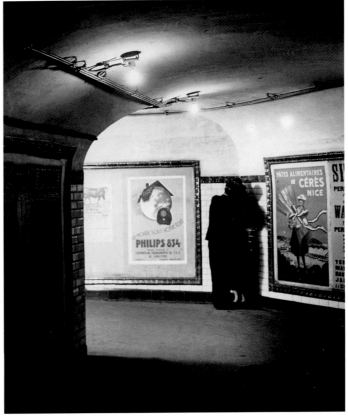

Boulevard Saint-Jacques, c. 1932

Passageway in the Metro, c. 1932–34

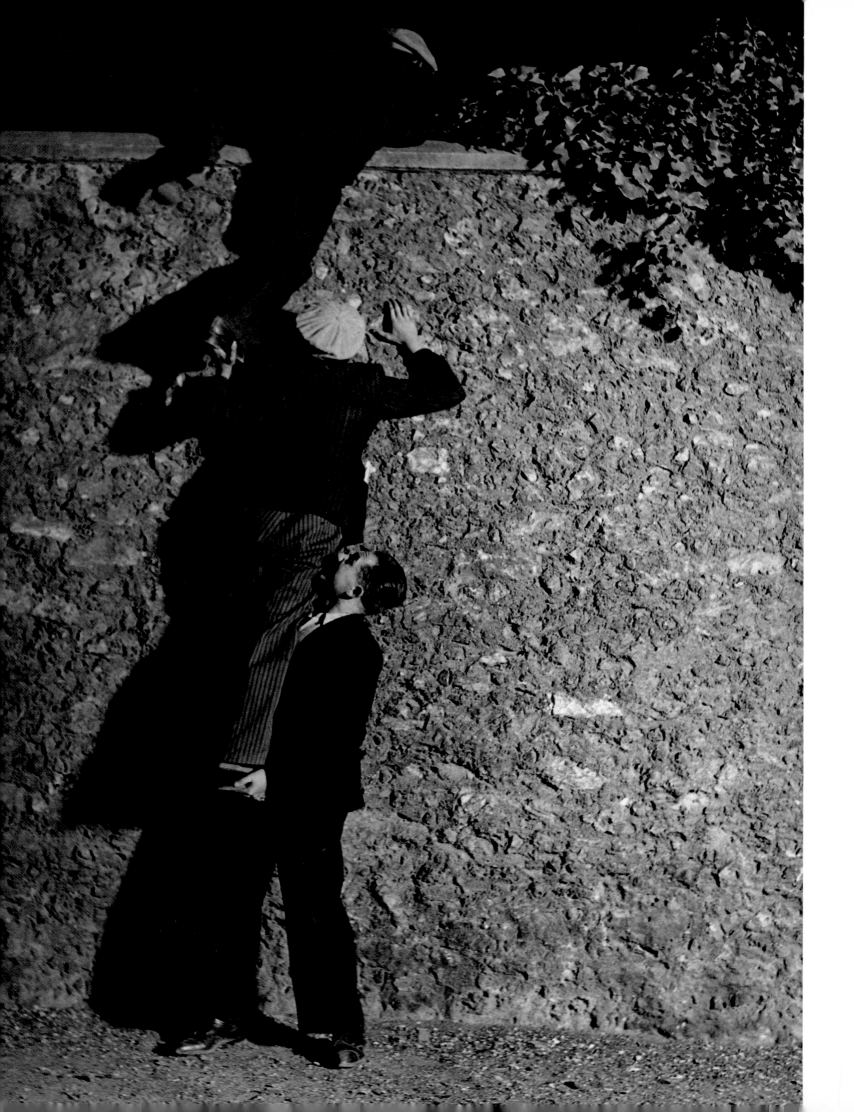

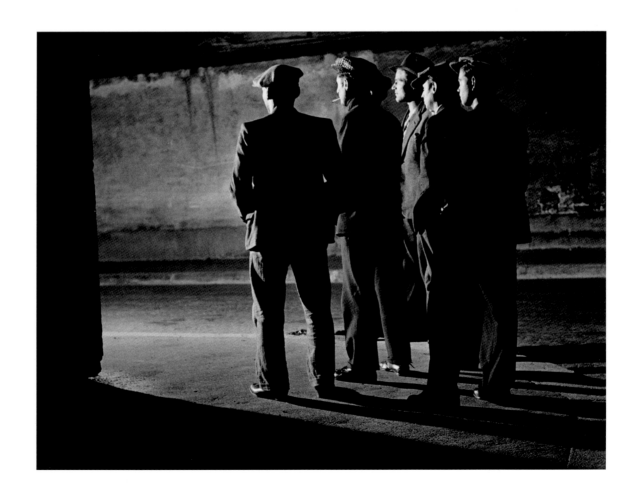

For a Detective Story, 1931–32

Big Albert's Gang, near the Place d'Italie, c. 1931–32

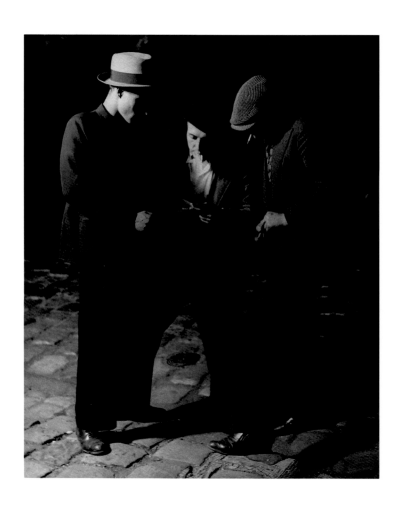

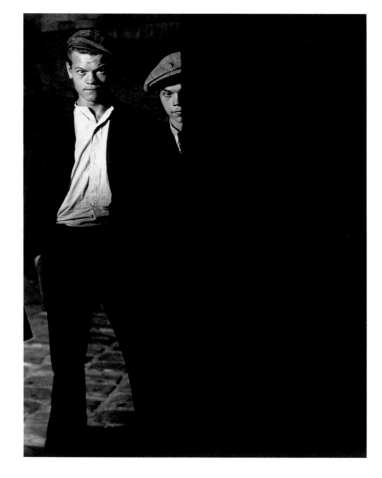

Toughs in Big Albert's Gang, c. 1931–32

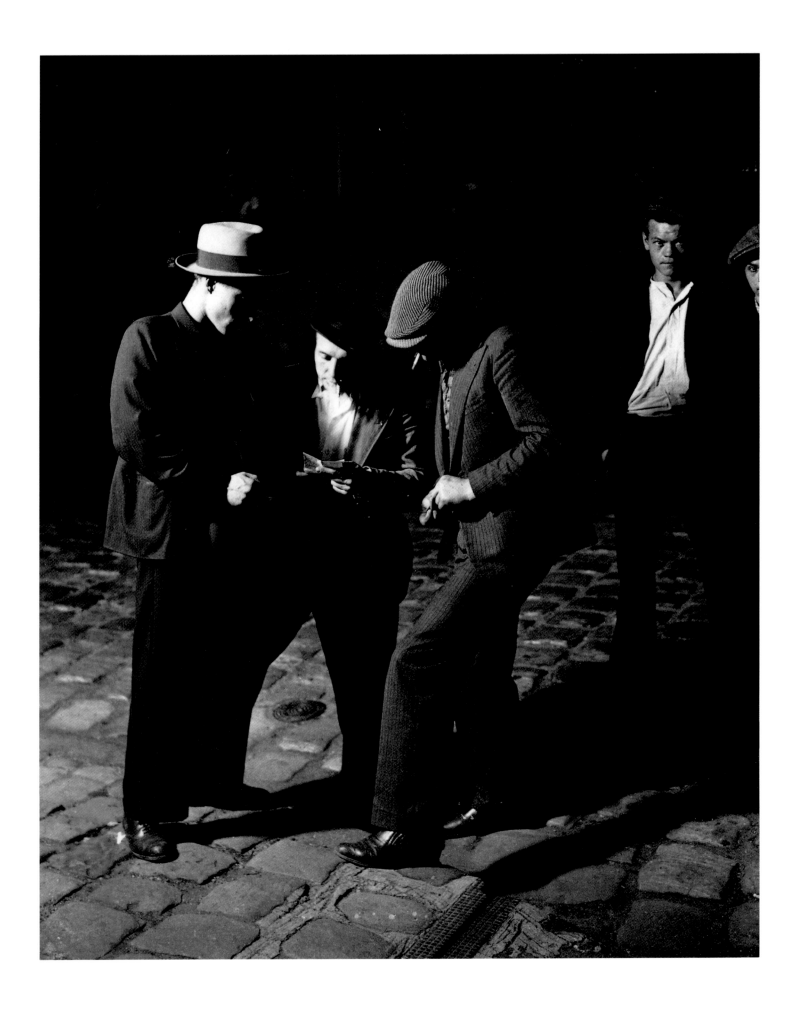

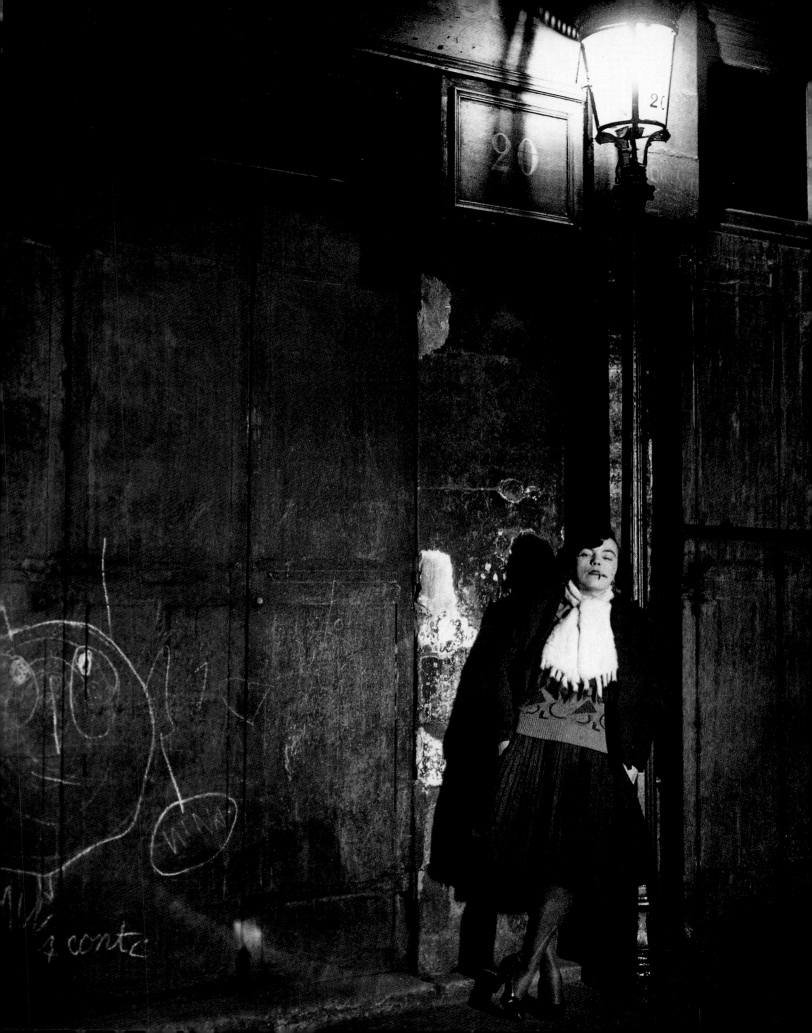

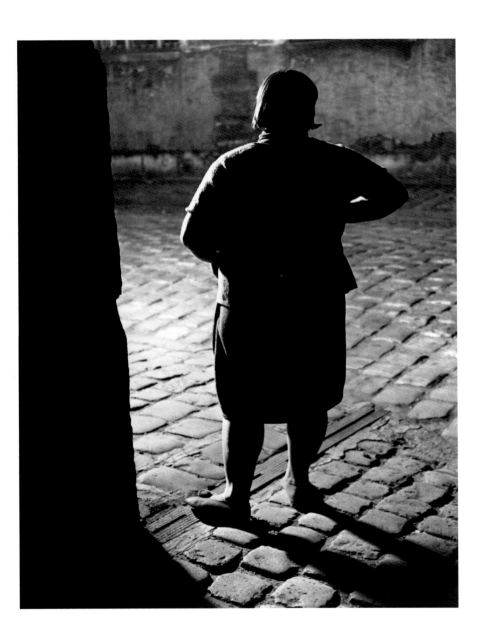

Streetwalker, near the Place d'Italie, 1932

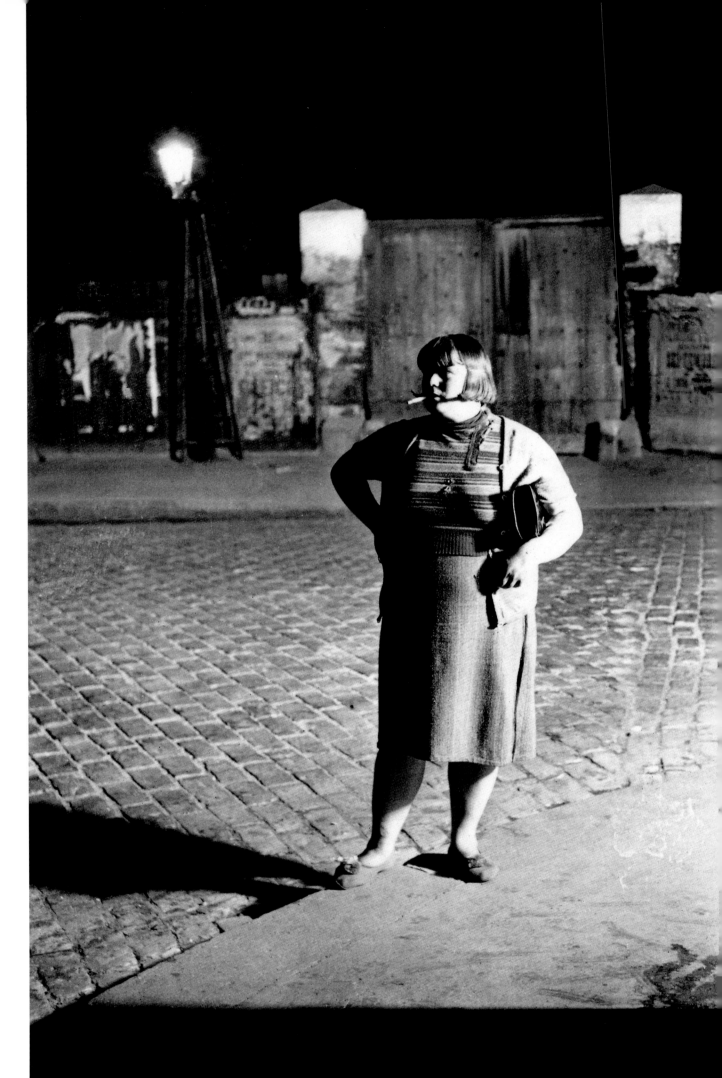

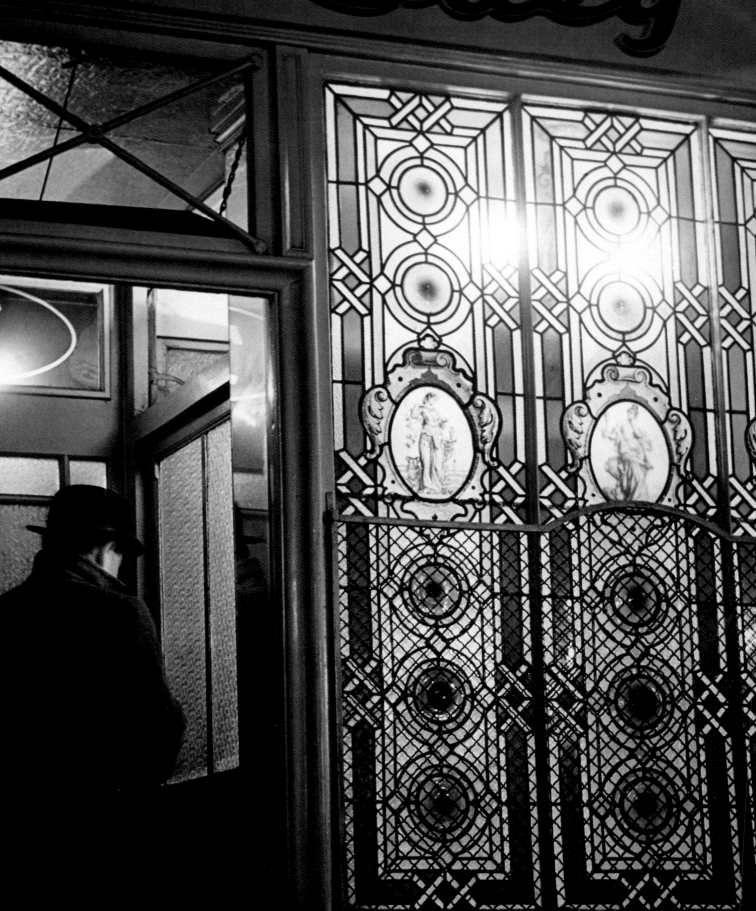

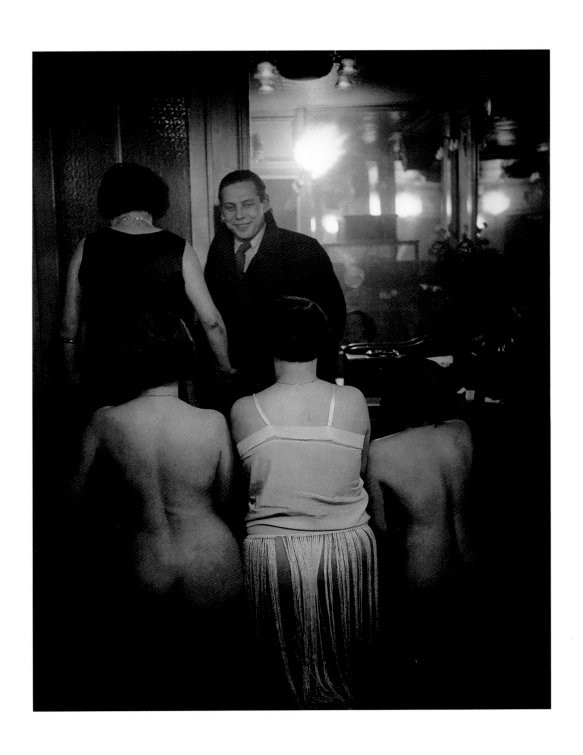

At Suzy's, Rue Grégoire-de-Tours, c. 1932

The Introduction, at Suzy's, Rue Grégoire-de-Tours, c. 1932

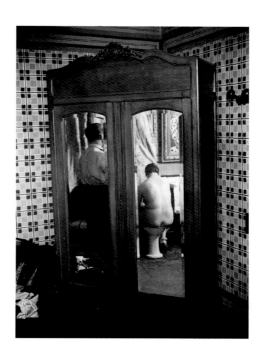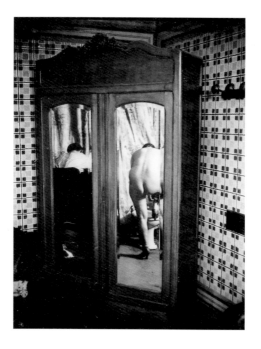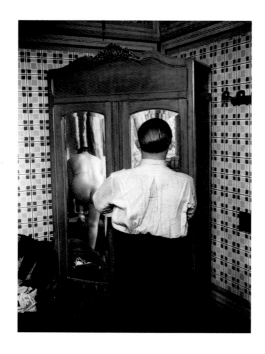

In a Brothel, Rue Quincampoix, c. 1932

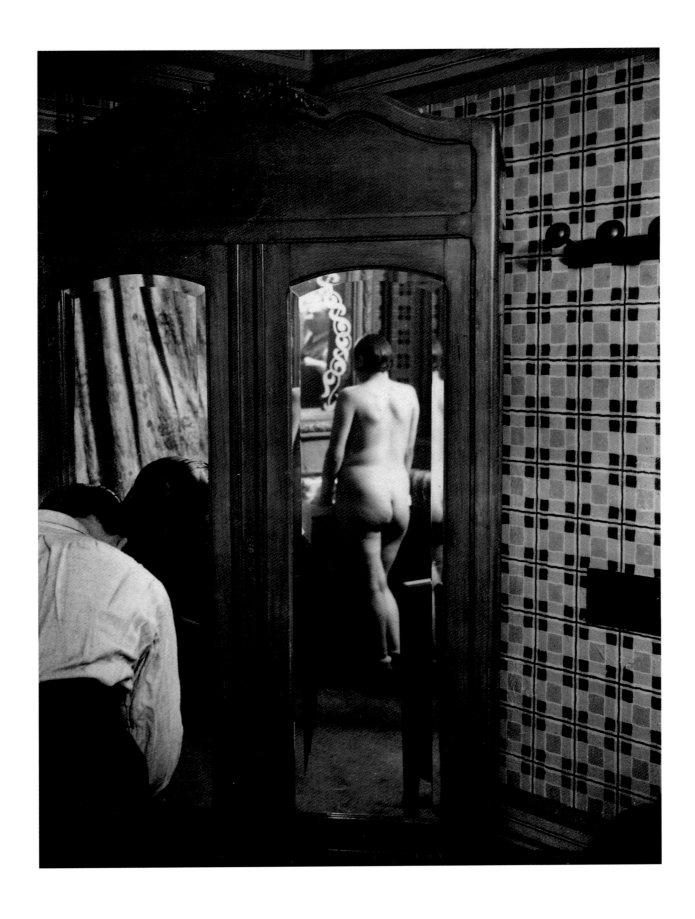

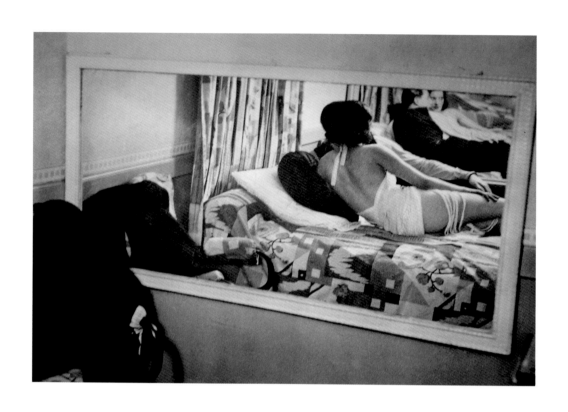

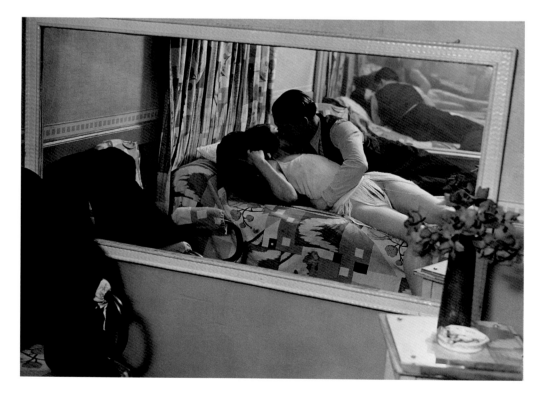

At Suzy's, c. 1932

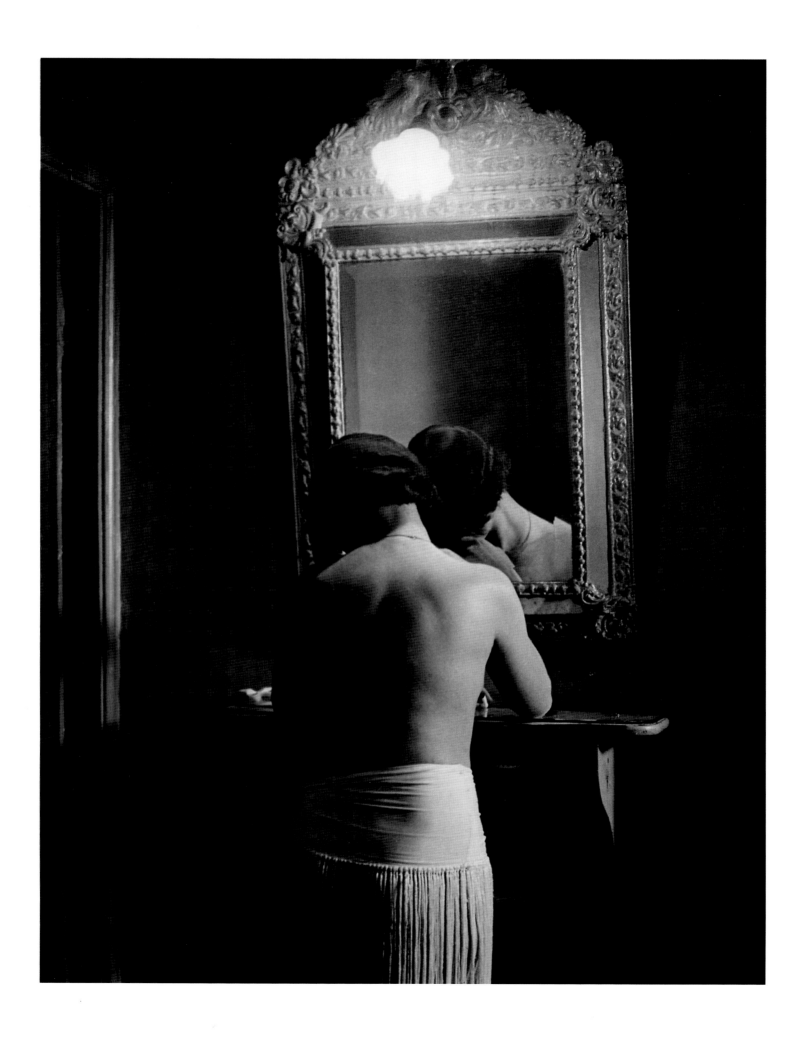

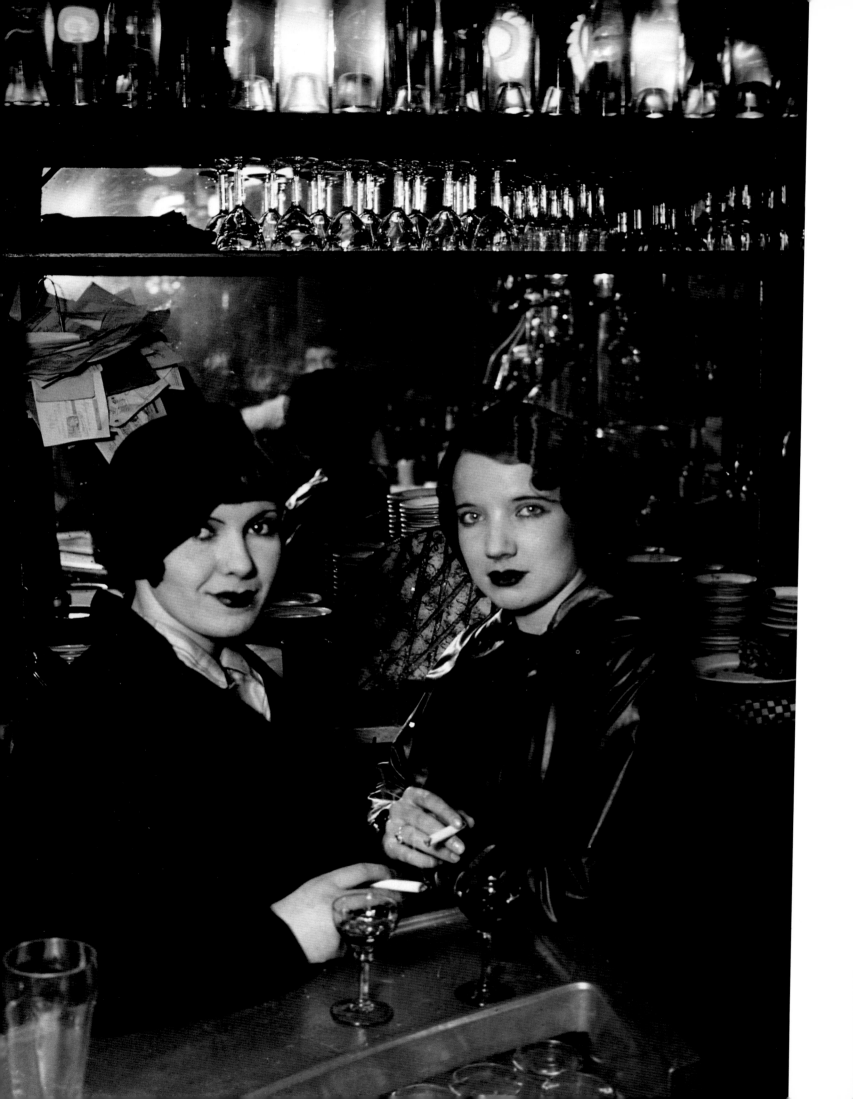

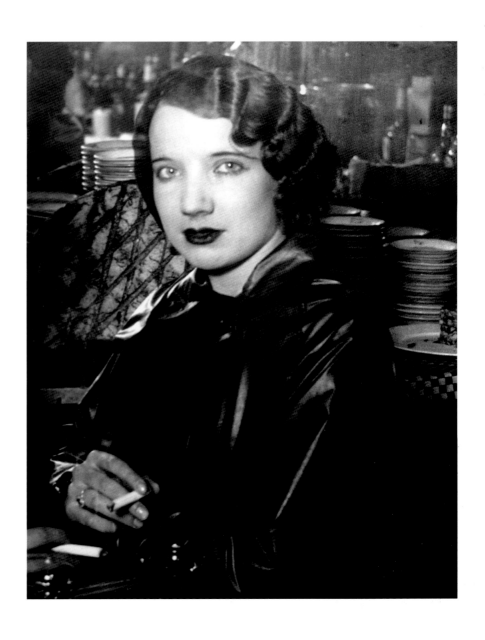

Prostitutes in a Bar, Boulevard Rochechouart, c. 1932

In a Bar, Boulevard Rochechouart, c. 1932

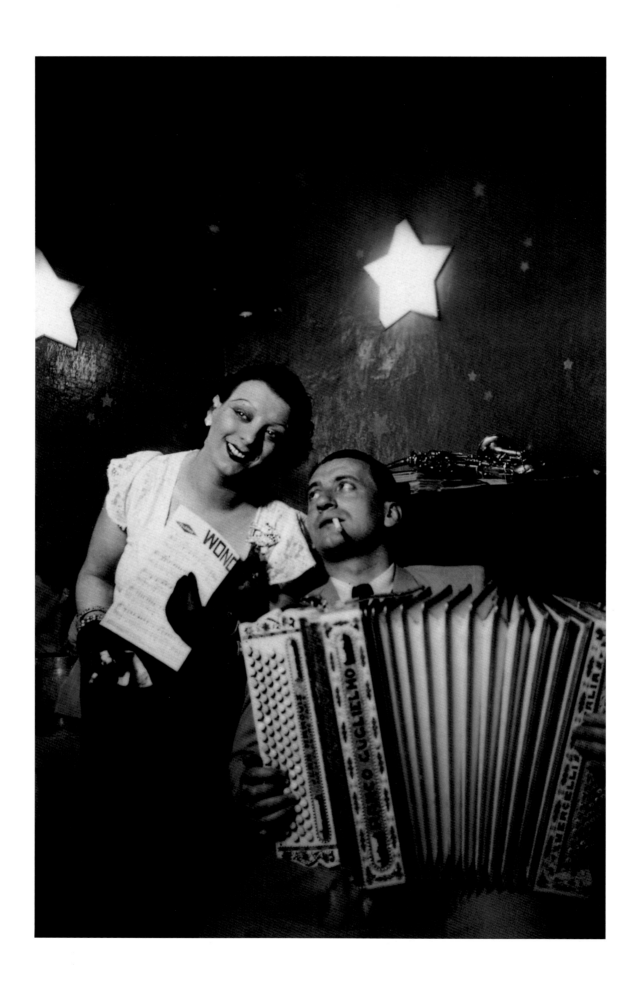

Kiki at the Cabaret des Fleurs, Montparnasse, c. 1932

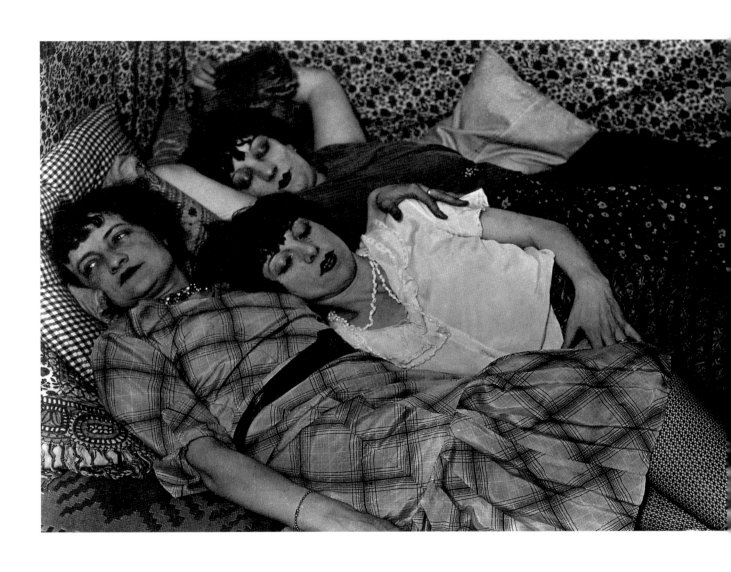

Kiki, Thérèse Treize and Lily, c. 1932

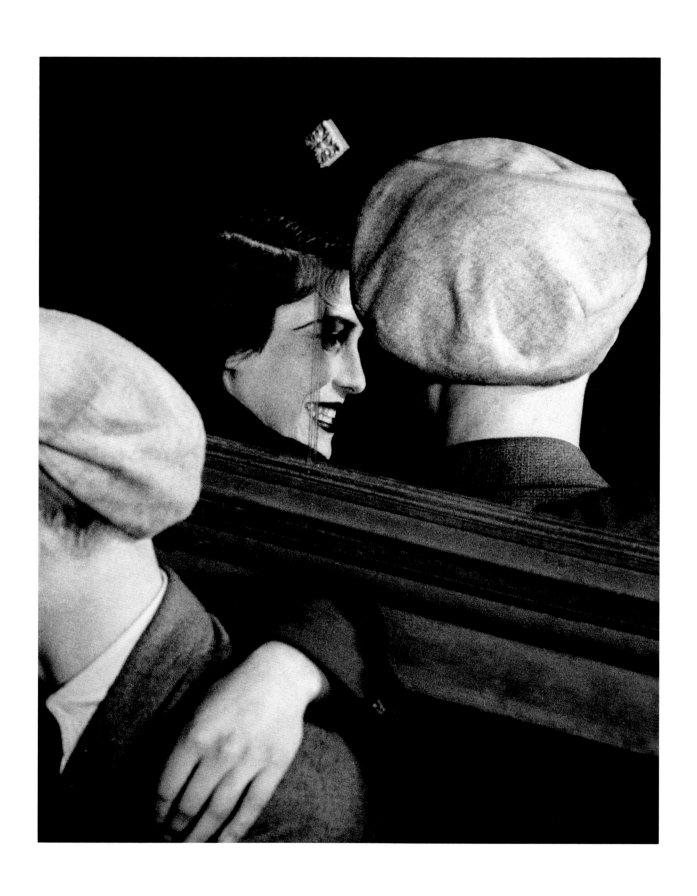

Bal Musette des Quatre-Saisons, Rue de Lappe, c. 1932

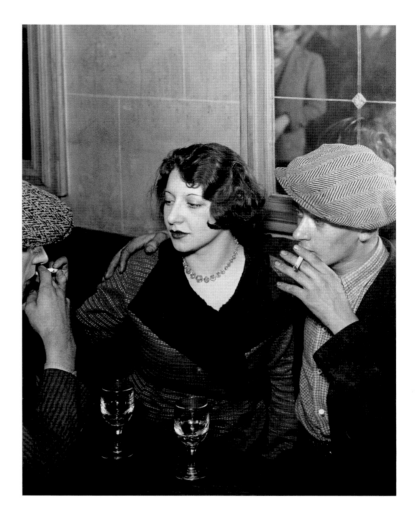

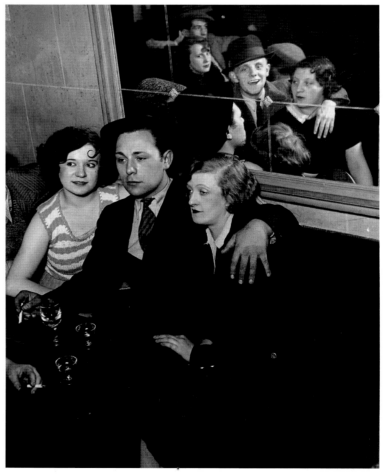

Bal Musette des Quatre-Saisons, Rue de Lappe, c. 1932

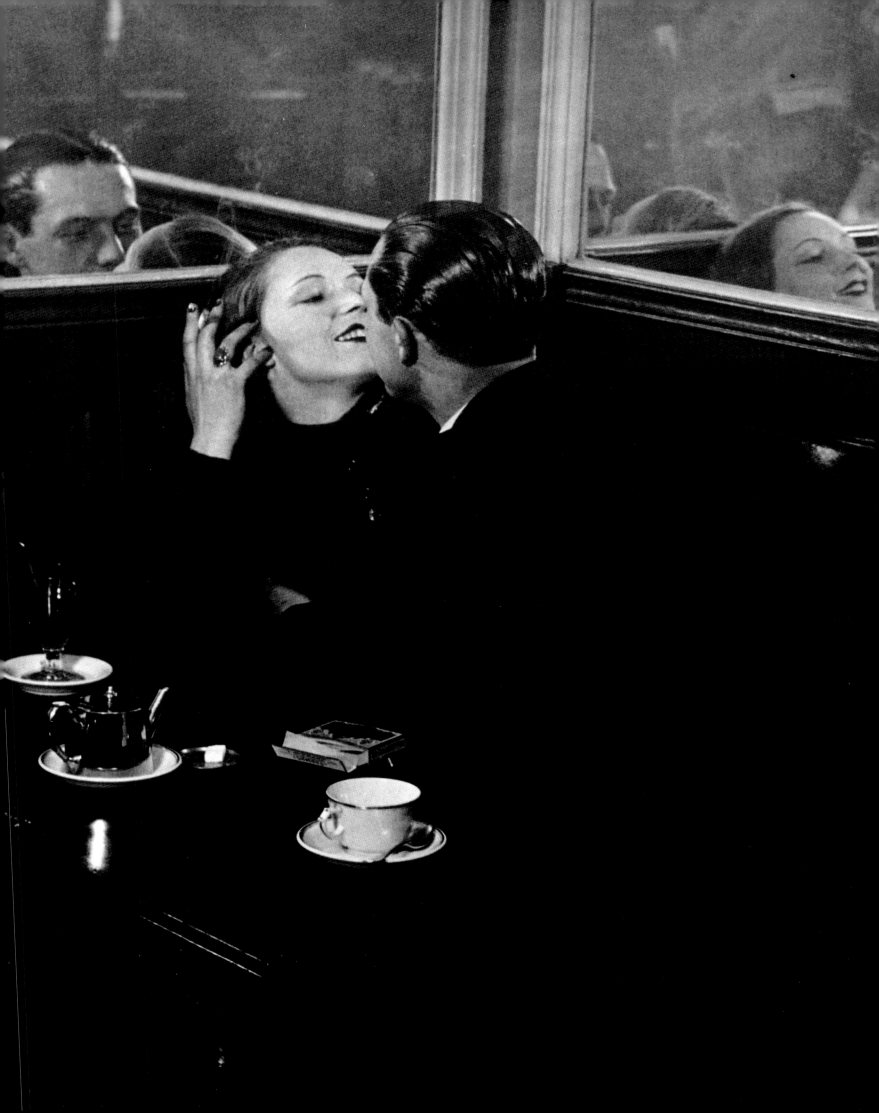

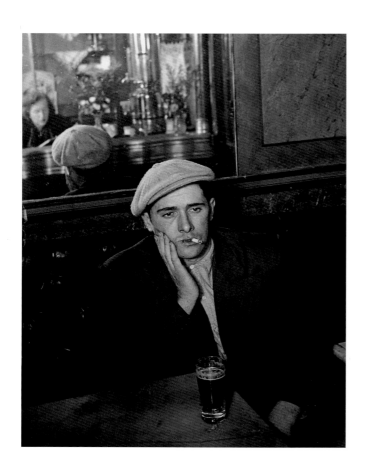 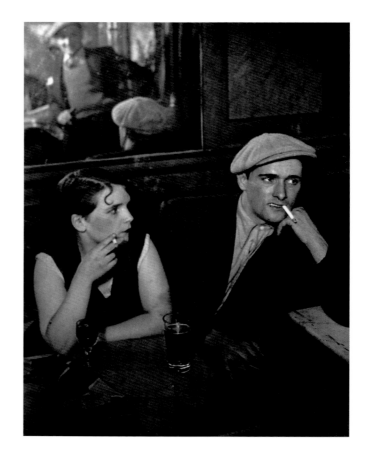

The Lovers' Tiff, Rue Saint-Denis, c. 1931

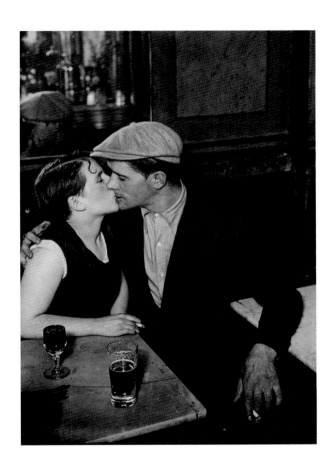
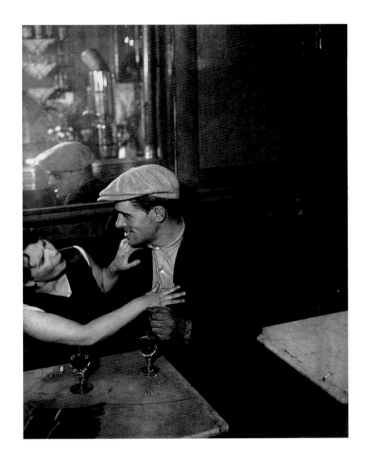

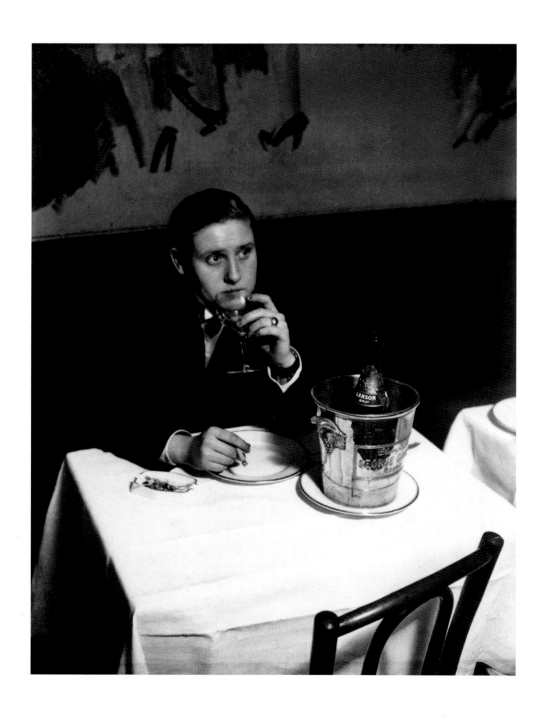

Lulu, at Le Monocle, c. 1932

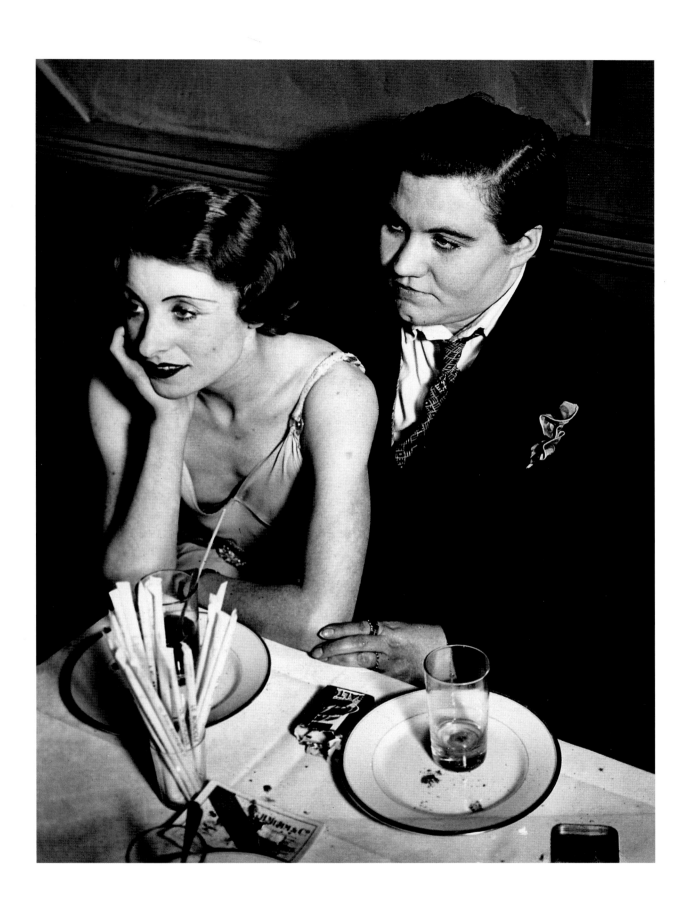

Fat Claude and Her Girlfriend, at Le Monocle, c. 1932

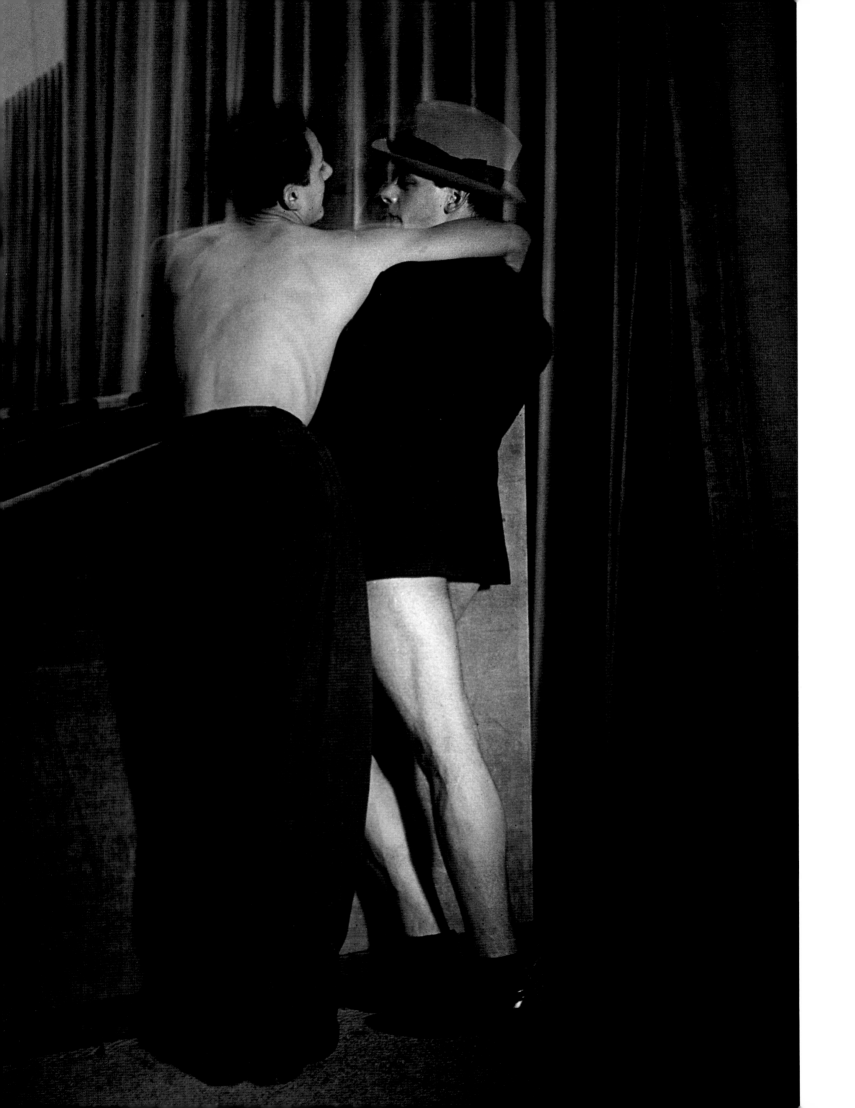

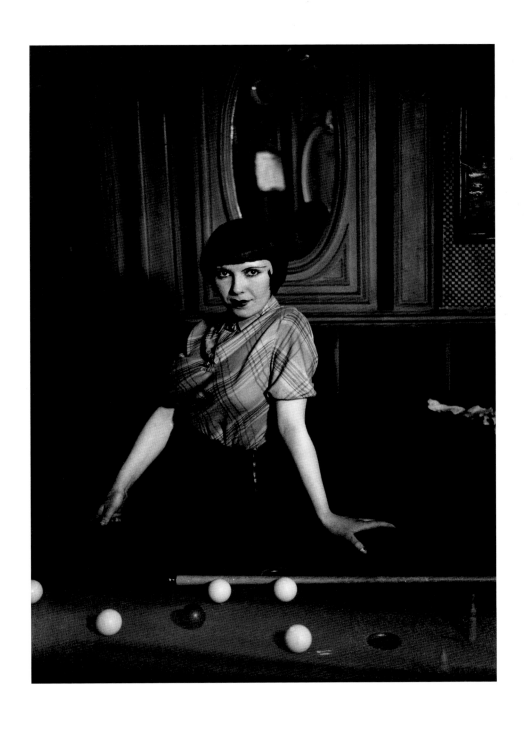

One Suit for Two, at the Magic City, c. 1931

Prostitute Playing Russian Billiards, Boulevard Rochechouart, 1932–33

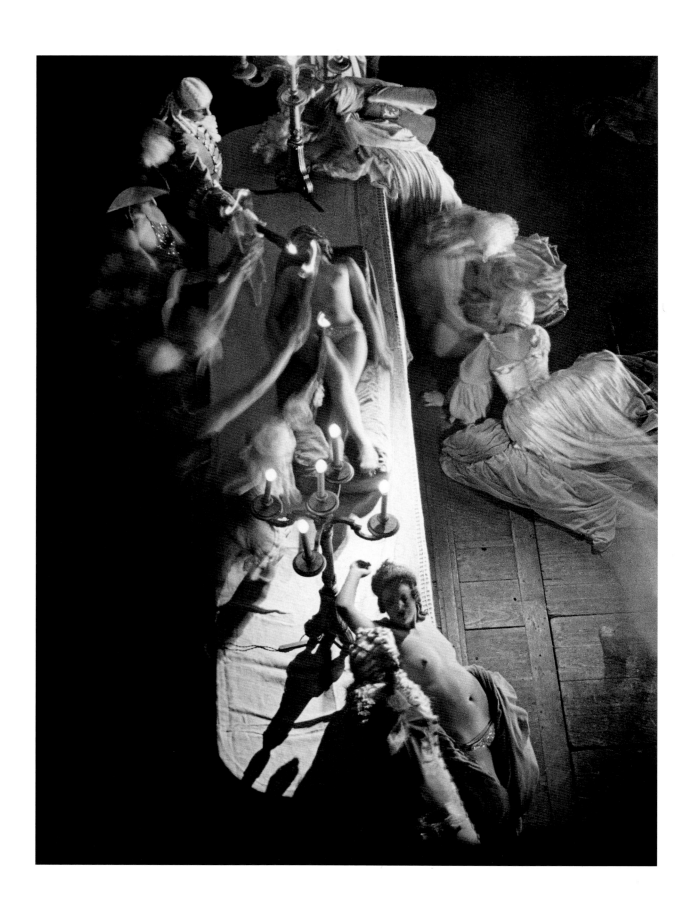

'The Regent's Orgy' at the Folies-Bergère, 1932

Duty Fireman, in the Wings at the Folies-Bergère, 1932

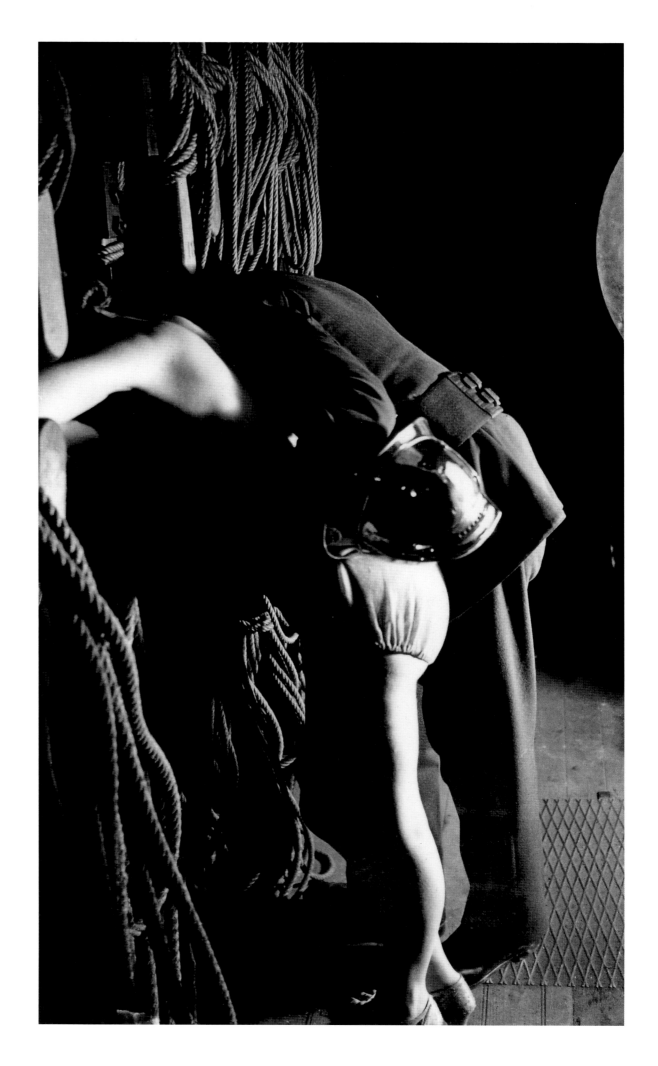

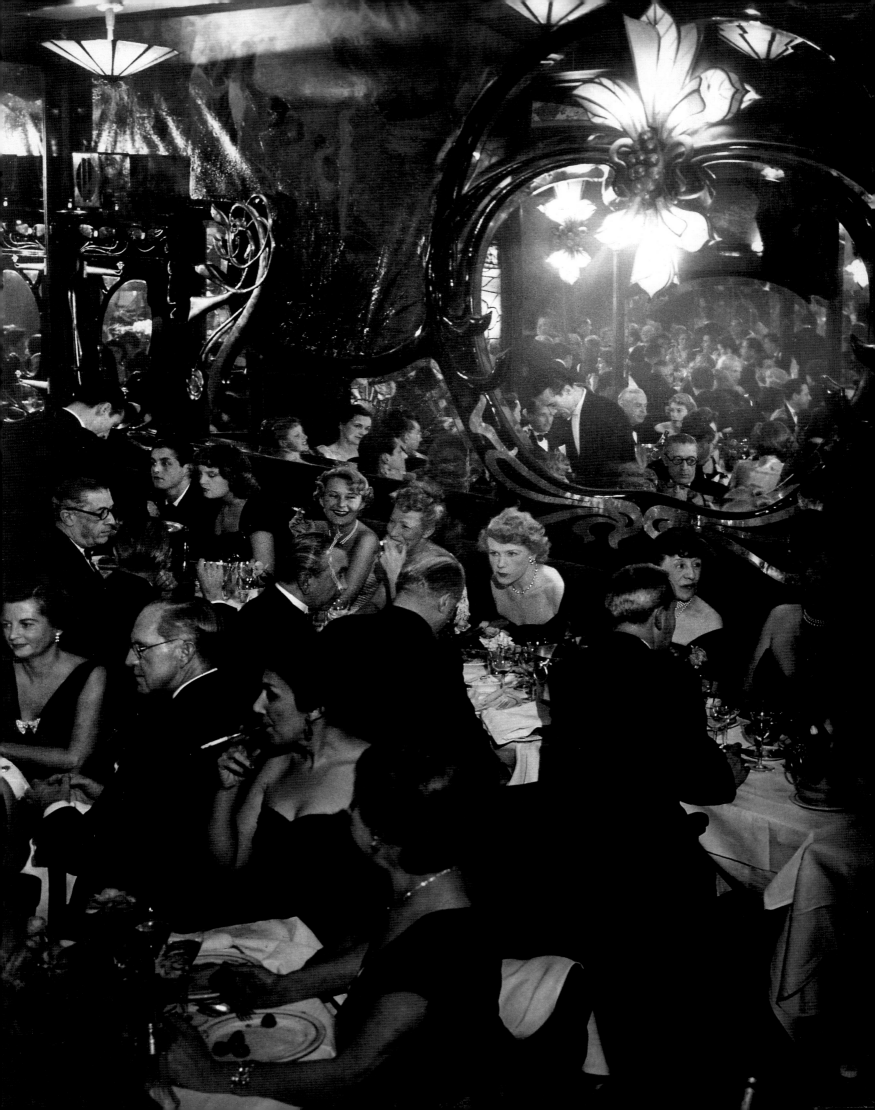

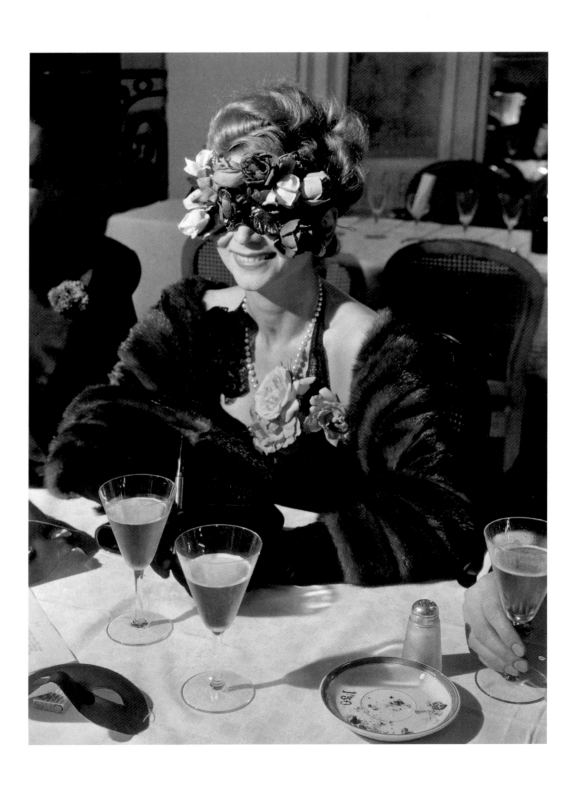

An Evening at Maxim's, 1949 *Masked Ball, Pré Catelan*, 1947

The 'Big Night' at Longchamp, July 1937

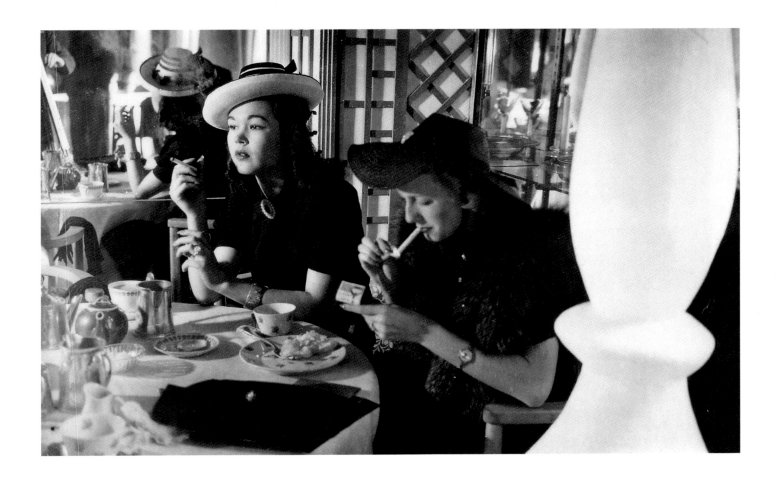

Tea Dance, July 1939

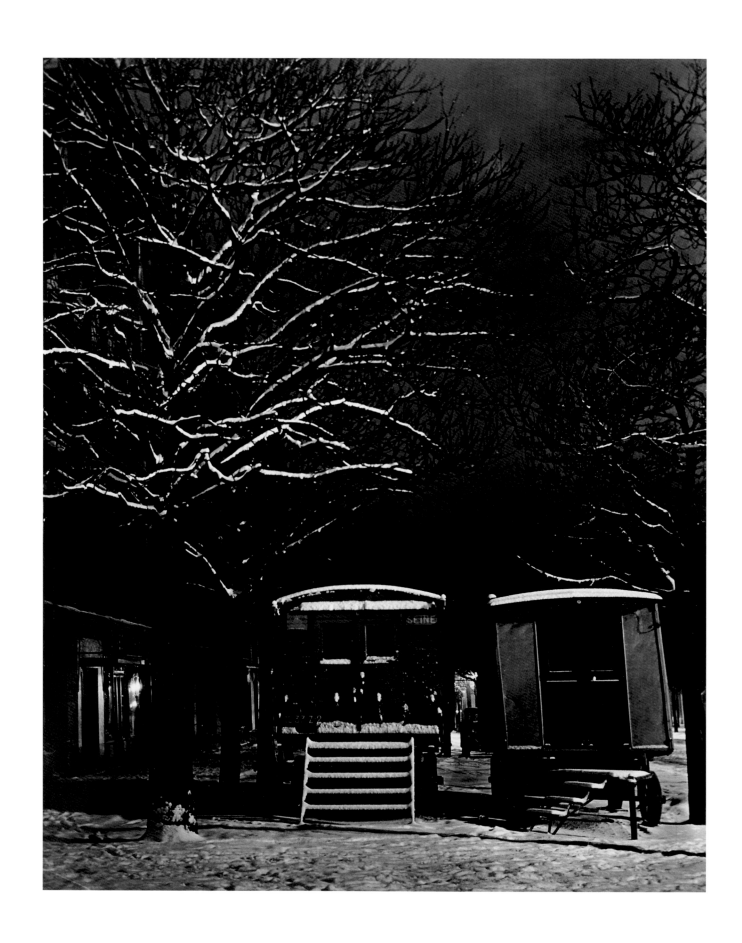

Caravans, Boulevard Arago, c. 1935–38

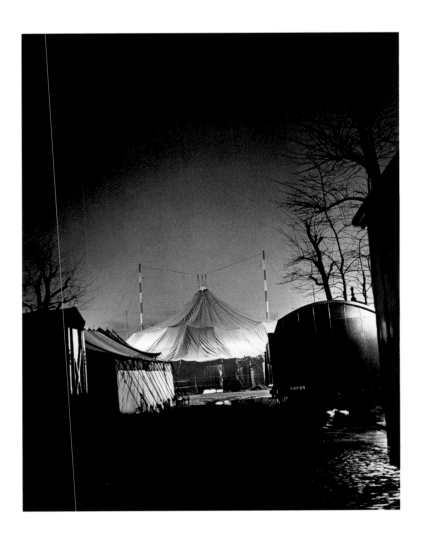

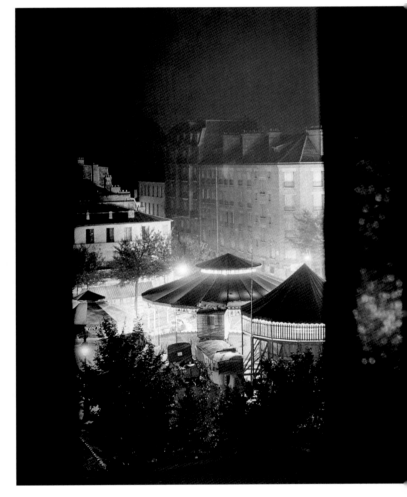

The Show's Over, Cirque Fanni, 1930–32

Street Fair, Place Saint-Jacques, 1945

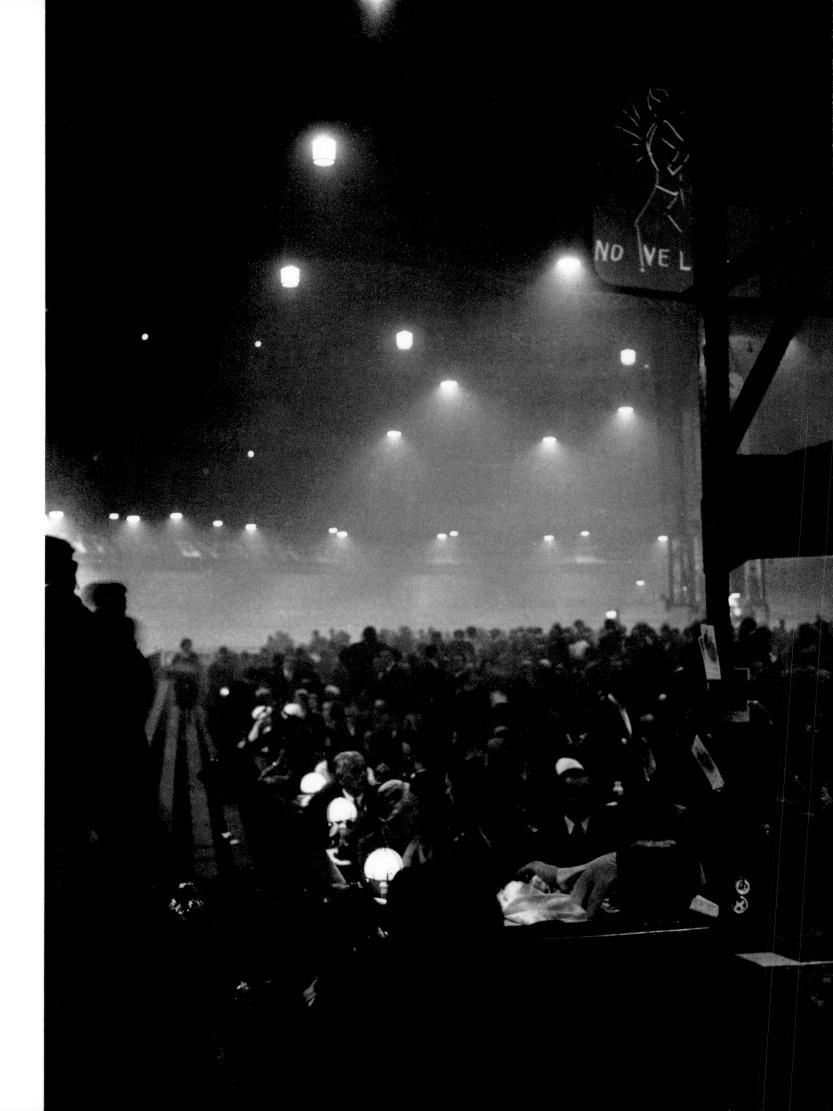

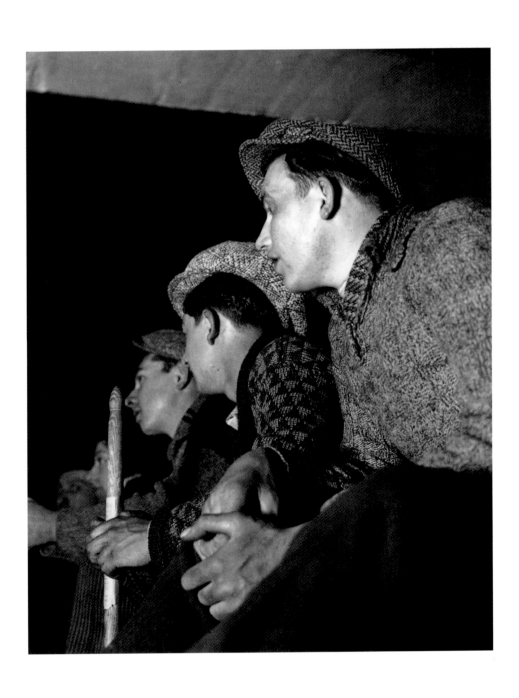

Six-Day Cycle Race at the Vélodrome d'Hiver, c. 1931–33

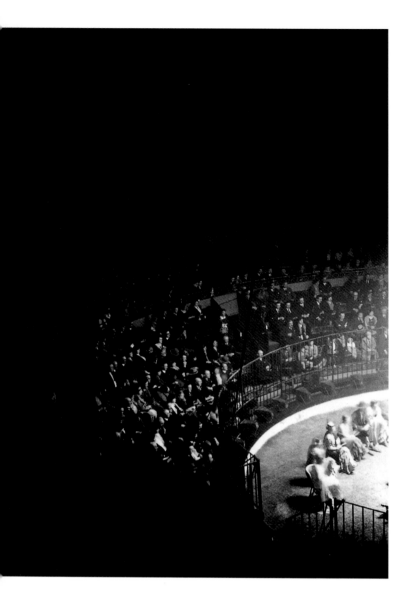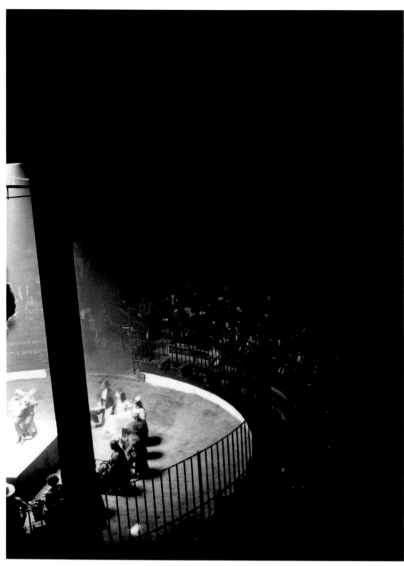

The Cirque Medrano, c. 1932

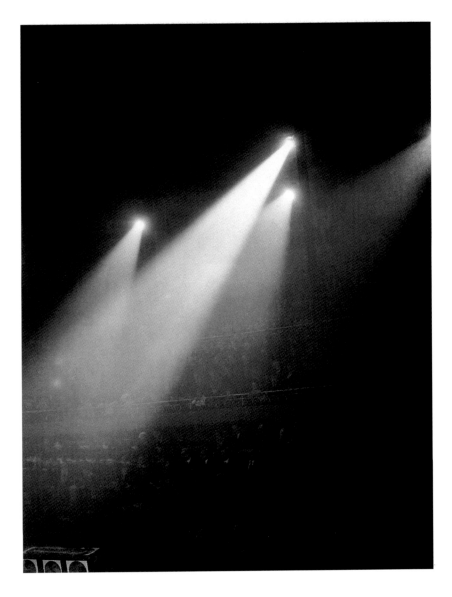

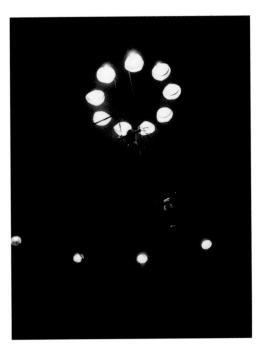

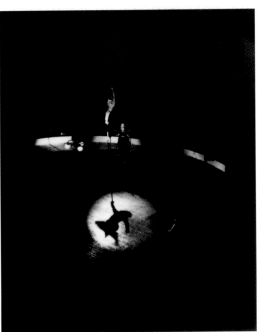

Tightrope Walker, Cirque Medrano, c. 1932 *Acrobat, Cirque Medrano, c. 1932*

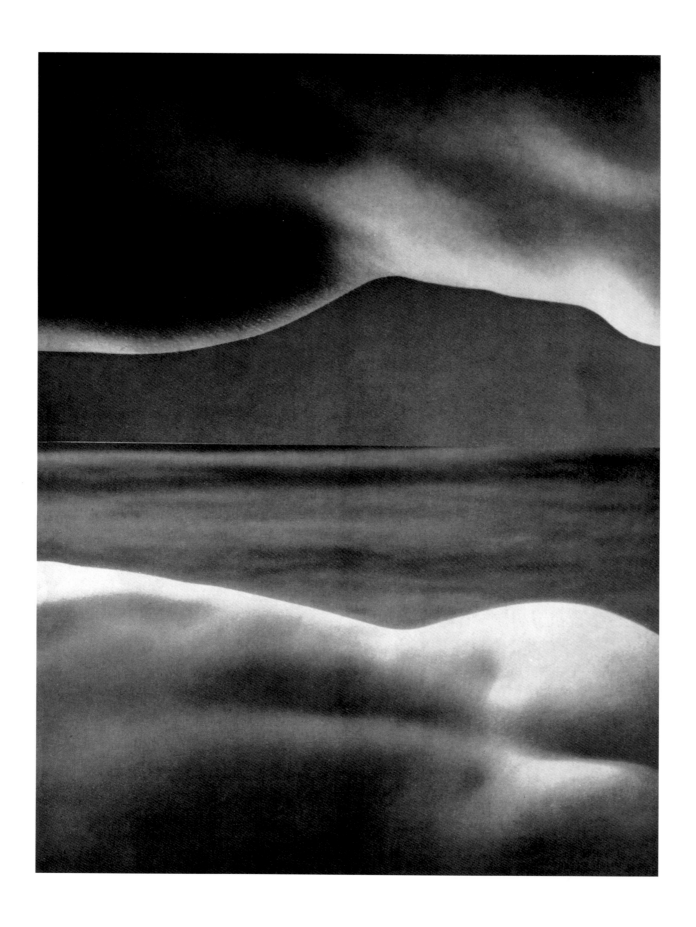

False Sky
Minotaure, no. 6, winter 1934–35, p. 5

Minotaure

From *Minotaure* to *Picasso & Co.*

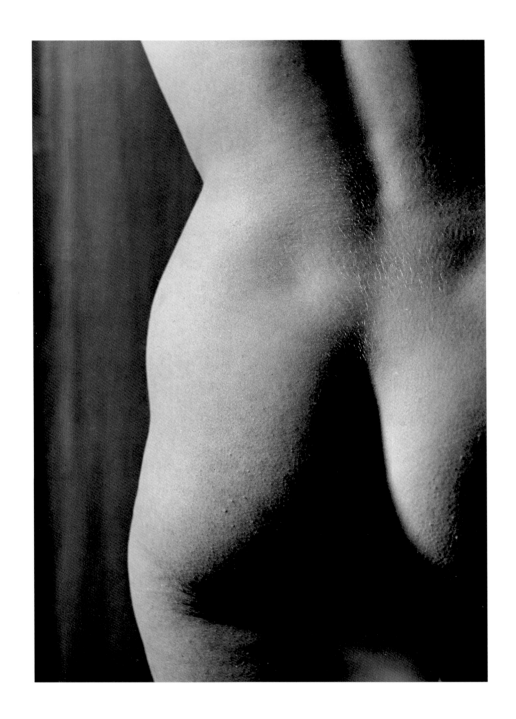

Nude, 1934

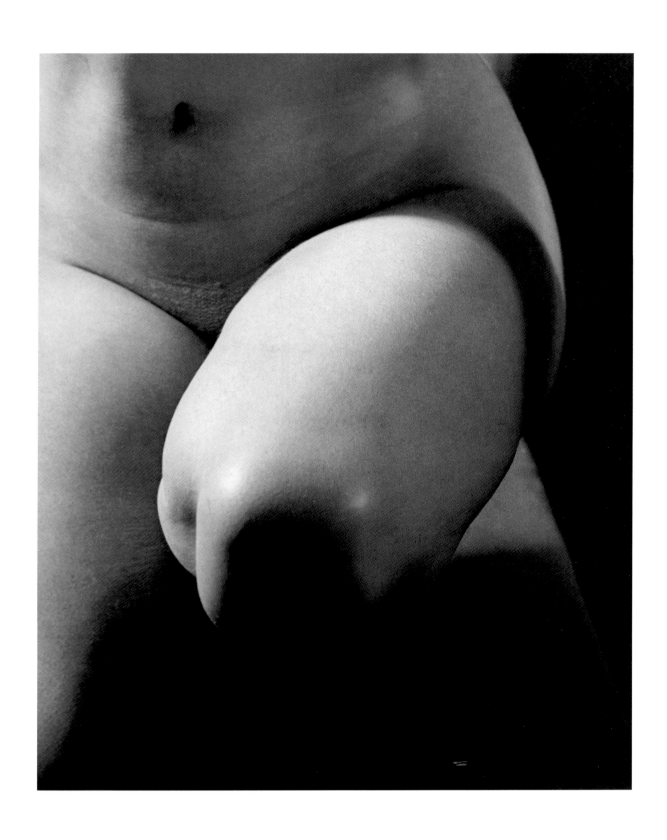

Nude, 1934

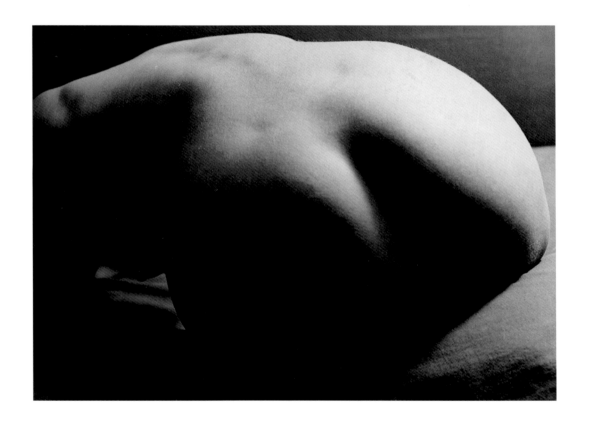

Nude, 1934

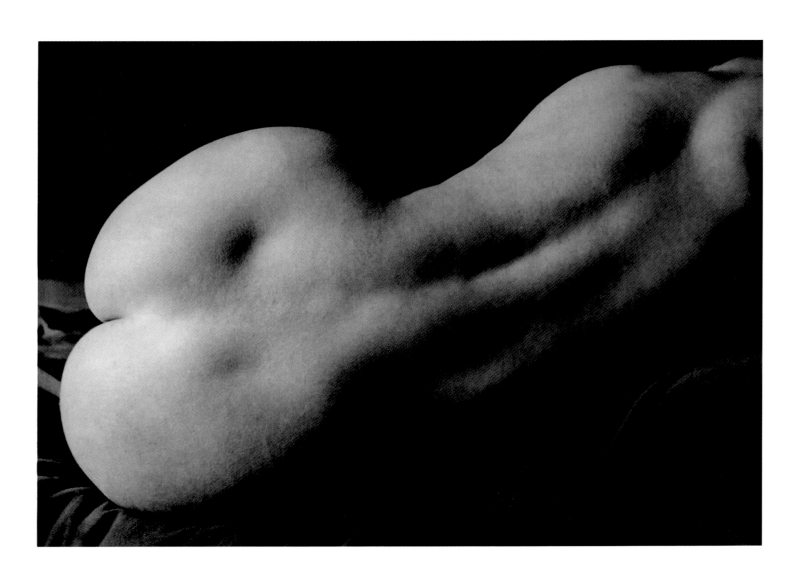

Nude, 1934

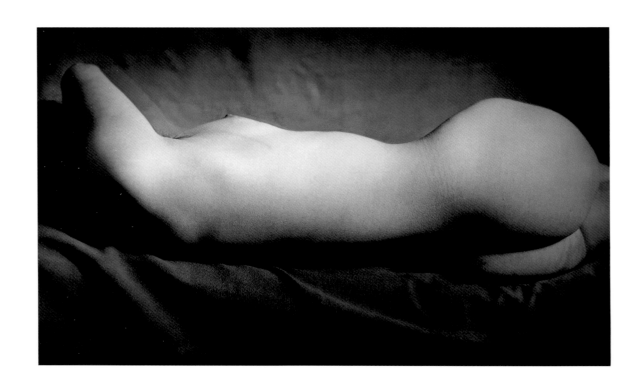

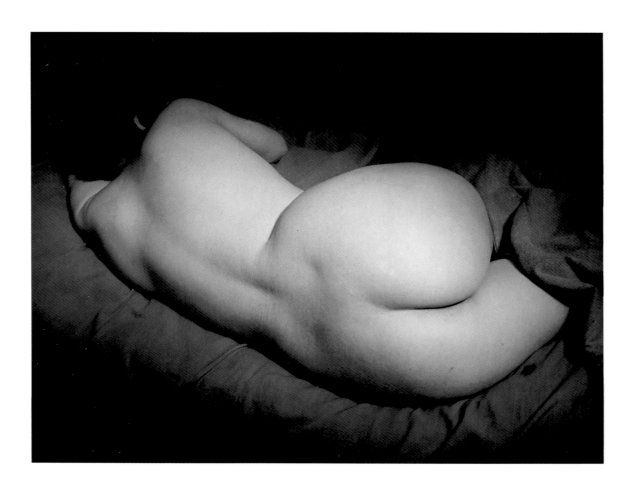

Nude, 1934

Nude, 1934

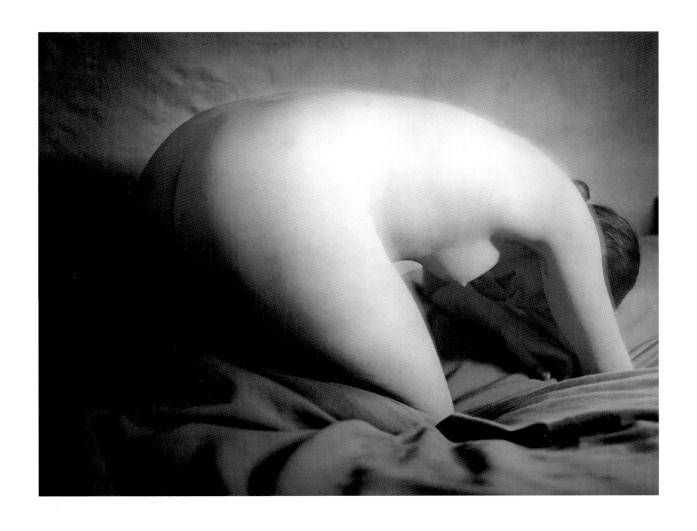

Nude, 1934

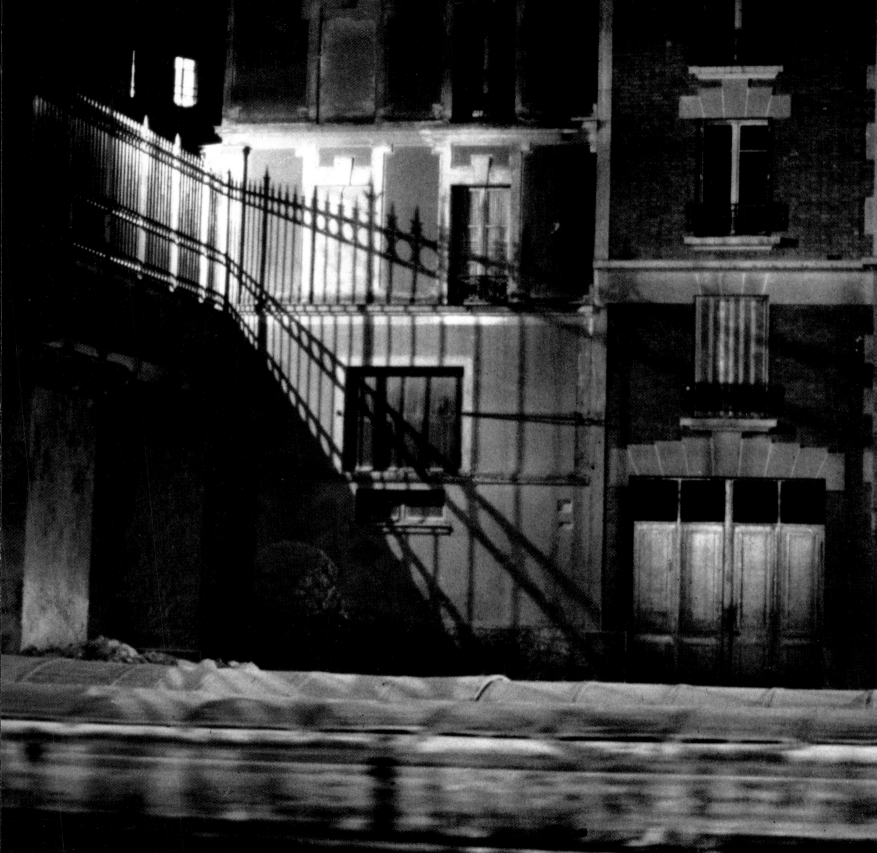

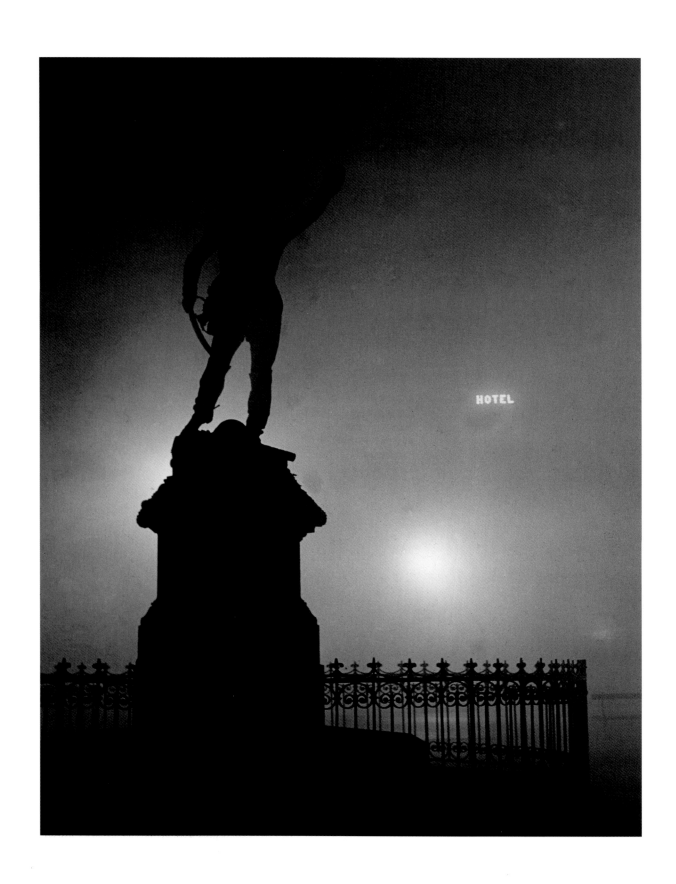

Statue of Marshal Ney in the Fog, 1932

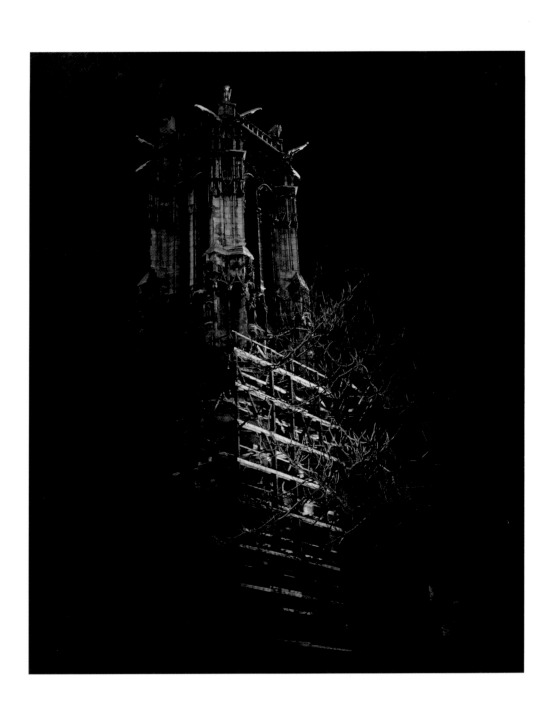

The Tour Saint-Jacques, c. 1932–33

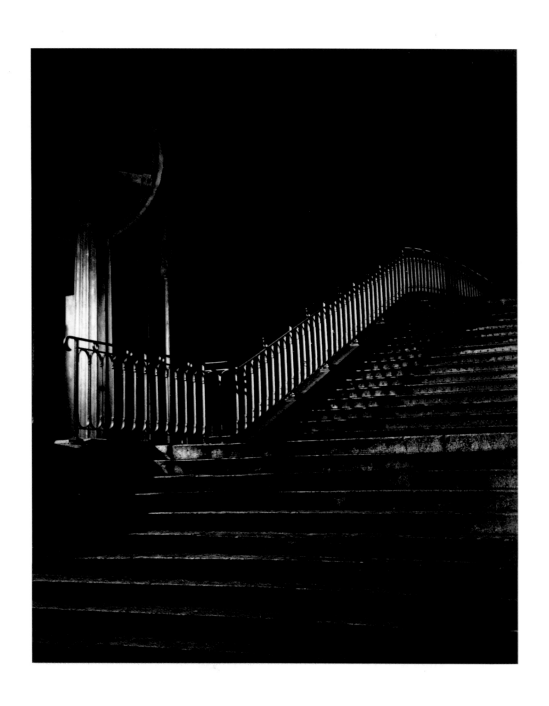

The Drawbridge on the Rue de Crimée between the
Bassin de la Villette and the Canal de l'Ourcq, c. 1933–34

The Canal de l'Ourcq, c. 1932

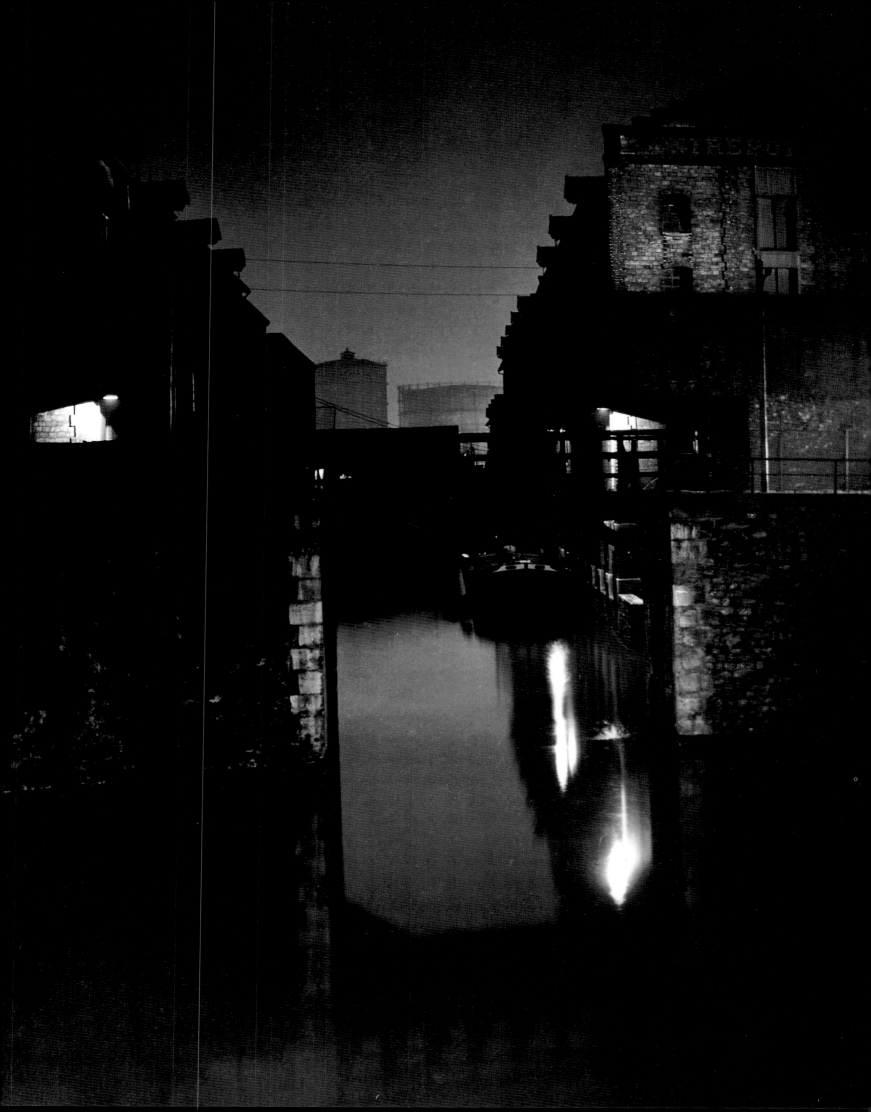

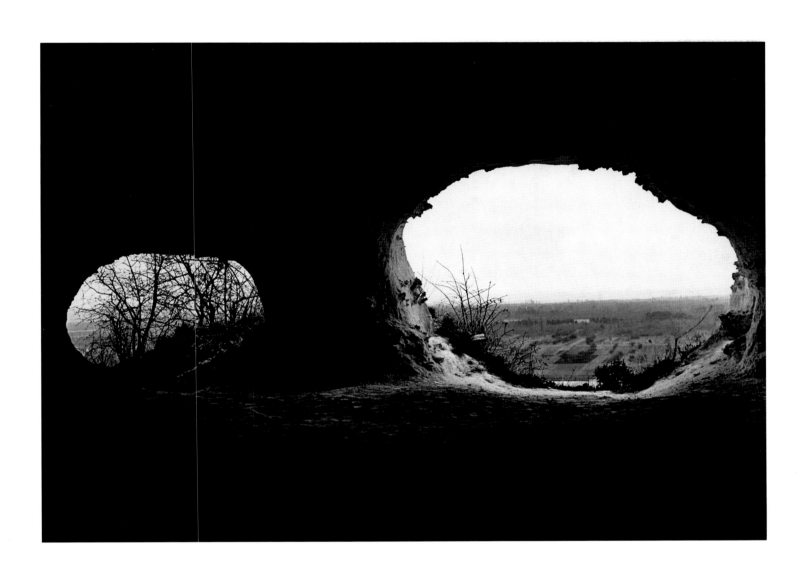

Troglodyte, c. 1935

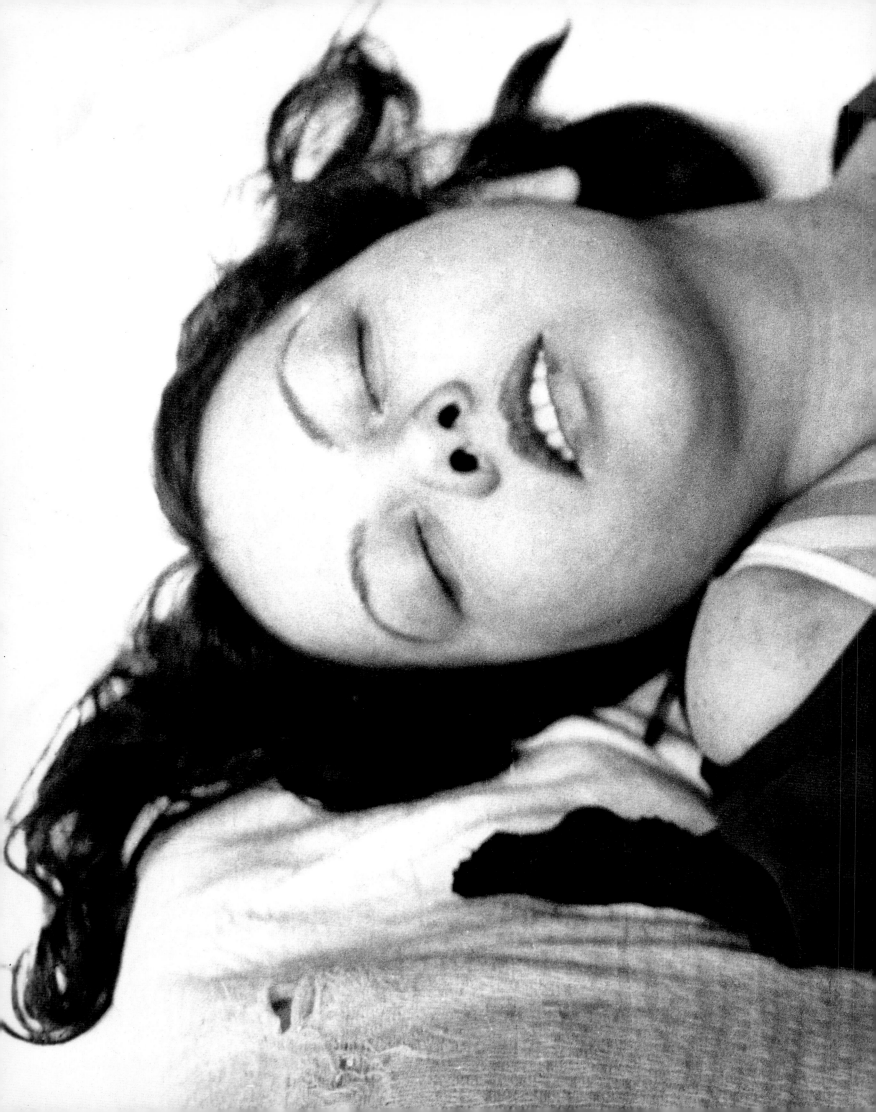

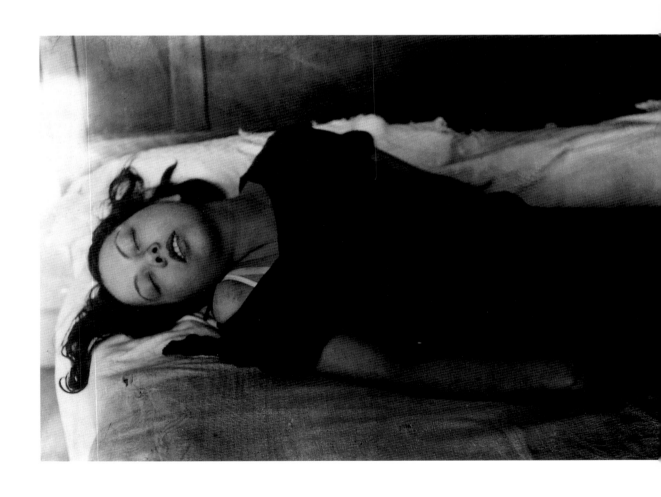

The Phenomenon of Ecstasy, c. 1933

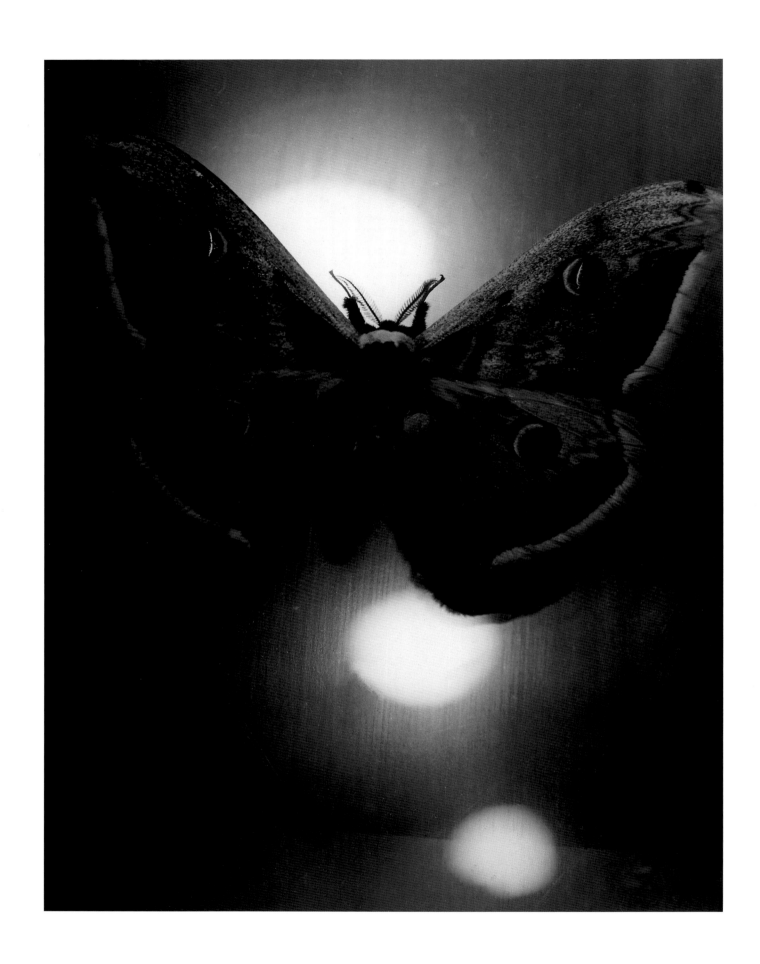

Moth and Candle, c. 1934

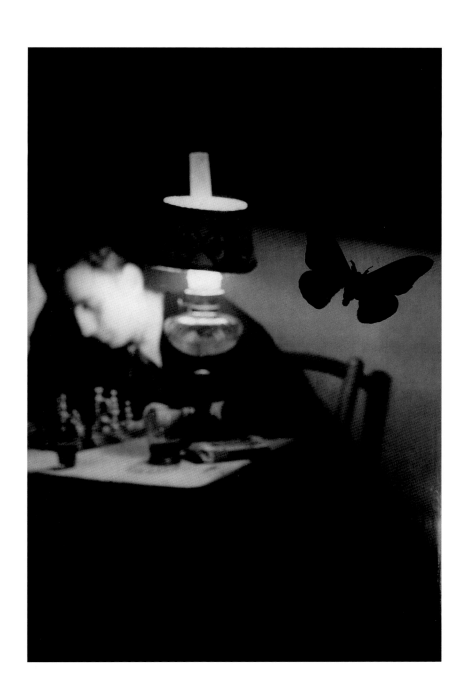

Moth and Lamp, c. 1934

The House Where I Live, c. 1932

Tulip Pistil, c. 1932

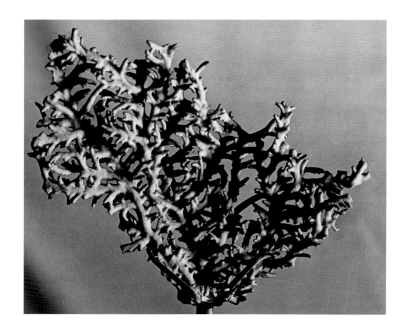

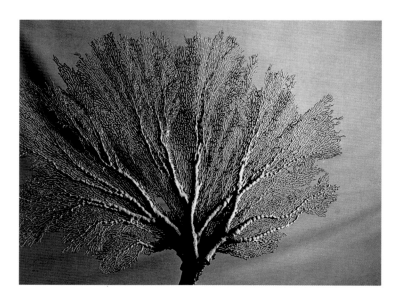

Madrepore, 1930

Madrepore, 1930

Rose Coral, 1932–33

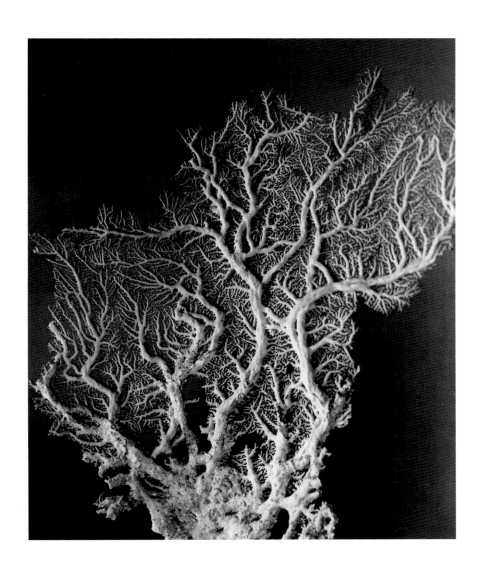

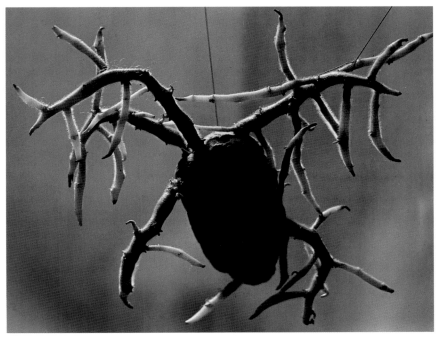

Coral, 1932–33

Circumstantial Magic or *Sprouting Potato*, 1931

When Enlarged, A Row of Small Needles in
Their Case Resemble an Organ, c. 1930

Paperclips, c. 1930

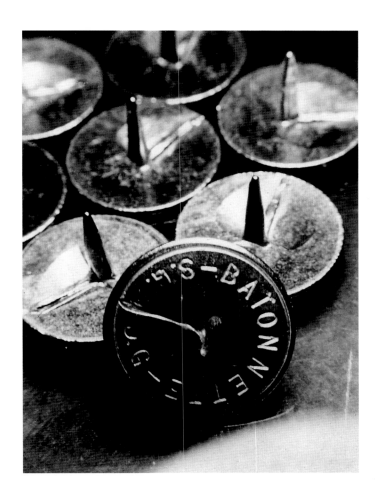

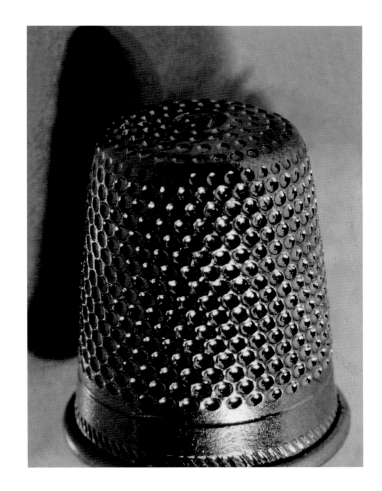

Drawing Pins, c. 1930

Thimble, c. 1930

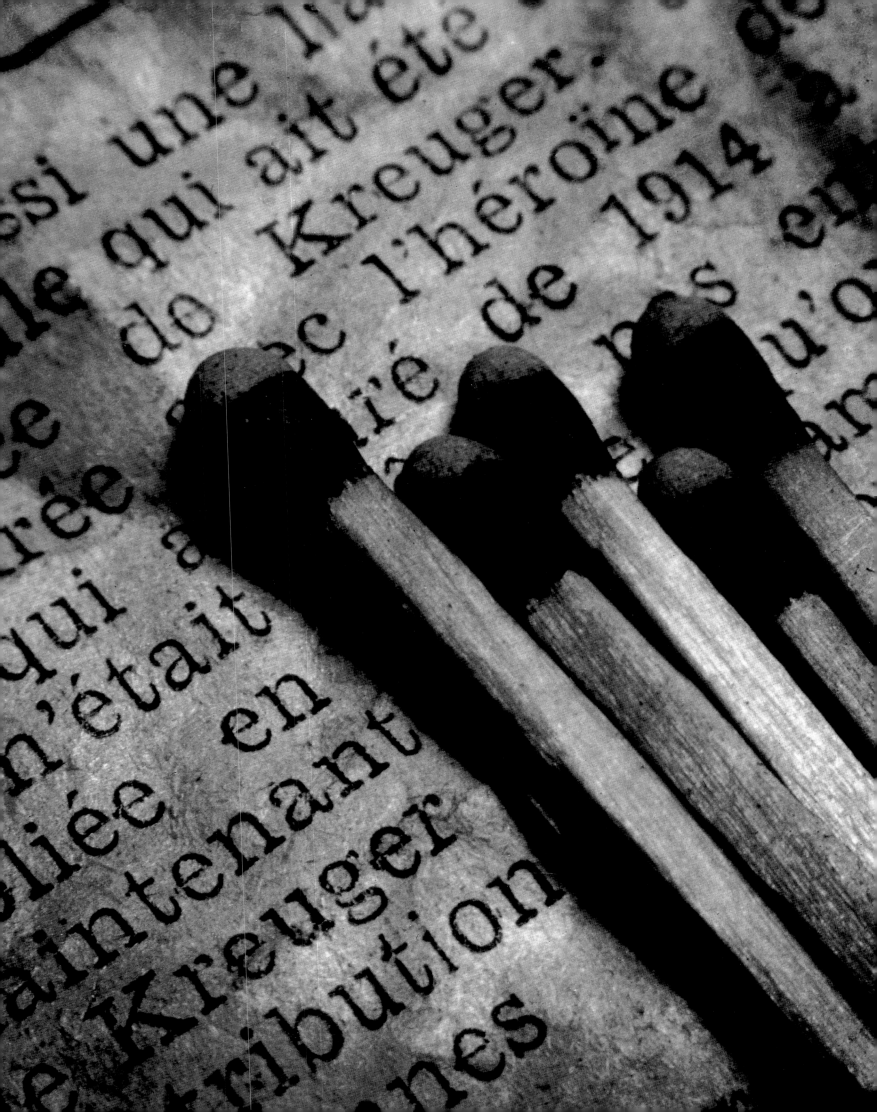

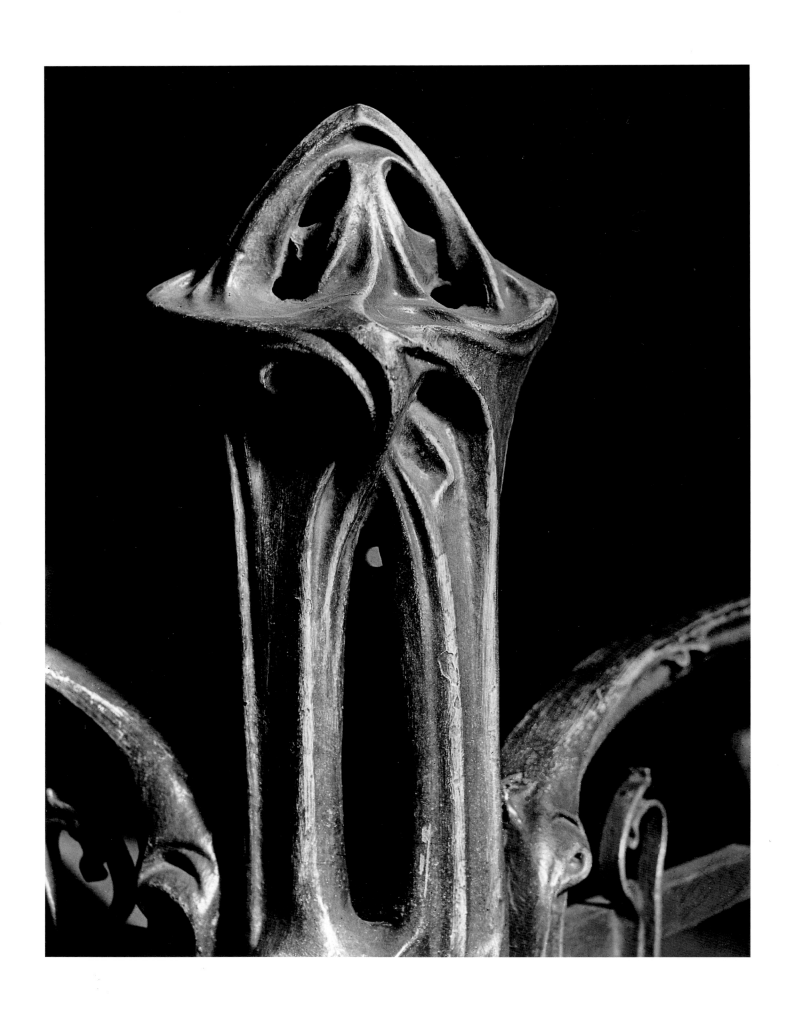

Have You Seen the Entrance to the Paris Metro? 1933

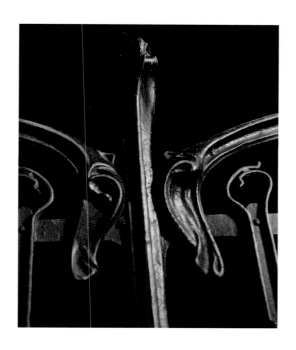

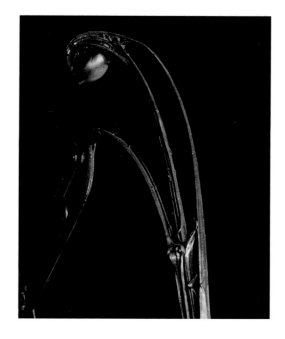

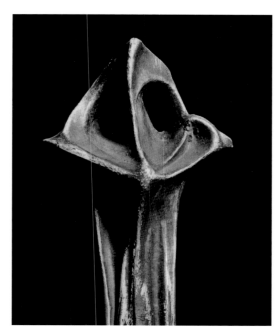

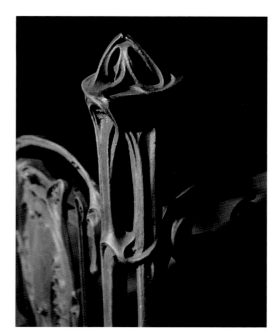

*Against Idealistic Functionalism, Symbolic-
Psychic-Materialistic Functioning*, 1933

*It Still Concerns a Metallic Atavism
from Millet's* The Angelus, 1933

Eat Me!, 1933

Me Too, 1933

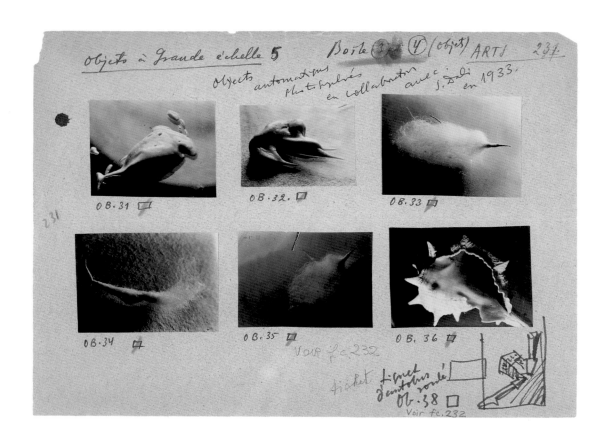

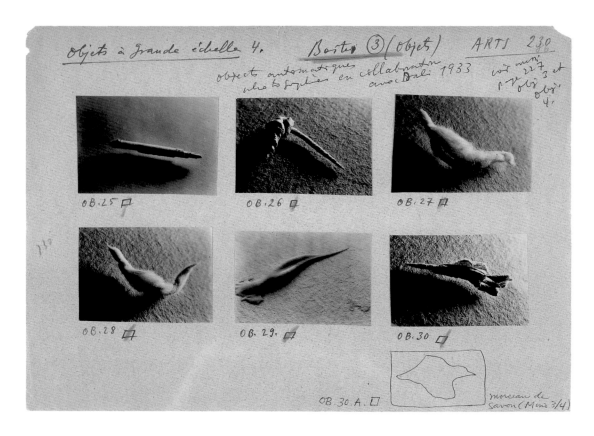

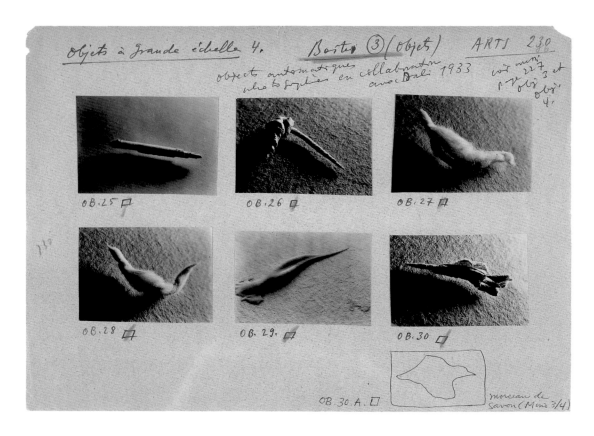

Involuntary Sculptures, 1932

Rolled-up Bus Ticket, 1932

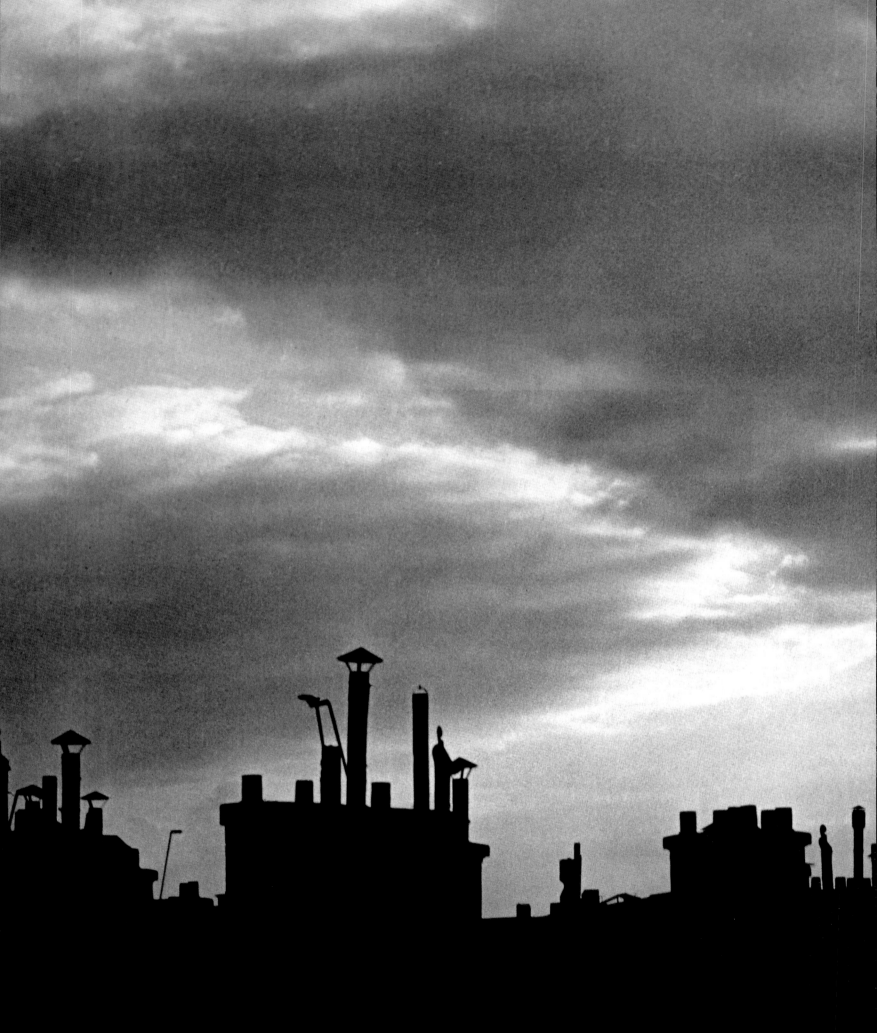

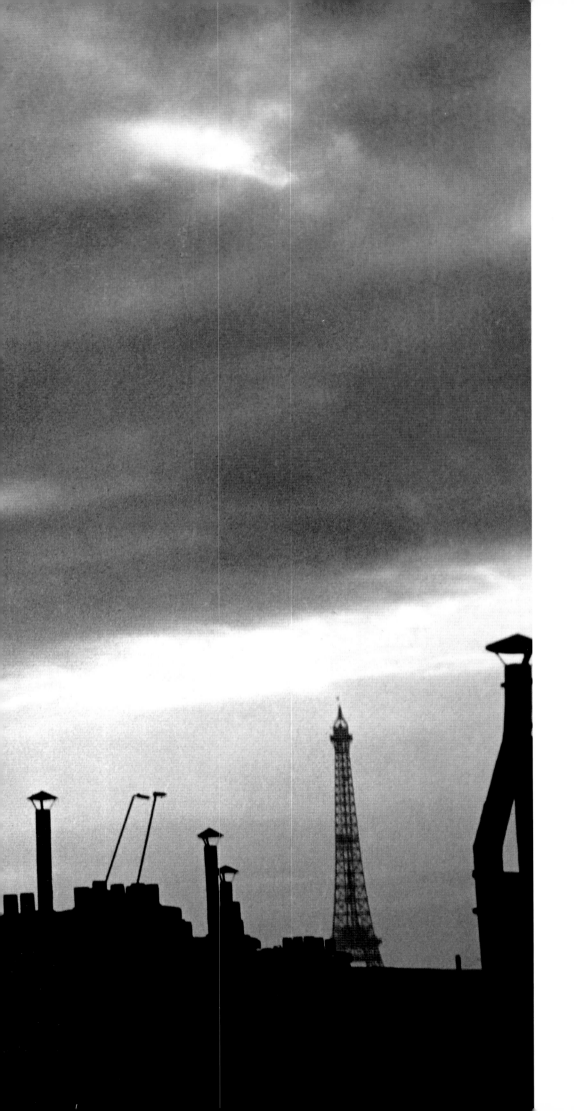

The Roofs of Paris Seen from Picasso's
Studio Window, Rue La Boétie, 1932

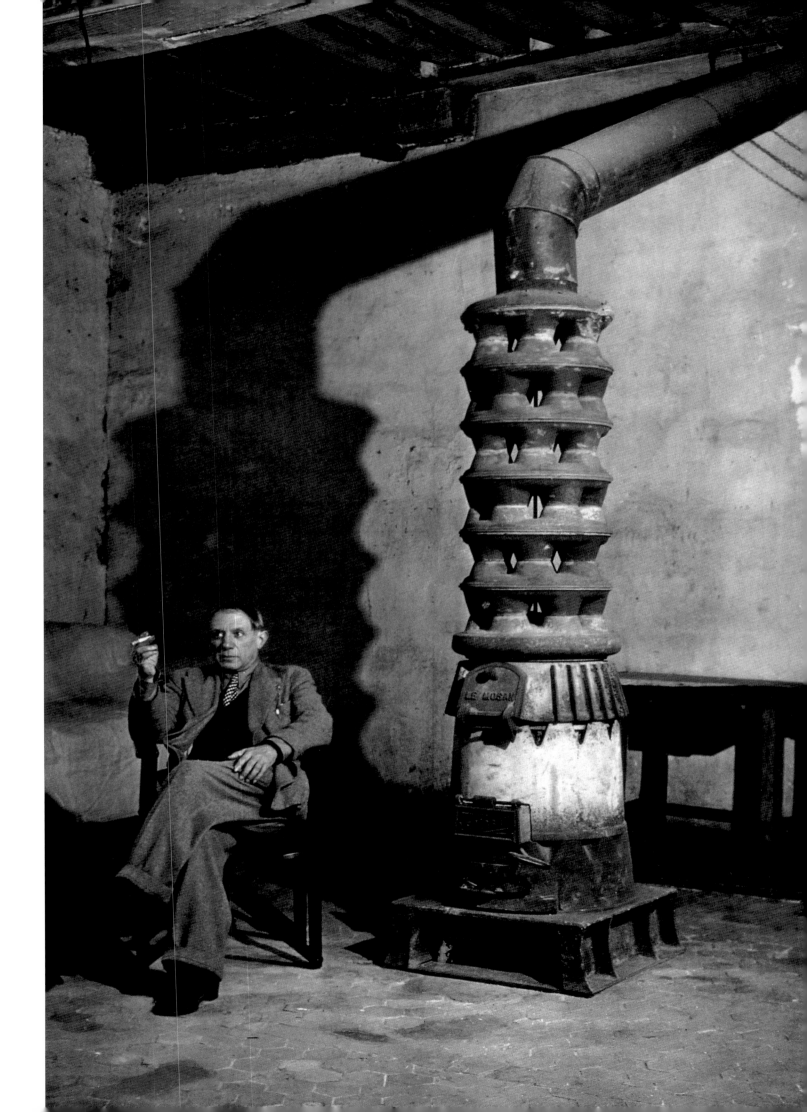

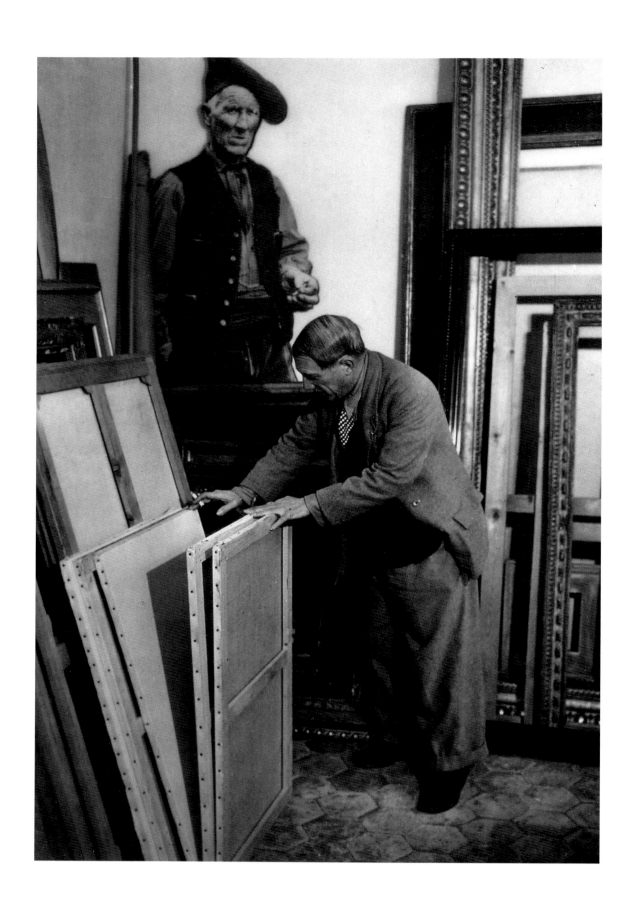

Picasso in His Studio in the Rue des Grands-Augustins, 1939

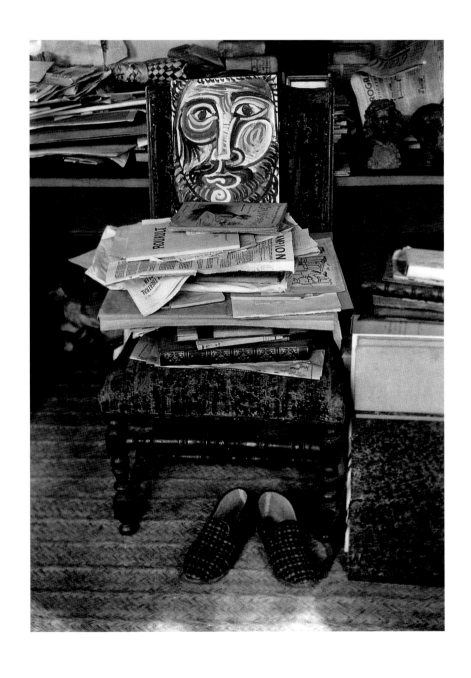

*Armchair and Slippers in the Studio in
the Rue des Grands-Augustins*, 1943

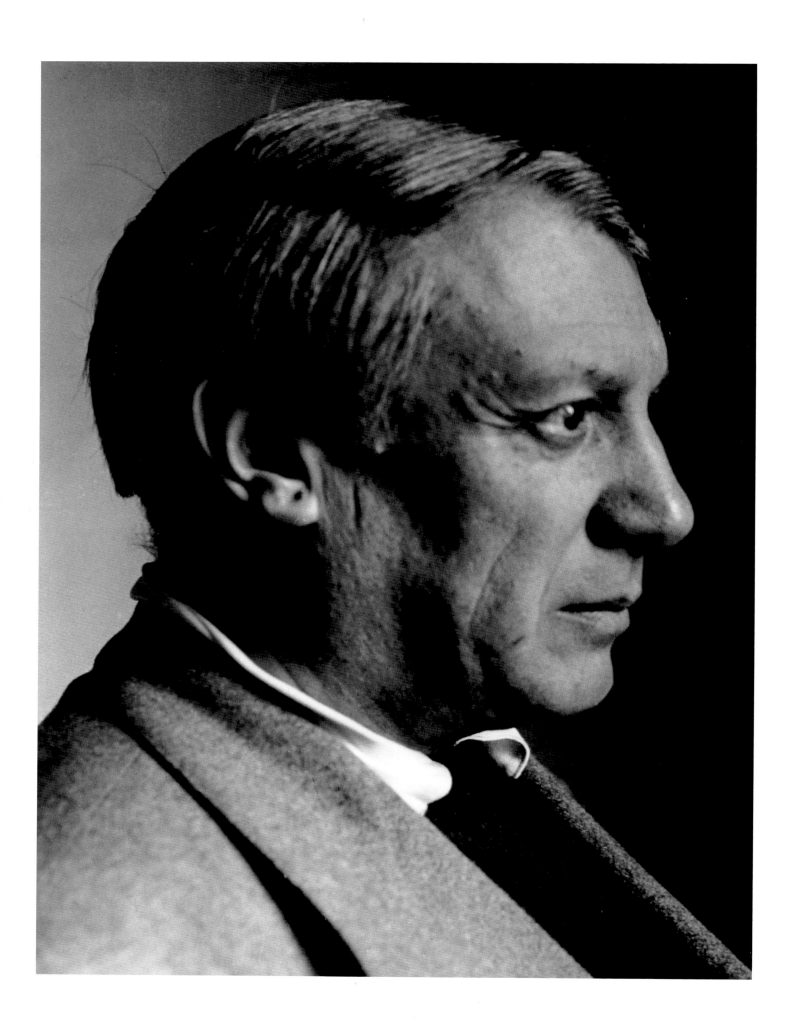

Picasso, 1932

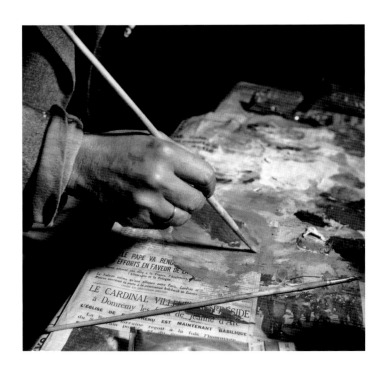

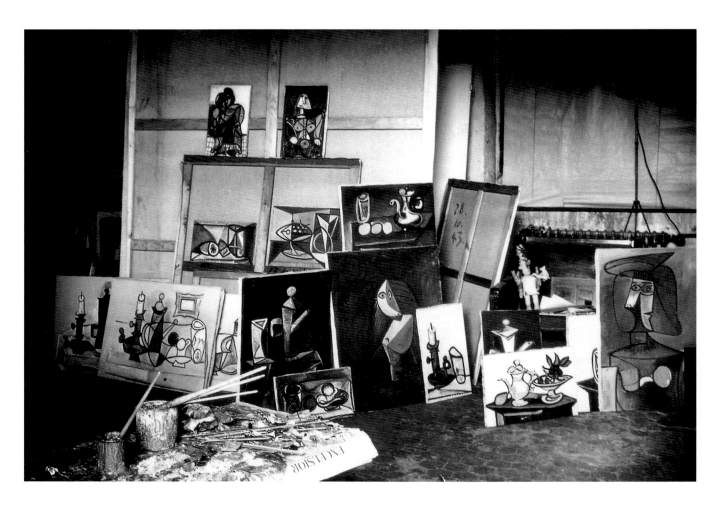

Picasso's Palette, 1944 or 1945

2 May 1944

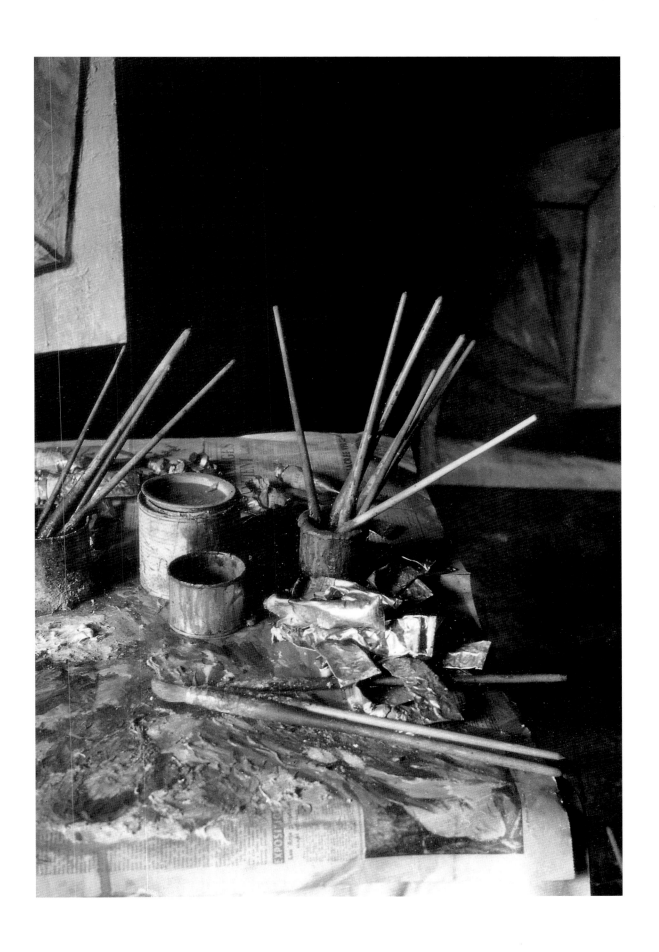

Picasso's Palette, Studio in the Rue des Grands-Augustins, 1945

Rue des Grands-Augustins, 1943

Doors of the Boisgeloup Studio, 1932

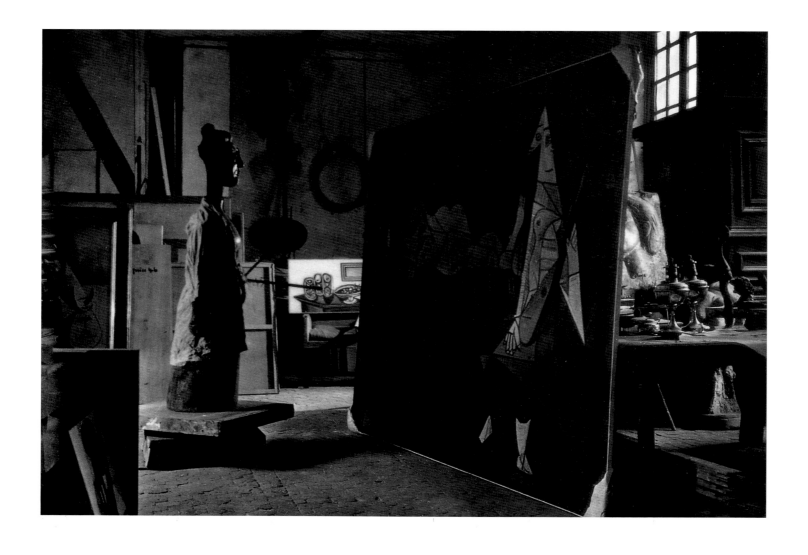

L'Aubade *in the Studio in the*
Rue des Grands-Augustins, 1946

Woman with a Palette *in the Studio in*
the Rue des Grands-Augustins, 1946

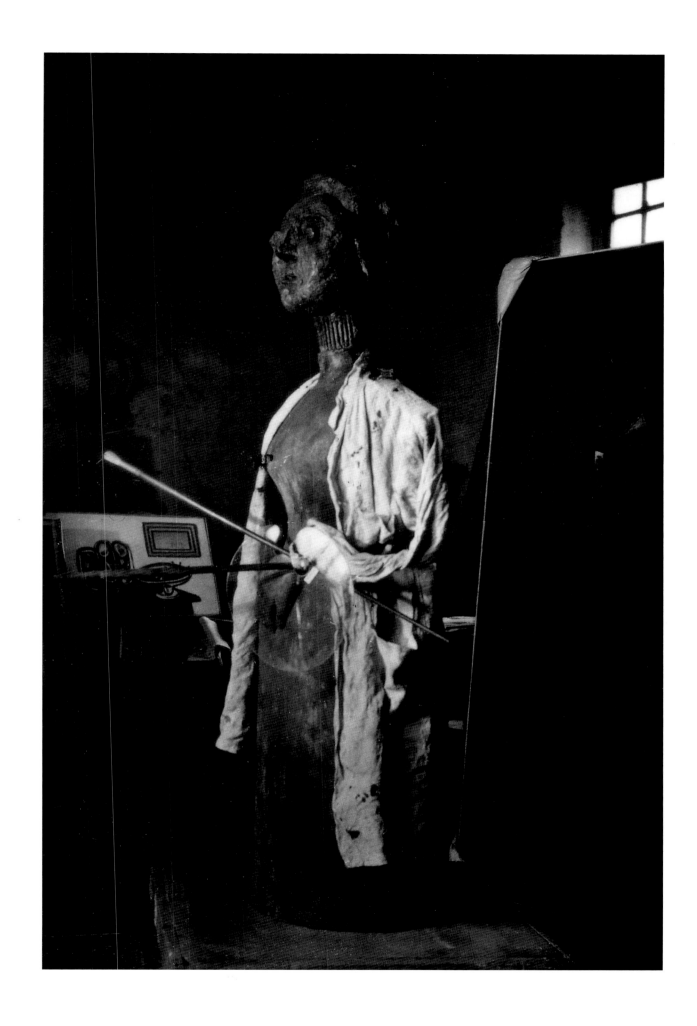

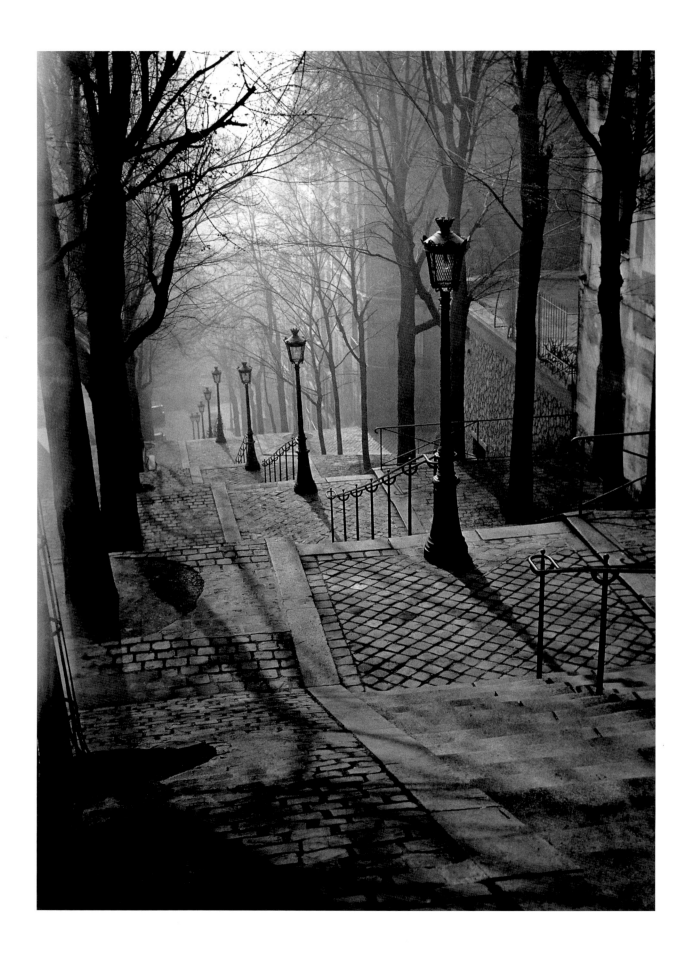

In Montmartre, c. 1935–37

Letting the eye be light Annick Lionel-Marie

1. Gilberte Brassaï Archives, notes to the publisher Grob, 1982.

2. As described by Louise League, who interviewed Brassaï for *Star News*, New York, 1 June 1973.

3. In a letter to him of 1 September 1963, Florent Fels wrote: 'I love your art and the astute, reserved and creative person that you are.'

4. Conversation with Mrs Yoshi Takata, October 1998.

5. His father's last visit to Paris was in 1956, when he was eighty-four.

6. Lajos Tihanyi (1885–1938). A self-taught painter, he became part of the Hungarian avant-garde when still very young. He was a genuine radical, and after the fall of the Hungarian Commune in 1919, he exiled himself first to Vienna and then to Berlin, where Brassaï met him in 1921. From 1923 onwards he lived in France, and became, in Brassaï's words 'one of the most interesting and charming characters in Montparnasse'. When he arrived in Paris, Brassaï went to live in the same hotel as Tihanyi, in the Rue Delambre. Brassaï believed in Tihanyi's talent, and was deeply affected when he died of meningitis in 1938. Brassaï, the painter Jacques de La Frégonnière and the photographer Ervin Marton carefully preserved Tihanyi's work during the war and the Occupation. They rented a studio to store the paintings and prevent their dispersal, as no-one was interested in them in his own country. They eventually organized an exhibition of his best work at the Galerie Entremonde in Paris in 1970, and subsequently passed the whole collection over to the Hungarian State.

7. Henry Miller (New York, 1891–Pacific Palisades, Los Angeles, 1980). 'I met him [Miller] in 1930.... I was busy photographing the Paris underground that fascinated him so much, the secret Paris that I published forty years later. There is undoubtedly an affinity between his writing and my photographs of that period; several of his books have been illustrated with my pictures.' (Brassaï, in an interview with France Bequette, *Culture et Communication*, no. 27, May 1980.) See below, pp. 173–79.

8. Johann Wolfgang von Goethe (1749–1832).

It is not easy to describe Brassaï's many-sided personality; he was a collector, scholar, lively raconteur, draughtsman, photographer, sculptor, writer and a minute observer of 'man's strange customs'. But he was also a reserved man who saw his private life as his alone, and believed that his books gave all the autobiographical information that was necessary. He hoped that 'his work would remain to some extent anonymous', at least during his lifetime,[1] allowing him to reveal as much as he wanted about himself gradually, simply through his books. This principle never changed, and at the time of his death in 1984 he had completed the last book that he wanted to leave as a personal account, *The Artists of My Life* (1982), and his *Proust* that he had been working on for ten years (not published until 1997).

Pictures of him show a man of medium height, alert and proud, his eyes thirsting to take in everything around him.[2] He gives the impression of a vivid intelligence, warmth and vitality, a 'high voltage' man, a term he used himself to describe Picasso. Those who knew him recognized him as 'astute, reserved and creative',[3] 'warm, sociable … free and independent … a genuine artist, living for his art and going his own way'.[4]

His wife, Gilberte Brassaï, describes him as a tireless worker, who would stay up all night in his studio, write on aeroplanes, or carve pebbles with little dentist's tools on train journeys. She also brings out an ascetic quality, a personal integrity which would not allow him to change his way of doing things, even when it seemed to others rather out of date.

Many people were important influences in his youth: his father, Professor Halász, a poet and intellectual, with whom he kept up a regular correspondence throughout his life;[5] the painter Lajos Tihanyi[6] whom he met in Berlin, where they became close friends (later Tihanyi was 'an indispensable part' of his life in the early years in Paris until his premature death, which profoundly affected Brassaï); Henry Miller,[7] who later wrote an outstanding description of him in 'The Eye of Paris'; the group of poets from the *Minotaure* magazine period; and lastly Picasso, 'whose company and friendship were worth a trip to the moon!'

Foremost among those who inhabited the world of his imagination was Goethe.[8] Brassaï's thinking was deeply influenced by him, and he read and reread him constantly, writing out the following passage many times over: 'My determination to see and understand all things just as they are, my unchanging reliance on my own eyes to illuminate them, my care to strip away all personal considerations, have all gradually made me very happy.… Little by little, objects have raised me to their own level.' This last sentence recurred so often in his notes and interviews that it almost became Brassaï's motto.

Brassaï chose to call himself a 'creator of images', adding that: 'Just as a poet reclaims overused words, the creator of images also challenges everything that has become too familiar. He wants to restore the power of ordinary, disregarded things, to surprise us with what we are tired of

Hans Reichel, Paris, 1931

9. Gilberte Brassaï Archives, undated page.

10. 'My native town, Brassó, is surrounded by pine forests, and with its towers and high walls, its tall pitched roofs and Gothic 'Black Church', is the last medieval site in the West. The East lies a few kilometres away, where the old Byzantine Empire begins.' (Brassaï, 'Souvenirs de mon enfance', *Brassaï*, Éditions Neuf, Paris, 1952.)

11. In 1924 Gyula Halász decided to use the pseudonym Brassaï, after his native town Brassó, to sign his newspaper articles. (Brassaï, *Elöhívás* [see note 14], letter 19, 17 March 1924.)

12. Brassaï, 'Souvenirs de mon enfance', *op. cit.*

13. According to *Elöhívás* (see note 14), they visited him in Paris in May 1927 and August 1931.

14. They were collected by Brassaï's brother, Kalman Halász, and published in Hungarian in Bucharest with the title *Elöhívás: Levelek (1920–1940)* in 1980. An English translation, *Letters to My Parents*, was published by the University of Chicago Press in 1997, at the instigation of Anne Wilkes Tucker of the Museum of Fine Arts, Houston. A French translation of the Hungarian edition is to be published by Gallimard in 2000.

15. Brassaï, *Elöhívás*, *op. cit.*, letter 29, 2 December 1924.

16. *Ibid.*, letter 33, 4 April 1925.

seeing every day, or which through habit we no longer even notice; for me, this is the role of a "creator of images".[9]

To get closer to understanding Brassaï it is important to look back over his life, with its wide range of activities, and to try to pick out its consistent features and its contradictions, while at the same time respecting his wish for objectivity.

'The wind blows in all directions'

Born a Hungarian in 1899 in the little Transylvanian town of Brassó (Braşov)[10] (which became part of Romania after the Treaty of Trianon in 1920), Gyula Halász, the future Brassaï,[11] first visited Paris at the age of five; his father, a professor of French literature, loved the city and had been given leave for a sabbatical year there. He was passionately interested in the eighteenth century, the Encyclopaedists, and above all, poetry. Gyula Halász senior (father and son both had the same given name) was finishing one last book, on the poet Pierre-Jean de Béranger, when he died at the age of ninety-seven.

The child was enthralled by the Jardin du Luxembourg, the rides on the top deck of the Madeleine to Bastille omnibus, the lavish public celebrations for the visit of Alfonso XIII, King of Spain, the Champs Élysées with their mansions, the luxurious carriages, and of course by the first cinematographic images, shown on the Grands Boulevards.[12]

He fulfilled his father's private wish that one of his sons would live in Paris, and came back in 1924 after studying fine art first in Budapest and then in Berlin, intending to make a career as an artist. Although he was always very close to his parents, who came to visit him in Paris several times,[13] he never returned to Hungary.

The most important available source of information on Brassaï the man, therefore, is the collection of letters that he wrote to his parents over a period of twenty years between 1920 and 1940.[14] The early ones, dated 1920, 1921 and 1922 were written in Berlin; all the others were sent from Paris, except for a few from Brittany or the South of France, where he occasionally spent summer holidays.

The letters are very informal, and sometimes read more like a private journal than a correspondence. In them Brassaï reveals a complex and energetic temperament: 'I have hundreds of faces I can use to conceal my real self and every person I meet knows a different mask.'[15] 'I have long since rejected everything peaceful and quiet – everything mean, mediocre and ordinary.... I am not interested in a boat trip around the coast, however idyllic – and above all, however peaceful and quiet – it might be. What I want is the ocean with its crested waves and deep troughs.'[16]

He analyses himself perceptively, and is already aware of the many contradictions and insoluble interior conflicts to which he will be subject all his life. 'I have had to accept that alongside the artist, and independently of him, I harbour another self that I could call a thinking or a philosopher self. After the artist had managed to make himself heard during their first bout, I was obliged to admit the force of my other self's claim to equal rights. These two roles each demand undivided attention,

17. *Ibid.*, letter 14, Berlin, 15 February 1922.

18. Hans Reichel (1892–1958) was a German painter and watercolourist; he rejected comparison of his work with that of Paul Klee. In May 1928 he took the room next to Brassaï's at the Hôtel des Terrasses, on the corner of the Rue de la Glacière and the Boulevard Auguste-Blanqui. 'We lived the first seven years of his time in Paris side by side; we saw each other almost every day and without fail every evening, night-owls that we were at that time.' (Brassaï, 'Mon ami Hans Reichel', *Hans Reichel*, Jeanne Bucher, Paris, 1962.)

19. Alfred Perlès, a correspondent on the *Chicago Herald Tribune*, was Austrian by birth; he was part of the group including Lajos Tihanyi, Hans Reichel and Henry Miller who were Brassaï's first friends in Paris. Perlès was for several years inseparable from Miller. (Henry Miller, *Quiet Days in Clichy*, Olympia Press, Paris, 1956.)

20. André Kertész (1894–1985). Brassaï listed the eight articles published in French and German magazines on which he asked Kertész to collaborate with him as photographer. They were: 'La Tour [Eiffel] a quarante ans', *Vu*, no. 63, 1929, reprinted with the title '40 Jahre Eiffelturm' in the *Müncher Illustrierte Presse*, no.19, 1929; 'Das Heilsarmee-Schiff auf der Seine', *ibid.*, no. 25, 1930; 'Die Technique in der Kirche', *Das Illustrierte Blatt*, Frankfurt, no.12, 1930; 'Kennen Sie schon Moochi und Broadway, Reportage aus einem tanzenden Kongress', *ibid.*, no. 27, 1930; 'Mr Molier und sein Privatzirkus', *Kölnische Illustrierte Zeitung*, Cologne, no. 20, 4 July 1930; 'Wochenend auf Bäumen', *ibid.*, no. 31, May 1931; 'Das Deutsche Paris', *Die Wochenschau*, Essen, 1930.

21. Relations between Kertész and Brassaï later became strained when Kertész claimed to have been an inspiration to Brassaï, which Brassaï always vigorously denied. He returned to the question during a conference at the Massachusetts Institute of Technology, Boston, 13 May 1977: 'André was my friend. And I liked his photos, but I never worked in his darkroom, and he never lent me a camera, contrary to the stories that are told.' Kertész emigrated to the United States, and on his first visit to him there in 1957, Brassaï was greeted with the bitter comment, 'Here, I am dead.' He was later moved to write a long article entitled 'My friend André Kertész' in *Camera*, Lucerne, April, 1963.

22. Henry Miller, preface to *Histoire de Marie*, p. 10, Actes Sud, Arles, 1995.

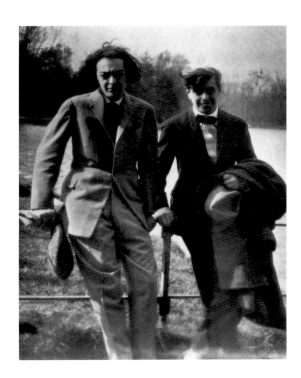

Brassaï and Tihanyi in the Bois de Vincennes, 1924

and do not coexist comfortably; however, in my case I am usually able to keep them apart. As soon as one of them is quiet – as soon as I stop reacting intuitively – the other, with its inexhaustible thirst for knowledge, takes over. And in this way one alternates constantly with the other.'[17]

He clearly knows that he is original and creative, many-sided and complicated, has unpredictable moods and is a mass of contradictions, and concludes (not without humour): 'I am a queer fish!'

His descriptions of Paris and his painter friends – Lajos Tihanyi, Hans Reichel,[18] Alfred Perlès[19] – and life in Montparnasse are very colourful and almost pointilliste in style, with great detail and in a very visual idiom. He managed to make a meagre living from articles that he sent to Hungarian and German newspapers. 'At that time I was working as a journalist, and I asked several photographers to illustrate my articles. That was how it came about that I asked André Kertész[20] to take the photos for two or three reportages.' Brassaï had not yet begun to think about being a photographer himself, but it is likely that while working alongside Kertész and other photographers he became captivated by the power of the image. He recognized in Kertész the two qualities he would always consider essential for a great photographer, 'an insatiable curiosity about the world, life and mankind, and an acute awareness of form'.[21]

The letters also gradually reveal the depth of his identification with Paris, described also by Henry Miller: '[Brassaï] was apt to meet in the most unexpected quarters.... He was always on the qui vive, always sniffing the air, always poking into corners, always looking beyond you. Everything, literally, was of interest to him.'[22]

He said he was never tired of looking at the Tuileries or the banks of the Seine. By contrast, the pictures in the Louvre and other galleries

became for him nothing more than a frozen reflection of 'real life'.[23] The 'trade' of painter – for which he was trained at the Academy of Fine Arts in Budapest, and then in Berlin – had lost its appeal. He saw it as a 'business', certainly one within his capabilities, but not one he wanted to pursue; to shut oneself away indoors to paint when life itself was so fascinating no longer interested him, since photography now seemed to him the most appropriate means of expression for the times he lived in.

'My father bequeathed me his poet's mantle'

It was with the proceeds of an evening's poetry reading that young Gyula Halász was able to finance his journey from Brassó to Berlin. Having spent his childhood and adolescence in a cultivated environment, becoming very sensitive to sound and the value of words, he suffered considerably from having had to give up his rich native language: 'My personal tragedy is that I had to exchange my mother tongue and the Hungarian vocabulary, which I spoke and wrote confidently and without inhibition, for a correct German. All the time that I was learning first German and then French, I was afraid of losing my mother tongue, the only language whose riches and subtleties can ever be truly known; it is irreplaceable.'[24]

In Berlin, he immersed himself in a particularly intense intellectual and artistic way of life. Then, soon after his arrival in Paris, he made important friendships with a large group of poets: Raymond Queneau,[25] his neighbour in the Hôtel des Terrasses, Rue de la Glacière; Léon-Paul Fargue,[26] about whom he would later write that he loved the run-down quarters and Paris at night 'like mistresses'; Robert Desnos,[27] whom he had met in 1927 when he still belonged to the Surrealist group, and who, by means of his extraordinary gift of poetic vision, was, in Brassaï's eyes, its very incarnation; Pierre Mac Orlan,[28] who, because of the similarity of their worlds, he hoped would write a text for the 'Secret Paris' that was intended to be a sequel to *Paris after Dark*. They all shared a keen sense of the poetry to be found in all areas of the city, a taste for the unusual, and responded to the special intoxication of the Parisian night. But it was probably to Henri Michaux,[29] Jacques Prévert[30] and Pierre Reverdy[31] that he was closest.

Brassaï met Michaux in 1925, soon after his arrival in Paris, through a mutual friend, the violinist Silvio Floresco. They had frequent long discussions about literature, the theatre or travel (see pages 181–85): Brassaï made typewritten notes of some of their conversations and telephone calls.

Brassaï and Jacques Prevért (and his brother Pierre) were introduced in 1929 by Georges Ribemont-Dessaigne; they too became inseparable companions, both socially and in their creative work. Stage-sets using photographic images were made for the first time – using photos by Brassaï – for a ballet by Prevért and Joseph Kosma, *Le Rendez-vous*. Prévert wrote, with a touch of genius, the poetic text to accompany Brassaï's nudes in the 1946 collection *Trente dessins* (see pages 192–98). Brassaï, Prévert and their friend and publisher René Bertelé frequently

23. Brassaï, *Elöhívás*, *op. cit.*, letter 19, 17 March 1924.

24. Gilberte Brassaï Archives, notes headed 'Autobiography'.

25. Raymond Queneau (1903–76). Brassaï's second photographic stage design, featuring passageways in the metro, was for a play by Queneau at the Théâtre Agnès-Capri in 1947. Brassaï dedicated *Henry Miller grandeur nature* to him (Gallimard, Paris, 1975).

26. Léon-Paul Fargue (1876–1947) See Brassaï, *Henry Miller grandeur nature*, *op. cit.*, p. 33.

27. Robert Desnos (1900–45). See Brassaï, *Picasso & Co.*, Thames & Hudson, London, 1967 (*Picasso and Company*, Doubleday, New York, 1966), pp. 114–15.

28. Pierre Mac Orlan (1882–1970). See Brassaï, *The Secret Paris of the 30's*, Thames & Hudson, London, and Random House, New York, 1976, pp. 9–10.

29. Henri Michaux (1899–1984). 'I have met a young Belgian writer, and we see each other almost every day.' (Brassaï, *Elöhívás*, *op. cit.*, letter 31, 27 January 1925.)

30. Jacques Prévert (1900–77).

31. Pierre Reverdy (1889–1960). See Brassaï, 'Reverdy dans son labyrinthe', *Mercure de France*, no. 1181, January 1962.

32. Jacques Prévert, *Paroles*, Éditions du Point du Jour, Paris, 1945.

33. Three of Prévert's collages in particular are based on Brassaï's graffiti: Untitled (cover of *Les Prévert de Prévert, Collages*, catalogue of the exhibition held in Paris at the Bibliothèque Nationale, 1982) based on photograph A 1404 U; *Hommage à Courbet*, based on the photograph of the Vendôme Column N 434; *Les Amants*, based on photograph A 1802.

34. Brassaï, 'Prévert', *Vogue*, December–January 1971.

35. Reference to *La Folle de Chaillot* by Jean Giraudoux (1945), with Marguerite Moréno in the title role. The director, Louis Jouvet, had asked Brassaï for a print of his photo of Bijou as the model for the make-up and costume for Giraudoux's character. See 'Brassaï. The Mad Woman of Paris', *Harper's Bazaar*, no. 2812, April 1946.

36. Brassaï, 'Reverdy dans son labyrinthe', *op. cit.*

37. 'Les chats de Paris', text by Colette, photos by Brassaï, *Harper's Bazaar*, no. 2814, June 1946.

38. Brassaï, 'Le sommeil', *Labyrinthe*, Geneva, no. 14, 15 November 1945.

39. André Calles, 'Brassaï', *Combat*, 18 July 1949. Reference to Brassaï's photograph of September 1931, *Dewdrops on a Nasturtium Leaf*, which was used to illustrate Louise de Vilmorin's text 'Ce soir' in *Minotaure*, no. 6, winter 1934–35.

40. Henry Miller, 'The Eye of Paris' [1933], *Globe*, Chicago, November 1937; *Max and the White Phagocytes*, The Obelisk Press, Paris, 1938; *Brassaï*, Éditions Neuf, Paris, 1952. See p. 174.

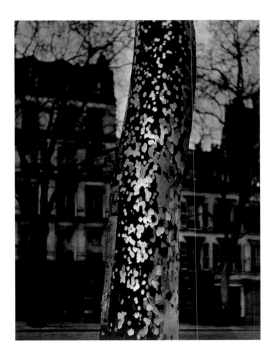

Parisian Plane Tree, c. 1938–45

met in the evenings in the Rue du Faubourg-Saint-Jacques. Together they had the idea of using one of Brassaï's photographs of graffiti on the cover of the first edition of Prévert's *Paroles*;[32] Prévert also based several of his collages on Brassaï's grafitti.[33] Brassaï declared an unqualified admiration for Prévert's ability to 'free images and words from their thick blanket of familiarity',[34] and to give a new freshness to the most ordinary things. For his part, Prévert was deeply moved by the impact of Brassaï's images: 'Your pictures have an unrivalled power. I see no difference between painting and photography in this respect. In cases where they have the same impact, and radiate the same poetry, it is immaterial to me whether I am looking at photos or paintings…. That outstanding photo of Bijou…. I would give Giraudoux's entire play[35] for that one photo.'

With Pierre Reverdy, whose *joie de vivre* and intense interest in the links between art and poetry he admired, he shared a strong feeling for the need to simplify, to highlight the essentials: '… Reverdy's poems. They were clear, strong, and pure as crystal. Each line was like a snapshot of an object or event, caught on the wing, firmly secured yet alive with their original power, captured for ever. I was amazed by this great poet's gift for giving a permanent form to things which had struck him, and by the sharpness of his vision. And how fastidiously he eradicated all signs of sentiment or sentimentality from his poems, taking care to conceal anything of himself behind other things…. "I merely seek out the individual powerful savour of each thing…. A tree: what a fine tree … but nothing more than a tree." This was so close to what I was looking for myself in another medium.'[36]

Brassaï knew how to see the hundreds of insignificant details of daily life; many of the subjects of his photos are at first sight not very original: windows, cats,[37] plane trees, people sleeping.[38] He was receptive to their poetry just as it was, but unlike Robert Doisneau, for example, who said that he allowed himself to be impregnated by such poetry 'like a piece of blotting paper' before re-creating it in effortless snapshots, Brassaï absorbed it and used it to give a more detached poetry to his work. His starting point could equally be a nasturtium leaf or an iron chair in the Tuileries gardens.

'Who else but Brassaï could make drops of dew on a nasturtium leaf look like the milky way?'[39]

'I think of chair because among all the objects which Brassaï has photographed his chair with the wire legs stands out with a majesty that is singular and disquieting. It is a chair of the lowest denomination, a chair which has been sat on by beggars and by royalty, by little trot-about whores and by queenly opera divas. It is a chair which the municipality rents daily to any and every one who wishes to pay fifty centimes for sitting down in the open air. A chair with little holes in the seat and wire legs which come to a loop at the bottom. The most unostentatious, the most inexpensive, the most ridiculous chair, if a chair can be ridiculous, which could be devised. Brassaï chose precisely this insignificant chair and, snapping it where he found it, unearthed what there was in it of dignity and veracity. THIS IS A CHAIR. Nothing more.'[40]

Beyond that simple reality, one of Brassaï's most startling abilities was to make us aware of the indefinable transience of things, such as 'the beauty of fog' (*Statue of Marshal Ney in the Fog*, 1932), 'the tense expressions and extreme concentration of the hurrying people who have stopped for a moment to watch a painting being created' (*Wet Paint*, 1946), or a shirt drying on a washing line, lit from behind by the setting sun, which is like 'a cast human skin' (*Washing*, Megève, 1946).

'A man of the big city'

Brassaï haunted Montparnasse in its heyday: 'At that time Montparnasse was like a powerful drug; we were a large group of friends, which included the poet Henri Michaux, and we stayed at the Dôme until one in the morning, only to move on to the Coupole, which closed an hour later. When time was up there, we migrated to the Îles Marquises in the

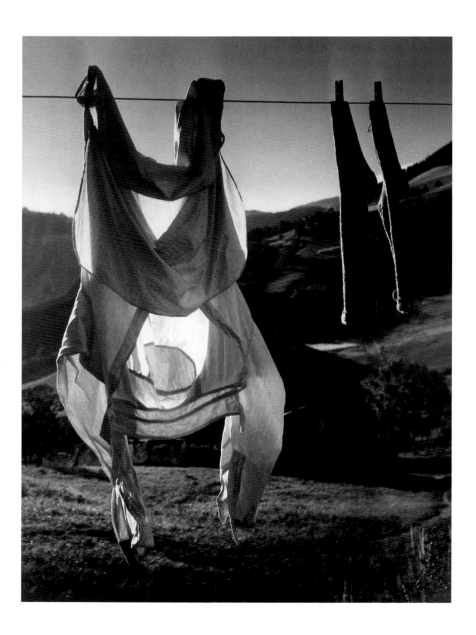

Washing, Megève, 1946

Rue de la Gaîté, always ending up at the Gare Montparnasse, when it was time for fresh coffee and the newspapers hot off the press.'[41]

He set out to discover Paris with an explorer's zeal, a wanderer's freedom, and the intoxication of a man enjoying a time without commitments. He criss-crossed the areas around the Canal Saint-Martin, the Canal de l'Ourcq, Les Lilas and the Place d'Italie, Belleville and Ménilmontant, often accompanied by Raymond Queneau, Léon-Paul Fargue or Henry Miller. 'Our favourite places to have a breather', wrote Henry Miller, 'were gloomy little corners like the Place Nationale, the Place des Peupliers, the Place de la Contrescarpe and the Place Paul Verlaine.'[42]

Brassaï responded to the enchantment of the street, and loved everything about it that was a reflection of people's real lives. He even wrote a few years later: 'The soul of Paris is in the process of being destroyed; on the pretext of clearing the 'slum areas', we are knocking down what used to be the essential magic of the capital; on the pretext of making space around the monuments, we are demolishing the streets which give them their context. Given the choice, I would rather they demolished the monuments and left the streets alone. There are no museums for the streets.'[43] He preferred night to daytime: 'Night only suggests things, it doesn't fully reveal them. Night unnerves us, and surprises us with its strangeness; it frees powers within us which were controlled by reason during the day…. I loved the way the night's apparitions hovered on the edges of the light; there is no such thing as complete darkness.'[44]

Why did he decide to take up photography? 'I became a photographer in order to capture the beauty of streets and gardens in the rain and fog, and to capture Paris by night.'[45] However, this raises the question of why he waited so long before starting to use photographs to record the Paris that fascinated him so much. The answer is simple: all those nights of wandering around Montparnasse, Montmartre, Pigalle, Les Halles, and along the banks of the Seine had been essential for him to become 'impregnated' with his subject. Eventually he was brimming over with it all: 'I was no longer able to keep these images to myself; I had absorbed so many, particularly during my night-time walks. It was now time for me to make something of them, but in a different and more direct way from painting.'[46]

From 1930 onwards he worked on his subject under various headings, lovingly uncovering the city layer by layer: Paris by day, Paris by night, secret Paris.

The original French edition of *Paris after Dark* (*Paris de nuit*) was published in December 1932. It contains sixty-four luminous night pictures that are startling in their poetry. Brassaï commented: 'A creative person is finally born when he has found his own route and voice. The only birth date which matters to me is not Brassó 1899, but Paris 1933.' Émile Henriot wrote a highly favourable review of the book in *Le Temps* of 30 January 1933 which, interestingly, ended with: 'We can easily imagine one of our grandchildren in the future, also turning the pages

41. Gilberte Brassaï Archives, undated page.

42. Henry Miller, quoted by Brassaï in *Henry Miller grandeur nature, op. cit.*, p. 156.

43. Brassaï, extract from a typewritten text 'Pour l'enquête sur la transformation de Paris' (For the Inquiry into the Transformation of Paris), 1959.

44. Gilberte Brassaï Archives, undated page.

45. Conference at the Massachusetts Institute of Technology, Boston, 13 May 1977. Brassaï probably began to take photographs at the end of 1929.

46. Statement reported by Andor Horváth in the postscript of *Elöhívás, op. cit*, p. 231.

of this collection of honest images, and being moved by their poetry. In the end, the strange attraction of the past comes from the reality of the most humdrum things.… Photographers of 1933, you are working for the recognition you will surely also receive in the year 2000.'

Although he rarely attempted to produce poetry in the strict sense, Brassaï always liked writing, and all his important albums are intended to be read as well as looked at, most of the texts being by Brassaï himself: 'Souvenirs de mon enfance' (Memories of My Childhood) in *Brassaï* by Robert Delpire (Éditions Neuf, 1952), the ethnological text of *Graffiti* (Brassaï's best book, according to Lawrence Durrell), the lively descriptive texts he wrote for *The Secret Paris of the 30's, The Artists of My Life* and, most importantly, *Picasso & Co.*

His first prose writings, such as *Le Bistro-Tabac* (1943) or *Histoire de Marie* (1949), confirmed his interest in 'eccentric, bizarre, unattached, individual people', who for him, as for Paul Léautaud, personify 'the magic of life, just as people who are no different from everyone else represent all that is most unattractive about it. I agree with him in seeing them as free beings, while others are slaves. To dress, behave and live as you like, without worrying about the idiots who are shocked or make fun of you, is in its own small way, a sign of a free spirit. Yes, I agree. They escape uniformity. They use their brains. As Léautaud says, they are guided by their own inclinations alone. I too wanted to compile a little collection of them.'[47]

His writing shows a taste for the fleeting moment and a readiness to detail reality as it happens rather than making a literary interpretation of it. Brassaï the writer shows the same instinct to avoid all subjective treatment as Brassaï the photographer. His *Histoire de Marie, Le Bistro-Tabac* or *Le Chauffeur de taxi* exactly balance a photo-reportage such as *A Man Dies in the Street*.[48] Apart from the posed scenes in *Paris after Dark* or *The Secret Paris of the 30's*, the principle of the first photo sequences, which include *A Man Dies in the Street*, runs consistently through a large part of Brassaï's photographic work. In *The Washington Post* of 2 June 1973, the critic Paul Richard described how it takes a little time to get the feel of Brassaï's way of looking at things, because his photographs are so stripped of personal ego that it is easy to forget entirely about the individual who took them. There is nothing to interrupt the direct communication established between the subjects of the photographs and the observer. It is as though they had somehow photographed themselves.

The desire to get to the essential, the desire for what is 'felt' and 'alive', is also present in his drawings: 'I don't like the convulsive shapes in Van Gogh's work', 'In drawing, all that matters is the line, everything else is cheating.'[49] This is underlined in the simple forms of the sculptures he made which were directly inspired by primitive Venus figurines.

'Thinker and philosopher'
A look through the books in his library gives an idea of the vast range and eclecticism of Brassaï's interests and knowledge; everyone who knew him remarked on the brilliance of his conversation. His copies of the writings

47. Gilberte Brassaï Archives, notes dated February 1952. *Histoire de Marie* was based on his own domestic cleaner, a strikingly bizarre and individual character, called Marie Mallarmé.

48. Published in *Vu*, no. 228, 27 July 1932, and entitled 'Dans la rue'; reprinted in *Labyrinthe*, 15 November 1945.

49. Handwritten notes in the margins of a copy of Adolphe Basler and Charles Kunstler, *Le Dessin et la gravure modernes en France*, Éditions Crès, Paris, 1930, p. 116.

of the philosophers Montaigne, Goethe and Henri Bergson are full of notes in black or red pencil; certain sentences are underlined more than once, with copious notes in the margins. His mordant comments show the extent to which reading was a dialogue for Brassaï, and throughout his life was the battleground for the two sides of his personality.

Where Montaigne[50] declares his intention of spending the rest of his life 'quietly', Brassaï lashes out with 'I dislike this laziness', reinforced further on with 'I've had enough of this! What's the point of a life of simplicity and ignorance, without literature, real life or art?'

La Pensée et le mouvant by Bergson provoked furious comments such as: 'He who *sees things* feels no need to philosophize about them', or 'What is needed is *inspiration* or poetic gifts. Method alone cannot produce a creator.'

Goethe, on the other hand, whom Brassaï first discovered during his stay in Berlin, overwhelmed him. Underlying this fascination is a shared *Sturm und Drang* temperament, frequently expressed in his youthful letters, and later tempered by an equally shared taste for classical balance, pace and harmony. 'My encounter with Goethe was shattering, particularly coming at that stage when feelings of apprehension about life are uppermost, and readily reinforced by rebellion and doubt; the last thing I expected was salvation when I began to read him. But the electricity that produced such a violent shock in previously unimagined areas of my being forced me to take notice of something that would not only change for me the way the world looked, but its whole fabric. I wonder if a mind so resigned to wandering aimlessly in a miserable vacuum has ever made such a complete about turn, coming triumphantly back to life, filling the nervous system with stars and the bones with constellations of them, to become positively part of the multiplicity of living.'[51]

Brassaï was first drawn to Goethe by his particular way of 'seeing', his need to reach what is real in all its forms, which made him simultaneously a poet, writer, artist, politician, geologist, botanist and collector. Brassaï noted on a loose sheet of paper: 'Goethe … a single way of thinking underpins all his thoughts, and one single organ dominates all the others: it is the inward vision, and the eyes are merely its instruments.' Brassaï, who is so often referred to as 'visual', denied it at this stage, showing his disappointment by underlining several times a passage in which Goethe expresses regret at not having 'more eyes to be able to take in everything'.[52]

The section of his library concerned with Marcel Proust (including his complete correspondence in the Plon edition) shows Brassaï's passionate interest in the novelist; he was one of his favourite authors. 'The French writers I particularly like are Diderot, Gérard de Nerval, Baudelaire of course, and Restif de La Bretonne, a real night person and graffiti enthusiast. And I often reread Proust.' His posthumous book, *Marcel Proust sous l'emprise de la photographie* (Marcel Proust and His Fascination with Photography), published in 1997, amounts to an examination of one of Brassaï's recurrent preoccupations: the *latent*, or what could have been and what has not been, what is buried, and yet close at hand, beneath reality. 'Photography illuminated for me a new Proust, as a kind of photographer

50. Montaigne, *Essais*, book III, Plon, Paris, p.147.

51. Brassaï's reply to a survey on 'La rencontre capitale de votre vie' (The Most Important Encounter in Your Life), *Minotaure*, no. 3–4, December 1933, p. 102.

52. From a letter to Charles Vulpius, 3 June 1812, quoted in Henri Lichtenberger, *Goethe*, vol. I, Henri Didier, Paris.

of mental images, with his own being as the sensitized plate; he was able to capture and store thousands of impressions during his childhood, and when he set off in search of lost time, he constantly developed and fixed them, so that the latent image of his whole life was made visible as the gigantic photograph which is *Remembrance of Things Past*.'[53]

Brassaï did not only select or create images, but also took particular pleasure in revealing an image that emerged like a watermark, just beneath the surface of an existing image of a wall, a rock or a pebble. The album *Transmutations*, compiled in around 1935 and published in 1967, contains examples of some of this work. By engraving on exposed photographic plates, he would transform images of female nudes into different, equally evocative, nudes or into African masks. There are sheets of contact prints marked 'latent image' here and there with his angular writing in black ink, intended for an album to be entitled *Images latentes*.

A Surrealist?

Brassaï's links with Surrealism are complex. The critic Maurice Raynal introduced him to Tériade just before he and Albert Skira launched their review *Minotaure*, when Brassaï was basking in the recent success of *Paris after Dark*. The beauty of his images and their innovative style was well received by them, and his name began to appear in the review from the very first issue, in June 1933. His contributions were many and varied. Photographs of Picasso's studio were published in the first issue, followed by nudes, graffiti, random objects, Parisian nights. In partnership with Man Ray, he illustrated such texts as Salvador Dalí's 'De la beauté terrifiante et comestible, de l'architecture modern style' (*Minotaure*, no. 3–4, December 1933). Man Ray photographed the work of Antoni Gaudí in Barcelona, while Brassaï covered Parisian art in 1900. Although he got on well with Man Ray personally, he wrote after his death: 'We were almost at opposite extremes in our approach to photography. Man Ray wanted to remove all reference to reality, whereas I was looking for the surreal in reality itself. If I could be said to have invoked the god of Chance as I took my picture, Man Ray did the same in the darkroom, hoping to create surprises and accidental effects by manipulating his negatives: his Dada frame of mind even influenced his photography.'[54]

Brassaï's ideas diverged from those of André Breton and his group over the definition of the surreal: 'It should *surprise*, but not with just anything. And certainly not with things which are astonishing, surprising or strange already because they have never been seen, are unusual or out of the ordinary.... The *surreal* is not a monster, a calf with five hooves or two heads, the freak result of nature bungling one of its creations, but it is a *normal* calf.... The *surreal* exists within us, in the things which have become so banal that we no longer notice them, and in the *normality of the normal*.'[55] Brassaï often returned to this question: 'There was a misunderstanding. People thought my photographs were "Surrealist" because they showed a ghostly, unreal Paris, shrouded in fog and darkness. And yet the surrealism of my pictures was only reality made more eerie by my way of seeing.'[56]

53. Brassaï, *Marcel Proust sous l'emprise de la photographie*, Gallimard, Paris, 1997, p. 20.

54. Brassaï, 'Man Ray', *Les Nouvelles littéraires*, 25 November 1976.

55. Taken from Brassaï's remarks at the banquet for the 'Image Profession' at UNESCO, 1 March 1963.

56. Interview with France Bequette, *Culture et Communication*, no. 27, May 1980.

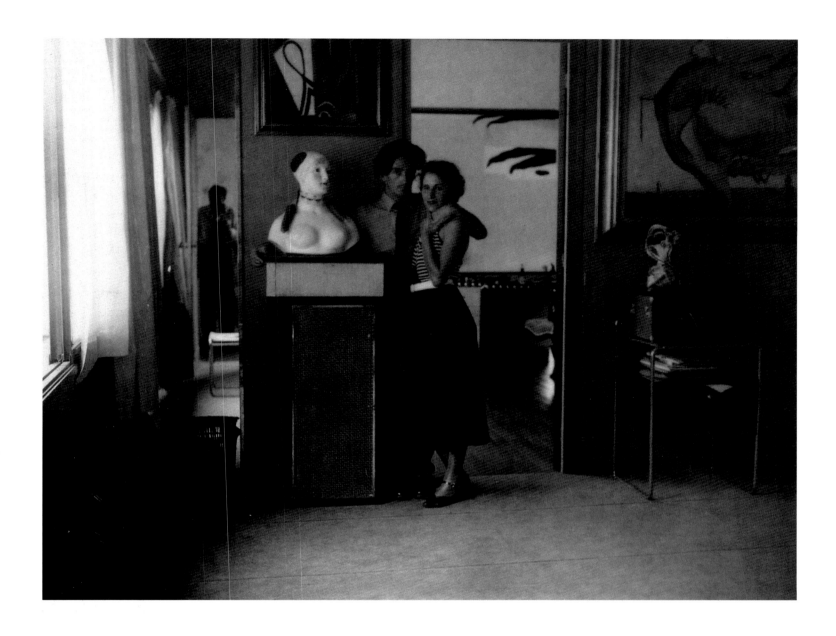

Dalí and Gala in Their Studio near
the Parc Montsouris, Paris, c. 1932

It is worth remarking also that the clannish aspect of the Surrealist movement did not appeal to Brassaï who, like Picasso, went his own way, concentrating on his own work and remaining instinctively independent.

'Specialist or dabbler, confusion or profusion?'

Brassaï was a painter and draughtsman in Budapest (1918–19) and in Berlin (1920–24), then simply a bohemian in love with Paris for six long years, a keen photographer for seven more (1930–37) before suffering a kind of 'photographic depression', which he described in the private journal that he kept at the time (see 'Cahier jaune', pp. 167–72); he photographed Picasso's sculptures during the war, drew and sculpted himself, and created photographic stage-sets; he was an occasional film-maker, a writer during the last twenty years of his life, produced more than three hundred images for *Harper's Bazaar* and continued throughout his quest for graffiti – Brassaï undoubtedly went through many periods

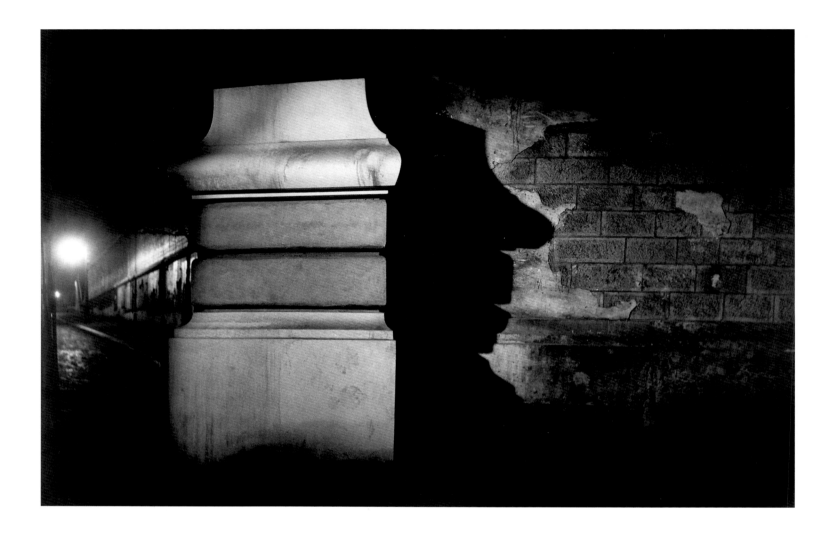

Metro Pillar, 1934

57. There is one known contact sheet of double exposures, Nostro series, plate 32.

58. Constantin Guys (1805–92), draughtsman, watercolourist and engraver, recorded military events (the Crimean War) and Parisian life (the 1848 revolution, romantic scenes) for the *Illustrated London News* and *Univers illustré*. Baudelaire admired his work very much. The quotation is from a typescript dated 4 April 1960, Gilberte Brassaï Archives.

of development and change, constantly moving from one medium to another.

Was he not really a professional, but a dabbler? A poet? An illustrator? Unable to categorize himself as either a reporter or a specialist in any particular area of photography, Brassaï often wondered exactly how to describe his work.

Although it is unsigned, the preface to *Camera in Paris* (1949, see pp. 280–84) is regarded as one of his definitive texts. He wrote in a letter dated 15 April 1948 to the publisher, Andor Kraszna-Krausz, that he intended it to be a serious text in which he would sketch a psychological portrait of the modern photographer and define his specific role.

He always disliked the terms 'artistic photographer' and 'picture hunter'. He also rejected what he called 'childish amusements' such as double exposure[57] or solarization. What should he call himself then? A description of Constantin Guys[58] by Baudelaire helped him to define his role; like Guys, he both felt like and wanted to be not so much an artist as an enthusiast. He saw himself as 'a sardonic and dedicated observer of the world, a plunderer of beauty of all kinds, a thief who with a click of the shutter, a slow polishing of the stone, a carefully drawn line, captures the

thing that has enthralled him', and he saw curiosity in its most positive sense as his driving force. This conclusion was reinforced by Henry Miller in his introduction to Brassaï's *Histoire de Marie* (1949): 'He is always on the alert, always ready to change and adapt himself, always looking for new "avenues" of expression. He is already overflowing with experiences of life, which even channelled into a dozen occupations would still not be enough for him.'

An article by Brassaï dated April 1960 returns to this subject. It has a double title, 'Specialist or dabbler, confusion or profusion?' He had just held a successful exhibition of his drawings and sculptures at the Galerie du Pont-Royal, yet he was still cross-examining himself. Painter, sculptor, photographer, film-maker, theatre designer, writer and traveller – had he spread himself too thin among his many interests? If his life had been full, had his work been consistent? He concluded that it had: if he had limited himself to what can be photographed, inevitably some aspects of reality would have been lost, and only a range of means of expression will enable a relatively true picture of the world to be achieved.

He called in evidence Renaissance Man, 'inhabitant of the world' and 'enemy to all specialization' because 'a man specializing in one thing relegates himself from the ranks of artist to that of artisan. Success in any one area encourages and even requires exploitation of this success, making a profession as a "specialist" out of what had been done for sheer pleasure as an amateur. The dilettante's passion for an art will always be greater than that of the man with the gift of practising it, for the dilettante's passion is like a hopeless love, for ever insatiable. All my life I have tried to preserve the amateur's freshness of vision, coupling it every time with the knowledge and awareness of the professional: this is the reason for my constant changes of tack, the scope of my curiosity, and my many parallel skills … this apparent inconsistency has been my own logic.'

Towards the end of his life, in 1978, in the closing lines of his preface to *Elöhivas* he wrote: 'Isn't it the case that each person's life is like the delta of a great river, the branches representing all the possible directions our lives can take? Some of the branches remain narrow, flowing slowly, while others widen. But whichever channel it flows along, shouldn't we accept that all the water comes from the same source, and is ultimately one river? In the end, I see no reason to regret that the widest branch of the river of my own life has been photography.'

'A universal man'

Henry Miller had 'photographed' Brassaï perfectly the moment they met and often mentioned his rare ability to adapt to any person's situation, to familiarize himself with any kind of work, to feel at home at all social levels. Brassaï himself declared: 'I have known hooligans and crooks, and been out with them. While I was doing a reportage on the filming of *La Dame de chez Maxim's* at the request of Alexander Korda, I met a film electrician with access to the underworld, and thanks to him I was able to witness the oldest and most authentic dance hall in the Rue de Lappe, the Bal Musette des Quatre-Saisons.'[59]

59. Gilberte Brassaï Archives, undated page.

Gyula Halász, c. 1919–20

60. To Brassaï she was 'the quintessential French "grande dame"' (*Előhívás, op. cit.*, letter 26, 11 October 1924). He was her frequent guest in both Paris and Brittany, and she provided the entrée to a number of Paris salons.

61. After living for two years at Clichy, Miller moved in autumn 1934 to 18, Villa Seurat in the 14th arrondissement of Paris.

62. Anaïs Nin (1903–77). American by birth, she lived in cosmopolitan circles both in Europe and in the United States. She knew many writers, among them Henry Miller, and wrote the preface to his *Tropic of Cancer*. She is known mostly for her monumental *Diary*.

63. 'Brassaï: il chasse l'homme avec l'amour' (Brassaï: He Hunts Man with Love), *L'Express*, 10 November 1960.

64. Brassaï's graffiti have been the subject of the following publications and exhibitions: 'Du mur des cavernes au mur d'usine' (From Cave Wall to Factory Wall), *Minotaure*, no. 3–4, December 1933 (see p. 292); 'Walls of Paris by Brassaï', *Harper's Bazaar*, no. 2900, July 1953; 'Language of the Wall: Parisian Graffiti Photographed by Brassaï', exhibition at the Museum of Modern Art, New York, in 1956; 'Graffiti parisiens', *XXème siècle*, 10 March, 1958; Brassaï, *Graffiti*, Belser Verlag, Stuttgart, 1960; Éditions du Temps, Paris, 1961; exhibition at the Galerie Daniel Cordier, Paris, 1962.

65. Gilberte Brassaï Archives, undated page.

At the time of his first sorties into Parisian society, his guide was Madame D.-B.,[60] who introduced him into some of the city's most exclusive circles at the homes of the Princesse de Faucigny-Lucinge or the wealthy patron Pierre Duchesne-Fournet; he also visited the salon of Maurice Barrès's sister, among others, and was a regular guest at the balls of the Comte de Beaumont and the Vicomtesse de Noailles. In this way he became familiar with both 'society' and the 'underworld', particularly as the attraction of life in the bohemian and 'rough areas' for the bourgeoisie, and conversely the lure of the aristocracy and its money for members of the underworld and bohemia, encouraged unpredictable and unexpected contacts. For example, Brassaï's group of friends from the Villa Seurat[61] – Henry Miller, Alfred Perlès, Hans Reichel and Lawrence Durrell – linked up with another group, Émile Savitry, Roger Klein, Helba Huara and Gonzalez Moré, through Anaïs Nin,[62] because she had fallen in love with Moré ('a suntanned Peruvian like an Inca god') and belonged to both groups. *The Secret Paris of the 30's* illustrates this mingling of the night worlds.

However, it would be wrong to give the impression that Brassaï restricted his interest and researches to these extremes of society. 'It is humanity' in the widest sense 'that Brassaï pursues with devotion', according to François Mauriac:[63] the workers, the tramway employees, the track repairers, the porters at Les Halles, the baker seen through his basement window, the watchmaker in his tiny workshop, the ruffians and the tramps; and most tenaciously of all, he spent some twenty-five years tracking down the graffiti on the black, encrusted walls of Paris made by 'inadequates', 'simpletons', 'misfits', 'rebels' or abandoned children.[64] He saw them as the most spontaneous expression of the great human themes: birth, love and death. He saw the spark of real life there, and even thought of the possibility of a ballet on the subject. 'The curtain would go up on a great wall covered with graffiti; in front of the wall, on the asphalt, three little girls would play hopscotch. Then the graffiti would come to life and leave the wall, the "Arrow" chasing the "Heart", the "Hammer" and the "Sickle". There would also be "Death", "Masks", the "Sexes" and other such symbols.'[65]

Brassaï's world consisted of several interpenetrating worlds, together producing images full of humanity, and deservedly unforgettable. His final, though unrealized, project was a kind of encyclopaedia of man, 'Les jours de l'homme', along the lines of Steichen's 1955 exhibition 'The Family of Man'. The idea for this project brings together all the strands of a mind focused insatiably and with fascination on people, animals and the beauties of creation, and attempts to convey the true quality of that beauty, the magic of the form it takes, and the unusual and mysterious impact of its nocturnal splendours. 'Nothing is finer or greater than reality itself; why wrap it up in our own confused emotions?' (1932).

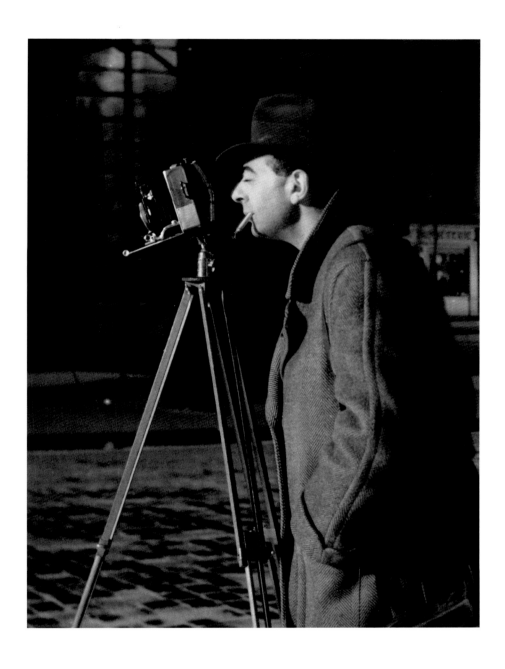

Brassaï, Boulevard Saint-Jacques, c. 1931–32

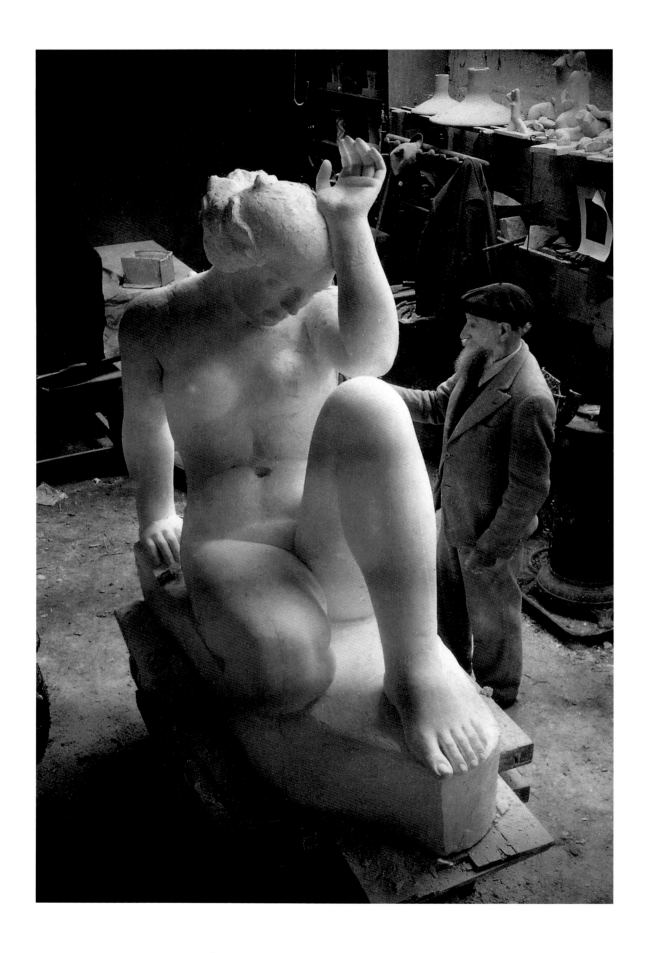

Maillol and The Mountain, 1936

'Cahier jaune'* (extracts) Brassaï

PARIS, 1 NOVEMBER 1936, ALL SAINTS' DAY

Bought this notebook this evening. Is it too late? No, not yet, but it's certainly high time! Some important memories are becoming indistinct. Now that I am attempting to get my life a bit more organized, I am all too aware of having allowed the past to slip away, and am determined not to risk letting it happen in future. Although I have forgotten faces and failed to record meetings with certain people, I have not yet lost it all. I have taken the first step with this yellow notebook.

Yves Allégret[1] has given me a camera; I'll try it out. I feel sure of succeeding straight away. I will find things by chance, without any preconceived ideas, without a script, just people going about their business. I will make 'sets' of images without a particular theme. They will have nothing in common but the eye which saw them, and be bound together by life more securely than by even the cleverest script.

Received the *Conversations* of Goethe and Eckermann that I ordered a few days ago. I am reading another fascinating book at the moment, a collection of all the conversations with Goethe recorded by people who met him. I also bought the three volumes on Goethe by Emil Ludwig.

Tihanyi[2] brought me the first proofs of the lithographs for his book.

Worked until midnight with Rado,[3] and chose 120 photographs to send to America.[4]

PARIS, 2 NOVEMBER 1936

Pale autumn sunlight. The chestnut trees on the Boulevard Arago and the planes in the Jardin du Luxembourg are almost completely bare. A walk along the embankments. Madrid is under threat, Mussolini makes a revisionist speech, but here the fishermen look at the Seine (calm as a lake today), idlers look at the fishermen and Notre-Dame highlighted against a leaden sky by the last rays of the sun.

Went at ten in the evening with Tihanyi to the Gare de Lyon to meet Vincent Korda[5] when he arrived from Rome. Hôtel Meurisse. Café Weber. Vincent gave me the Kert-Beufin camera that I bought through Korda's film company four years ago for eight thousand francs. I will repay him with photos....

PARIS, 3 NOVEMBER 1936

... I had been short of money for long enough, without any commitments, and spending most of my time and energy earning just enough to keep my hotel manager happy, and otherwise quite likely to die of hunger; so that for some time now I have been leading an ordered existence, with a respectable flat, a company name, assistants working for me,[6] bills to pay by a certain date, doing undemanding but necessary work, to keep 'maison Brassaï' going for me, its chief drudge; and in the end I have realized that what would make me really happy would be a modest income and a studio with the rent paid in advance, so that I would have the necessary security to devote

* Journal kept by Brassaï from 1 November 1936 to 8 September 1937, Gilberte Brassaï Archives. It consists of 29 typed sheets, to which Brassaï gave the title *Cahier jaune no. 1*. The Archives also contain other fragments of private journals (1952, 1959, 1960).

1. Yves Allégret, film director (1907–87). At the time he was assistant to Jean Renoir and his brother Marc Allégret. His own career as a director was not properly launched until after the war, notably with *Dédée d'Anvers* [English title: *Dédée*] (1948) starring Simone Signoret – his wife – and Bernard Blier, *Les Orgueilleux* [*The Proud and the Beautiful*] (1953) with Michèle Morgan and Gérard Philipe, etc.

2. His friend the painter Lajos Tihanyi, see note 6, p. 151.

3. Charles Rado, Hungarian founder of the Rapho agency, for which Brassaï worked before the war. Rado left for New York at the beginning of the war and settled in the United States, where he set up another agency and became Brassaï's transatlantic representative.

4. Photographs by Brassaï appeared in the magazine *Coronet*, published in Chicago, from September 1937 onwards.

5. Vincent Korda, brother of the British film director Sir Alexander Korda, Hungarian by birth, who founded the London Film Company in 1932. Alexander Korda invited Brassaï to work on his film *The Girl from Maxim's* following the publication of *Paris after Dark*. Brassaï was attracted by the tempting financial prospects and the opportunity to learn about filming, and joined the team for four months, but his role in it remains unclear (see *Elöhívás, op. cit.*, letter 69, 12 August 1932).

6. Brassaï insisted on making his own prints, and in fact he had only one assistant, Émile Savitry (1903–67), from the end of 1935 to March 1937, when they separated and Brassaï handed over to him his work for *Coiffure de Paris*. A young Hungarian named Kiss worked for him as a messenger, factotum and bodyguard; interestingly, Brassaï asked him to pose in some of the pictures in the series 'At Suzy's'.

myself to painting and sculpture at last, and be able draw breath again....

PARIS, 7 NOVEMBER [1936]

Several mysterious telephone calls in the last few days from a Mademoiselle Yves; it's Léone, I recognized her hoarse voice today; she is the model who posed unpaid for my first nudes at the Rue de la Glacière. I met her one evening at Montagne Sainte-Geneviève; she was with Maud and Mademoiselle Claude. We have been out of touch for three years already. She went on tour with a tenth-rate company to the Côte d'Azur. She wants to meet up today. Of course we must. I liked the girl very much, with her disconcertingly natural manner, her sensuous voice, her firm legs and breasts, her body slightly on the heavy side, but extraordinarily sculptural. Well, this girl Léone came today with her body completely out of shape, seven months pregnant, abandoned, penniless, but with a face made even more beautiful by worry and suffering. I was very disturbed by this apparition. 'My figure is ruined. I won't ever be able to dance naked again.' 'He moves, you know, – it's definitely a boy – he never stops punching my belly, it's enough to drive me mad.' ... I gazed at this girl lying on my bed, with her enormous belly, without really taking in what she was saying, and it seemed to me that all her physical beauty had gradually retreated to her face; I had never seen her looking so beautiful.

In the evening I had a visit from Medina,[7] Bouthoul and Mme Bouthoul. I showed them some photos and drawings....

PARIS, 8 NOVEMBER [1936], SUNDAY

Very busy all day. In the afternoon to the publisher Vishniac, dinner with Tihanyi, Rado, Adolphe Dehu, in the Avenue de New York.

PARIS, 16 NOVEMBER 1936

Less tired, in a better mood today. It would have been a mistake to turn down this job that has been depressing me for the last few days. It's a catalogue of 'forty-eight pages of

articles' available from Lancel, the well-known supplier of leather goods and jewelry in the Place de l'Opéra. Lighters, cigarette cases, watches, ashtrays for bridge parties, tea services, liqueur glasses, travelling bags, lamps and vases.

I would have been wrong not to agree to doing this catalogue, because one always learns something from this kind of work, and photographing things for a catalogue is a (hard) lesson in humility. There is no place for telling stories or playing the 'artist', it's only about the object, clearly shown, nothing but the object for what it is. I can't say that it makes my heart beat faster to photograph a cigarette lighter, but if I do it well, at least I can be pleased with a workmanlike job, producing from reality an image that does it justice, or even improves on it; it really is hard to make a good photograph of a cigarette lighter!...[8]

PARIS, 28 NOVEMBER 1936

Dinner at Queneau's. Made him go with me to the Hairdressers' Dance at the Boulogne-Billancourt town hall. The taxi took us (through the fog across the Bois de Boulogne) to the public hall and the Hairdressers' Dance, perhaps the hundredth I have been to. I explained to Queneau that I have another life here. Everyone knows me. The point is that I can learn about France via the middle classes. Peasants are the same everywhere, and the lives of the upper middle classes are becoming more cosmopolitan. It is the workers, and above all the petty bourgeoisie, who are the key to a country's outlook.

PARIS, 29 NOVEMBER [1936], SUNDAY

I am working too hard on these reportages. Another two this evening. Spent an enjoyable few minutes reading the life of Goethe. There has never been anyone in the world before with such an awareness of his cultural inheritance. He has studied life in all its forms with equal concentration, as if he were a legatee taking charge of his possessions. To him everything is of equal importance, from the most ordinary, mediocre things to the most exceptional. When Napoleon said of him after their meeting, 'Now, there is a man', to me the words mean something probably rather different from what he intended: 'There is a man who speaks to me as an equal.' Either way, he (perhaps unconsciously) attributed to Goethe the highest of qualities. If there have been men who have surpassed him, either with their creative genius, like Shakespeare, or with their determination, like Napoleon, or with their reasoning, like Pascal, there has not been one whose life

7. Paul Medina, political journalist, correspondent on the *Frankfurter Allgemeine Zeitung*.

8. The collection of contact prints suggests that Brassaï in fact carried out very few publicity assignments. Among them is an advertisement for the Robert Piguet perfume *Bandit*. Nevertheless, in letter 80 (*Elöhívás, op. cit.*) dated 17 October 1935, he refers to advertising commissions for Hutchinson tyres, Monsavon, l'Oréal and others.

and work (which are really the same thing) have given the word 'man' such profound meaning, or who has tested the possibilities of human existence to its limits as conclusively as he has.

PARIS, 19 DECEMBER 1936, SATURDAY

This afternoon to see Aristide Maillol[9] at Marly-le-Roi. I looked for his house in the Rue Thibaud in complete darkness, hidden behind its bushes, and found it at last thanks to the wash-house which I remembered noticing next to the studio. The little maid opened the door and said, 'Monsieur Maillol will be back soon, he is at Monsieur Van Dongen's studio.' I later learnt that this was the studio of Van Dongen the sculptor, brother of the painter, where Maillol is finishing a large sculpture called *The Mountain*, which will be in the exhibition in April. I have already been several times to Maillol's studio, but never into his house, which is to the left of the path, and I found myself in the dining room, warming up in its pleasant country atmosphere. Here there is a very fine 1886 landscape by Bonnard, another painting by Bonnard, a street scene of the same period, a few Greek statuettes, a large tapestry whose colours have faded in the sunlight....

And then he arrived, in his big cape, with his little Basque beret on his head, very spry and alert in his old age, simply dressed like a house painter, or like a Basque pelota player, in his wide grey-green Manchester-cloth trousers, a light beige jacket and espadrilles, and with his sensitive hands, beard and hair all sprinkled with plaster dust. He is so straightforward, so unassuming! I sensed that he was pleased to see me again, and wanted straight away to see the photos I took two years ago which he has never seen. 'Now these are photos I really like. You have a proper understanding of my work. Very few photographers understand about sculpture....'

'It's easy for me to take good pictures of your sculptures, because I like them.'

And I explained to him that I would like nothing better than to photograph *The Mountain*, and that I would like to

do a complete reportage on his work, both at Marly-le-Roi and at Banyuls-sur-Mer....

I showed him my book *Paris after Dark*, and other photos.

UNDATED

To *Vogue* this morning. Very positive response from M. de Brunhoff and his women colleagues. I am to complete the series on the Opéra Ballet, and cover both suburban style and the sporting style of racing cyclists.[10]

PARIS, 20 DECEMBER 1936

Pale November sunlight. Sunday at the Luxembourg. Dinner with Tihanyi and Medina. Tomorrow I will go to see Maillol. I hope the sun breaks through the fog on this shortest day of the year.

PARIS, MONDAY, 21 DECEMBER 1936

I arrived at Maillol's house at a quarter to ten.... There seemed to be twice as many statues in the studio as on my last visit. A positive swarm of statues! They were on all the shelves, in every corner, one on top of the other, made of plaster, terracotta, clay and stone, bronze and marble, and of all sizes.

It was like the harem of some licentious and sadistic sultan. Buxom, wide-hipped, well-covered women were relegated to the shadows, as if they were out of favour with their master. In the foreground youth took pride of place. They were all the bodies of young women, standing, lying, sitting, bending over, curled up, bodies both modestly concealing and proudly displaying their femininity. Others appeared to be enduring horrible tortures, lying bound hand and foot, tied up with string, gagged and trapped in a straitjacket. Sometimes a marble buttock, leg or arm stuck out of its wrappings of old copies of *Paris-Soir*. Or firm thighs revealed the presence of a body imprisoned in a sack or wrapped up in wet cloths....

PARIS, 25 DECEMBER [1936], CHRISTMAS DAY, FRIDAY

Visit from Lucien Maillol. Lunch together at Les Marronniers. Left for Marly at four o'clock. I took the photographs of his sculptures for Maillol....

'They're good, but you took rather a high viewpoint, so that the statue looks elongated, when my idea was to make a big square piece.' I took some more, 'square' ones, although the size of *The Mountain* and the lack of space in the studio meant I couldn't do exactly what he wanted....

9. Brassaï had known Aristide Maillol since the winter of 1932, when he took his first pictures of him for issue no. 3–4 of *Minotaure*. Here he is responding to Maillol's request for a photograph to use on the poster for his retrospective exhibition at the Petit Palais in 1937. The final choice was the head of *Venus in a Necklace*, printed by Mourlot.

10. 'À Paris, la grande saison', *Vogue*, August 1937.

TUESDAY, 12 JANUARY 1937
The photo of the bust has definitely been accepted as the official poster for the Maillol exhibition at the Petit Palais. I will suggest to M. Escholier that he include my set of Maillol photographs at the Petit Palais in April. It would be something new. As well as seeing the finished statues, visitors to the exhibition could see them as they were before they left the studio.

Made lots of prints for the magazines. Very harassed. Money worries.

WEDNESDAY, 13 JANUARY [1937]
At twelve o'clock to the Russian Orthodox church in the Rue de Crimée. Extraordinary atmosphere in this building. There are fantastic, unbelievable things hidden away in Paris. Going in through a plain metal grille between a grocer's and a haberdashery shop, in a street in an ordinary neighbourhood, one steps instantly into the middle of Tsarist, Orthodox White Russia. Candles, icons, Orthodox priests, chiming bells, I was astounded. I must go again: it's so incredible!

Two pages of fog have been published in *Vu* (but unfortunately very badly reproduced).[11]

SATURDAY, 16 JANUARY [1937]
Had dinner at Mary Meerson's[12] with Tihanyi, the Trauners,[13] Gazelle Duhamel.[14] At midnight met Medina, Neugeboren[15] and Mary's sister.

SUNDAY, 17 JANUARY 1937
To the Russian Church. Liturgy. To the Buttes-Chaumont.

11. *Vu*, no. 461, 13 January 1937.

12. Wife of the film-set designer Lazare Meerson, later the partner of Henri Langlois, creator of La Cinémathèque française (1934).

13. Alexandre Trauner, born in Budapest in 1906, assistant to the Russian art director Lazare Meerson, who had come to France in 1924 as a result of the Revolution. Trauner was part of the close-knit group of young film makers centred around Jacques Prévert, and his first designs were for the Prévert brothers, Pierre and Jacques, in their film *L'Affaire est dans le sac* (1932); he went on to design the sets for several of Marcel Carné's films, as well as for Jean Grémillon, Marc Allégret and Yves Allégret. He died in Paris in 1993.

14. Romanian by birth, Gazelle Dabija was the wife of Marcel Duhamel before becoming Gazelle Bessières. She was the sister of Gréty Wols.

15. Heinrich Neugeboren, musician and composer, originally from Brassó.

Met Léon-Paul Fargue in a bistro. There was a hairdressers' dinner going on. Life in a big city really is fantastic! We had an aperitif together. He again asked me to visit him at his hotel on the Boulevard Saint-Germain....

PARIS, 27 FEBRUARY 1937
Spent the evening with Yves Allégret in the brothel at no. 4, Rue de Hanovre. I had already heard about the 'smartest place to meet' in the Rue de Hanovre. Yves, with the impatience of someone who has discovered a rare treasure, suggested at ten o'clock taking me to this luxury brothel, the most fashionable one in Paris. The coat stands were still empty, we were the first clients. The salon is decorated in a rather Pompeiian style with an enormous mural at the back with a view of the Acropolis. The foreground shows a Roman bath, with women bathers in a variety of ecstatic poses. In the middle of the huge room, women were dancing on a transparent floor, lit from below, wearing evening clothes carefully designed to show as much bare flesh as possible, in keeping with the scene in the fresco, while others talked in the shadows behind the columns decorated with Greek statues. Yves was greeted like a regular customer, with the same obliging and rather oriental smile, by the cloakroom girl, the madam and her second-in-command, the kind of smile which immediately makes a visitor feel at home in these unconventional surroundings, where all the usual social and moral constraints are almost completely discarded, and where the most wretched of men can be persuaded for a while to feel like the most desirable male in the world by the women's eagerness to please him.

'House of illusions' seems to me a very appropriate name for such places, because they are designed to create an illusion of success for the clients; and since everything in life is an illusion, this is one that can halt a man on the road to despair, and restore his lost confidence after painful experiences. I saw many men come in hesitantly, looking down at the floor, and later leaving head high and with a firm step.

PARIS, 1 MARCH 1937
Dinner with Marianne.[16] I showed her my flat. It's at least five years since she has been to my home. But what a difference between 'my home' then and now.

Marianne was enchanted by its atmosphere. And yet I have nothing of any value, or any stylish things. Anyway, I am only interested in ordinary people's treasures. What I

really love to do is give a value to a worthless thing, simply by finding it, and giving it a dignity by welcoming it into my private world. Of all the things I have chosen to share my life with, my favourite is probably the amazing mask of dough made by a baker in the Boulevard Raspail for 6 January, Epiphany. It sums up French life, optimistic in spite of all, restricting itself to transient, egocentric pleasures.

PARIS, 2 MARCH 1937
Letter from my mother. A cry of despair and worry. Is my heart entirely devoid of feeling?

PARIS, 3 MARCH [1937], TUESDAY
… I give the engravings titles when I have finished them. While I am working I have no preconceived ideas, literary or otherwise, and I concentrate on the problem of form to be solved. I have given them such names as *The Temptation of St Anthony*, *Black Venus*, *Head with a Spinning-top Eye*, *Sleeping Bohemian Girl*. I haven't yet published any of these engraved pictures; I must have at least twenty very good ones before I can think of letting them be seen.[17]

PARIS, 6 MARCH 1937, SATURDAY
Visit from Lorant[18] and his girlfriend. He chose some photos for a new English magazine.

In the evening I took some photos of Jacqueline Prévert. I'm beginning to learn about the art of make-up. Jacques Prévert and one of his friends came at eleven o'clock. He loves the feel of my flat. 'It's the nicest place to live that I know.' There was no end to the things that I found to show him. Prévert shrieked with delight. We have so much in common; we understand each other without having to spell things out. My photographs correspond for him with the people and settings of his own poetic world. We are both interested above all in the real heart of the city and its hidden world. All the inhabitants of the lower depths.

He looked at the piles of boxes on my shelves with pleasure and fascination. And he recited their titles so well that he made them sound like a poem: 'Underworld, police,' 'Rain, snow, fog', 'Paris statues', 'Streets, river banks, gardens', 'Fires, lightning,' 'Canal Saint-Martin', 'Pastis', 'Opium', 'Romantic shots', 'Walls', 'Marks on walls', 'Graffiti', 'Sundays and holidays', 'Spring', 'Brothels', 'Lodging houses', 'Prostitution', '14 July', 'Dance halls', 'Pavements', 'Picasso', 'Ghostly nights', 'Circus', 'Fun fairs', and so on.

I showed him the series of nudes, and then my drawings. His reaction to these reassured me and upset me at the same time. The more I find that what I am doing distances me from painting, the more I feel like a painter, and the more I see painting, and even more so sculpture, as my true vocation. Fifteen years on – is it already fifteen? – these drawings seem to me to be the work of a stranger. 'There is such power in these drawings,' said Prévert, 'at first I misunderstood them. But the more I look at them, the less I am aware of any distortion, what seems arbitrary becomes vital, what seems abstract becomes astonishingly real. These figures are a race apart, but with a logic that links them to the human race.'

I must get back to the plastic arts. This longing is becoming more and more of a physical need. Photography is really only a starting point. Even when completely successful, I am somehow not completely satisfied by it. It is choice and not expression. The process has its limitations, and although I know them, I accept them in all humility. I quite like being able to remain anonymous. After all, photography has allowed me to come out of the shadows by showing what I see.…

WEDNESDAY, 10 MARCH [1937]
Days of no interest. I waste my time and energy on stupid projects. This evening was at the Café de Flore, with Jacqueline [Prévert], Vigny[19] and his brother Trauner.

Got permission today to take photographs at the Gare Denfert-Rochereau. Worked from 9 to 12 photographing the engines. Introduced to the harsh lives of the mechanics and drivers.

THURSDAY, 11 MARCH 1937
More rain, it's always raining. Back to the engines this evening. The mechanics and drivers are so straightforward, friendly and full of common sense: I spent three hours with them. I was touched by their kindness.

16. Madame D.-B., Brassaï's mentor in his early years in Paris. See note 60, p. 164.

17. These engravings were only published much later, in the portfolio entitled *Transmutations* (1967). See Brassaï's preface for that album, pp. 213–14.

18. The Hungarian Stefan Lorant, who established various magazines in Germany, Hungary and Great Britain, including the *Münchner Illustrierte Presse*, *Lilliput* and *Picture Post*.

19. Sylvain Vigny (1903–71), Austrian-born painter.

SUNDAY, 14 MARCH 1937

Had it out with Émile: Our partnership no longer works. You are neither in charge, nor an employee, you are not comfortable and neither am I. We get in each other's way more and more. It's essential that you take responsibility for your own life.... Make the most of the advantages you have: you know how to be a photographer, you have contacts, you have ambition, but you must have the courage and the will to face life on your own.... I'm sure it would give us both a new lease of life to go our own ways.

Émile, rather upset, answered that he perfectly understood my point of view and that it was inevitable that we should separate. He will start trying to raise the money to set up on his own.

PARIS, 27 JUNE 1937

I have made absolutely no entries in this notebook since ... March. Yet ... what a lot has changed in my life!

This afternoon to the Longchamp Grand Prix with Rado and Eva. Photographed Martinez de Hoz, the Aga Khan, Edmond de Rothschild....

I mustn't fall asleep (it's half past one and I've still got six films to develop), so I will just quickly note (with great pleasure) the most important things that have happened in the last three months. I got rid of three things that I had reluctantly become hampered by: my assistants and *Coiffure de Paris*. None of my friends had thought me capable of such determination. And I must admit that (knowing my own weaknesses) I surprised myself by this uncharacteristic resolution. It was very unlike me to say exactly what I think with brutal frankness; I had got into the habit of leaving it to time for a solution to present itself, when I should have found one and made it work.

How has this happened? I have seen that I can't afford to waste any more time: I am nearly forty, and must get a move on. The heavy responsibilities that go with having a talent become clearer. Photography has brought me out of the shadows, it has given me the momentum I needed. I must now make the best possible use of it, even if it means a change of direction. I have got used to distancing myself now from things which I used to think of as indispensable. I think a clean break with a way of life which arose out of particular circumstances is not necessarily disastrous. On the contrary, although missing the skin that is shed, I am suddenly aware of having a brand new one....

Now that I no longer have my 'faithful assistants', my life is freer, and I am doing more interesting things.

PARIS, 8 SEPTEMBER 1937

I have picked up this yellow notebook again by chance. It really is a mistake not to have made entries every day, as I had originally intended. As it turned out, instead of making rapid notes that would be true and spontaneous, I find myself having to make recapitulations, observations on the past months, which is a completely different thing.

This is what has been happening. First of all, I have been discovered in America. I sold seventy-one photos to the magazine *Coronet*, then *Harper's Bazaar* asked me to do four reportages. I sold another 117 photos to *Coronet*. So I have miraculously improved my financial situation. I must have made (including other income from the Rapho agency, London, Berlin, etc.) about forty thousand francs in two or three months. I still feel a bit dizzy with this material success.

I can now admit that, for the first time in my life, I can breathe relatively easily, that I feel materially more secure. The time is right.

'The Eye of Paris'* Henry Miller

Brassai has the rare gift which so many artists despise – *normal vision*. He has no need to distort or deform, no need to lie or to preach. He would not alter the living arrangement of the world by one iota; he sees the world precisely as it is and as few men in the world see it because seldom do we encounter a human being endowed with normal vision. Everything to which his eye attaches itself acquires value and significance, a value and significance, I might say, heretofore avoided or ignored. The fragment, the defect, the common-place – he detects in them what there is of novelty or perfection. He explores with equal patience, equal interest, a crack in the wall or the panorama of a city. Seeing becomes an end in itself. For Brassai is an eye, a living eye.

When you meet the man you see at once that he is equipped with no ordinary eyes. His eyes have that perfect, limpid sphericity, that all-embracing voracity which makes the falcon or the shark a shuddering sentinel of reality. He has the eyeball of the insect which, hypnotized by its myopic scrutiny of the world, raises its two huge orbs from their sockets in order to acquire a still greater flexibility. Eye to eye with this man you have the sensation of a razor operating on your own eyeball, a razor which moves with such delicacy and precision that you are suddenly in a ball room in which the act of undressing follows upon the wish. His gaze pierces the retina like those marvellous probes which penetrate the labyrinth of the ear in order to sound for dead bone. Not the eye of a shark, nor a horse, nor a fly, not any known flexible eye, but the eye of a coccus new-born, a coccus traveling on the wave of an epidemic, always a millimetre in advance of the crest. The eye that gloats and ravages. The eye that precedes doom. The waiting, lurking eye of the ghoul, the torpid monstrously indifferent eye of the leper, the still,

all-inclusive eye of the Buddha, which never closes. *The insatiable eye.*

It is with this eye that I see him walking though the wings of the Folies-Bergères, walking across the ceiling with sticky, clinging feet, crawling on all fours over candelabras, warm breasts, crinolines, training that huge, cold searchlight on the inner organs of a Venus, on the foam of a wave of lace, on the cicatrices that are dyed with ink in the satin throat of a puppet, on the pulleys that will hoist a Babylon in paint and papier-mâché, on the empty seats which rise tier upon tier like layers of sharks' teeth. I see him walking across the proscenium, the inky squib which has swallowed the seats and the glass chandeliers, the fake marble, the brass posts, the thick velvet cords and the chipped plaster. I see the world of behind the scenes upside down, each fragment a new universe, each human body or puppet or pulley framed in its own inconceivable niche. Brassai does not wait for the curtain to rise; he waits for it to fall. He waits for that moment when all the conglomerations artificially produced resolve back into their natural component entities, when the nymphs and the dryads strewing themselves like flowers over the floor of the stage gaze vacantly into the mirror of the tank where a moment ago, tesselated with spot-lights, they swam like gold-fish.

Deprived of the miracle of color, registering everything in degrees of black and white, Brassai nevertheless seems to convey by the purity and quality of his tones all the effects of sunlight, and even more impressively the effects of night light. A man of the city, he limits himself to that spectacular feast which only such a city as Paris can offer. No phase of cosmopolitan life has escaped his eye. His albums of black and white comprise a vast encyclopaedia of the city's architecture, its growth, its history, its origins. Whatever aspect of the city his eye seizes upon the result is a vast metaphor whose brilliant arc, studded with incalculable vistas backward and forward, glistens now like a drop of dew suspended in the morning light. The Cemetery Montmartre, for example, shot from the bridge at night in a phantasmagoric creation of death flowering in electricity: the intense patches of night lie upon the tombs and crosses in a crazy patchwork of steel girders which fade with the sunlight into bright green lawns and flowerbeds and gravelled walks.

* Written by Henry Miller in 1933, 'The Eye of Paris' was first published in the Chicago *Globe* in November 1937; then in Henry Miller, *Max and the White Phagocytes*, The Obelisk Press, Paris, 1938; and finally (in French) in a shortened form rearranged by Brassaï, in *Brassaï*, Éditions Neuf, Paris, 1952. The text reproduced here has been revised to reflect the final French version.

Brassai strikes at the accidental modulations, the illogical syntax, the mythical juxtaposition of things, at that anomalous, sporadic form of growth which a walk through the streets or a glance at a map or a scene in a film conveys to the sleeping portion of the brain. What is most familiar to the eye, what has become stale and commonplace, acquires through the flick of his magic lens the properties of the unique. Just as a thousand diverse types may write automatically and yet only one of them will bear the signature of André Breton, so a thousand men may photograph the Cemetery Montmartre but one of them will stand out triumphantly as Brassai's. No matter how perfect the machine, no matter how little of human guidance is involved, the mark of personality is always there. The photograph seems to carry with it the same degree of personality as any other form or expression of art. Brassai is Brassai and Man Ray is Man Ray. One man may try to interfere as little as possible with the apparatus, or the results obtained from the apparatus; the other may endeavor to subjugate it to his will, to dominate it, control it, use it like an artist. The thing that registers is the stamp of individuality.

I think of chair because among all the objects which Brassai has photographed his chair with the wire legs stands out with a majesty that is singular and disquieting. It is a chair of the lowest denomination, a chair which has been sat on by beggars and by royalty, by little trot-about whores and by queenly opera divas. It is a chair which the municipality rents daily to any and every one who wishes to pay fifty centimes for sitting down in the open air. A chair with little holes in the seat and wire legs which come to a loop at the bottom. The most unostentatious, the most inexpensive, the most ridiculous chair, if a chair can be ridiculous, which could be devised. Brassai chose precisely this insignificant chair and, snapping it where he found it, unearthed what there was in it of dignity and veracity. THIS IS A CHAIR. Nothing more.

Perhaps the difference which I observe between the work of Brassai and that of other photographers lies in this – that Brassai seems overwhelmed by the fullness of life. How else are we to explain that a simple chair, under the optical alchemy of Brassai, acquires the attributes of the marvellous, whereas the most fantastic inventions of other men often leave us with a sense of unfulfillment? The man who looked at the humble chair transferred his whole personality to it in looking at it: he transmitted to an insignificant phenomenon the fullness of his knowledge of life, the experience acquired from looking at millions of other objects and participating in the wisdom which their relationships one to another inspired. The desire which Brassai so strongly evinces, a desire *not* to tamper with the object but regard it as it is, was this not provoked by a profound humility, a respect and reverence for the object itself? The more the man detached from his view of life, from the objects and identities that make life, all intrusion of individual will and ego, the more readily and easily he entered into the multitudinous identities which ordinarily remain alien and closed to us. By depersonalizing himself, as it were, he was enabled to discover his personality everywhere in everything.

Perhaps this is not the method of art. Perhaps art demands the wholly personal, the catalytic power of will. *Perhaps.* All I know is that when I look at these photographs which seem to have been taken at random by a man loth to assert any values except what were inherent in the phenomena, I am impressed by their authority. I realize in looking at his photos that, by looking at things aesthetically, just as much as by looking at things moralistically or pragmatically, we are destroying their value, their significance. Objects do not fade away with time: *they are destroyed!* From the moment that we cease to regard them awesomely they die. They may carry on an existence for thousands of years, but as dead matter, as fossil, as archaeologic data. What once inspired an artist or a people can, after a certain moment, fail to elicit even the interest of a scientist. Objects die in proportion as the vision of things dies. The object and the vision are one. Nothing flourishes after the vital flow is broken, neither the thing seen, nor the one who sees.

And so it is, when I look at the photographs of Brassai, that I say to myself – chicken *prime*, chair *prime*, Venus *prime*, etc. That which constitutes the uniqueness of an object, the first, the original, the imperishable vision of things. When Shakespeare painted a horse, said a friend of mine once, it was a horse for all time. I must confess that I am largely unfamiliar with the horses of Shakespeare, but knowing as I do certain of his human characters, and knowing also that they have endured throughout several centuries, I am quite willing to concede that his horses too, whoever and wherever they are, will have a long and abiding life. I know that there are men and women who belong just as distinctly and inexpugnably to Rembrandt's world, or Giotto's, or Renoir's. I know that there are sleeping giants who belong to the Grimm family or to Michelangelo, and dwarfs who belong to Velasquez or Hieronymus Bosch, or to Toulouse-Lautrec. We have

reached the point where we do not want to know any longer whose work it is, whose seal is affixed, whose stamp is upon it; what we want, and what at last we are about to get, are individual masterpieces which triumph in such a way as to completely subordinate the accidental artists who are responsible for them. Every man today who is really an artist is trying to kill the artist in himself – and he must, if there is to be any art in the future. We are suffering from a plethora of art. We are art-ridden. Which is to say that instead of a truly personal, truly creative vision of things, we have merely an *aesthetic* view.

It happens that the man who introduced me to Brassai is a man who has no understanding of him at all. He secretes himself in his room, but he has absolutely no feeling for the streets, no wanderlust, no curiosity, no reverence. I mention this only as an example of the strange fatality by which two men of kindred spirit are sometimes brought together. I mention it by way of showing that even the despised cockroach serves a purpose in life. Like a spider luring me to its lair, there lived all the while this man Brassai whom I was destined to meet. I remember vividly how, when I first came to Paris, I wandered one day to his hotel looking for a painter. I had to return to America, come back to France once again, starve, roam the streets, listen to silly, idiotic theories of life and art, take up with this failure and that, and finally surrender to the cockroach before it was possible to know the man who like myself had taken in Paris without effort of will, the man who, without my knowing it, was silently slaving away at the illustrations for my books. And when one day the door was finally thrust open I beheld to my astonishment a thousand replicas of all the scenes, all the streets, all the walls, all the fragments of that Paris wherein I died and was born again.

How then am I to describe these morsels of black and white, how to refer to them as photographs or specimens of art? Here on this man's bed, drained of all blood and suffering, radiant now with only the life of the sun, I saw my own sacred body exposed, the body that I have written into every stone, every tree, every monument, park, fountain, statue, bridge and dwelling of Paris. I see now that I am leaving behind me a record of Paris which I have written in blood – but also in peace and good-will. Tenderly, reverently, as if I were gathering to my breast the most sentient morsels of myself. I pick up these fragments which lie on the bed. Once again I traverse the road that led me to the present, to this high, cool plateau whence I can look about me in serenity. What a procession passes before my eyes! What a throng of men and women! What

strange cities – and situations stranger still! I see the corners of walls eroded by time and weather which I passed in the night and in passing felt the erosion going on in myself; corners of my own walls crumbling away, blown down, dispersed, reintegrated elsewhere in mysterious shape and essence.

Looking for an instant into the eyes of this man I see therein the image of myself. Two enormous eyes I see, two glowing discs which look up at the sun from the bottom of a pool; two round, wondrous orbs that have pushed back the heavy, opaque lids in order to swim up to the surface of the light and drink with unslakeable thirst. Eye that lurks in the primal ooze, lord and master of all it surveys; not waiting on history, not waiting on time. The cosmologic eye, persisting through wrack and doom, impervious, inchoate, *seeing only what is.*

Henry Miller, Paris, c. 1931–32

Brassaï and Henry Miller Annick Lionel-Marie

Henry Miller, like Henri Michaux, played an important part in the bohemian life of Brassaï's early years in Paris and, like him, remained a life-long friend, with many shared experiences, setbacks, separations and reunions.

They were brought together by Lajos Tihanyi: 'My friend the painter Lajos Tihanyi introduced Henry Miller and me. He performed the function of social secretary at the Dôme. He was a familiar sight in his olive-green overcoat of worn corduroy, his wide-brimmed grey felt hat, with his monocle and protruding bottom lip – he was the double of Alfonso XIII [King of Spain], but without his little moustache. He would go from group to group and from table to table on the packed terrace, which in the green light of the trees on the boulevard, had a festive 14th of July atmosphere every night. Although he was deaf and almost mute, he was the best-informed person in Montparnasse.'[1]

'Henry Miller: I will never forget the sight of his fresh face above a crumpled raincoat, his full lips and sea-green eyes ... their gaze calm and full of serenity ... alert behind his large horn-rimmed glasses.... Slender, sinewy, without an ounce of spare flesh, there was something ascetic about him, like a mandarin or a Tibetan sage.'[2]

Miller also described the occasion: 'Our first meeting!... I can still see you standing on the edge of the pavement in front of the Dôme, on the corner of the Rue Delambre and the Boulevard Montparnasse. You were holding a newspaper.... At the time I had the (fleeting) impression that you had a great sense of humour. Everything you said seemed to be a joke. Your eyes were hypnotic – just like Picasso's. The memory of that meeting will always be with me.'[3]

That was in 1930. Henry Miller had already been to Paris with his wife June in 1928, but interestingly on that occasion he had not liked Paris at all. Two years later he

came back alone and penniless; living like a tramp, but full of life and optimism, he discovered both Paris and his talent for writing, which until then had hardly begun to develop. Brassaï was busy photographing the secret Paris. Drawn together by their shared love of the city at night, understanding each other in spite of the language barrier, the two friends relished endless rambles, joined by another enthusiast for little cafés and working-class streets, Léon-Paul Fargue. Miller already felt so close to Brassaï that he wrote to his literary agent, Frank Dobo: 'I have found my counterpart in dear Halász; he is a man of insatiable curiosity, a "wanderer" like me, who sets out on an exploration with no other aim but continual investigation.'[4] Most importantly, Miller immediately understood the range of Brassaï's gifts and the creative potential of his young friend: 'If Halász were to follow his instincts, his photographs could illuminate new worlds for us. I am sure of it because, as we said last night, he is a man with ideas.... He is certainly not intimidated by the fuss and bother surrounding technique.'

They both had a great love of books and literature, and Brassaï tried hard to make Miller understand his admiration for Goethe – eventually succeeding. Their different means of expression provoked some sharp discussions between them; one favoured a tumultuous flow of ideas – 'His prose was diffuse, baroque, as disordered as a dream' – while the other looked for structure and a pleasing balance: 'I see the role of the artist differently.... Instead of being the torrent himself, he should be what contains it, and give form to what is formless.'

One evening in 1933, Miller deposited the manuscript of his famous 'The Eye of Paris' in the safe at Brassaï's hotel (see pp. 173–75). Brassaï found the essay 'disproportionately flattering', but he also saw it more as a coded reverse portrait of Miller by Miller than as a portrait of himself: '... to be just a witness, a scrupulous witness of *what is*, is the opposite extreme to which Henry Miller sometimes turns, almost with longing. It so happens that I am the one who, in his eyes, can be described as *entirely given over to the object*. And the real subject of his essay 'The Eye of Paris', is not a portrait of me, but his own longing for his opposite: *the expression of what is*. And the interesting thing is that at the same time as building up my portrait, line by line, he was also drawing his own ... in reverse.'

1. Gilberte Brassaï Archives, undated sheet.

2. Brassaï, *Henry Miller grandeur nature*, Gallimard, Paris, 1975, p. 8.

3. H. Miller, letter to Brassaï, 25 November 1964, Gilberte Brassaï Archives.

4. Brassaï, *Henry Miller...*, *op. cit.*, pp. 39, 42, 44, 45 and 170 (for this quotation and the four following).

Whatever the truth of this view, Miller made a strikingly accurate assessment of Brassaï's photography from the beginning: 'All I know is that when I look at these photographs which seem to have been taken at random by a man loth to assert any values except what were inherent in the phenomena, I am impressed by their authority. I realize in looking at his photos that, by looking at things aesthetically, just as much as by looking at things moralistically or pragmatically, we are destroying their value, their significance.'[5]

After their separation at the end of Miller's ten years in Paris (they met again on several occasions, including in 1960 at Cannes and in 1973 in Los Angeles), they regularly wrote each other long letters. Miller asked Brassaï for photographs to illustrate his articles, and offered one of his own watercolours in exchange. Brassaï's archives contain 168 letters from Henry Miller, most of them long and fizzing with life, with accounts of his reading, or descriptions of shared memories, underlining the strong link of friendship between the two men.

The letters also reveal that, after reading *Picasso & Co.*, Miller was very keen for Brassaï to write a pen portrait of him, too, which explains the relatively late publication of the two volumes on Miller.[6]

The first of the two books, based on Miller's time in Paris, gave Brassaï the opportunity to correct parts of what Miller had written about him in *Tropic of Cancer*,[7] which according to him contained passages of pure invention.

But apart from the inevitable differences of opinion, there was undoubtedly a real bond of friendship between them, and a reciprocal admiration, put into words by Miller in this dedication: 'To Brassaï, a giant, a great friend, a writer, a sculptor, all things in one, like the great minds of the Indies.'[8]

5. H. Miller, 'The Eye of Paris'. See p. 174.

6. Brassaï, *Henry Miller...*, *op. cit.*; idem, *Henry Miller rocher heureux*, Gallimard, Paris, 1978.

7. H. Miller, *Tropic of Cancer*, The Obelisk Press, Paris, 1934.

8. H. Miller, *Lettres à Anaïs Nin* [1967], Bourgois, Paris, 1986.

Two letters from Henry Miller to Brassaï*

BIG SUR, APRIL 4TH, 1948

My dear Brassaï,

Delighted to have your long letter *(almost unreadable because of your modern pen, alas!) but I made it out. Of course I will write you a preface — for both editions — as soon as Dobo lets me have your manuscript.*[1] I wish I could do the translation for you, but honestly I am the worst translator in the world and my French gets poorer and poorer (though I understood perfectly well your Marie, even if it had been in Hungarian!)

I am not at all surprised that you are also a good orator — and a painter and a sculptor and a writer too! *Don't forget your discourse on Goethe and St Thomas Aquinas in the middle of the night (at Rue Villa Seurat on the very day that Tihanyi was cremated).*[2] *The quote from Goethe in your letter is wunderbar — I would love to have it in German! (When I want to I can understand that wretched language; I have just finished reading* Siddharta *by Hermann Hesse in German (!) which I haven't read for thirty years or more — the language, I mean. I recommend the book to you — it's a masterpiece!)*

With another war imminent, I doubt that I shall come over this year. Besides my wife is going to have another baby in a few months. I am planting vegetables and fruit trees here, in expectation of a famine when the war comes. Like you, I neither read the newspaper nor listen to the T.S.F. [radio]. If anything happens my friends are sure to let me know....

Perlès[3] is still in London and writing more books — especially now one about the Villa Seurat days. He wanted to come to America but could not obtain a visa because he had once been a Czech. *Funny old world, isn't it? Perhaps it will take another war to get rid of the world's prejudices and stupidity and ignorance!*

* Gilberte Brassaï Archives. © The Estate of Henry Miller. The passages in *italic* were written in French, the remainder in English.

1. The preface was for *Histoire de Marie*, Éditions du Point du Jour, Paris, 1949.

2. See note 6, p. 151.

3. See note 19, p. 153.

I am just sending Reichel[4] a beautiful big Navy coat and a suit of clothes. Give him my warm regards. I wish I could see his new work. And your paintings too! I have been told that Picasso is very much interested in you as a painter – is that true? But sculpturing is even more interesting work.

As for me, it is difficult to find even two hours a day to work; there is so much to do in the country. On top of which there are constant invasions of people, although I live in an isolated place forty-five miles from the nearest town (Monterey) – there is not even a village here – just open country, sea and forest and bush everywhere. But sublime! Which is why I'm in no hurry to go round the world. I would like to be able to be a carpenter or a mason, and do more work with my hands. Life is so simple and good when one lives far away from towns. I read a lot of French – reviews, newspapers, books, etc. I recommend a book by Blaise Cendrars, published by Denoël, L'Homme foudroyé.

Well, more when I write the preface for you. I hope Laughlin will keep his promise and publish the book here. Anything you write – especially about photography – will interest the American public. I suppose you don't have another copy of *Paris la nuit*, do you? I lost mine somewhere and I miss it very much....

All good wishes to you, dear Brassaï,

Henry Miller

4. See note 18, p. 153.

13 MARCH 1952

My dear old Brassaï,

Your splendid book (or album) only reached me yesterday.[1] I hasten to congratulate you on it. What a fine photo of yourself on the cover! Very Transylvanian, I find. And so young, and good-looking!

I love your text, especially the panoramic view you give of high life at the turn of the century. I did the same in my last three books. But alas, I didn't get the chance to have a good hat crushed by a Princesse [sic] de Guermantes' coach horses![2]

Allow me to say what a great honour it is to see my face among such an illustrious bunch – some of them very dear to me – Léon-Paul Fargue, Henri Michaux.... I look at myself – as I was in 1932 – with amazement. I remember very well the day you took that photo at your flat. And the clothes! I will send you some more recent photos so that you can see the ravages of time. And some of my children. I am separated from my wife now, and only see the children from time to time. I live all alone like a monk, a celibate, an exile. Perlès writes to me fairly regularly.... He sounds as young, active and zany as ever. He's the 'angel of zaniness', as Fargue called Ravel.

Your drawings are marvellous! Picasso is right. I know he is always right, even when he's wrong, because I like your sculptures very much. Carry on, my dear friend, continue to flourish. You will always be young. Greetings to you and all my friends over there. I will come one day.

Henry Miller

1. *Brassaï*, Éditions Neuf, Paris, 1952.

2. See below (p. 210) for Brassaï's description of his first visit to Paris.

Henri Michaux, c. 1943–45

Brassaï and Henri Michaux Annick Lionel-Marie

They were born in the same year (1899), and both arrived in Paris in 1924, Henri Michaux from Belgium and Brassaï from the Carpathian Mountains; their paths soon crossed, and they quickly found that they had a great deal in common. Both were gifted with a rare breadth of vision. 'From the widest view to the most detailed, every subject interests him', wrote Yves Peyré of the first,[1] echoing Miller on Brassaï: 'Everything, literally everything, interests him.'[2] But while one lived through his inner eyes, focusing on the movements, upheavals and private despair of the inner being, the other concentrated on the reality of the outside world: 'I invent nothing', and found images that reflected his own responses: 'I imagine everything.'[3]

They were interested in the bizarre, in primitive art and in enchantment, and had a taste for what is different, latent, concealed. They were carried along on the Surrealist wave, which touched an innate poetic streak in both of them, identifying easily with the mood but remaining wary of the artistic movement itself. In Brussels, Michaux had been involved in the production of Franz Hellens's periodical *Le Disque vert*.[4] In Paris, as associate editor, he supervised the preparations of issues on suicide and dreams, which put him in contact with André Breton, Louis Aragon, Paul Éluard, Roger Vitrac and others. Their experimentation, their deliberate non-conformity and Breton's 'graphic incontinence' sometimes provoked an ironic response from him; nevertheless, Michaux concluded that 'The Surrealist supernatural is a bit predictable, but given the choice between the supernatural and anything else, I would have no hesitation. Long live the supernatural! Even if it is shallow, a dip into it is very good for us.'[5]

Brassaï's pictures were indisputably a crucial feature of *Minotaure*;[6] the *Statue of Marshal Ney in the Fog*, the *False*

Sky collage, the 'random object' sculptures, the comments on art nouveau are all tackled from a different angle, and with a thoroughly mastered Surrealism. But apart from these particular photographs, he was careful to point out on more than one occasion that the idea of his pictures being 'Surrealist' came more from a 'Surrealist reading' of work whose only inspiration was reality than from a desire on his part to distort that reality. The importance that Brassaï attached to form, and his search for an increasingly classic means of expression, became a stumbling block between the painter-poet and the photographer-writer. Although Brassaï was impressed with Michaux's poetry, 'the powerful and solemn voice of a driven man, ill at ease with himself', he could not help feeling unhappy with his painting.

Michaux was plagued by a feeling of perpetual uncertainty and continually changing views, and was reluctant to look at his own face. 'A me can only ever be provisional.... There is not one me. There are not ten me's. There is no me. Me is merely a moment of balance.'[7] He wanted to distance himself, to feel more detached from his 'noble features', and yet he could not help returning to them again and again in oil paint, watercolour and ink: '... heads ... these heads which are all one and the same ... come from an obsession, the depths of memory and my innermost being'.[8] Perhaps this explains his genuine phobia about photographic portraits, mentioned by Brassaï in his account of one of their conversations.

All the same, after Claude Cahun and Gisèle Freund and before Paul Facchetti, Michaux did finally agree to submit to being photographed by Brassaï (1945), whose own preference among the portraits he took of him is very striking. Subtle and expressive, it shows just the head and shoulders and one hand, a relatively unusual format for

1. Yves Peyré, *Henri Michaux, permanence de l'ailleurs*, Éditions José Corti, Paris, 1999, p. 8.

2. Henry Miller, preface to Brassaï, *Histoire de Marie*, Éditions du Point du Jour, Paris, 1949.

3. Nancy Newhall, 'Brassaï: "I invent nothing, I imagine everything"', *Camera*, Lucerne, no. 5, May 1956.

4. Franz Hellens, Henri Michaux (ed.), *Le Disque vert*, Brussels, 3rd series, 4th year, 1925.

5. Henri Michaux, *Surréalisme* [1925] in *Henri Michaux, Œuvres complètes I*, Gallimard, 'Bibliothèque de la Pléiade', Paris, 1998, pp. 58–61.

6. *Minotaure*, artistic and literary journal, under the editorship of Albert Skira and Tériade, 1933–39.

7. H. Michaux, postscript to *Drame des constructeurs* [1930] in *Henri Michaux, Œuvres complètes I, op. cit.*, pp. 662–65.

8. H. Michaux, *Peintures*, Gallimard, Paris, 1939.

Henri Michaux and His Wife on Mont Joly, Megève, 1945

Brassaï, who normally showed an artist in his own environment and did not allow himself to get involved with the sitter's psychology: 'When I am taking somebody's portrait, I prefer their face to be in repose, and to reflect their own solitude.'[9] However, in this one, Michaux's eyes look straight into those of the spectator, and the half-ironic, half-enigmatic expression is arresting. The overriding impression is of the photographer's intimate understanding of his friend. From then on, Michaux always referred to him as 'that dangerous Brassaï'.

9. 'Brassaï ou les yeux d'un homme', television programme by Jean-Marie Drot, Radio télévision française, 1re chaîne (Channel 1), 3 November 1960.

Conversations with Henri Michaux*

FRIDAY, 30 OCTOBER 1959
The telephone rang. I heard a distant voice. It was Henri Michaux. I knew he would phone me. Two days ago *Arts* published a whole page on Michaux with an enormous photo of him (mine). Under the photo they had printed: '... the author of *Plume*, *Ecuador* (sic) and *Misérable Miracle* shuns publicity, politics and photographers. This is one of the few known pictures of him. It is by the famous photographer Brassaï.'

> **Michaux**: How are you? I heard that you were in Brazil.... What made an impression on you in Brazil?

> **Me**: I was amazed by the botanical garden in Rio. I had very little time, but I managed to go there four or five times. I spent some unforgettable hours among all that incredible vegetation, unknown and even unimaginable to me.

> **Michaux**: I too was very excited by it! I spent all my time in that garden. When I went there I was in my element.... All those mingled shapes, the palms and lianas....

> **Me**: There are 1,500 different kinds of palm there. And those royal palms thirty-two or thirty-five metres high! When I went to the botanical garden in Palermo, I thought there couldn't be anything more beautiful. There are enormous fig trees there, and colonnades of aerial roots, walks lined with kapok trees.... But the garden at Rio is even more beautiful!

> **Michaux**: I don't know the botanical garden in Palermo.

> **Me**: Goethe thought it was absolutely wonderful; it was there that he conceived the idea of the metamorphosis of plants....

> **Michaux**: I must go to Palermo then....

But after this preamble, Michaux's voice suddenly changed.

> **Michaux**: Have you seen the latest number of *Arts*? My photo, I mean yours, to my embarrassment covers a whole page! I want to know what happened, whether they asked you for that photo, whether you gave them

permission. I myself absolutely forbade them to publish a photo with the article! So I have sent them a strongly worded protest.

> **Me**: I had a conversation with André Parinaud. He said to me: 'It has taken us six months finally to get an interview with Henri Michaux, and I want to print a picture of him with it.' I refused him permission.

THURSDAY, 12 NOVEMBER 1959
I waited for Michaux with 'Fuego', outside the Villa Adrienne. He was early. I saw his tall silhouette coming towards us.

When we were in my flat, I was about to light a cigarette. Michaux retreated in horror: 'I am totally allergic to tobacco. And I'm afraid that if you smoke I will cough the whole evening.' So I didn't smoke.

Michaux immediately noticed 'The Big Hand', a palmist's shop sign, a marvellous painting of the hand's lines; I've had it for about twenty years....

Michaux looked at the sign, and then he took my hand; palm lines fascinate him. He felt my hand and cried out: 'You have an enormous Mount of Venus. It's very powerful. Look at it,' he said to Gilberte, 'this dominance is really quite unusual. By contrast, his Mount of Mars is almost nonexistent. He is really not aggressive. But this Mount of Venus! I understand you perfectly now. If I forgot your face, your name, your eyes, and everything I know about you, I would never forget your hand.'...

And we talked about Brazil.

> **Me**: The trip, though short, was very tiring.... All the same, I am really pleased I made the journey. And above all to have been able to spend two nights at one of the most authentic *Macumbas* in Rio. It was fascinating. I was actually trembling in the middle of all those black sorcerers and witches, I was almost mesmerized and on the point of collapse....

The *Macumba* I had witnessed, and had even managed to photograph, took place in the open, in a clearing among trees. The first sight of it was magical. I had been taken by car to the foot of a mound. We climbed about forty muddy steps through the trees. Then, in the middle of an enclosed space, we saw about twenty black women in long white dresses and the same number of black men in white suits. They swayed in unison and with the same movements. The two facing lines of men and women, moving from side to side to the rhythm, followed the lead of the 'chief', a fine bearded black man with his feet and torso bare who was

* Notes typed by Brassaï, Gilberte Brassaï Archives.

standing in the middle. The moonlight made it an unforgettable spectacle. The first time I was taken to see it, it was nearly midnight and I only stayed an hour. The healing session was about to begin, the witches appeared one after the other, in a trance, and the sick people followed, with screams and incomprehensible sounds. I was so stunned by this spectacle that I was determined that, whatever happened, I would go again....

Another day, the same guide, a devotee of *Macumba*, took me to the same place at nine in the evening, and I was able to stay until four in the morning....

On this second occasion, I was beginning to have an idea of the order of the magical evening. I think it always starts with a kind of warm-up session to create the right atmosphere, [illegible] to summon the spirits to guide the healing session which follows. The divination session always comes after that, and always after midnight, itself followed by the orgiastic rites themselves, lasting until dawn. The master of ceremonies rings a bell five minutes after midnight, at which point men and women disappear among the trees. This could be called the 'wee-wee' session, immediately preceding the divination.

Michaux: But how were you able to take the photographs?

Me: My guide, who was actually an Italian, had been living in Rio for six years, and had made preliminary approaches. He had managed to get what amounted to an authorization from the master of ceremonies. I was introduced to him as soon as we arrived, and the Italian said to me, 'He has said "yes", so you are free to take as many photographs as you like.'

SATURDAY, 14 NOVEMBER 1959
I telephoned Henri Michaux at around ten in the morning.

Michaux: I was bowled over the other evening! I was really impressed with your colour photos. You have found a new way of working; you are rejuvenated!

Me: I rejected the use of colour for a long time.... I loved colour too much to be happy with an approximation to it in photographs. But when I was in the United States, I was under such pressure to try it that in the end I had to find out for myself. I took the first films in Louisiana, and then some in New York. I wasn't entirely convinced. I was only pleased with a few of the night photos I took in New York. When I got back to Paris, I tackled it again by reversing the

problem. If you want colour in a photo, I said to myself, you don't want to start with the 'subject', even if it lends itself to the use of colour, because it will still be a 'subject' or 'document', but in colour; you must start with the colour itself, colours as such, and sometimes it will have the same feeling as a well-painted picture, even if the subject has no intrinsic interest at all, and is only a vehicle for the colour. I became interested in the surfaces of walls for the same reason.

PARIS, FRIDAY, 21 FEBRUARY 1964
I telephoned Michaux.

Me: I very much enjoyed your film about hashish and mescaline. The incantations and extraordinary images create a really spellbinding effect, combined with the excellent music. Sometimes one can be really bowled over....

Michaux: I'm glad to hear you like my film. You are a good judge.... The cameraman I worked with carried out my ideas and my 'cutting' very conscientiously.

Me: I'm sorry that this film won't be seen by the general public, that it won't be shown in cinemas. Don't you think it should go on general release?

Michaux: Yes, it's under discussion. But only if the drug addict himself and the doctor who introduces the film are cut. But they would keep my voice.

Me: So really, although the film has been shown five or six times, very few people have been able to see it. The Salle de Géographie was completely packed when I went; I couldn't find a seat. I watched the film while lying on the floor at the feet of Jean Paulhan and Dominique Aury....

I hesitated to talk to him about my book on Picasso. I have mentioned some of our conversations in it, and referred to him in several places. I would like to show him what I have written, but you never know, he is quite capable of asking me to suppress parts of it.

Me: I have written a book called *Conversations avec Picasso* [*Picasso & Co.*] using notes I made day by day when I used to visit him during the Occupation. When I found and reread them nearly twenty years later, I was absolutely fascinated, and that's how I started writing the book. But I hadn't thought of writing a book at the time. If I had, I would have gone to see him more often.... I've

got a great deal of good material. I've written it all in the present tense, as if it were 'live', as they say today … it will be like hearing Picasso's voice and actually seeing him. I don't know whether I've succeeded. At least, that was the idea: to somehow bring Picasso to life. I also decided to concentrate on him as a person rather than on his work. Each conversation is given a date. And since I tell it all in the present tense, each visit is full of surprises and unexpected happenings….

Michaux: Three hundred pages…. I'd love to read some extracts.

Me: With pleasure, particularly as you are in it too…. Sometimes we were with Picasso together.

Michaux: I would be really interested to read all that. Memory is short. It's often a surprise to read what one has written or said some time ago….

Me: For instance, you talked to me about Claudel. You very much liked *Le Soulier de satin*. And one day, as we were leaving Picasso's, you said some prophetic things to me….

Michaux: Claudel…. I really don't remember….

Me: Neither did I, but it's in the notes…. I had said to you that I found it hard to see any 'successors' to the likes of Picasso, Braque or Matisse among the young artists. And you replied, quite rightly, that it's never a question of 'succession', it's not a matter of replacing painters, and that renewal will take a different form. You also said that Picasso's work, with its monsters and mythology, in spite of his genius, nowadays seems somehow out of date….

Michaux: When can I read some of your book?… Come at about seven, then, and we can spend an hour together.

16, Rue Séguier…. This brought back a lot of memories. No. 18, next door, used to be the offices of Arts et Métiers Graphiques, publishers of my book *Paris de nuit* [*Paris after Dark*]. My whole career started here.

In this patrician house where Michaux lives, the magnificent staircase has been completely rebuilt. Michaux was with a young woman; they were discussing a tape recording. I lit a cigarette. Michaux rushed towards me. 'Quick, put it out! The smell of tobacco is fatal for me! I am very susceptible to all my allergies at the moment.' When his visitor had gone, I gave him my *Graffiti* album.

He looked through it carefully. Then he said to me: 'I wasn't too sure about the graffiti. I thought it was a very limited field, reduced to a few symbols and designs that never change. Your book proves the opposite. The surfaces of walls are really much more revealing than I thought…. There are some amazing things here. All this was really worth collecting together….'

And then I opened my bulging package of manuscripts. I looked out all the passages with references to Michaux to read to him. And Michaux the character as he appears in my book, someone a bit like a twin brother of 'Plume', amused him very much….

I read him several chapters of my book; he listened with great interest….

Me: I'm not worried about Picasso's reactions. I have shown him my manuscript and read him several chapters; he was very pleased with them. 'It is as truthful as your graffiti,' he said, 'you must publish it.' And he encouraged me to make a thorough portrait of him, not a glamorized or flattering one, but a true likeness…. This demand for truthfulness is a character trait that does him credit. He has nothing to hide, no need to pretend, even if this sometimes puts him in a difficult position with other people….

I read to him for two hours…. We overran the time limit by a long way.

Michaux: One thing I have noticed is that you are really in your element writing about Picasso…. You talk more freely about him than about me…. That's my impression after the small amount of it that I've just heard….

Me: That's inevitable when the book is predominantly about Picasso. I gathered a few friends around him too, whomever I might bump into, but I couldn't affect the balance of my book by introducing a detailed portrait of each of them. Perhaps I will do that eventually, like the ones I have done of Pierre Reverdy and Hans Reichel.

Michaux: But how have you managed to remember so much? Do you take notes?

Me: It depends. I sometimes do when a conversation has been a very striking one, and when I feel it would be an irreparable loss if I failed to note it down…. Unfortunately, it must really be done straight away, and often, if I haven't got the time, I lose the whole flavour of it….

Torso, undated

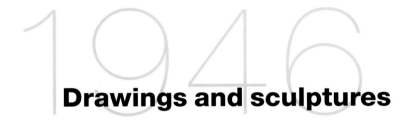

Drawings and sculptures

From the years of apprenticeship to the exhibition at the Galerie Verrière

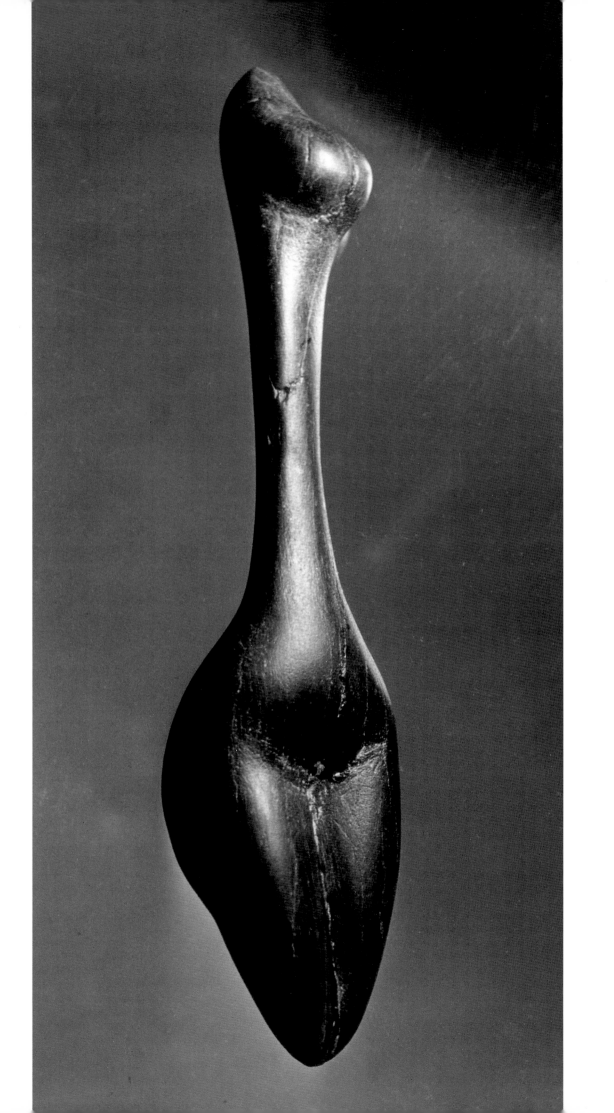

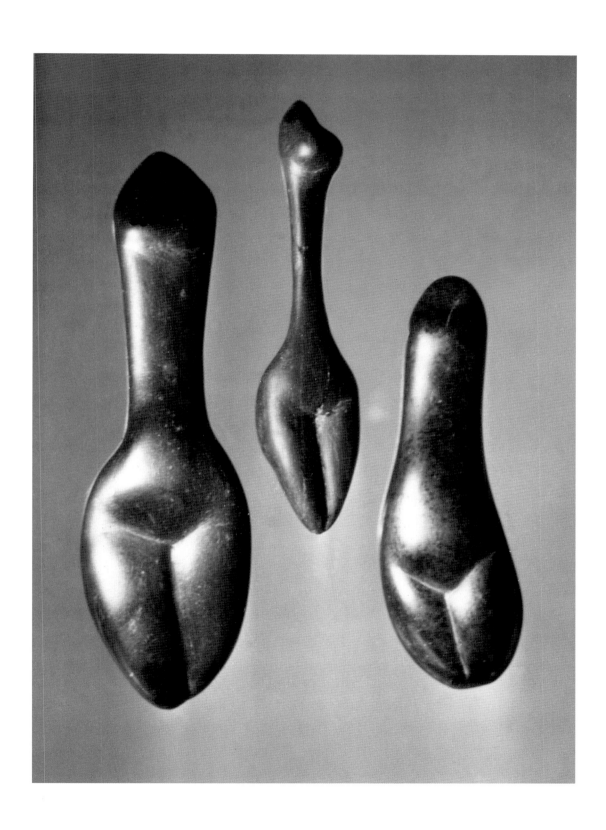

Mandolin Woman, No. 1, 1961

Nubile Woman, Mandolin Woman and Almond Woman, 1961

Phallic, 1968

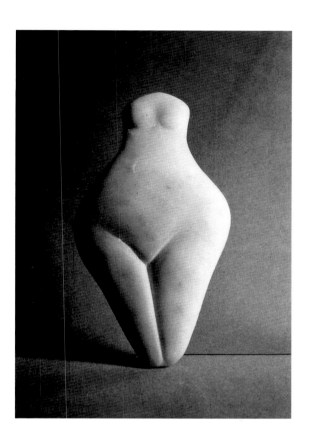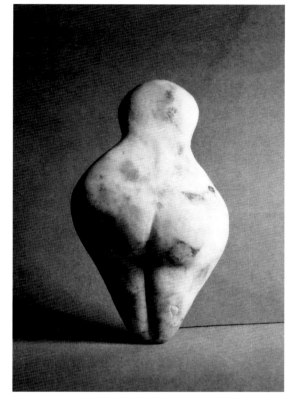

Amuletta II, 1971

Amuletta I, 1971

'Brassaï'* poem by Jacques Prévert

In a still life
completed
by painter-harpists and cultured folk
light
that's tired depressed depraved
solicits
on behalf of a poor unshaven and neglected sky
abandoned
desperate
covered in sun spots
bitter and distraught
at being so despised ignored forgotten
hated and demeaned
And offers up furtively
hastily
to her incurable clients
(since all it takes to be happy
is a little art)
a few transparent sheets
where beauty parades
infinitely reassuring
desperately drowsy
unavoidably charming
and the man with the soft pencil
is satisfied with this
And he even believes
that the world happens
to be this way
a pretty low-ceilinged room
in a museum
with four walls and three dimensions
a pretty well-mannered world
humbly submitting to the laws of perspective
An artists'-model world
responding to their every wish
and like the hollow tooth for the dentist
made specially for them
And so the man of art
the ardent lover of nature
persuaded that artists
are the Honoured Masters of this world
whose task it is to serve them as a subject
begins to play the great I AM
and imagining himself suddenly
owner of the landscape
decides to patrol it
pencil in hand
Then seized with an austere joy
a joy crepuscular despotic neo-new

* This poem was first published, without a title, as the text of the album *Trente dessins* (with drawings by Brassaï), Éditions Pierre Tisné, Paris, 1946. It appears entitled 'Brassaï', in the *Œuvres complètes de Jacques Prévert*, vol. II, Gallimard, Paris, 'Bibliothèque de la Pleiade', 1996, © Gallimard. The English translation is by Ruth Sharman, © Thames & Hudson, London.

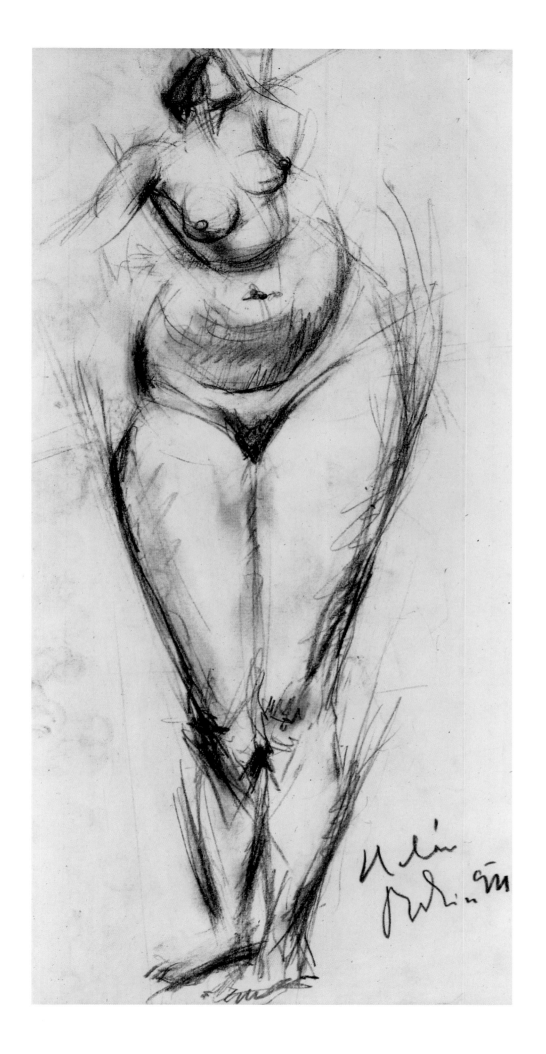

Nude, Berlin, 1921

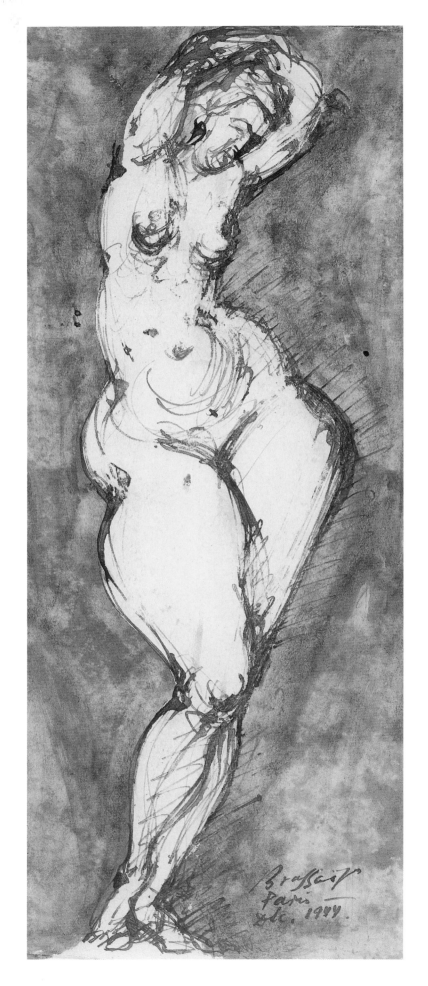

Caryatid, 1944

nostalgic
pre-anthological
(and even a little balneal
if he draws on the notion of drawing the sea)
he falls
objectively naturally
and statutorily
into a trance
and just as the snail
leaves his mark
on the road that leads him to Rome
to run in the Grand Prix
he leaves on the white paper
his flimsy transfer
image of his megalomania
and clearly visible
in large anthropometric letters
the delicate signature of his material menopause

Whereas
the man with the hard pencil
for his part
remains standing
alone in the midday light
as still as a sundial
standing in front of the great grimy wall of the town
in all its torpor
and passes unseen
discreet incognito
anonymous as a piece of graffiti

And it's Brassaï
I'm thinking of in writing
what I write
and the drawings reproduced in this book
representing women
and a handful of men

Cathedral pillars and café pillars
Just listen to the hail
falling on the cobbles
of the Rue du Faubourg-Saint-Jacques
Close by the prison
known as La Santé
a beautiful Arab horse
appears out of nowhere
And this horse has neither saddle nor harness
and its haunches shine like a polished floor
Each passer-by stops
for a moment
and gazes at those haunches

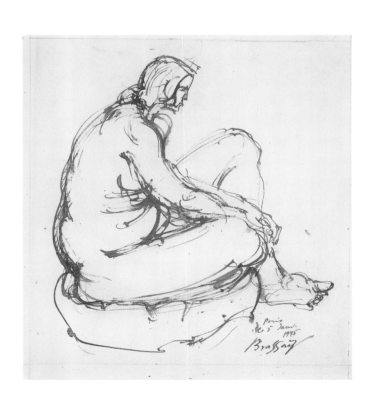

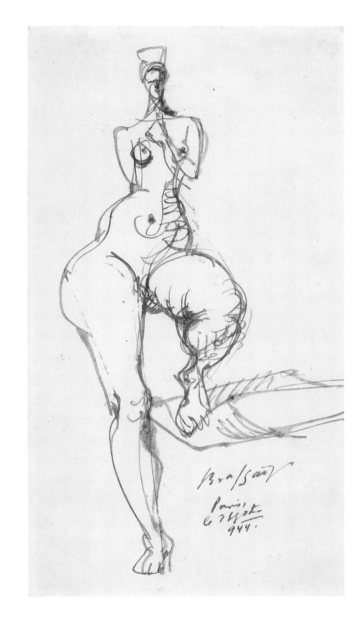

Nude Seated on a Cushion, 5 January 1945 *Nude*, 1944

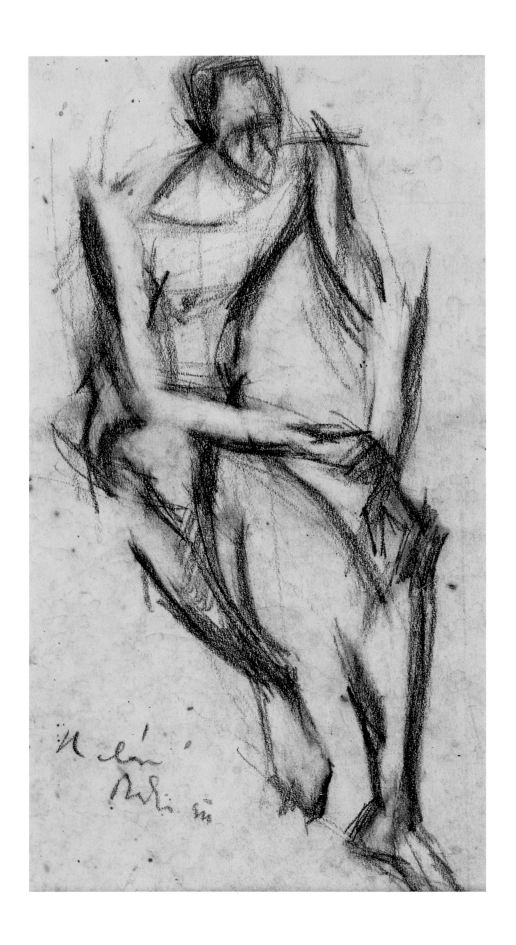

Male Nude, Berlin, 1921

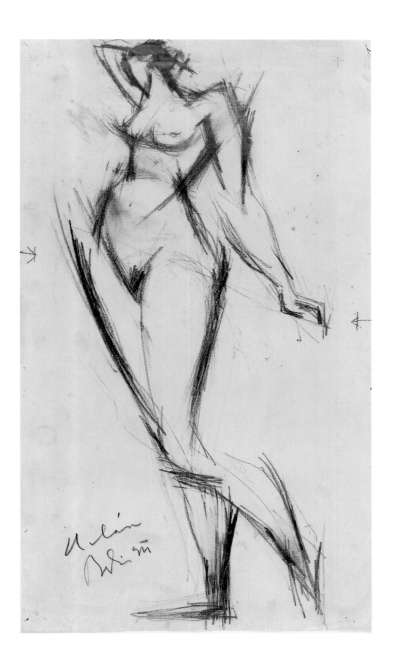

Nude, Berlin, 1921

fascinated
And the men think of women
and the women think of men
each of them dreaming
of the beauty of a vanished world
a world acceptable
simple brutal
and naked
And the horse like this world fleetingly evoked
disappears in its turn

The women that Brassaï draws
resemble this horse

Women such as we seldom see
Seen as nowhere else
Light as trees
Vast as flowers
Emerging from the stifling steam baths
Of day-to-day life
Displaying themselves shamelessly
In the violent freshness
of their raw materials
Callipygian Venuses and Belles Ferronnières
Model girls from Joinville-le-Pont
Wives of Hercules and Gaston
escaped from Piranesi's prisons
in a scene littered with extras
Everyday women
Young women of all times
Women of flesh and blood
Daughters of mothers and fathers
alive with the uncontainable
disparate life of today
and equally alive
with the strange splendour
of life once lived

Cathedral pillars and café pillars
Women from the bordello
Women from the harem
Women bound by marriage
watching a shower of hail
falling on the cobbles
of the Rue du Faubourg-Saint-Jacques
close by La Santé

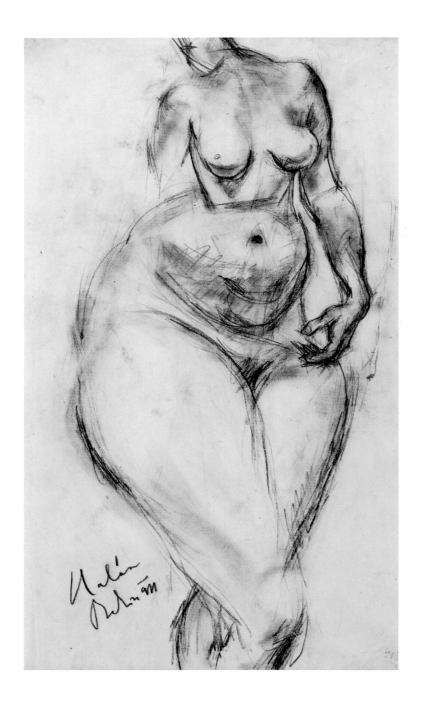

Nude, Berlin, 1921

And Brassaï
who knows better than anyone
that nature doesn't breed in captivity
delivers these poor odalisques
by drawing their likeness
and they make themselves beautiful for him
frighteningly beautiful
provocative troubling and disproportionate
as a secret desire
confessed
and undressed

Firmly planted like plants
on the flat of their feet
they thrust towards a sky
that's washed out shocked and dismayed
the soaring columns of their legs
with poised upon them
the splendid hanging gardens
of their buttocks and breasts

And cultured man
civilized man
fanaticized man
devitalized man
organized man
terrorized man
psychoanalysed man
thesaurized man
sterilized man
watches with astonishment that's undisguised
but undeniably dumb
this luscious corps de ballet
these big cosmic-opera girls
dancing on the extinct volcanoes
of an academic world
that's ill presented
and ill represented

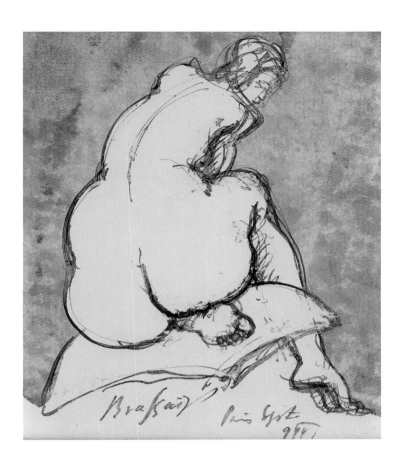

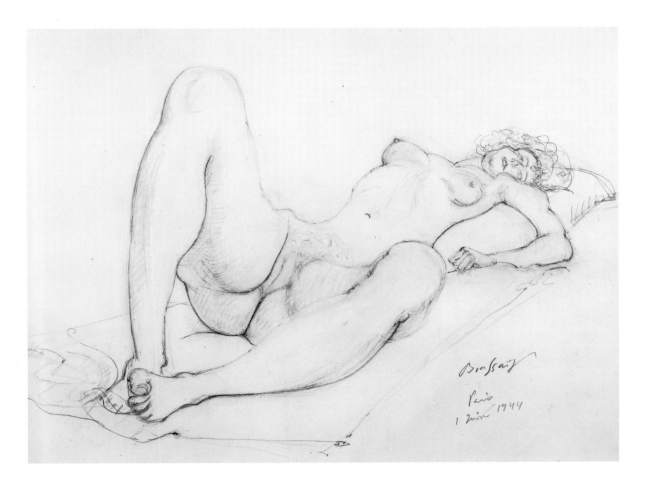

Nude, Paris, September 1944

Nude, Paris, 1 January 1944

Sculptures* Brassaï

The sea is a marvellous sculptor. This came to me as a revelation just a quarter of a century ago on a shore of the Pyrenees. Being struck sometimes by the natural beauty of the forms of the pebbles, the starting point of my first sculptures were such stones picked up on the beach. When eroded and polished by the incessant movement of the waves, these stones are as if manufactured in some gigantic tidal factory; such are their already sculptured shapes that one would say a sensual hand had been at work. Elements of the primary vocabulary of the lapidary arts, these shapes may suggest a face, a head, a bird, a fish or a human figure – according to one's imagination or particular obsession. On occasions the recognition is immediate; at other times, years may pass before a certain stone speaks to you and reveals its identity. The 'model' is never on the surface; it lies in the stone itself. And one never has the feeling of 'invention' or 'creation' – but more of **delivery**…. I am persuaded that art is not born of forms invented out of nothing, but rather out of those to which the imagination may give significance. And I know that I have had to submit to this order of things.

Roughly hewn, spiked with needle and chimney shapes, the rocks rise vertically and break up in angular fashion. They are '**male**'. But the pieces which fracture away and which are smoothed down and carried away by glaciers, floods, streams and the undertow of the surf – these pieces erode and little by little lose their virility to assume the roundness of '**femaleness**'. A sexual metamorphosis occurs. The pebbles suggest the swell of the belly, the gentle dip of the back, the curve of the hips, the fullness of the rump, the rise of the breasts and the line of the thighs; it is as if the sea, moulding an abundance of fleshy pebbles, was trying to rival the Aurignacian and Neolithic sculptors – creators of those buxom goddess-mothers.

Sculpture is above all a '**sensual**' art – the most sensual; that of the touch – and how this sense is frustrated today! Doesn't one run into everywhere the injunction: 'Don't touch'? The very first figurines which history has preserved for us, all those Venus's of Lespugue, of Willensdorf, all those 'femmes-violons' of Persia and Anatolia and even most of the sculptures of The Cyclades are reduced to the dimensions of the hand – in order to satisfy that essential need to feel, to discover in the hollow of the hand, a sensation of the body of a woman.

It seems to me important to emphasize the modest size and the 'intimiste' nature of all these first statuettes; it was only later that the paramountcy of the sense of touch gave way to that of 'sight' and when sculpture became lodged in the monumental and gigantic.

* This text appeared in a bilingual French/English version in the exhibition catalogue *Brassaï: sculptures, tapisseries, dessins*, Galerie Verrière, Paris, 1972.

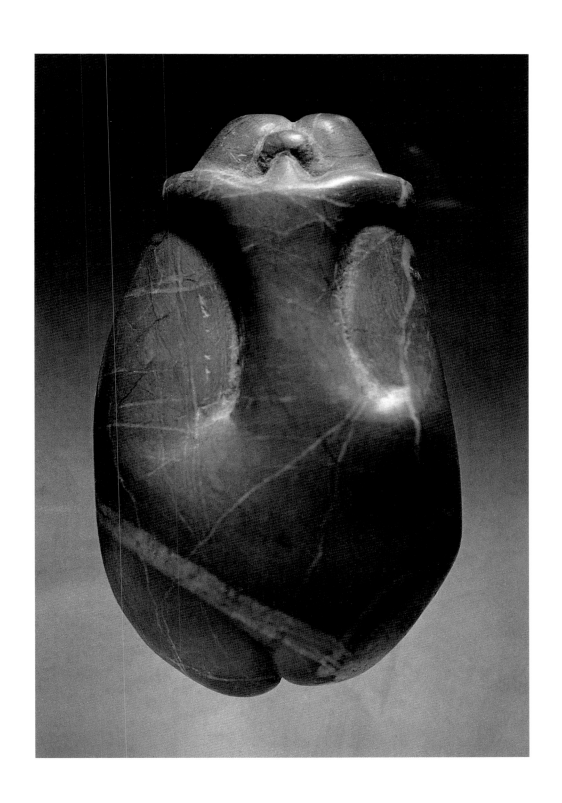

Squatting Woman, undated

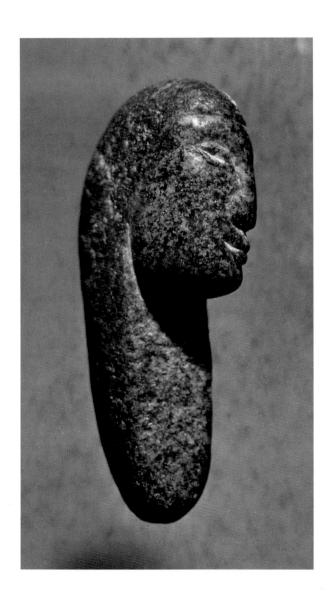
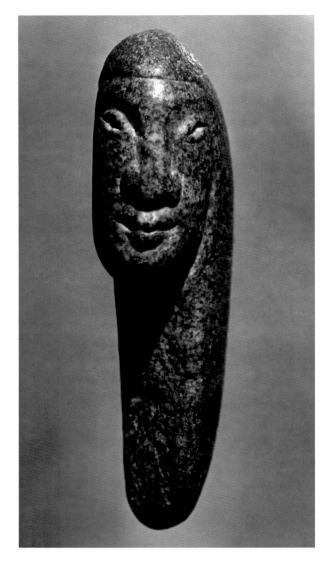

Venus of the Adour, 1946

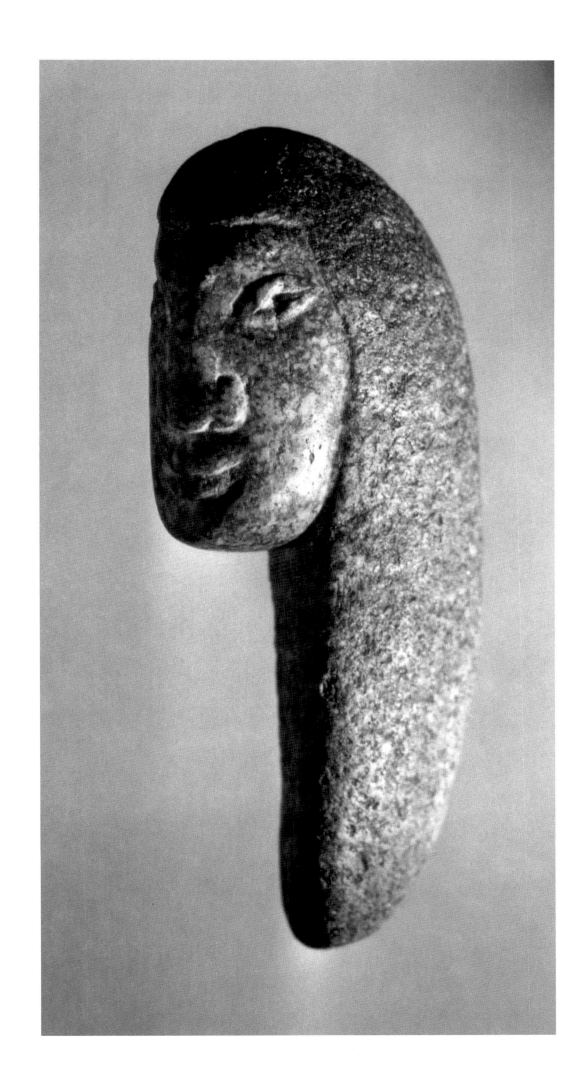

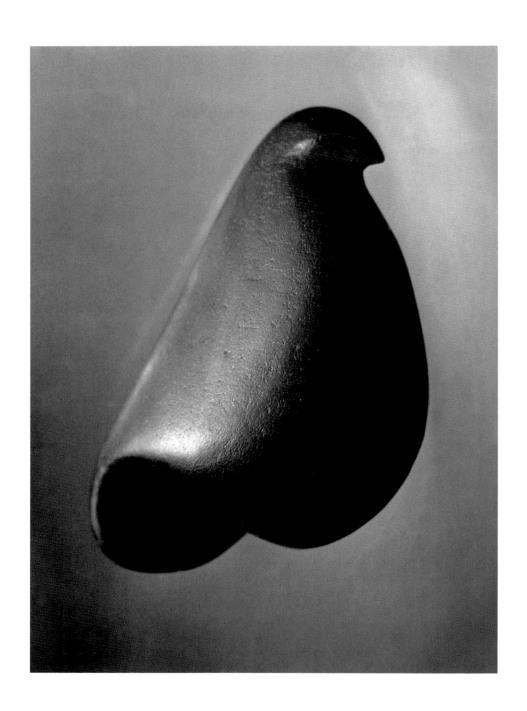

Black Bird I, 1948

Black Bird II, 1960

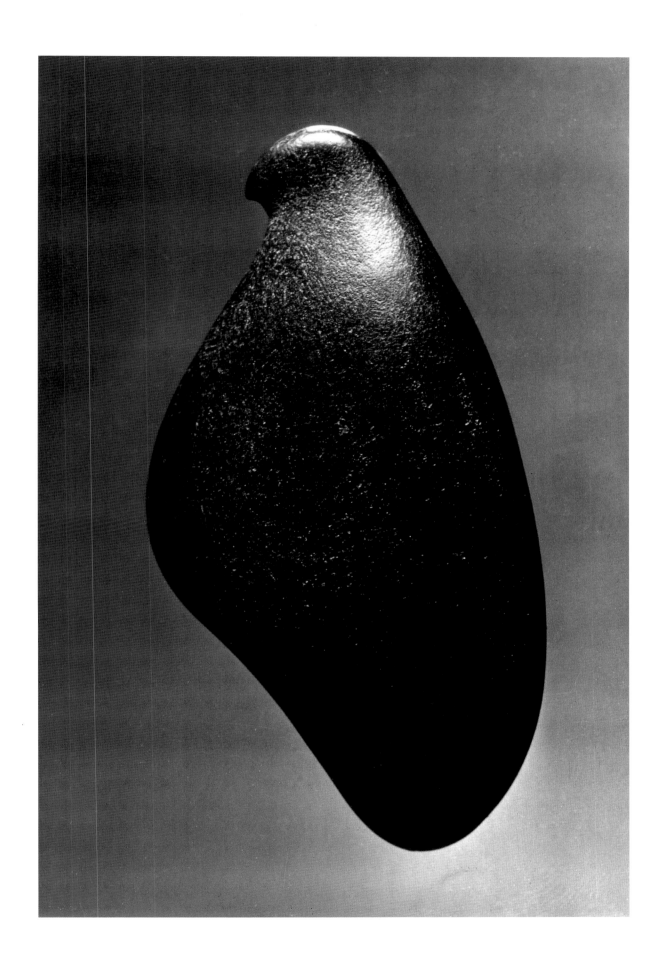

Brassaï and literature Roger Grenier

Favourite reading

A scholar, a great reader, the friend of many writers, and a writer himself.... Yes, it's Brassaï I'm talking about, the Brassaï who is normally thought of as a photographer. I spent a lot of time with him, over a period of forty years, and I never remember seeing him take a single photo, Rolleiflex round his neck. There he is in front of his bookshelves. He has no qualms about scribbling notes in the margins of his books. He talks to me of Diderot, of Strindberg's *Dance of Death*, of St Thomas Aquinas. When Breton and Éluard ask him what was the most important encounter in his life, he replies, 'My discovery of Goethe.' It was because she looked like something out of a nightmare by Baudelaire that he photographed La Môme Bijou – Little Miss Jewel – the septuagenarian prostitute who was one of the sights of Montmartre. If, of all the hotspots of Les Halles, he had a special affection for the Rue des Lombards, it was because – something that is not widely known – in the year of grace 1313, it was Boccaccio's birthplace. Brassaï, the photographer of the night, adored prostitutes and rogues, even killers. In that respect, he took after his favourite writers, Stendhal, Mérimée, and above all Dostoyevsky, who was fascinated by the criminals he met in jail, in 'the house of the dead'. Brassaï added: 'For me too … this infatuation with seedy places and seedy youths was doubtless necessary. How else could I have snatched those few images from the strange nights of Paris in the thirties, before they were swallowed up without trace?'

He had a plan to do a book with Pierre Mac Orlan: 'My whores, my pimps, my sailors, seemed to him to have come straight out of his world.' Sadly, the plan never came to anything.

Brassaï could not visit his house in Èze without remembering, as he clambered up the winding path to the village, that it was here that Nietzsche had planned the chapter 'On Old and New Tablets' for his *Zarathustra*. In *Ecce Homo*, Nietzsche wrote that this decisive part of the third book 'was composed on the most onerous climb from the station to the marvellous Moorish village of Èze, perched on the rocks'. Brassaï used to tell a rather extraordinary story about all this: 'Henry Miller came to visit me in Èze, in 1960. Naturally, we talked about Nietzsche. Then we went to a bistro, and who should we

see sitting there, writing? A chap with glasses and a big moustache. There was a book next to him and it was *Zarathustra*!' Of course, the two friends struck up a converation with this reincarnation. They discovered a character something between a prophet and a con man, who said he was working on 'political meteorology', a science he claimed had been invented by Nietzsche.

I used to see Brassaï writing all the time, more and more, right up to the essay on Proust and photography which occupied his latter years. His love of literature may have come from his father, a professor of French literature and a poet, who had a passion for Hégésippe Moreau and wrote a book on Pierre-Jean de Béranger.

Literary friendships

In Paris, his first literary encounters took place at the Hôtel des Terrasses in the Rue de la Glacière. There's a garden nearby that has now been given the name Brassaï. His friends in those days were Henry Miller, Raymond Queneau and Henri Michaux.

He'd known Michaux, since 1925. 'There was a ring at the door. It was for an express letter on which there was postage due. I had to pay two francs, all I had. I opened the letter. It was from Henri Michaux asking me to lend him a hundred sous. But because he had written it on the carton of a packet of Salammbô cigarettes, it was over the weight, hence the surcharge. So, at a stroke, we were both ruined.'

In 1936, Brassaï met up with Michaux in Antwerp. 'We spent the whole night wandering round the port of Antwerp without seeing a single boat. I still don't understand why.' In 1946, they went on several trips to Chamonix. 'Together we climbed the crumbling mountain across from Mont Blanc, which paradoxically is known as Mont Joly, then the glaciers of Argentière and Les Bossons, where I saw how Michaux was exhilarated by this hostile world of crystal and ice.'

Through *Minotaure*, the upmarket Surrealist review founded in 1932 by the publisher Albert Skira and art critic Tériade, he met Léon-Paul Fargue, Pierre Reverdy, Paul Éluard and Robert Desnos. *Minotaure* published André Breton's *La Nuit du tournesol*, with two photographs by Brassaï as illustrations, one of which was the mysterious nocturnal image of the Tour Saint-Jacques tottering under the weight of its scaffolding. With the addition of two more

photos, this text became the fourth chapter of *L'Amour fou*. 1932 and 1933 were 'the two most important years of my life', Brassaï intimated. It was through *Minotaure* that he got to know Picasso.

His tales of the nights he spent in the company of these artists were worthy of Restif de La Bretonne. Under cover of darkness, he scaled the towers of Notre-Dame, expecting at any moment to meet Quasimodo or, on the streets of the Cité, bump into Verlaine or Villon, the Marquis de Sade, Nerval or even solitary old Restif.

Léon-Paul Fargue used to take Brassaï on interminable excursions to Ménilmontant, Belleville and Charonne, and out to the Porte des Lilas. One night, Fargue invited a third friend, Edmond Jaloux. Off they trudged through the mud, shadowy outlines in the fog. Unresponsive to the charms of these empty streets, Jaloux left as soon as he could. Fargue said to Brassaï, 'Poor old Jaloux, he's got no imagination!'

It was some time before 1930 that Brassaï met Henry Miller, shortly after he had arrived in Paris. He and his close friend Alfred Perlès, to whom he gave the name Carl in his books, were then living at the Central Hôtel on the Avenue de Maine. The two men soon began to spend all their time together, at the Central, the Hôtel des Terrasses, the Dôme, and later on, the Villa Seurat. Six years later, a young lad joined them. This was Larry, otherwise known as Lawrence Durrell. At the Villa Seurat, Anaïs Nin posed for Brassaï as a Spanish dancer. Miller mentions his expeditions with the photographer in *Tropic of Cancer*.

Brassaï explored the Bassin de la Villette with Jacques Prévert, and together they discovered 'the beauty of sinister things'. It was again with Prévert, and also Joseph Kosma, that he experienced the great exodus of 1940, setting off from the Café de Flore and ending their journey in Pau (in the Basses-Pyrénées). Brassaï had worked out a cunning itinerary. On the way, they encountered a regiment of French soldiers. An officer demanded: '*Vos cartes*.' They thought he wanted to see their identity cards and got quite worried. In fact, the retreating regiment was lost and just wanted these civilians to lend them their Michelin maps. [*Carte* means both 'card' and 'map' in French.] They were presented with a pot of jam to say thank you, which broke inside Brassaï's rucksack and created havoc with his underwear. After the war, Brassaï designed theatre sets for writers: for the ballet *Le Rendez-vous* by Prévert and Roland Petit; for Raymond Queneau's play *En passant*; for the ballet by Elsa Triolet *D'amour et d'eau fraîche*; for *Phèdre*, Cocteau's ballet that was staged at the Opéra with Toumanova and Serge Lifar.

Jean Genet visited Brassaï at the Rue Saint Jacques to have his photograph taken. 'He happened to glance out of the window, and then he couldn't tear his eyes away.'

The point was that the window overlooked La Santé prison.

Genet returned another day with a young friend. He told him to look out of the window. The boy didn't react.

'Come on,' said Genet, 'don't you recognize it? La Santé!'

'The thing is, I only know it from the inside.'

When he walked in the street outside his home on the Rue du Faubourg-Saint-Jacques, Brassaï often met Blaise Cendrars, who lived just behind the prison and used to walk his dog on the Boulevard Arago.

Brassaï has left us portraits of, among others, Jean Genet, Henry Miller, Jean-Paul Sartre, Simone de Beauvoir, Colette, Henry de Montherlant, Paul Claudel, Jean Giono, Thomas Mann. He also collaborated on occasion with writers: for the Concours Lépine with Benjamin Péret, and at the prison in Fresnes with Marguerite Duras.

Writings

After the First World War, like most young European artists, Brassaï wanted to live in Paris. But that was not possible, because he was a citizen of a former enemy country. He therefore moved to Berlin, which may have been the capital of a defeated nation but was humming with life. In 1924, he finally got to Paris. His *Elöhívás* (Letters to My Parents) is both a wonderful record of bohemian life in the two cities in the years between the wars and effectively his first work of literature.

When he first arrived in Paris, Brassaï earned a living by his pen, contributing articles to Hungarian and German papers – the subject matter was almost immaterial.

Every time he published an album of photographs, he had a compulsion to write something. It started with captions to accompany the photos, which soon expanded to become stories in their own right, so that these books are as much for reading as for looking at the pictures. I remember *Séville en fête*. Robert Delpire, then a young publisher, had asked Montherlant to write the preface and Dominique Aubier to contribute a lengthy commentary. That was not enough for Brassaï. He produced a series of footnotes describing the scenes and filling in the literary and historical background quite as accurately as any ethnologist could have done it, thus rendering the other texts pretty well superfluous. When he put together *The Secret Paris of the 30's*, he accompanied his photos of this

underworld with a series of anecdotes trawled from the lower depths. Like the story of the Human Gorilla and his wife, a Loïe Fuller lookalike, poor people who even then were fleeing Nazism; or his crazy night with the cesspool cleaners.... In 1949, Brassaï took the plunge and published a short book called *Histoire de Marie*, which contained not a single photograph (just one engraving by him). Henry Miller wrote the introduction. The managing editor of Les Éditions du Point du Jour, which launched Brassaï as a writer, was René Bertelé, a friend of Prévert and Michaux. It was Bertelé who patiently assembled the poems Prévert used to scatter to the winds and who published the famous collection of his *Paroles*. One of Brassaï's photographs of graffiti appeared on the cover of the first edition of 1945.

Brassaï claimed he wrote *Histoire de Marie* and *Paroles en l'air* in the same spirit as he took his photographs, 'the eye having given way to the ear'. In the preface to *Paroles en l'air*, he explained his self-imposed rules. 'It was no longer a matter of portraying images, but of showing people in their true light: with no commentary, without explanation or psychological analysis, without depicting their surroundings or external appearance, without stage directions.... Shrouded in obscurity, these protagonists have been abandoned by their creator, who has simply removed himself from the scene and become invisible. The only way they can make themselves known is by the use of their own voice.' Yet *Histoire de Marie* is not like a tape-recording, it does not simply reproduce the things his housekeeper said, it re-creates them, in much the same way as Proust re-created Françoise from a number of different models. Brassaï said he had not had Françoise in mind when he wrote *Marie*, but after the event could see several points of similarity.

Francis Ponge regards Marie as 'the quintessence of *obviousness*'. And Samuel Beckett 'laughed sadly' as he read *Marie*. There is another extraordinary thing about the book. Marie's words form a highly wrought text that is aimed at a literary readership, and yet they lend themselves perfectly to being spoken aloud. Maurice Bénichou successfully adapted the book for a production at the Théâtre des Bouffes du Nord starring Geneviève Mnich.

It was not long before Brassaï repeated the exercise, this time with a character who was no mere housekeeper. 'It's going to be the *Histoire de Marie*, but on the scale of Picasso!' he announced to Henry Miller. In 1932, in Boisgeloup, he had started to photograph the great man's sculptures, which were not then well known. More than ten years later, in 1943 and 1944, he spent several months

Portrait of Jean Genet, 1955

at Picasso's studio in the Rue des Grands-Augustins working on an album of his sculptures. He listened, and noted down what was said. In his book [*Picasso & Co.*], you can hear the voices of Picasso and his close friends, visitors like Prévert, Éluard, Reverdy, Sartre, Camus, Cocteau, Michaux. But, once again, Brassaï goes beyond the purely anecdotal to embark on a discussion of Picasso's art and the questions it raises. Picasso never thought much of the things that were written about him, but he told Ilya Ehrenburg, 'If you really want to know about me, read Brassaï's book.'

At the Rue des Grands-Augustins in the last months of the Occupation, Brassaï had the luck to take two extraordinary photos. Michel and Louise Leiris had moved to the Quai des Grands-Augustins, just round the corner from Picasso. They had the idea of organizing a reading of his farce, *Le Désir attrapé par la queue* [Desire Caught by the

Tail]. It was directed by Albert Camus and the actors were Michel Leiris, Raymond Queneau, Jean-Paul Sartre, Georges Hugnet, Jean Aubier, Jacques-Laurent Bost, Zanie de Campan, Louise Leiris, Dora Marr and Simone de Beauvoir. To say thank you, Picasso invited them all back to his place. And there they are, most of them, all together in the same photo, along with Jacques Lacan, Valentine Hugo and Kazbek, the resident Afghan hound. Kazbek is missing from the second photo, presumably having had enough. But this time Brassaï has set the exposure to delay and joined the group. Not since the collective portraits of Fantin-Latour and Max Ernst had so many artists appeared together in one picture.

When Brassaï was assembling the material for the album *The Artists of My Life*, about painters and sculptors, he was seized with his usual desire to write something, and produced a series of articles to accompany the photos. The item on Picasso should be read as a companion piece to his *Picasso & Co.*, being more direct and probably more indiscreet.

The novels and personality of Henry Miller inspired two of Brassaï's books: *Henry Miller grandeur nature* and *Henry Miller rocher heureux*. I was lucky enough to be present at some of the meetings between these two cronies. As Henry Miller listened to Brassaï's stories, he used to utter little grunting noises that emerged from the pit of his stomach. Suddenly his eyes would light up. Then off he would go, in his turn. Miller and Brassaï shared the same ability to sum up a situation in an instant. One evening, in a small restaurant in Montparnasse, I was surprised to hear them start talking about Lourdes. I was brought up in that area and thought I knew the town of the miraculous shrine pretty well. Neither Miller nor Brassaï could have spent more than twenty-four hours there in their lives, but they had seen and assimilated everything – the pathetic hopefulness of the sick, the charlatans, the faith, the money-changers in the temple....

In July 1962, when Henry Miller was living in California, in Pacific Palisades, he wrote to Brassaï expressing his admiration for his texts on painters and writers. He added: 'I hope that after my death you'll do the same for me as you did for Reichel, Reverdy, Picasso and who knows who else?'

It was like a trigger. Without a moment's delay, Brassaï started writing. He told his friend about it in September 1964. By return of post, Miller gave him the 'green light' and his 'blessings'. After that he never stopped bombarding Brassaï and his wife Gilberte with letters demanding to know where the book was, and if it would soon be finished: 'Will I be able to read it before I die?' Brassaï sent him *Henry Miller grandeur nature* in 1969 and received a few annotations in response. The book appeared in 1975. Beginning in August 1969, the same rigmarole occurred with the second volume, *Henry Miller rocher heureux*. Miller wrote of his impatience to read the manuscript, which was finally published in 1978. 'Happily, in Miller's lifetime', as Brassaï was to say. Henry Miller died in 1980.

The first volume tells of the bohemian life the two artists shared in the pre-war years, and consists of a more or less inexhaustible supply of anecdotes. The second is about Miller after he became an international celebrity. It takes the form of a journal of the meetings that took place between the two men over a period of twenty years from 1953 to 1973. More than that, it is a discussion of the psychology and art of the author of the *Tropics*.

I now come to Brassaï's last book, *Marcel Proust sous l'emprise de la photographie*.

Why Proust? First, because Brassaï's pictures depict a world that exhibits the same contrasts as the world of *Remembrance of Things Past*. He was photographing members of the Jockey Club at the same time as he was taking shots of sordid rooms in hotels that catered for highly specialized tastes, of the type run by Jupien.

But we need to go back further. In describing his memories of childhood, this is how he recalls his first visit to Paris, in 1903, when he was four years old: 'At that time my brother and I used to wear great big black hats, as hard and shiny as the material used to make records – in fact it was cuir-bouilli, apparently. Crossing the Champs-Élysées used then to be even more perilous than crossing the Boulevards, because the speed was greater, the horses were more nervous and went like the clappers. Once, in the extreme confusion of crossing the avenue, I happened to lose my hat, which at once shattered into a thousand pieces under the hooves of the horses harnessed to a victoria. Mauve veils and a large flowery hat hid the face of the woman seated alone in the carriage. Not till much later did I learn that this was Oriane, Duchesse de Guermantes.'

At his house in Èze, Brassaï was no distance at all from Laghet, a place of popular pilgrimage where the walls of the church were covered with hundreds of votive offerings. He was perfectly aware of Odette Swann's devotion to the Virgin of Laghet, and how, following her miraculous cure, she always wore the gold medal of Laghet on her bosom. In one of his jealous fits, Swann asked Odette to swear to him on her Laghet medal that she had never been unfaithful to

him with women. She confessed, because she could not bear to betray the sanctity of the medal.

All that is anecdote. What really fascinated Brassaï more than anything was the importance of photography in Marcel Proust's life and work. Shortly after the war, he organized a conference on this topic. In his latter years he concentrated almost exclusively on his account of what he called the 'ascendancy' of photography over Proust. There was not a letter in which he did not speak to me about 'his Proust'. The manuscript went with him everywhere – New York, Bludenz in Austria, London, Beaulieu…. This, briefly, is his argument.

Marcel Proust occupied an unequivocal position in the great debate that had raged ever since the invention of photography. He was in no doubt that photography was an art. But, more than that, he was a true enthusiast with an absolute passion for the camera. It was something that ran in the family, and he may have got it from his mother. He had his portrait taken at the most famous studios of the day, he used to hand out photos of himself, and if he met anyone he found interesting, he would ask for a photograph, stealing it if necessary. He used to show his collection to visitors, who had difficulty in suppressing their yawns.

When he was doing his military service as a volunteer, he could not wait to be photographed in uniform and present his picture to his superior officer, Lieutenant de Cholet, who gave him his own in exchange. He asked Réjane for a picture of herself dressed as the Prince de Sagan. The dedication written on the back of a photograph became for him a method of seduction. Brassaï concluded that such a passion must have had an influence on the writer's imagination and on his work. Most writers will know the huge importance a simple photograph can assume, how it can provide the germ of a story, inspire a poem, or jog the memory into recalling a whole other world or age.

Brassaï demonstrates how photography is a continuous theme running through *Remembrance of Things Past*. It often plays a decisive role in the thousand and one dramas of which the novel consists. How could one not think, first and foremost, of the famous desecration scene when Mademoiselle Vinteuil spits on her father's photo? There are also the estrangement of the Duc and Duchesse de Guermantes, which is brought to light by the large photograph of the coins of the Order of Rhodes; the photograph of Charlus, which makes Morel run away; and that which reveals Miss Sacripant and Odette to be

one and the same person. What jealousies are fuelled by these scraps of card that supply the irrefutable record of a moment it is impossible to deny!

This list of examples is only the beginning. Brassaï establishes a relationship between photography and Proust's narrative method – the way he uses changes of perspective, range and focus. Photography is deeply embedded in his vocabulary and his metaphors. Brassaï demonstrates that Proust does not operate like a film-maker, but presents a series of snapshots. You could imagine he might have been inspired by Marey's chronophotography, which involved the use of a sort of repeater mechanism capable of registering between ten and one hundred images per second, thus enabling Marey to obtain weird superimposed images – walkers in white against a black background, seagulls in full flight. This is exactly the way Proust describes Saint-Loup emerging surreptitiously from Jupien's brothel in the Rue de l'Arcade. He speaks of the 'extraordinary disproportion between the number of different points his body passed through and the small number of seconds within which this exit, which looked like that of someone trying to escape from a siege, was performed'. It is the same with the famous scene of the kiss: 'As my lips travelled the short distance towards her cheek, it was ten Albertines I saw.'

Finally, Brassaï likens the *involuntary memory* to the *latent image* that appears in the developing tank. It is a metaphor used by Proust himself. In photography he discovered his best ally, for it too was born of the desire to freeze time, to preserve the moment for ever in a sort of eternity.

Brassaï combines two qualities rarely found in one writer. He was a prodigious storyteller; but his narrative skill was matched by his philosophical cast of mind. Whether confronted by the loftiest or the most trivial expression of human life, he seemed to say: that too exists, and merits investigation. He belonged to the Surrealist generation, but kept his distance from them, retaining his affection for the simplicity of the real world: 'I never sought to express anything but reality itself, than which there is nothing more surreal.' That was the secret of his art. It is as true of his books as of his photographs. Like Flaubert, he believed life was no more than a series of accidents, and it was the job of the artist to make of them something immutable.

Odalisque, 1934/1967

Transmutations* Brassaï

The engravings assembled in this album date from 1934–35. What impulse
was I obeying, to what temptation was I succumbing, when I picked up a
few glass plates and thought of etching them? I, who was so respectful of
the image imprinted by light, and hostile to all 'intervention', had I, in
spite of myself, been influenced by the Surrealists with whom I was then
spending my time? Who knows? The person we once were becomes such
a stranger to us after a few years have passed that we often forget not
only our actions but the reasons for them. I have spoken elsewhere of the
occasion when I was reloading the printing frames at Picasso's in 1932 and
left a blank plate behind in his apartment in the Rue La Boétie. When he
discovered it, he immediately attacked it with a stylus and drew a picture
of Marie-Thérèse. Probably the story of this little forgotten plate is what
led to my own engravings. I did not then know that other painters before
Picasso had tried their hand at engraving on photographic emulsion:
Delacroix, Rousseau, Daubigny, Millet and a few others. And I knew
nothing about Corot's *clichés-verre* [literally 'glass negatives'], a major series
of which is owned by the Cabinet des Estampes [in Paris]. All his life,
Corot loved this technique of etching on glass covered with collodion,
which is also known as 'heliographic autography', 'crystallography',
'heliotypy', 'glass print', 'phototype', etc. He executed his sixty-sixth
cliché-verre in 1874, at the age of seventy-eight.

But what attracted me to this novel venture was not the technique
itself, which is probably less rewarding than etching proper or dry-point,
but the possibility of introducing into engraving something peculiar
to photography. Probably the most beautiful photograph will never be
a match for a beautiful drawing – so at least we have been told often
enough ever since photography was first invented – but could the most
beautiful drawings in the world ever fulfil the functions of photography,
uniquely equipped as it is to record a moment of time, and the best
substitute for reality we possess? Unlike my predecessors, I put aside the
unexposed plates, which said nothing to me, and just worked on exposed
negatives whose subject matter happened to appeal. As a sculptor, I have
always restricted myself to releasing the form glimpsed for a second in
a pebble picked up on the seashore. In the same way, in this instance,
I confined myself to revealing the latent figure buried within each
image. Photography became my raw material, the point of departure
for mutations and transmutations that no longer had any connection
with the original.

I was almost like a sleepwalker as I experienced these acts of
destruction and creation. The dislocated elements of the photographs
reorganized themselves into new combinations. I saw a rock crystal
transform itself gradually into a mysterious stone face; a cage of doves
and a roulette wheel at the fair become the eyes of a Kanaka mask; a
weatherbeaten statue standing in front of a crumbling wall turn into a
black totem pole. Photos of nudes and scantily clad women became the
sources of different images entirely. The strangest was a reclining nude

* Text written by Brassaï to accompany the
exhibition of the portfolio *Transmutations*, Galerie
Les Contards, Lacoste (Vaucluse), 1967.

The 'transmutations' are engravings on
photographic plates, executed in a similar manner
to the photographic etchings or *clichés-verre* made
by Delacroix, Rousseau, Daubigny, Millet, Corot
and even Picasso, except that here exposed plates
have been used. These prints were made in 1967
from plates dating from 1930–32 and reworked in
1934–35.

that was gradually swallowed up by what looked like the leering face of St Anthony. The intensity of his desire had turned one of his eyes into a woman's breast. I carved these pieces of flesh as you carve a block of stone, to release the figure within. A tart taking off her clothes in a hotel room in the Rue Quincampoix was transformed into an array of musical instruments. The wallpaper and the suspenders on the couch were the last vestiges of the photograph that remained. Other forms that were 'delivered' became guitar women, viola women and mandolin women. I have always been haunted by this obsession with reducing the female body to a musical instrument; it is probably one of the archetypes of primitive art.

In moving from a photographic image to engraving, realism gives way to fantasy. Sometimes the photo is obliterated. Sometimes there are a few surviving fragments: a bit of a heaving bosom, a foreshortened face, a thigh, an arm. When subsumed within the drawing, they bring freshness and instantaneity, a breath of life, to our obsessions and dreams. Probably we are engaged at different levels of our being in the photographic and the engraving processes. Photography, which is the very image of self-effacement, does also reveal the personality, but always indirectly, through the medium of an interposed world. That is why I chose it. But can it assuage all our hunger and thirst? I remember Picasso saying to me one day: 'It is impossible photography will ever manage to satisfy you completely....'

Mineral Face, 1934/1967

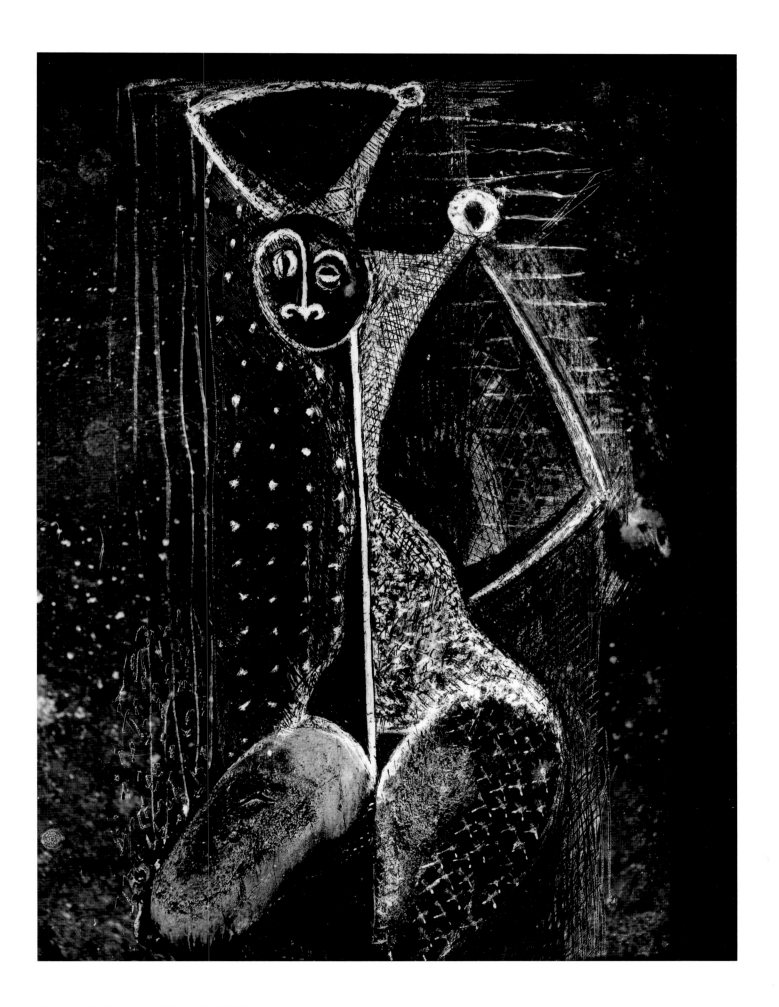

Woman of Seville Stripped Bare, 1934/1967

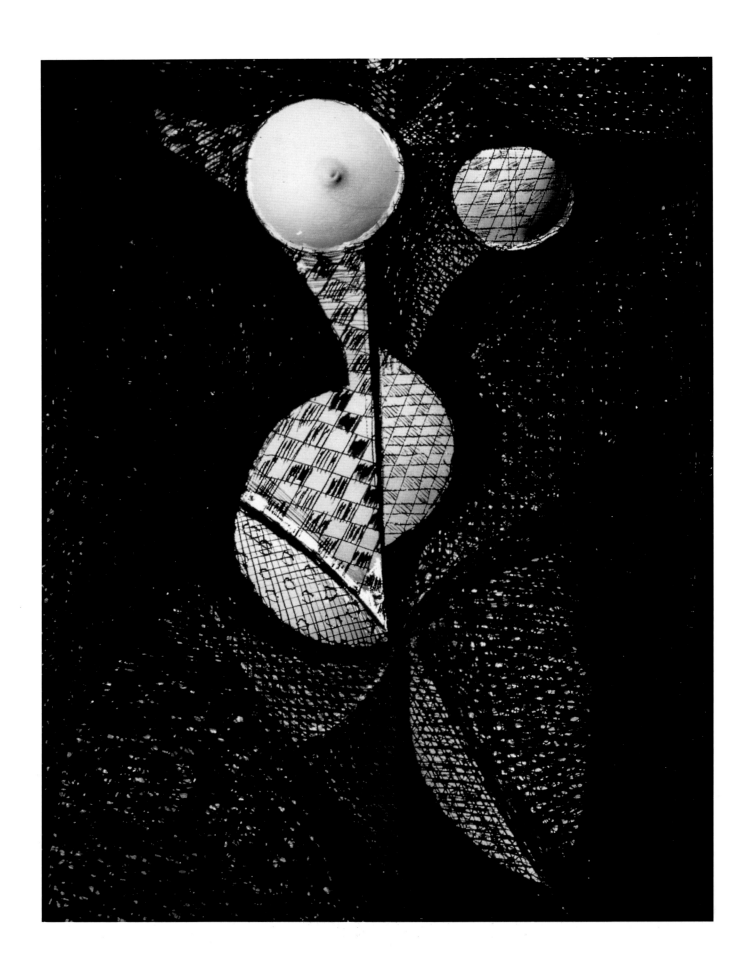

Fruit Woman, 1934/1967

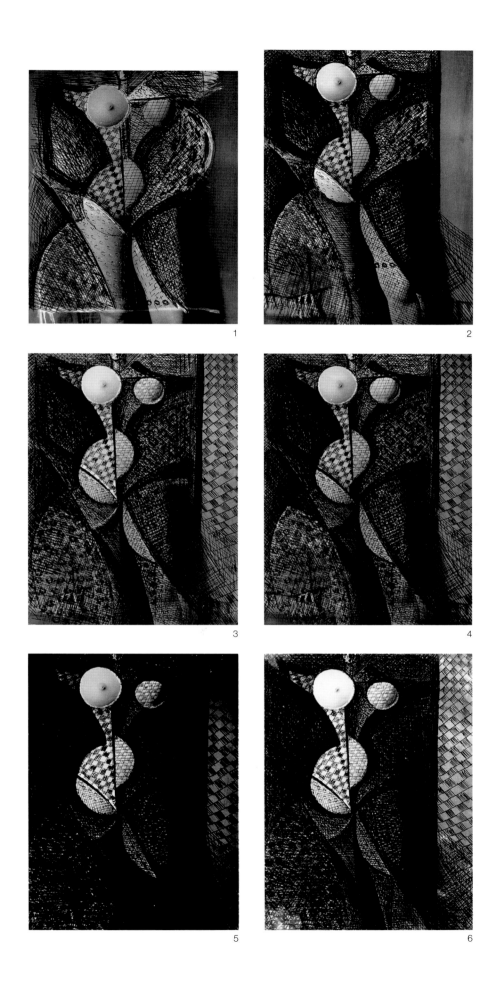

Fruit Woman, 1934, 1st to 6th states

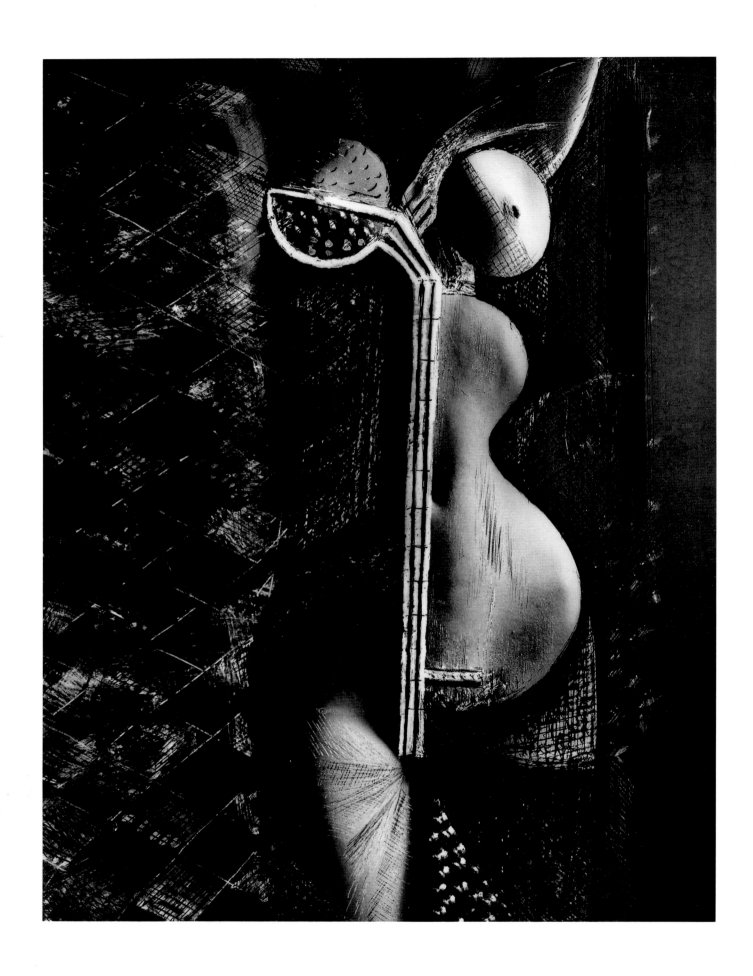

Offering, 1934/1967

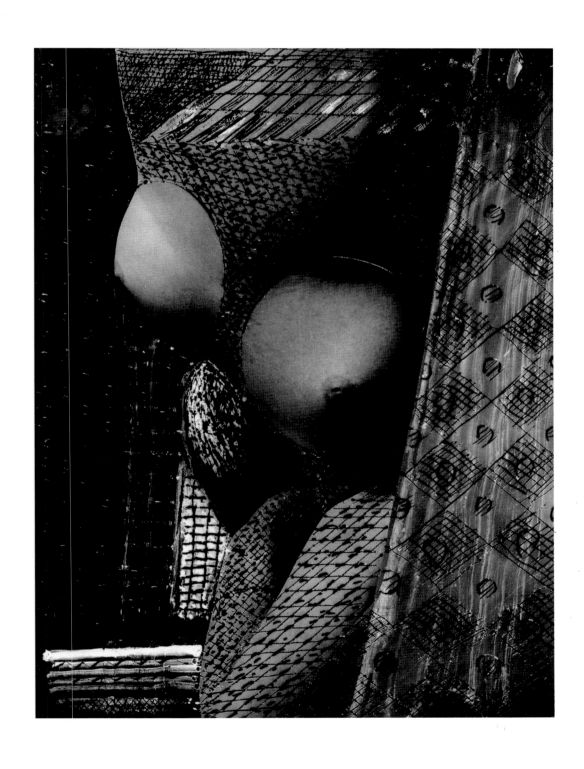

Girl Dreaming, 1934/1967

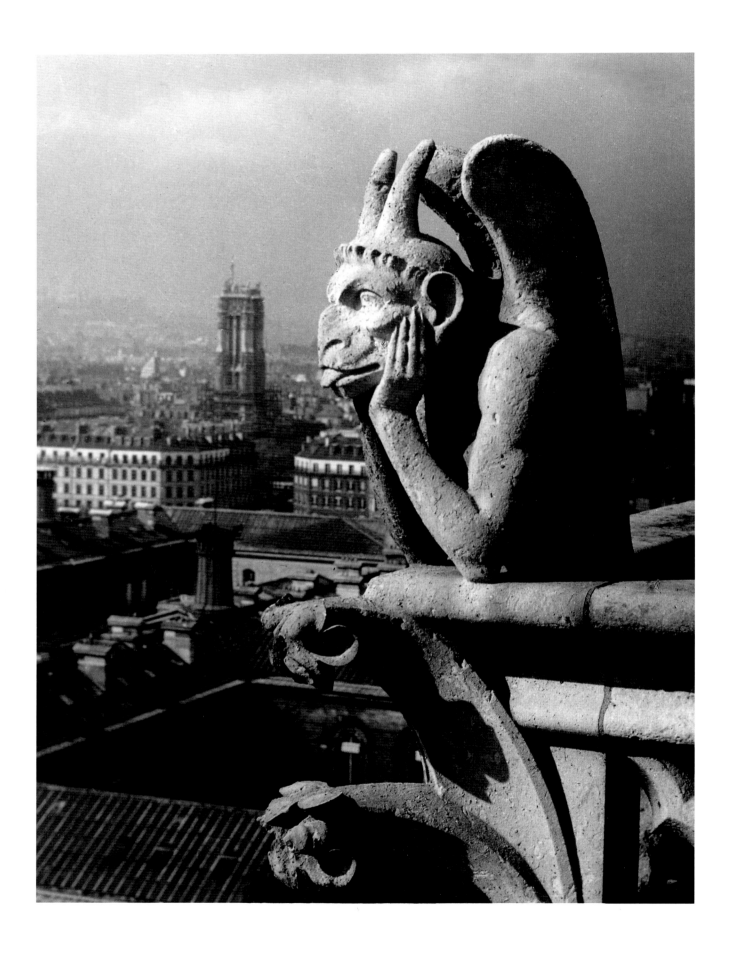

The Devil of Notre-Dame and the Tour Saint-Jacques, 1933

Camera in Paris

From images of Paris by day to those for *Harper's Bazaar*

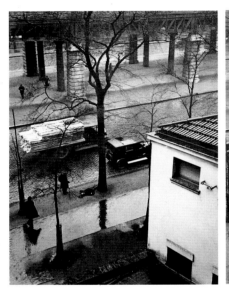 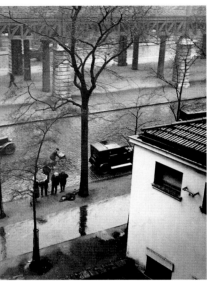 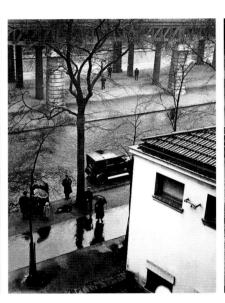 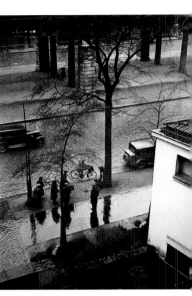

A Man Dies in the Street, Boulevard de la Glacière, 1932

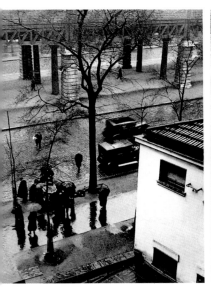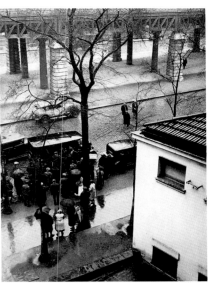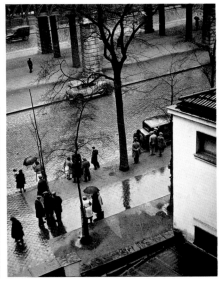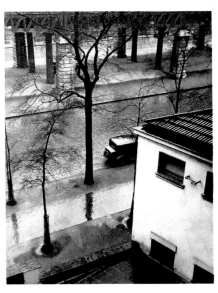

Wall of La Santé Prison at the Corner of the
Boulevard Arago and the Rue de la Santé, c. 1930

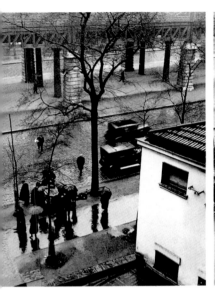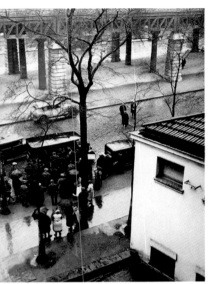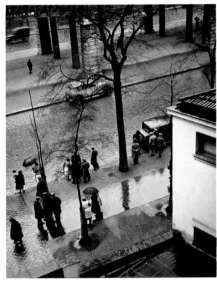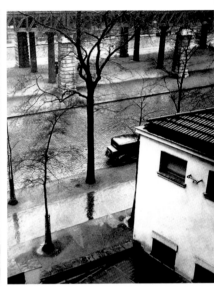

Wall of La Santé Prison at the Corner of the
Boulevard Arago and the Rue de la Santé, c. 1930

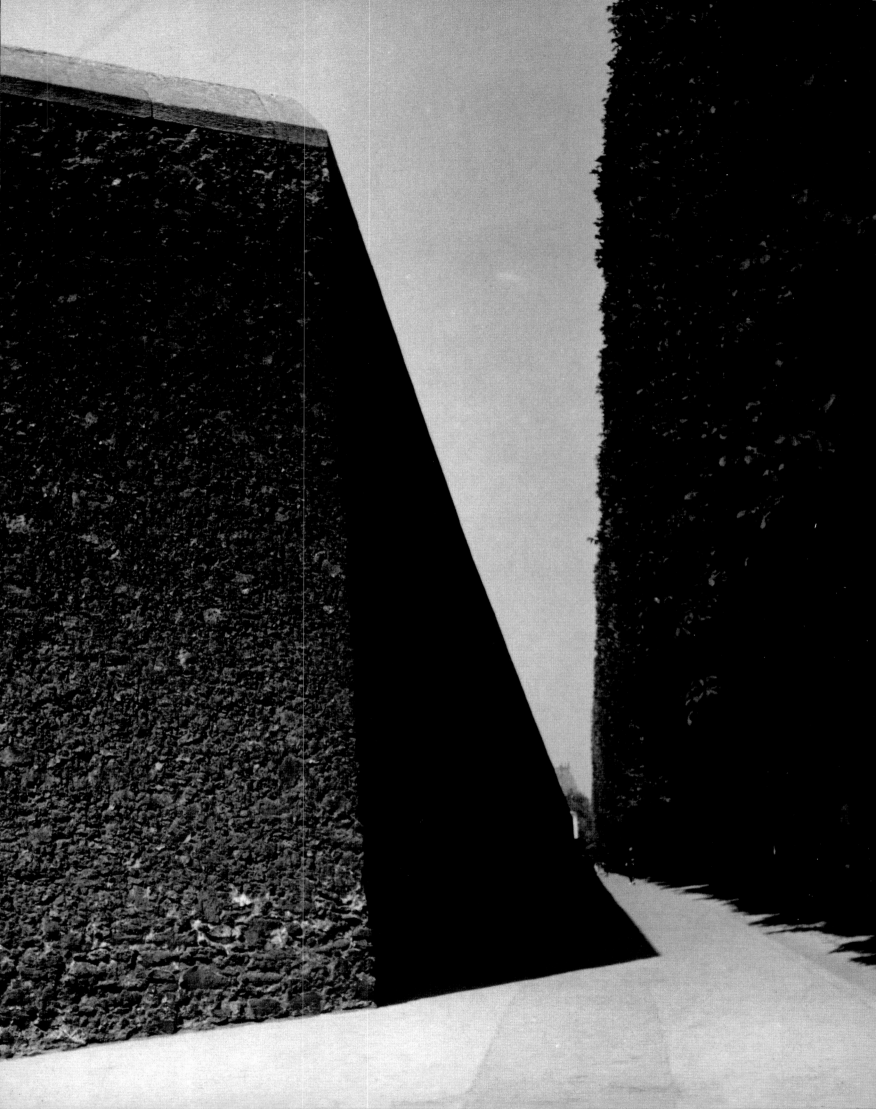

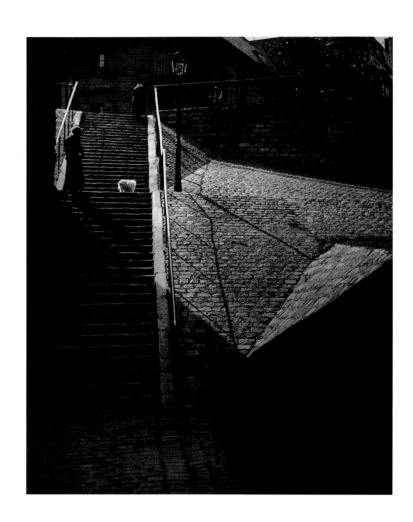

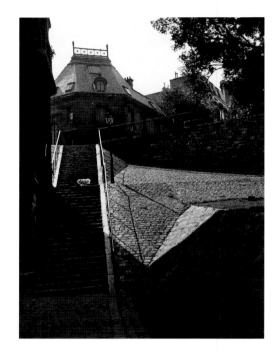

Steps of the Butte Montmartre with a White Dog, c. 1932–33

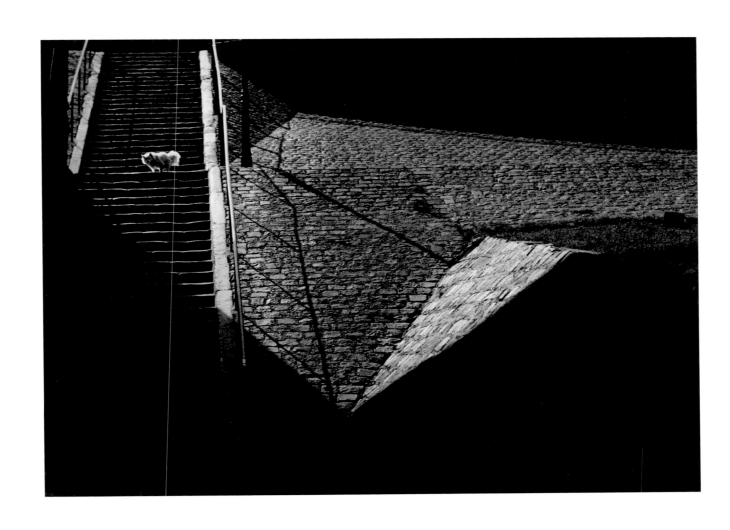

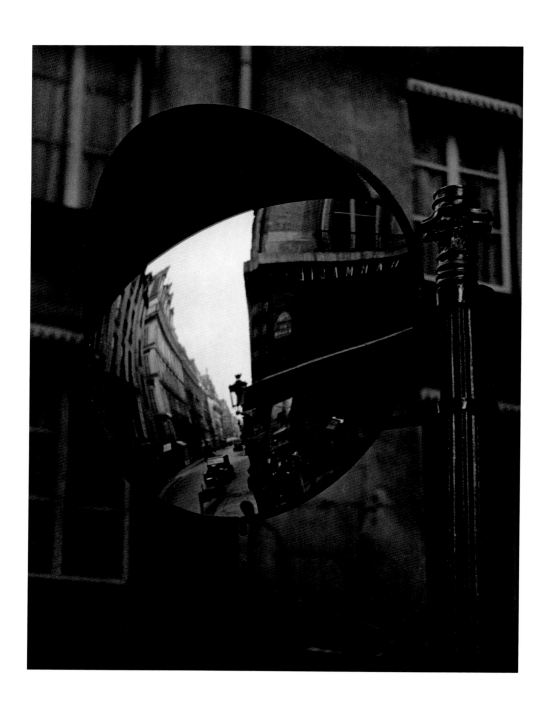

Round Mirror, c. 1932–34

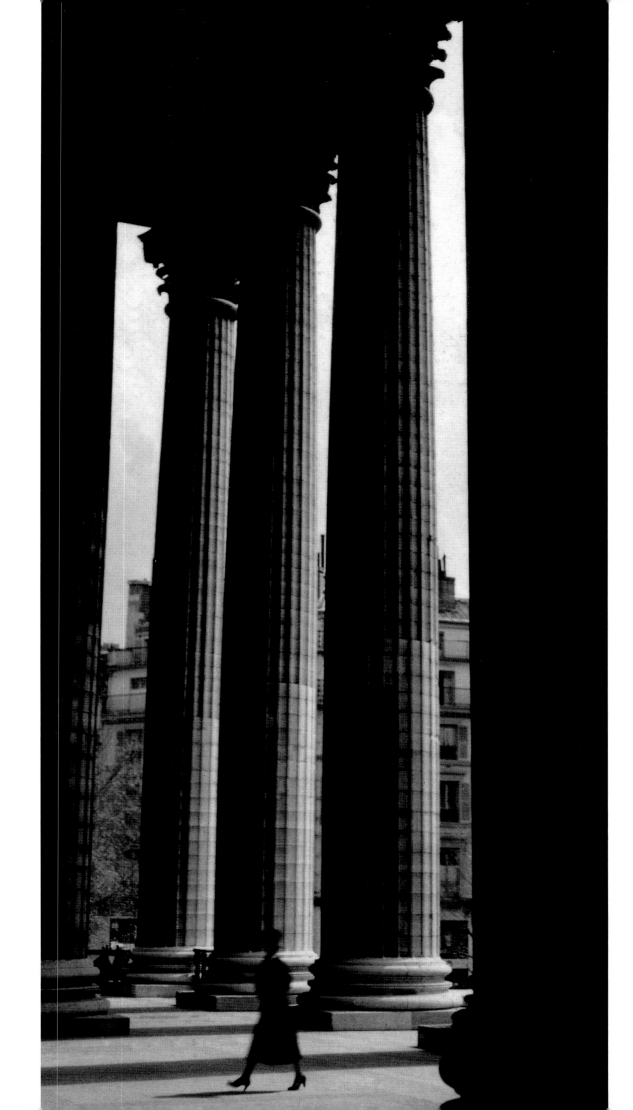

The Madeleine, undated

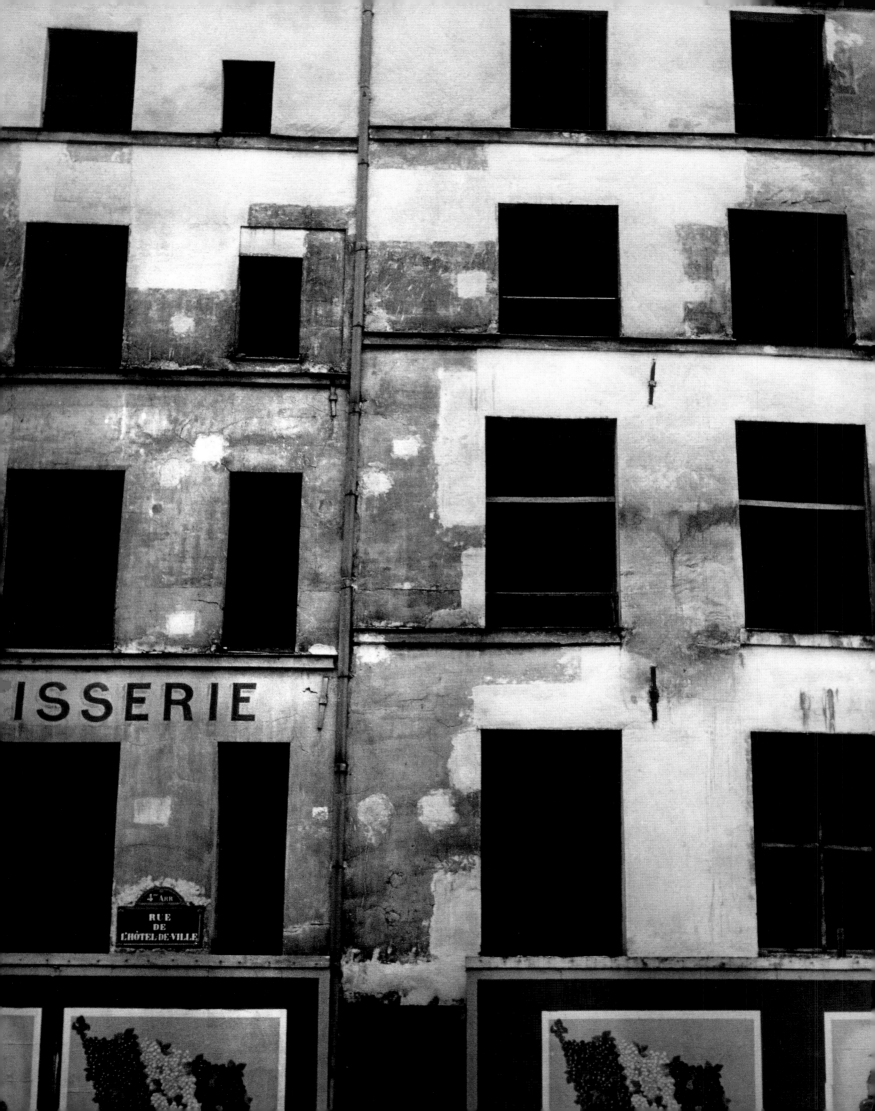

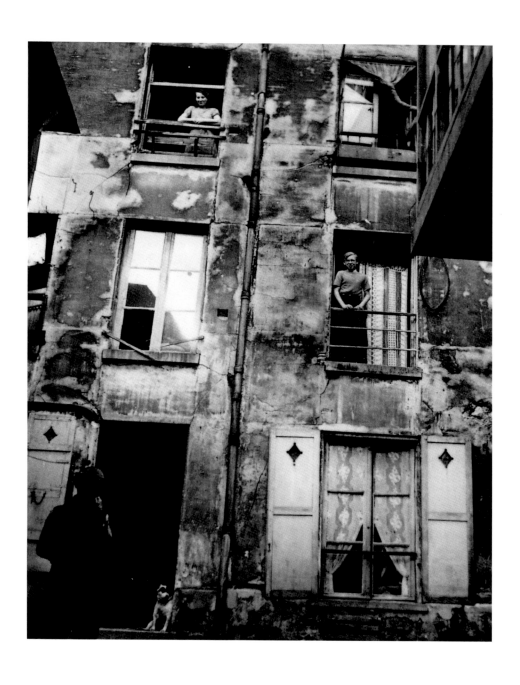

Rue de l'Hôtel-de-Ville, c. 1936

Courtyard of a Building in the Suburbs of Paris or *Slums*, 1939

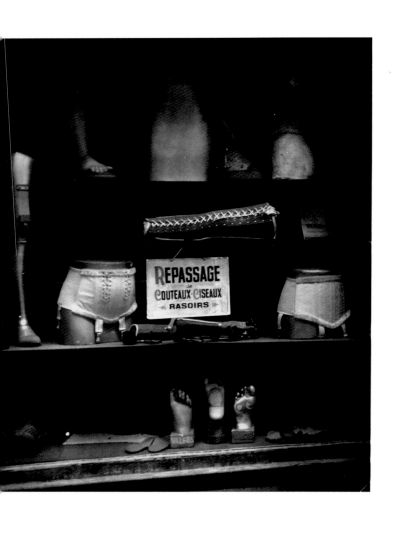

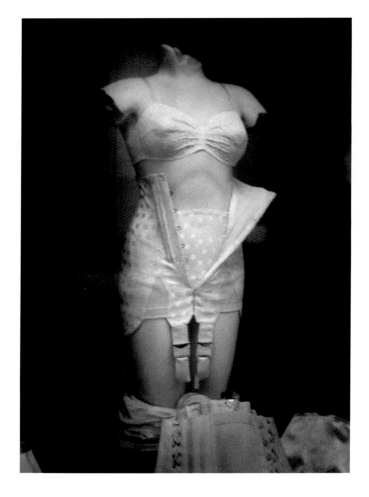

Near the Panthéon, undated Mannequin, undated

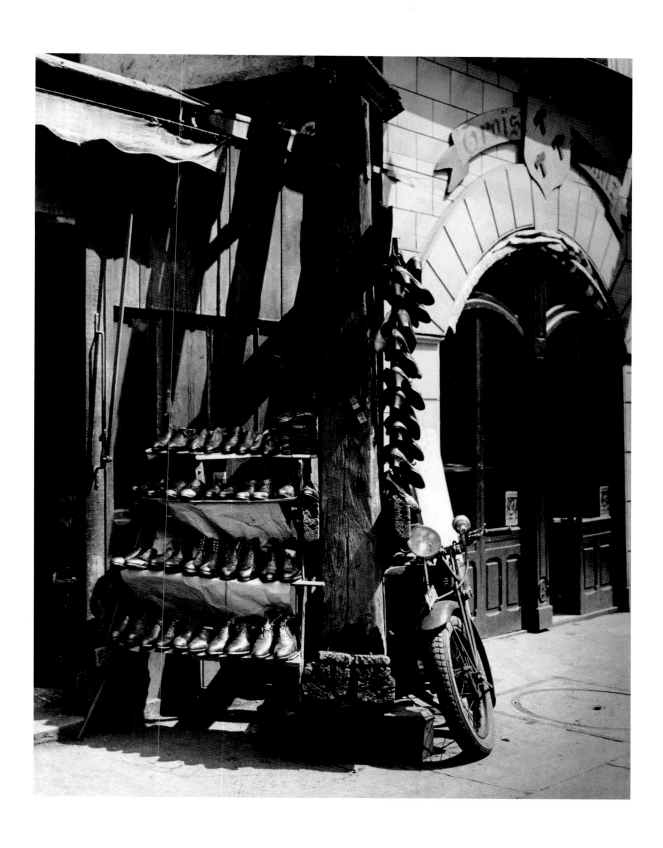

Secondhand Dealer in the Rue Galande, c. 1931–32

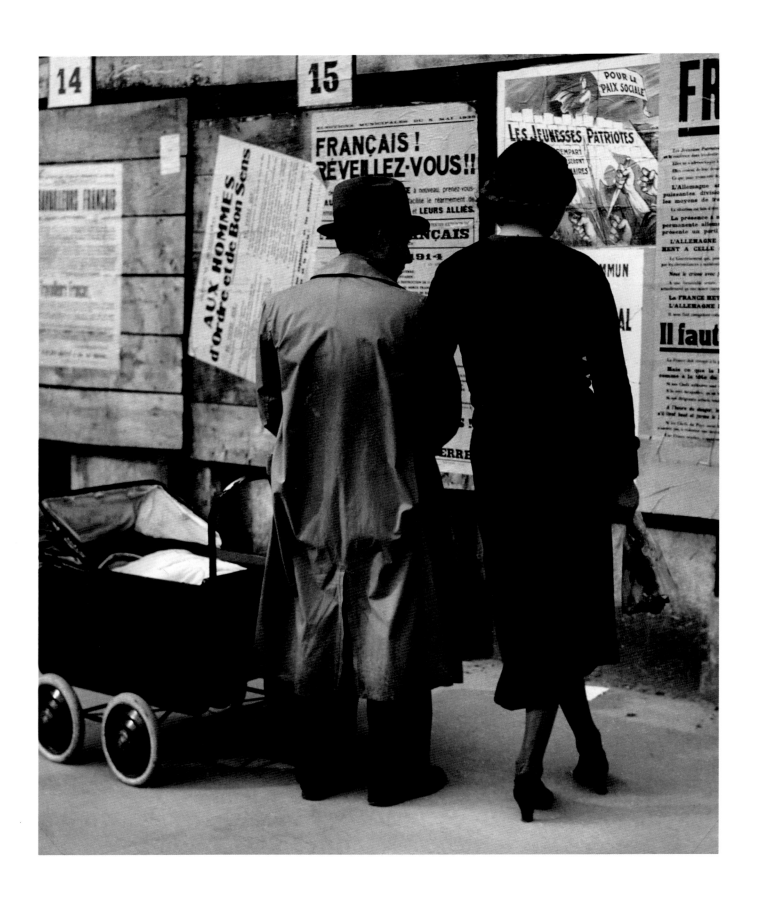

Frenchmen! Wake Up! Municipal Elections, May 1935

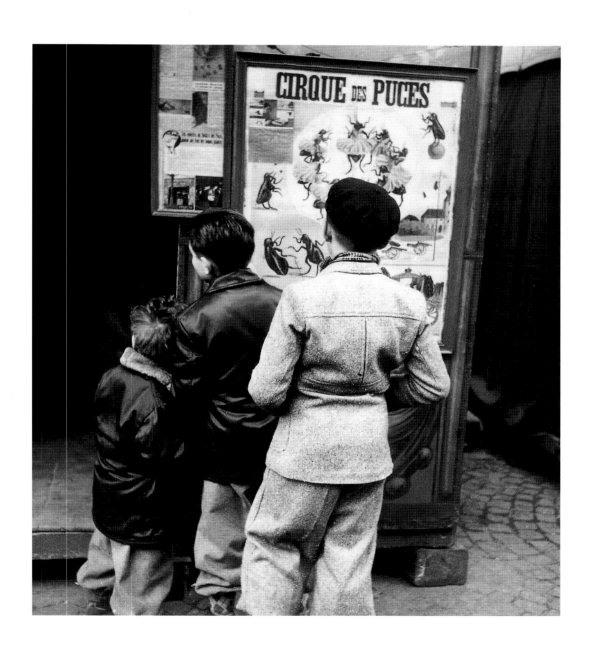

Flea Circus, undated

Parc Montsouris, the Strolling Photographer, 1930

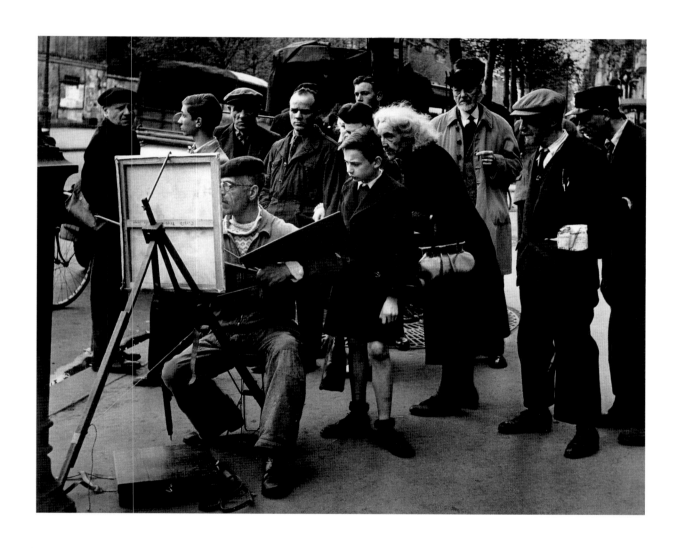

Wet Paint, 1946

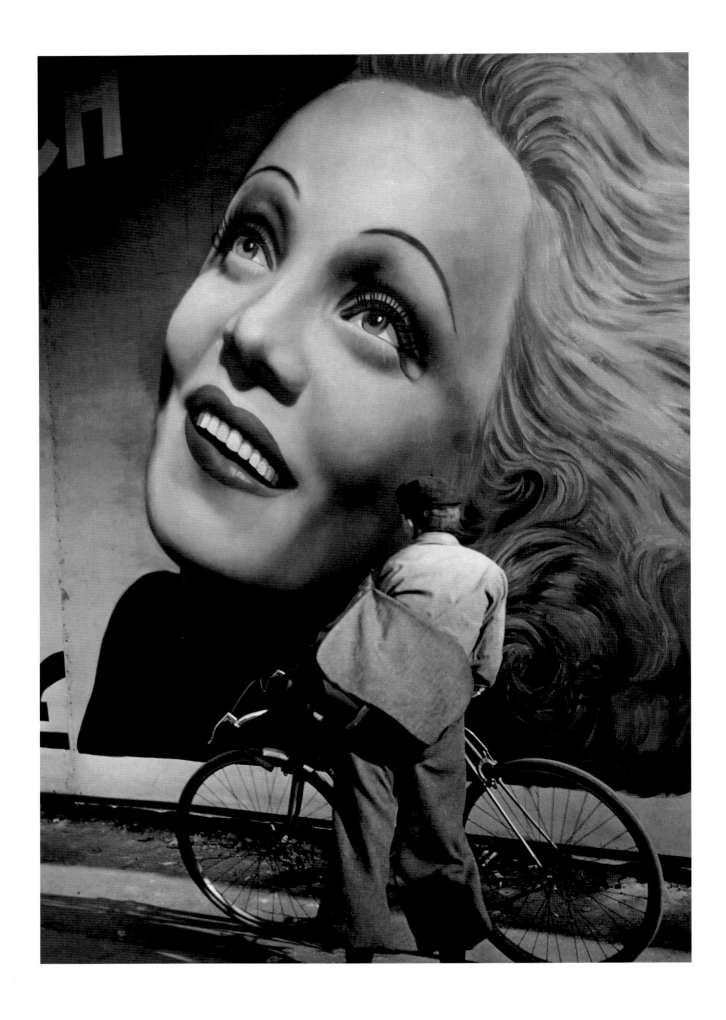

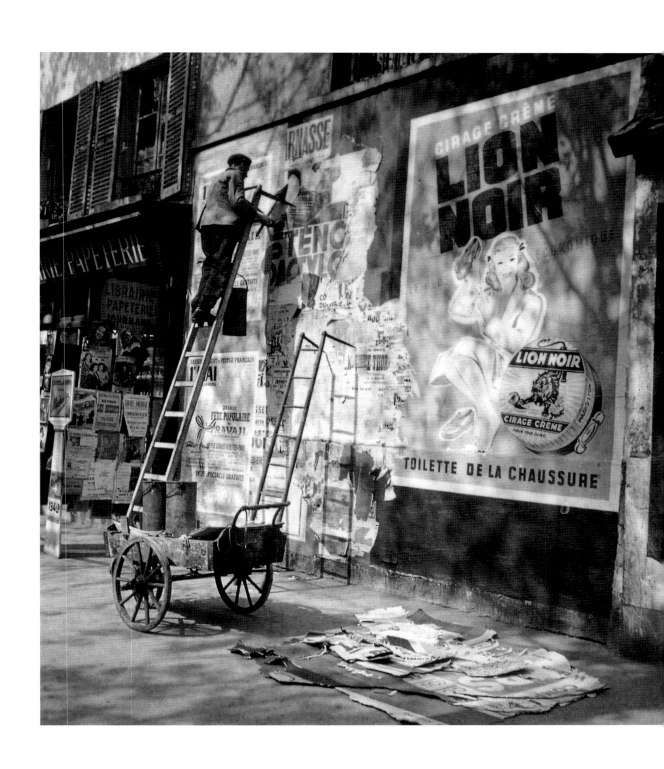

Marlene, 1937 *Billsticker,* 1948

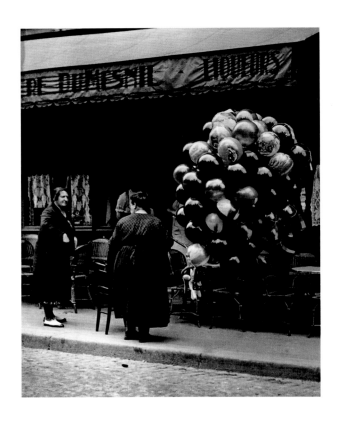

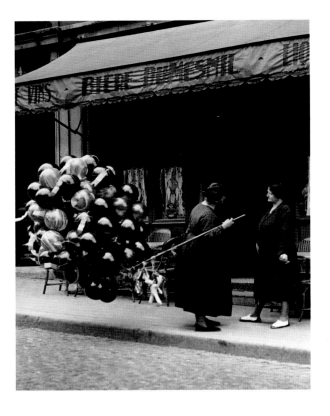

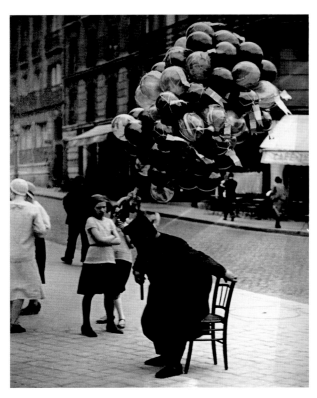

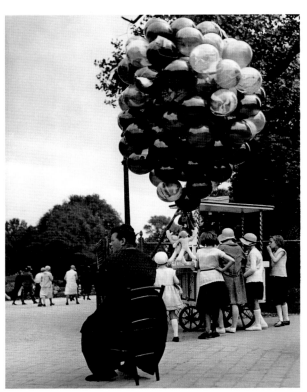

The Balloon Seller, 1931

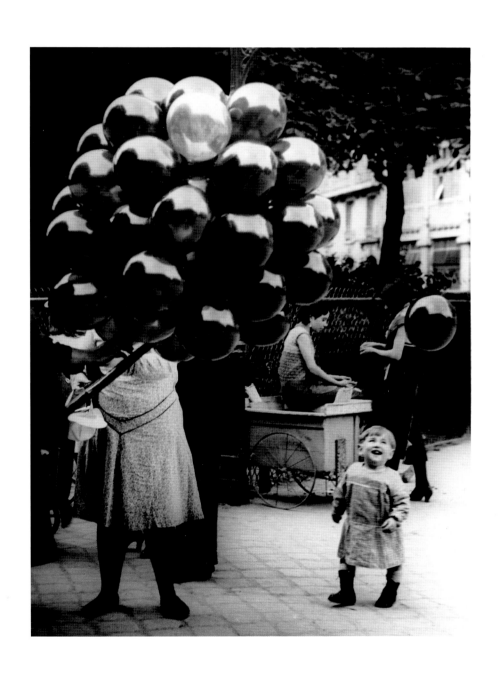

Picnic on the Banks of the Marne, c. 1936–37

Square Viviani, 1947

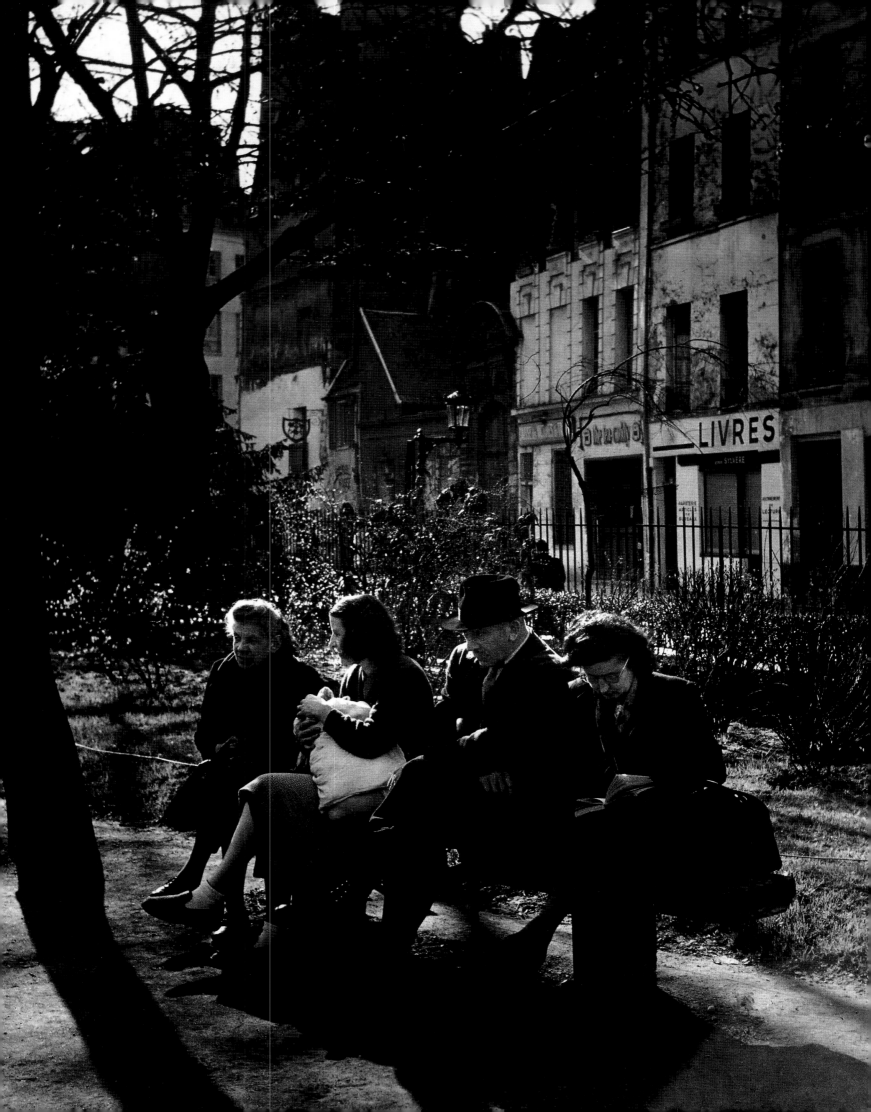

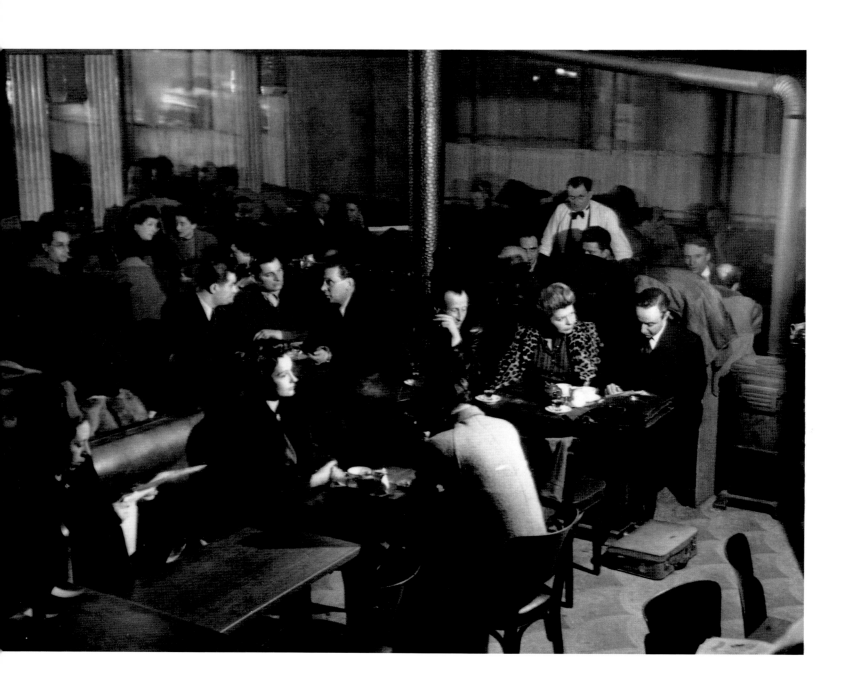

At the Café de Flore, 1944

Sartre, Café de Flore, 1944 *Simone de Beauvoir, Café de Flore*, 1944

The Café de Flore's Cat, 1944

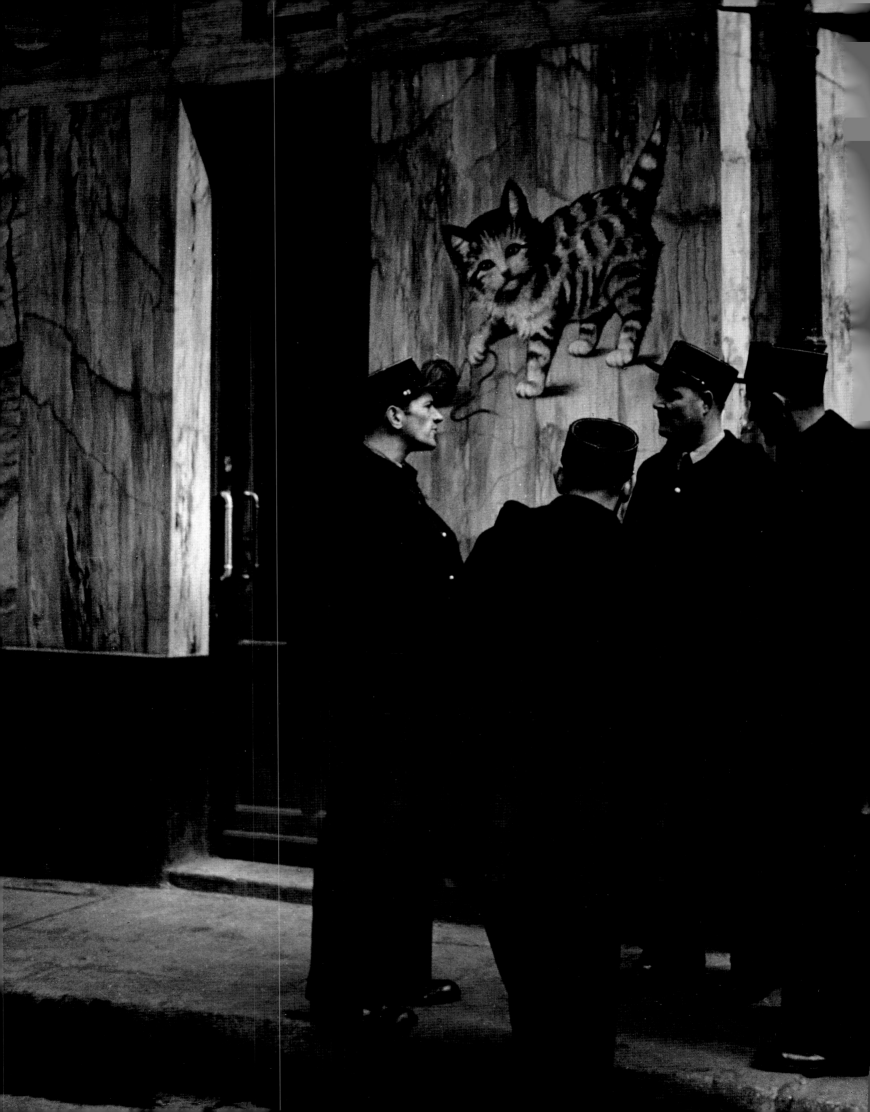

Conchita on Display in Front of the Booth of 'Her Majesty, Woman', Boulevard Auguste-Blanqui, c. 1931

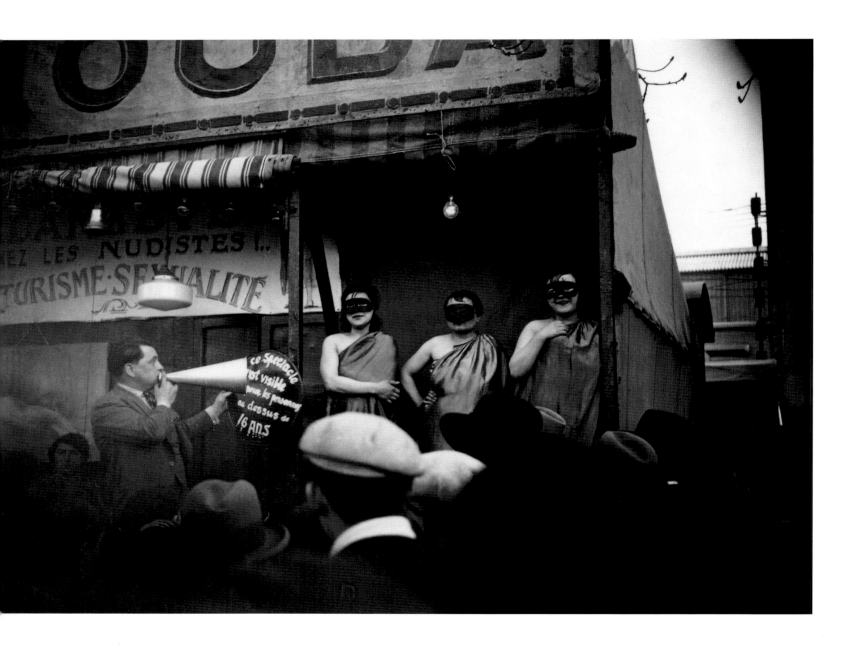

The Three Masked Women and Their Barker, Street Fair, c. 1931

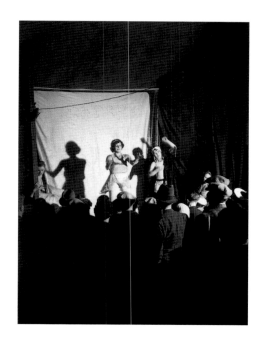
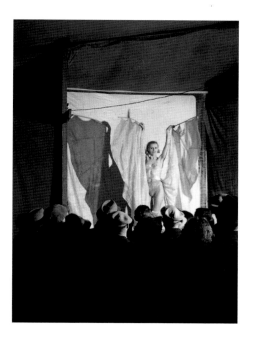

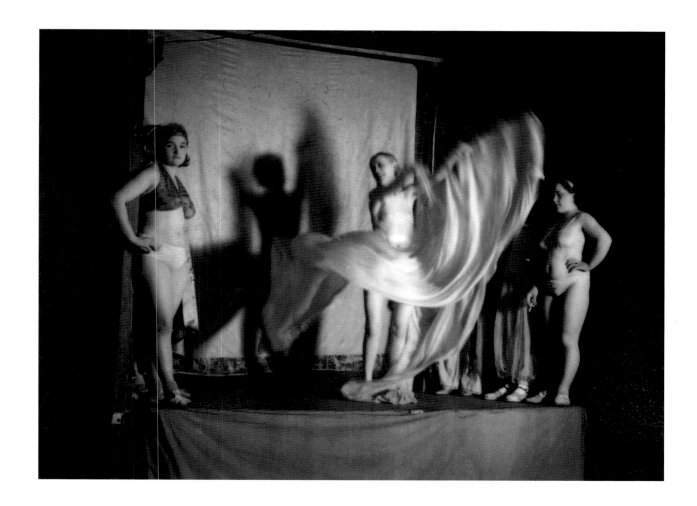

Conchita's Dance, Boulevard Auguste-Blanqui, c. 1931

The Wife of the Human Gorilla in her Loïe Fuller Dance, Place d'Italie, c. 1933

Fairground Boxer, c. 1930

Market Porter at Les Halles, 1939

Fruit and Vegetable Seller, c. 1932

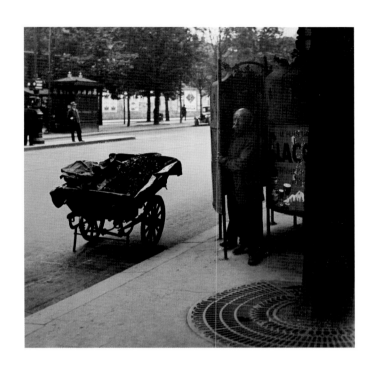
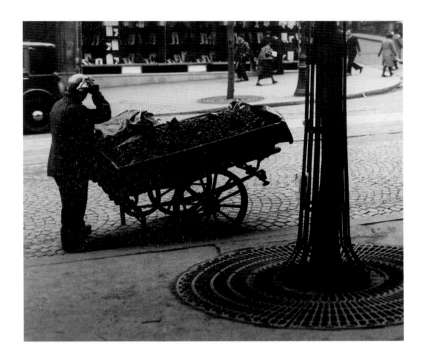

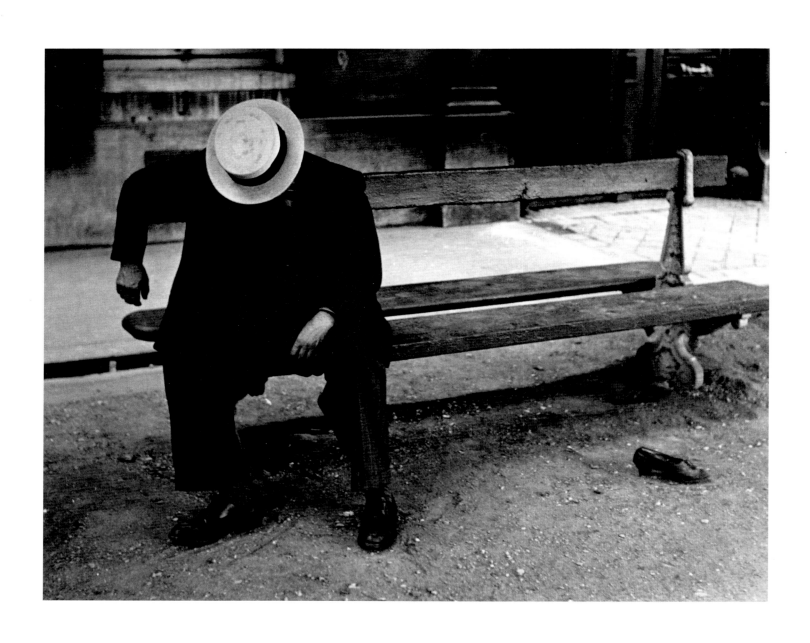

Sleeping Man Wearing a Boater, c. 1934

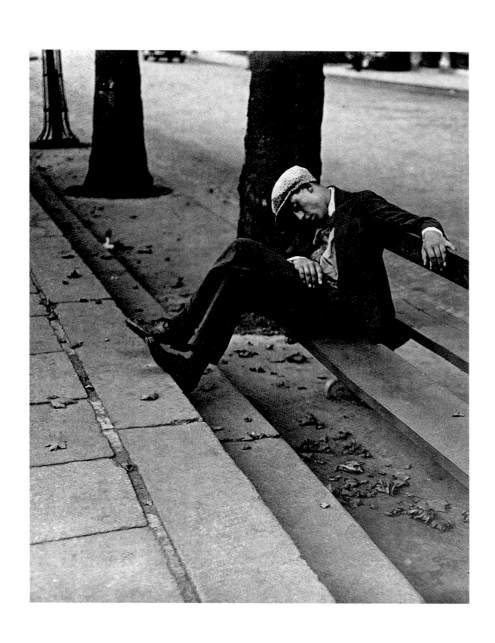

Sleeping Man, Montmartre, c. 1930–31

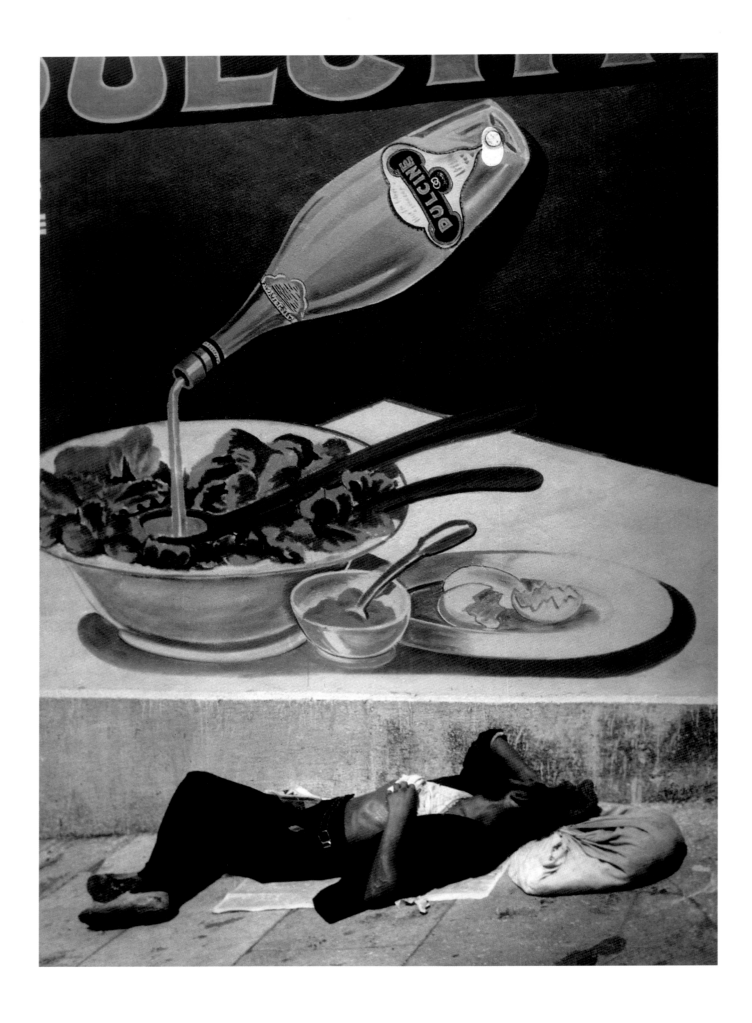

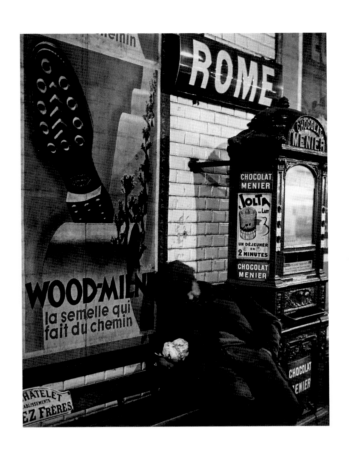

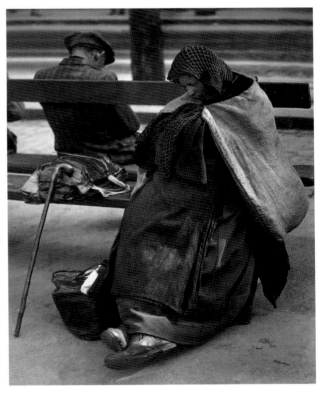

Rome Metro Station, c. 1933–34

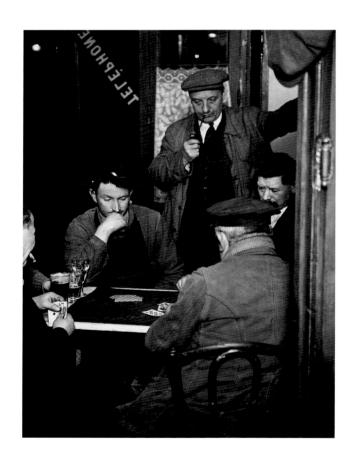

Belote Players, 1933

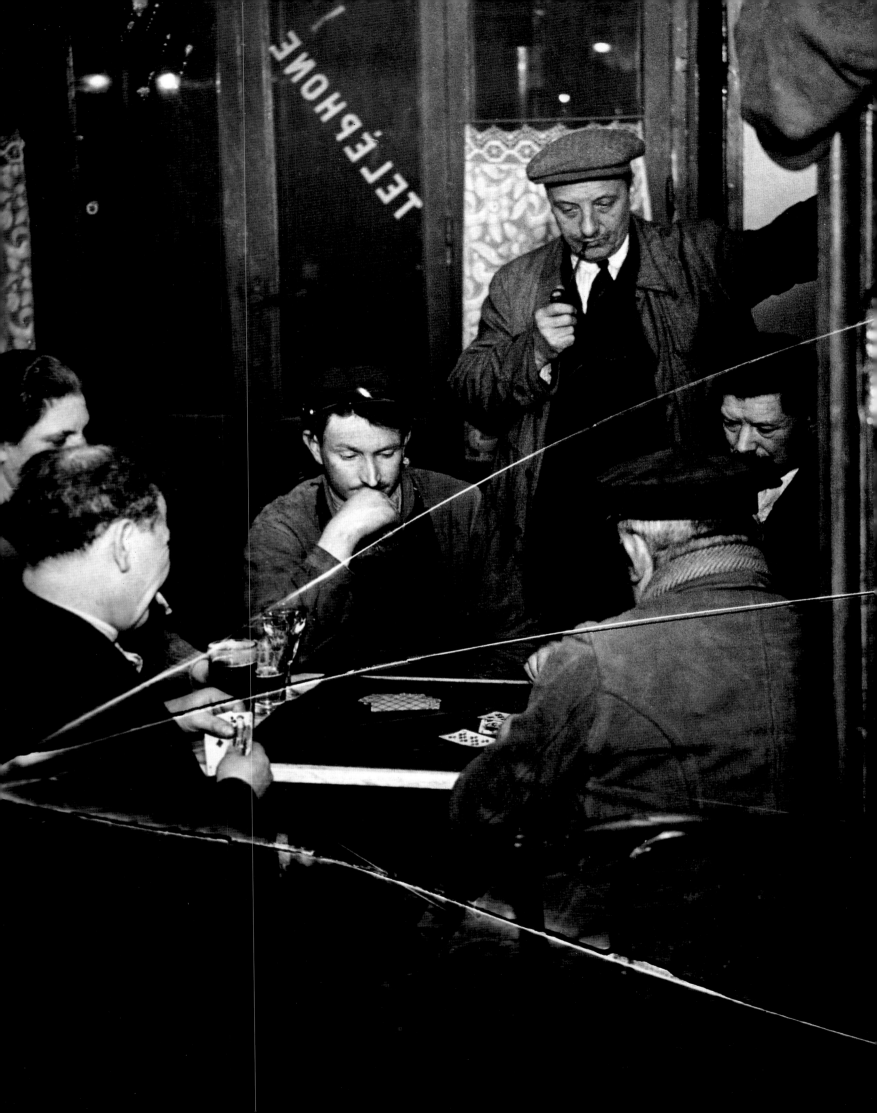

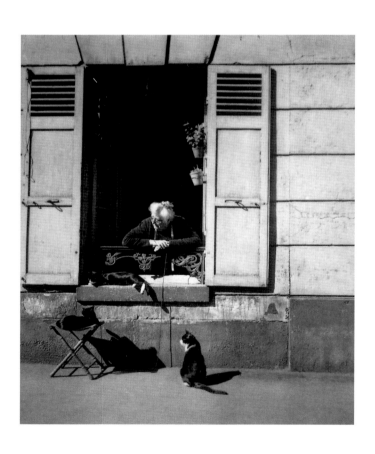

Concierge, 1946

Window, undated

Window, Grasse, 1947

Window with White Flowers, 1946

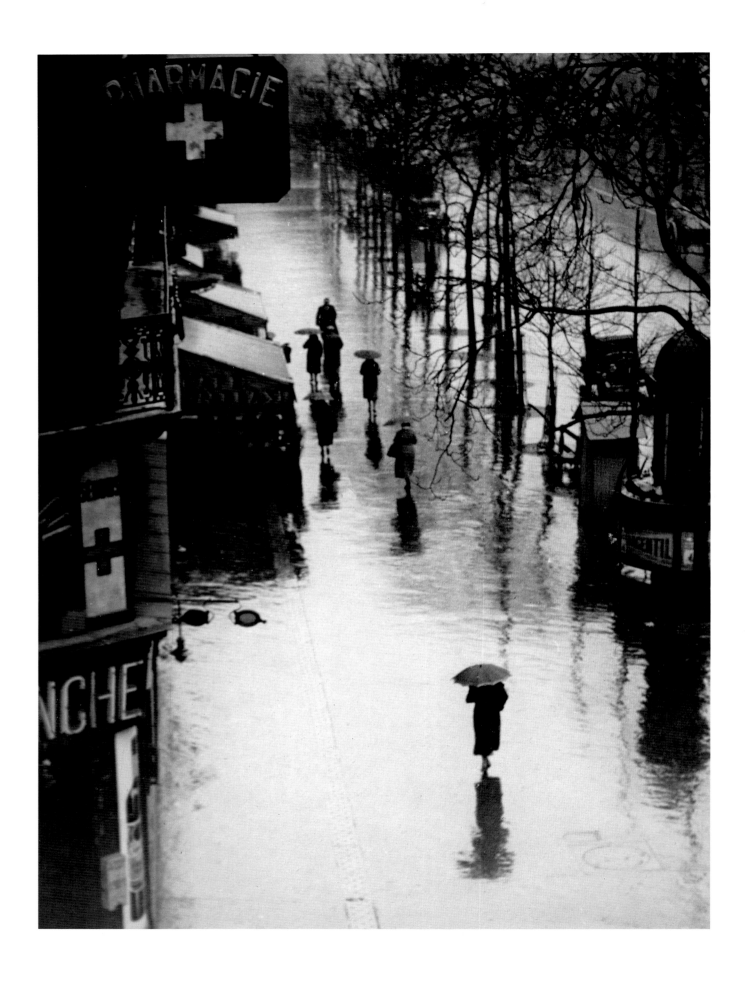

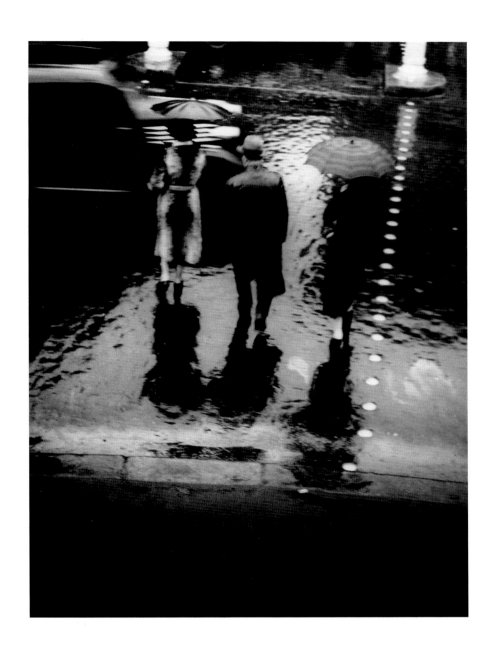

Walkers in the Rain, 1935 *Rue de Rivoli*, 1937

Walkers in the Rain, 1935

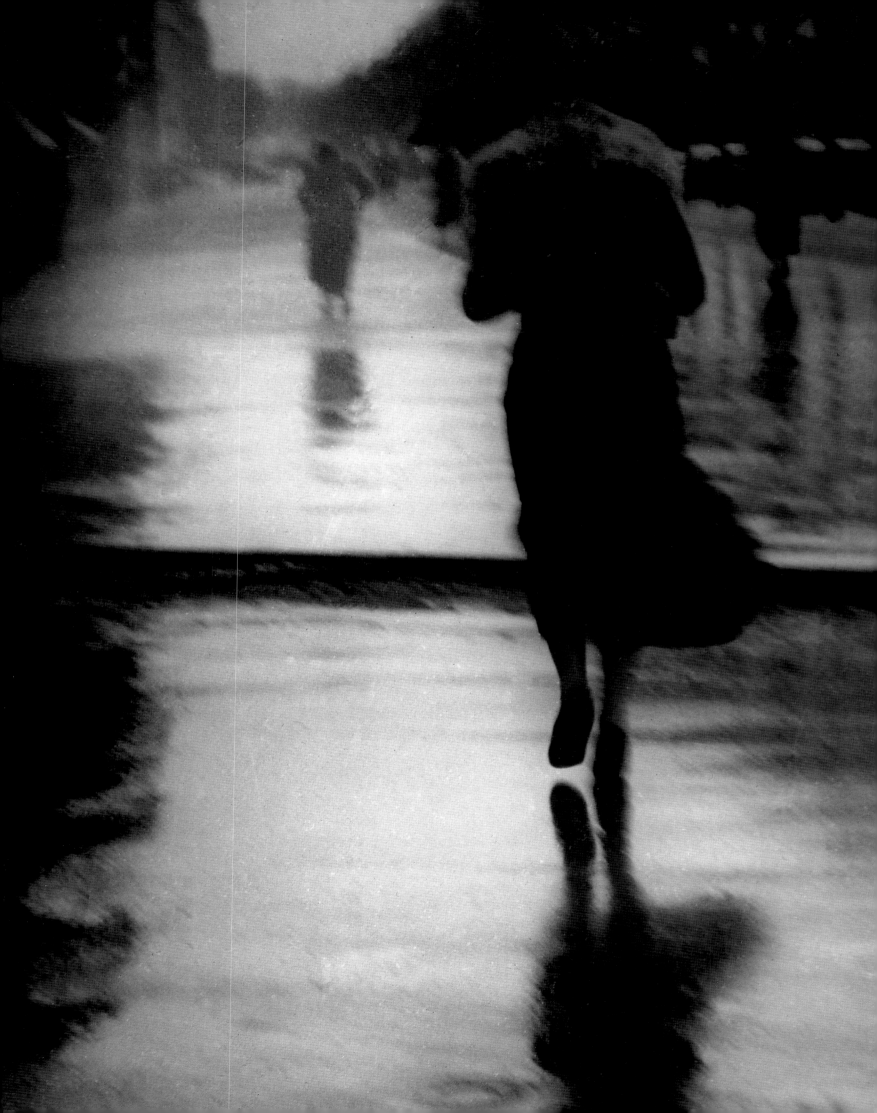

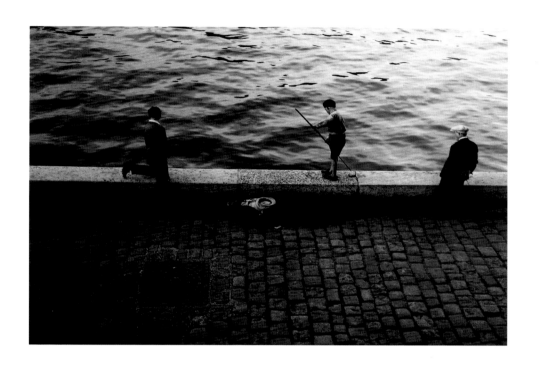

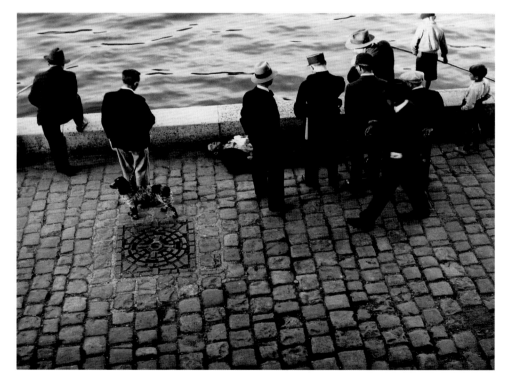

Dead Man on the Embankment, 1931

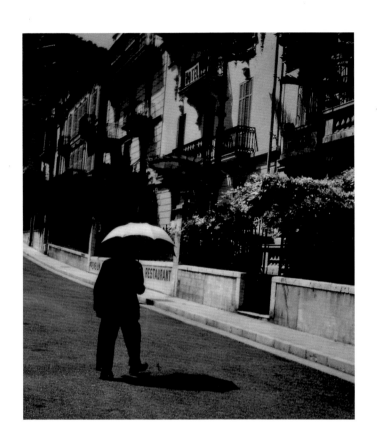 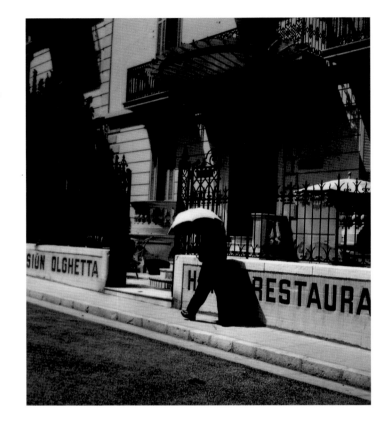

The Riviera, 1936

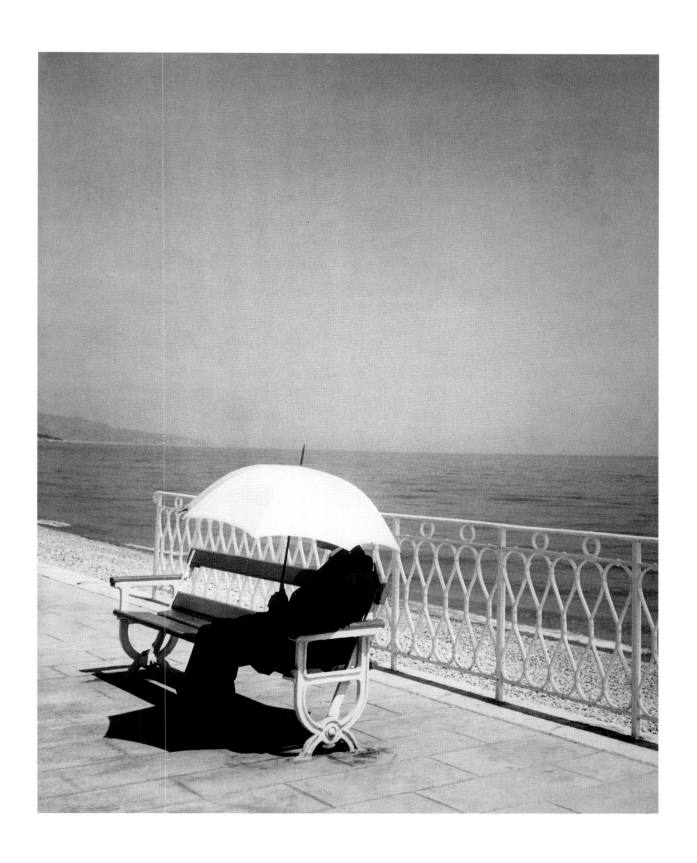

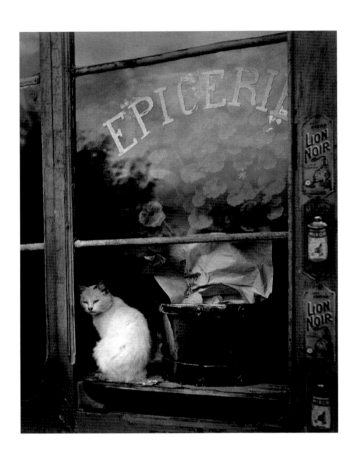

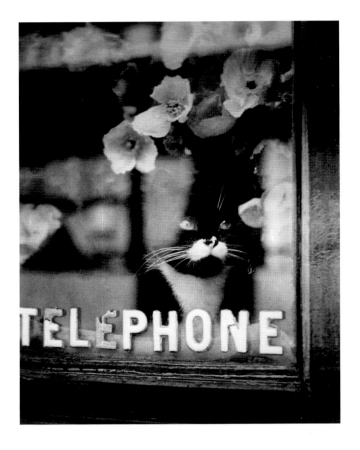

The White Cat and the 'Black Lion', c. 1938

Colette Cat, c. 1938

Stray Cat, 1946

The Black Cat on the Steps, *c.* 1945

The Kiss, c. 1935–37

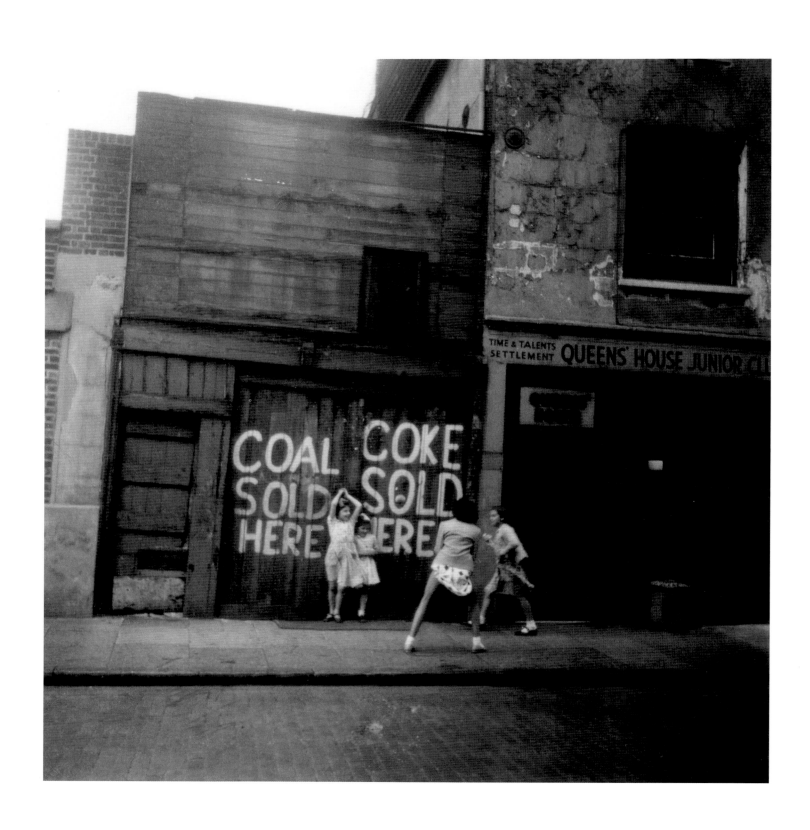

London, undated

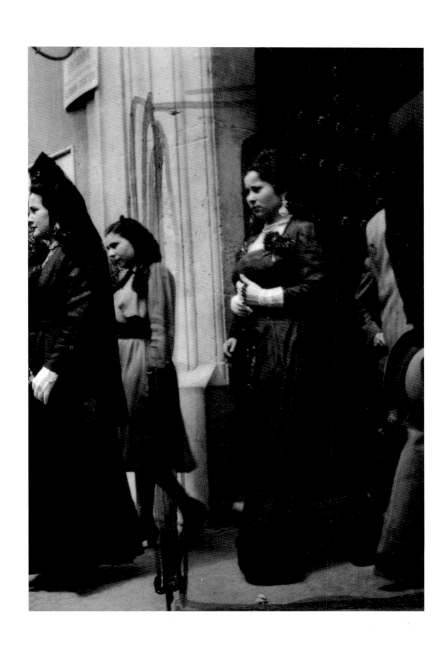

Maundy Thursday, Church of San Lorenzo, Seville, 1950

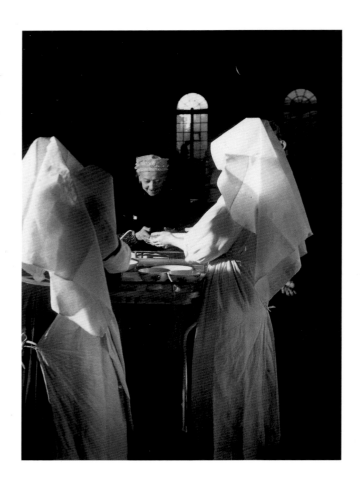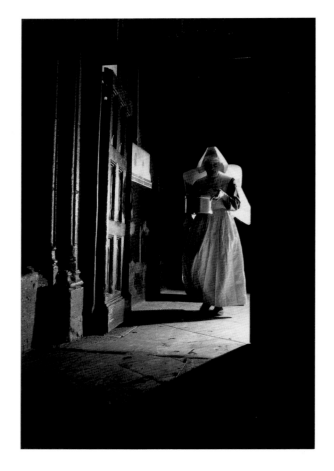

Hospices de Beaune, 1951

Hospices de Beaune, the Pharmacy, 1951

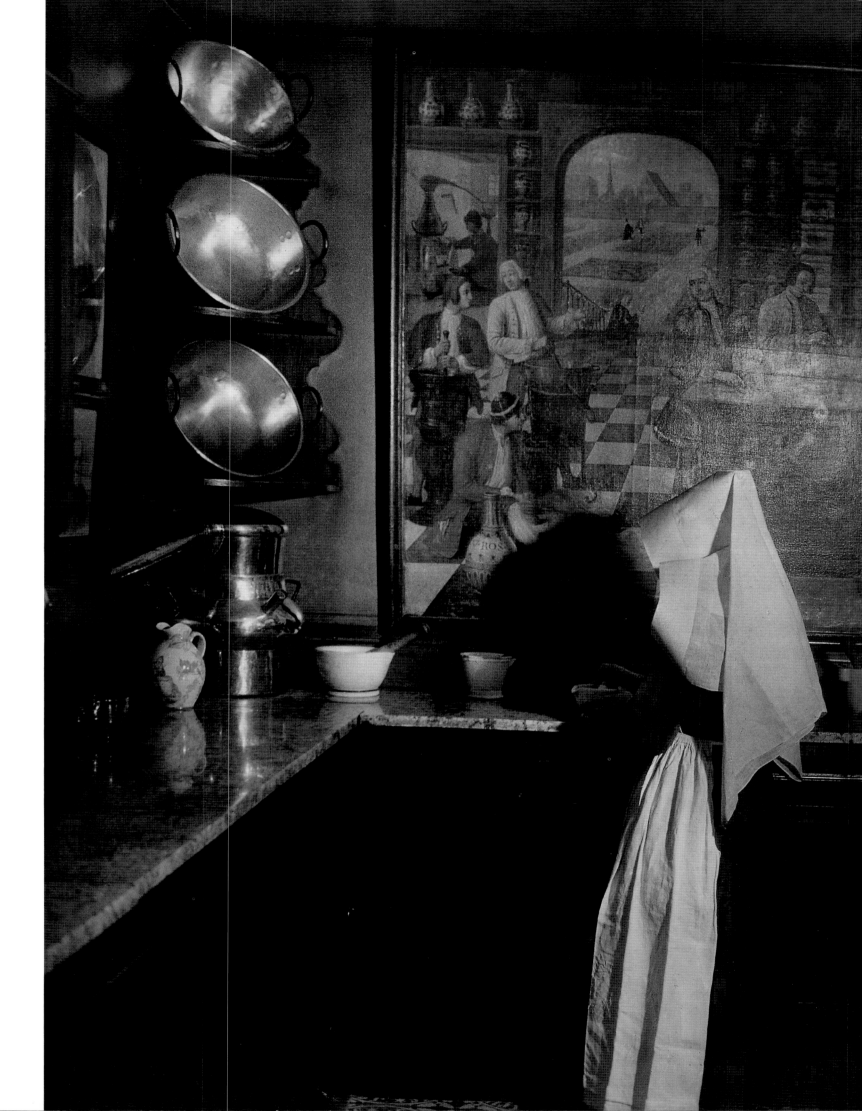

Preface to *Camera in Paris** Brassaï

It is legitimate for a man who has given the best part of his life to an occupation of absorbing interest, to seek to justify his activity and to relate it to some broader aspect of life, either in the present or in the past.

But the difficulty is to find a name for what he considers his vocation. For though many names describe it, none exactly fits. Seen with a camera in his hand, he is called a photographer. Yet he possesses no studio, nor does he deal with portraits, publicity, sport or fashion. He does not indulge in documentary or scientific photography. Nothing would horrify him more than to be taken for a professional photographer – a specialist. Does that mean that he's an amateur? No, for he execrates the dilettantism which, for lack of technical skill, is incapable of expressing ideas, of communicating them with form and authority. A reporter, then? Does he rush off to the scene of an accident or a crime? Is he always on the look-out for unusual, spicy details? Does he follow the travel of statesmen or the campaigns of generals? Does he go exploring or visit strange lands beyond the sea? Is he really anxious to witness and record the stupendous, the extraordinary? Why, no. He has the utmost distaste for 'news' and avoids it when possible. He dislikes travel and loathes sensationalism from the depths of his soul. The most thrilling event for him is daily life. But that is not to describe him as an illustrator, although his pictures do appear in albums and illustrated papers. But what do they illustrate? They do not at any event serve to adorn, explain or comment upon a text. They have captions, usually as clumsy as they are superfluous. It is rather a case of the text, reduced to its simplest expression, illustrating the photographs.

This man is sometimes said to hunt for pictures. But he hunts nothing at all. He is the quarry, rather, hunted by his pictures. Sometimes, flatteringly, they call him a poet. Then he gets frightened. Has he taken the wrong turning, he wonders? He has never looked at anything with an ulterior, poetic motive, and has always instinctively avoided what is usually known as poetry. Well, then, he must be an artist. An artist? He hates the very sound of the word when applied to photography. 'Artistic photographer'! Horrible! He is not the man to shut himself up in an ivory tower to play

with puzzle-pictures, or to chase after 'against-the-light' effects, luminous haloes or stream-lined nudes. Nor is he interested in view-points from awkward angles, dizzy bird's-eye views, or the world seen through the eye of a microscope. He has always shown a sovereign disdain for 'artistic' effect, for the 'pretty' or the 'picturesque'. He has never wasted his time with such childish amusements as super-impression, solarizations and other tricks, which, though legitimate from the technical point of view, are condemned utterly and absolutely by the rules of photographic art. He has never felt the itch to overstep the bounds, to ape the latest fads in painting, in order to prove that he, too, can invent, that he, too, has an imagination, and that photography, too, is Art (with a capital 'A').

Now this man, who yearned in vain for a name, a name that should correspond to his aim and his function, discovered to his great surprise a portrait of himself which was so faithful that he had no difficulty in recognizing himself in it. Strangely enough, it is a portrait of *Constantin Guys*, a draughtsman-chronicler of the Second Empire and the great Victorian era, and it was drawn by that great enemy of photography, *Charles Baudelaire*. This nameless man, then, attentively studied the features of this portrait, which explained himself to himself.

'I saw', says Baudelaire, 'that I was dealing not so much with an artist as with a man of the world. A man of the world is one who understands the world and its mysterious springs of action. An artist is a specialist, chained to his palette like a serf to the soil. This connoisseur of life, this collector of impressions, dislikes being called an artist. Is he not right to do so? His interest is the world at large; he wants to know, to understand, to appreciate everything that happens on the surface of our planet. The artist knows little or nothing of life; the man of the world is in spirit a citizen of the universe.'

But that is not all. Our friend was amazed by the delicate perception of the poet who saw in his universal curiosity the *fons et origo* of his calling.

'He will dash through a crowd of people to track down an unknown face, a glimpse of which has caught his imagination. For him curiosity has become an all-absorbing, irresistible passion.' He recognizes himself again in the convalescent 'who revels like a child in his ability to be intensely interested in things, even the most trivial

* Brassaï, *Camera in Paris*, The Focal Press, London, 1949.

in appearance'. 'The child', he says, 'sees everything as something new. He is always intoxicated. This deep and joyful curiosity explains the child's fixed gaze of animal extasy in the presence of something new, whatever its nature.' Baudelaire goes on to speak of the 'man-child' who, at every moment, has the genius of childhood, that is a genius 'for which no aspect of life has become stale'.

And how could he remain unmoved by these lines, in which the poet situates him in his real element, namely, the crowd?

'The Crowd is his element, as is air for the bird and water for the fish. His desire and his profession is to identify himself with the crowd. For the complete gaper, the hardened observer, it is a thing of sheer delight to take up his residence among the multitude, the swaying, moving, fugitive, infinite multitude. To be out, and yet to feel everywhere at home; to see the world, to be in the centre of the world – these are some of the lesser joys of those independent, passionate, objective spirits which language is too clumsy to define. The Looker-on is a prince, who, wherever he is, keeps his incognito.

'Thus this lover of life in the round plunges into the crowd as into the immense reservoir of electricity. We might compare him also to a mirror, as vast as the crowd itself; or to a conscious kaleidoscope which, at every movement, reflects all the multiple facets and the ever-changing beauty of every element of life.'

It is no accident that this man, whose function words express so inadequately, this man with a camera, was able to recognize himself so clearly in the portrait of a man armed with a pencil, or that his secret aspirations were found to have so much in common with those of *Constantin Guys* – this 'universal man'. Here we are on the trail of a genealogy reaching back far into the past; a trail which this man, with the desire of knowing more about his own vocation, will follow hotly. He will find that he is exploring a great family of minds, the members of which, all intent on reality, breathe it in, probe it with eyes and hands. These are the men who, from time to time, awaken painting from the torpor of convention by administering to it a whiff of fresh air from the street. A secret demon drives them on to take hold of life wherever it can be found, to snatch the fleeting image of their time. Nature for them is not merely a pretext for expressing their dreams or for making works of art; their whole curiosity is turned towards the myriad facets of human existence. With *Goethe* they consider 'the world more fraught with genius than themselves'.

Consider *Rembrandt*, the ancestor of all us reporters of life. We do not see him scouring the universe or shutting himself up in his studio. From the surroundings of Amsterdam he gathers his humble subjects, his every-day scenes: old men and wealthy merchants, long-bearded rabbis and peasants. He visits the populous quarters of the town, markets and taverns, all teeming with life. He notes the pancake seller busy with his frying-pan and the urchins standing round attracted by the smell, a woman sewing by the fire, a man drinking and tipping back his chair. He stops and gazes in wonder at a newly-flayed ox, hanging by its legs from the beams of the butcher's shop. He watches the beggar hobbling along the high-road. His whole output is based upon a few thousand subjects – one might almost say snapshots – captured on the spot and collected with all the loving curiosity of a man who never ceased to wonder at and to glory in every aspect of this strange phenomenon of life.

Or consider *Goya*. He, too, loves the street with its crowded life, beggars, townsmen, labourers, workers. He watches them and sketches them at their ordinary daily tasks. He does not forget the hunchback, the halt and the blind, the idiot or the prostitute. With the same calm intensity he notes the outdoor games, picnics on the river bank, the harvest, the fair-ground, the lunatic asylum, the execution, the disembowelled picador or the horrors of war. 'Yo lo vi' he writes beneath a certain engraving – I saw it. His whole work lives, even his nightmares served to swell the rich hoard of pictures stored up ready for use in his memory. *Goya* saw with his own eyes every side of life; he was the eye-witness of his time. He painted the society of his day at every level.

Or again, let us take *Daumier*. *Daumier* too comes to us from the streets. It was his observant strolls through the streets of Paris that opened his eyes to the world. All his art is the art of 'things seen'. In the heyday of the Romantic movement, when the artists were all absorbed in their own souls, *Daumier* alone plunged headlong into life. What did he draw? Street scenes – Parisian types: laundresses and small shopkeepers, picture fanciers, lawyers and magistrates, citizens and their wives, actors and the theatre world. Like *Goya*, he seized the reality of every day so intensely that he achieved fantasy at one bound.

It is impossible here not to recall *Hokusai*, that vivid observer of every living manifestation, of every organic activity; a man who was literally intoxicated by the spectacle of life and by the multiplicity of its forms. In a self-portrait which he has left us, the 'old man, mad with drawing' portrays himself with a paintbrush between his

teeth, one held in each hand and by both feet, frenziedly attempting to express his emotion in the presence of living forms. Never has the world of phenomena, the fleeting passage of things and living creatures been observed with such clear vision or translated so concisely in terms of art. He, too, was the faithful Chronicler of his time. And what do we find in his vast collection of engravings and the famous *Mangwas*, the fourteen volumes of snapshots, and the stenography of the yellow books, containing riches as vast as those of the universe whose truthful mirror he wished them to be? Women and children, interiors and outdoor scenes, living landscapes, everything that the street, the daily occupations of the people, their festivals, the changing scenes, the wealth of animal and plant life can give; a thousand faces sketched with lightning strokes, the fat and the lean, wrestlers and acrobats, every trade, every occupation of social life, every inanimate object associated with human life and assuming by virtue of the fact, character and personality.

And what of *Degas*, so near to *Hokusai* and to ourselves, classified against his wish among the Impressionists; what was his ambition? To 'dip his pencil into the sap of life' – to tap reality at its unsullied source. He, too, thanks to his way of looking at the world and the sincerity of his expression, is a remarkable painter of his own times. He observes and notes, more or less successfully, laundresses, jockeys, members of the orchestra, music-hall artistes, girls drinking on the café terrace and, above all, dancers and women at their toilet.

Toulouse-Lautrec is the last of the great artist-chroniclers. What are his favourite haunts? Why, the characteristic haunts of Paris: the theatres on the boulevards, cabarets, the *Moulin Rouge Palais de Danse*, the Opera, the circus, the cycle-racing track, the race-course, the Courts of Justice and the brothels. His curiosity even takes him to *Dr. Pean's* operating theatre, just as *Rembrandt's* had led him to *Dr. Tulp's* post-mortem room. Like all the other members of his family of artists, *Lautrec* throws himself body and soul into life, filled with admiration for its spectacle. He is always watching, noting, sketching features and outlines of this intensely living world, the human being, his face, his gestures, clothes, customs and eccentricities. His work is a mirror reflecting the pleasures of Paris during the last two decades of the 19th century and is a rich treasure-house of human documents, constantly added to by an acutely observant recording pencil.

And now *Constantin Guys* himself. What of this 'painter of modern life'? He, too, recorded the life of his time in all its aspects. And what made this self-taught artist take up his pencil was not some artistic urge, but a passion for the extravaganzas presented by a society which abounded in contrasts. As with *Daumier*, the only teachers of *Guys* were the sights of the streets. As first it was London that held him, not only by its dashing carriages, its elegant aristocrats, its gentry; but also by its slums, its haunts of vice and crime, which had already provided so many subjects for *Gavarni*. Paris attracted him with the luxury of the Second Empire, its horses and fine carriages, its popular dancing halls and Court levees, the boxes at the Opera, filled with pretty women; so, too, did the venal love, the soldiers and hooligans of the slums. But what is especially interesting for us in *Constantin Guys* is not so much his sometimes affected drawings, as the fact that his work constituted to some extent the first important eye-witness reporting in the modern sense. It was as a topical artist or artist-reporter that he was known in London towards 1845, and, as is well-known, he joined the staff of *Punch* and the *Illustrated London News*, of which latter journal he would appear to have been one of the founders. He was engaged as a war-correspondent in the Crimea as well as in Spain and at Constantinople.

In his portrait of *Constantin Guys, Baudelaire* was in fact anticipating by a century the psychology and physiognomy of the chronicler of the modern age – the photographer. To recognize oneself in a portrait of that kind, and to claim as ancestors such illustrious names as *Toulouse-Lautrec, Degas, Guys, Daumier, Goya, Hokusai* and *Rembrandt*, is, I realize, presumptuous and will appear to many people as a sign of mild megalomania. It would, indeed, be ridiculous to put on the same level the drawings of these great artists and the pictures of modern photographers. Is it, in any case, possible to compare works of such different modes of expression? It is a matter of recognizing that the function of photography and of cinematography, like that of the other graphic arts, is to fix the most fleeting aspects of life – its moments and its movement. To relate these modern activities with the high tradition of the great draughtsmen, is to suggest that they go to work in the same spirit and that they deal with an aspect of reality which belongs to them by right. For by playing their part in modern life, in filling vast libraries with innumerable living documents, the cinema and photography are speaking their own language and giving expression to the true twentieth century style. These constant changes in forms of expression – and the history of art is full of them – spring from one of the most fundamental needs of nature, or rather of culture of which

we may say, as *Shakespeare* said of *Cleopatra*, that:

> Age cannot wither her, nor custom stale
> Her infinite variety.

In short, culture, like a pretty woman, must be always in the fashion. So, it is not enough for the artist of to-day to express the meaning of our age; he must express it in the modern medium. Our generation can only recognize itself completely in images expressed in the new languages of our century. Hence the power and prestige of the cinema and of photography. The great respect in which oil-painting is held, for example, is due to its former glory and not to the part it plays in modern life.

Ever since the reign of the great masters, the field of actuality has remained vacant. Painters have deserted this domain which, in the days of *Toulouse-Lautrec*, was still the preserve of the creative artist. Whether they like it or not, the painters of modern life are the photographers and the cinematographers. Since they possess the real power, it matters little whether they are considered to be 'artists' or as mere operators of picture-machines. On the other hand, it is essential — and this is our main contention in these pages — for the photographer to understand the nature of the part he has to play, the nature, in fact, of his high mission. He must be fully aware of the overwhelming legacy which has fallen to him and of the heavy burden he must shoulder in our age. With the film-man, the photographer is the only survivor, the sole inheritor of that great family of artists of which we have spoken. Nor is it illegitimate to trace his ancestry back, not to *Daguerre*, *Niepce* or *Talbot*, not to the great Renaissance painters who dreamed of photography, but to those enthusiasts of everyday life, such as *Lautrec, Goya, Hokusai* and *Rembrandt*.

Rembrandt was the first of the great masters in the West for whom drawing was not merely the preliminary stage for a picture, or the sketch for a painting, but something existing in its own right, a new art-form, final and independent. *Rembrandt* is the first *modern* artist who, obsessed by every aspect of the human condition, intoxicated by the ever-new drama of life, invented an entirely new instrument, designed to capture life closer to its source than was possible by the traditional artistic medium, to preserve it from fossilization and retain its warmth for ever. *Rembrandt's* cursive style, the veritable shorthand of his drawings, is the first instrument designed for the purpose of seizing the fleeting moment. It was the birth of the snapshot two hundred years before the invention of photography. *Rembrandt* notes the things he sees, as soon as he sees them, before they change or

he himself changes. He 'takes' his views; he makes a simultaneous recording of his visual impressions. In order to reduce to a minimum the time between the view and its fixation, *Rembrandt* is obliged to snare his royal prey with one sweep of his arm and to confine it in a net formed of a few bold strokes. And because, in the excitement of seeing, every superfluous detail would be a waste of time, he is obliged not only to seize the impression quickly, but to reduce it to its bare essentials, extracting from it just that significant detail which indicates and suggests human beings and inanimate objects. This is no limit to the boldness, the vigour, the incisiveness, the swift precision of his strokes. This explains why even his smallest drawings are vibrant with life, often surpassing his finished pictures in perfection of style and beauty.

I have spoken here of *Rembrandt*, for he is the ancestor, the forerunner, the prototype; but the same considerations apply to all his great rivals, those undisputed masters of the 'snapshot' who revel in the living subject. It is clear that they all find pleasure in watching the spectacle of the world, in jotting down in their notebooks the allurements of daily life. The implements they use for capturing their prey are the pencil, the pen, the charcoal, or the split bamboo dipped in walnut stain or Indian ink. Is there really an unbridgeable gap between these instruments and the camera shutter, invented for the same purpose, to satisfy the same need? When *Delacroix* claims that the artist should be skilful enough 'to make a sketch of a man jumping from a window in the time it takes him to fall from the fourth floor to the ground', he is in effect calling for a camera with a shutter-speed of one thousandth of a second. And the man who used to wander among the city crowds with his bottle of walnut-stain in his belt and his sketching-pad in his hand, ready to pounce at any moment on an item which caught his eye, is the image of the man who will later be known, for want of a better word, as the reporter, the picture sleuth, the observer, the news-gatherer, the illustrator, and so on and so forth.

A thousand strands attach this man to the family of the great draughtsmen: his respect for his subject, amounting almost to religious veneration; the keenness of his powers of observation; his patience and hawk-like speed in swooping on his prey; his impulsiveness; his preference for the human race and his indifference to mere 'nature'; his love of the transient; his sense of the magic beneath the surface of reality; his spurning of colour and the enjoyment he derives from the restraint and sobriety of black upon white; and, finally, his desire to get beyond the anecdotal

and to promote his subjects to the dignity of types. The photographer of this kind, who depicts the variety of human existence in the light of common day, interpreting the dominant traits of the living creature, the character of its surroundings or the intrinsic life of the group, is, therefore, accomplishing a task handed down to him by the great draughtsmen of the past and disdained by the artists of to-day. He has taken his camera in his hand because he has discovered and plunged into the heart of the life around him. He too culls the ephemeral beauty of the present moment. He too converts his chance encounters into lasting pictures. He too gives a semblance of durability to the brief moments captured in the flight of time. Like his great ancestors he is an implacable spectator, an impartial witness and a faithful chronicler.

The countless pictures which, by dint of patience, ruse or diplomacy, he has stolen or extorted from time, are a living record. But they are more than that; they are moments of his own existence entered day by day in the pages of his log. They say not only: 'Such or such a thing happened', but also 'I was there', 'I saw this thing', or even 'I was this thing'. For something very strange has happened to him: the more scrupulously he has respected the independence and autonomy of his subject, and the closer has he gone towards it instead of bringing it nearer to himself, the more completely has his own personality become incorporated in his pictures. They betray his presence by a tone, a light, a familiar twist which it would be difficult to define. And by restoring to nature the multitude of subjects of which he had plundered her, it seems as though he had given away part of his own personality – the best of himself – as if man were never so entirely himself as when he forgets himself completely and merges his individuality with the sum total of things in the universe.

Untitled (in *Anthologie de la poésie naturelle*, 1949)

Interview with Gilberte Brassaï

Conducted by Annick Lionel-Marie

ALM: *Brassaï's real name was Gyula Halász. He took his pseudonym from the town of Brassó in Transylvania, where he was born, yet he never went back to Hungary. How do you explain that?*

GB: That's quite right; although his parents on several occasions came to visit him in France, Brassaï himself never went back to Transylvania. The Hungarians and the Romanians both claimed him as their own, and he was often asked, sent official invitations, but he always turned them down. His refusal had a lot to do with his desire to preserve his memories of childhood and growing up, and with the fear of being disappointed. On top of that, he hated formal ceremonies and banquets; he would have preferred to travel incognito. And he was frightened of the regime that was in power, of not being able – who knows? – to return to France.

Although he disliked any kind of bureaucracy, Brassaï took out French citizenship after the war, in 1949, and regarded himself as one hundred per cent French. Although, in 1976, he wrote to a Zurich friend, the collector Georges Bloch, whom he had got to know through Picasso and who had a house in Saint-Moritz: 'I was sad not to be able to come and visit you up there on the mountainside. I was born in the Carpathians; mountains and altitude are where I feel at home (much more so than by the sea), and I still feel nostalgic for fir trees, larches, rhododendrons, edelweiss and gentians. It is my only "Heimweh" [homesickness].'

ALM: *You met Brassaï in 1945. Who were his friends at that time?*

GB: Brassaï liked to be surrounded by young people, and friends of mine like Roger Grenier were given a warm welcome. Brassaï had a gift for improvisation when he was with a group of people – he was a raconteur. Always generous with his time, he was also quite happy to spend the whole afternoon talking to a young photographer or writer. We often used to meet up at the Dôme or the Coupole, the Closerie des Lilas, somewhere in Saint-Germain-des-Prés....

There was Vincent Korda, a very good painter

before he got involved with his brother Alexander's films. Lawrence Durrell, a friendly and amusing man, Hans Reichel, William Hayter, Alexander Calder, Joan Miró, Frank Dobo, János Reismann the photographer, Marcel Duhamel and all of 'Prévert's gang', sometimes Henry Miller and his young wife Eva, and Stefan Lorant, who started *Lilliput* and *Picture Post*....

But Brassaï remained very much within his own narrow little world. I encouraged him to travel; and in particular to go to the United States. He was shy because he didn't speak English. On our first visit, in 1957, we went for several months, including a stay of several weeks in Louisiana.... Brassaï was bowled over by his first glimpse of the United States; he used to say: 'In America I see everything in colour.' That first trip gave him a taste for travelling. Later, he used to travel for *Harper's Bazaar.*

ALM: *Is it true that one of the first things you discovered about Brassaï was that he was a collector?*

GB: When we first met, Brassaï liked nothing better than to show me all the wonderful things in his collection of small skeletons – chickens, newts, tiny skulls – he used to enthuse to me about their sophisticated articulations and mechanisms, the delicate way they were put together.... There was also the mineral world of crystals and pebbles and other objects that appealed to him, such as wooden sculptures discovered in second-hand shops and folk paintings like 'The Big Hand', a sign for a clairvoyant painted by a stallholder at a fair, which Brassaï thought quite as good as any primitive painting; old-fashioned flat-irons, which he later used to 'iron' his pictures; models of hands used by glove-makers, hat blocks, votive images ... and even a Saint Sebastian, a stone sculpture he bought in Boulogne. He replaced the arrows with Gauloises cigarettes.

Of course, all that was very much on a par with his interest in works like those by Facteur Cheval, and the sculptures in the park of the Villa Orsini at Bomarzo in Italy ... and primitive art in general.

ALM: *Speaking of which, there is one book Brassaï must have been happy to play a part in, and that is the* Anthologie de

la poésie naturelle *by Camille Bryen and Alain Gheerbrandt (Editions Kra, Paris, 1949). 'Natural poetry': 'torn posters in the streets, stones that look like human faces, popular songs that turn into weird chants when people forget the words … poets who have no truck with our language's insistence on tenses, or its ridiculous spelling, children's conversations, mediums' tricks, windows broken in curious shapes….' [p. 167], isn't that one of Brassaï's favourite themes?*

GB: Alain Gheerbrandt, the explorer, and Camille Bryen found they had a lot in common with Brassaï's work on alternative art forms and Art Brut, and often used to come and discuss it with Brassaï – as did Dubuffet, incidentally.

Art Brut and primitive art always fascinated Brassaï. They were the inspiration for his study of graffiti, which he worked on for more than thirty years, and which I helped with too. It was an obsession. The graffiti were very different in different countries. We found some in Morocco and Turkey, in English prisons…. Miró, Braque, Picasso, they all admired them…. Braque asked Brassaï for a photograph of a fish graffito. It was a motif he used a lot.

ALM: *Let's go back to* Harper's Bazaar. *Brassaï began working for the magazine in 1937, and continued to do so for more than thirty years. It seems, from looking through your archives, that there was a very warm relationship between Brassaï and Carmel Snow, who was editor-in-chief of* Harper's Bazaar *(there are a number of telegrams on the lines of this one, dated 15 August 1954: 'Brodovitch and I think Brassaï's photographs of Majorca really marvellous…. the most exciting photographs we have received in a long time.') We also see that they picked up on your idea of making a series to be featured in the magazine, and Carmel Snow wanted you to accompany Brassaï?*

GB: The collaboration with Carmel Snow was extremely fruitful; she was an enthusiastic and generous woman. Also, there was a lot of freedom at this time because Brassaï could suggest his own subjects.

ALM: *It is not widely known that, in 1951, Brassaï did mock-ups of 'photographic' fabrics for haute couture, based on Paris paving stones, metro tiles, dewdrops and butterfly wings?*

GB: Madame Brossin de Méré, a Swiss woman of Slav origin, used to design fabrics for haute couture – Christian Dior, Balenciaga and Hubert de Givenchy among others…. These fabrics and embroideries were usually manufactured in Switzerland and printed in Como in Italy, in the subtlest of dyes. She approached a number of artists, telling Brassaï, for example: 'Monsieur Dior told me he saw some butterflies swooping over a sunlit cornfield in high summer. How would you interpret that for a fabric?' So Brassaï amused himself for a few weeks doing photographic mock-ups based, for example, on enlargements of butterfly wings, which were then executed in a range of different colours on pleated silk. The simultaneous appearance on the podium of six models pirouetting in iridescent colours was magical. It was Madame Brossin de Méré's mother, herself a talented painter, who chose the colour ranges for printing. One of these models appeared on the cover of *Life* in March 1951, and Queen Elizabeth II was photographed wearing a 'butterfly' dress. Brassaï also did mock-ups based on Paris paving stones, white ceramic metro tiles, dewdrops…. I wore a 'graffiti' dress myself made of pleated brown crêpe de Chine.

ALM: *About the United States, could you say a few words on Brassaï's relations with Robert Frank and Ansel Adams, both of whom he met while he was there?*

GB: He hardly knew Robert Frank. Ansel Adams he knew much better. They met in Washington through the gallery owner Harry Lunn, at the time of Brassaï's exhibition at the Corcoran Gallery in June 1973, and we saw him again in Yosemite Valley, in Carmel and in Paris, where he enjoyed the atmosphere of La Closerie des Lilas, and then again in Arles, where he had an exhibition on at the same time as Brassaï at the Musée Réattu in 1974. Brassaï was very appreciative of his vision of nature, his human warmth and also the beauty of his prints. Ansel Adams, for his part, wrote to him : 'It is not the subject so much as the creative penetrating eye that is impressive. I'm always amazed at the quality you achieved from flashlight, especially that of earlier days. Modern journalists can certainly learn tremendously from your book [*Paris after Dark*].' (Carmel, California, 18 November 1976)

ALM: *Brassaï wrote in his notes: 'A negative means nothing for my kind of photographer, it's the* artist's proof *that counts.' Could you expand on that a little?*

GB: Brassaï developed his own negatives, he prepared the developing baths and did the prints and enlargements

for himself in his laboratory. He had a dozen bottles of different preparations and there were endless chemical formulas pinned up on the wall. He used to stand there and work for hours on end, especially at night; I could hear the noise of the metronome, from which he would not be parted. He liked to control the process from start to finish, and never allowed anyone else to develop his prints (except for formats exceeding 40 x 50 cm, which his enlarger could not cope with).

But after the appearance of the book *Paris de nuit*, in December 1932, Charles Peignot asked Brassaï to let him have the original negatives. Prints were made in larger formats than Brassaï's originals, destined for an exhibition at the Batsford Gallery in London, in 1933, to promote the English edition, *Paris after Dark*. In spite of his repeated appeals, Arts et Métiers Graphiques did not return the negatives to my husband, claiming they had been lost. Brassaï was very much affected by it. An American photographic historian, Kim Sichel, discovered them in June 1984 in the magazine archives.

ALM: *At what date did Brassaï start to make 'multiple' sets of double-weight prints?*

GB: In 1968, at the time of the Brassaï exhibition at The Museum of Modern Art in New York, organized by John Szarkowski, the gallery owner Robert Schoelkopf offered to represent him in the United States. That was how it came about that Brassaï agreed in future to make double-weight prints on more substantial paper, surrounded by a broad margin of white, and also signed, of the type you see in the collections of numerous institutions.

ALM: *As well as images, writing was important to Brassaï wasn't it?*

GB: Brassaï was certainly far from indifferent to the power of words and was always keen to write commentaries and annotations to accompany his photographs, like the notes he did for *Séville en fête*.

He wrote long prefaces for some of his books: *Camera in Paris*, *Paroles en l'air*, *Elöhívás*, *The Artists of My Life*, and an introduction to his *Proust sous l'emprise de la photographie*, in which he set out his ideas about photography and writing.

He conducted a lengthy correspondence with Henry Miller. In Hungarian, there are the letters he exchanged with his father and later his brother, and

Brassaï and Gilberte Brassaï at Genoa, spring 1956

also with his friend the painter Tihanyi. But he used to say his personal life was his own affair, and if people wanted to get to know him, they had only to read his books, which in many ways were like autobiographies.

ALM: *Since Brassaï's death, you have devoted yourself to making his work available to a wider audience, you look after a collection of more than thirty thousand pictures, respond to requests of all kinds from students and researchers, and assist with the countless exhibitions and publications that concern Brassaï to a greater or lesser degree.... We are indebted to you for producing an authorized biography, for writing prefaces, and for the publication of* Proust sous l'emprise de la photographie, *as well as the French version of* Elöhívás (Lettres à mes parents).... *During the preparation of this volume, you have been kind enough to place your unpublished archives at our disposal, enabling us to build up a more detailed picture of the life and work of Brassaï, the passionate truthfulness of his vision, his understanding of beauty. Thank you for that.*

Graffiti from Series VII, 'Death', 1933–56

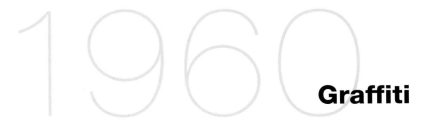

Graffiti

From the first graffiti to the exhibition at the Galerie Rencontre

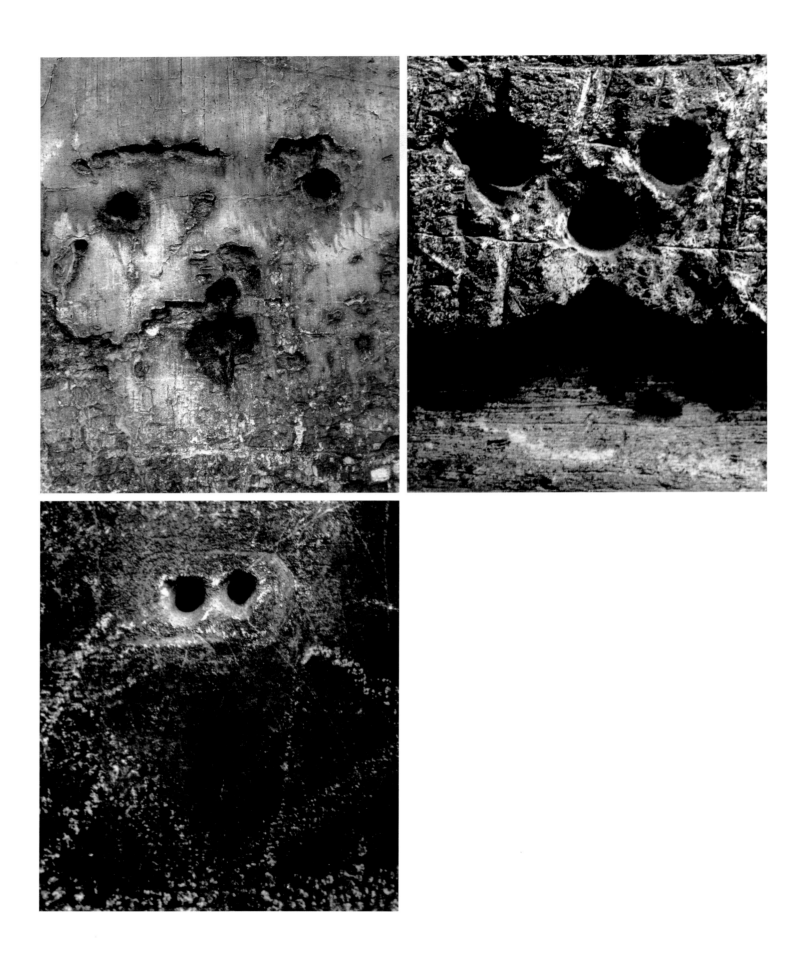

Graffiti from Series III, 'The Birth of the Face', 1933–56

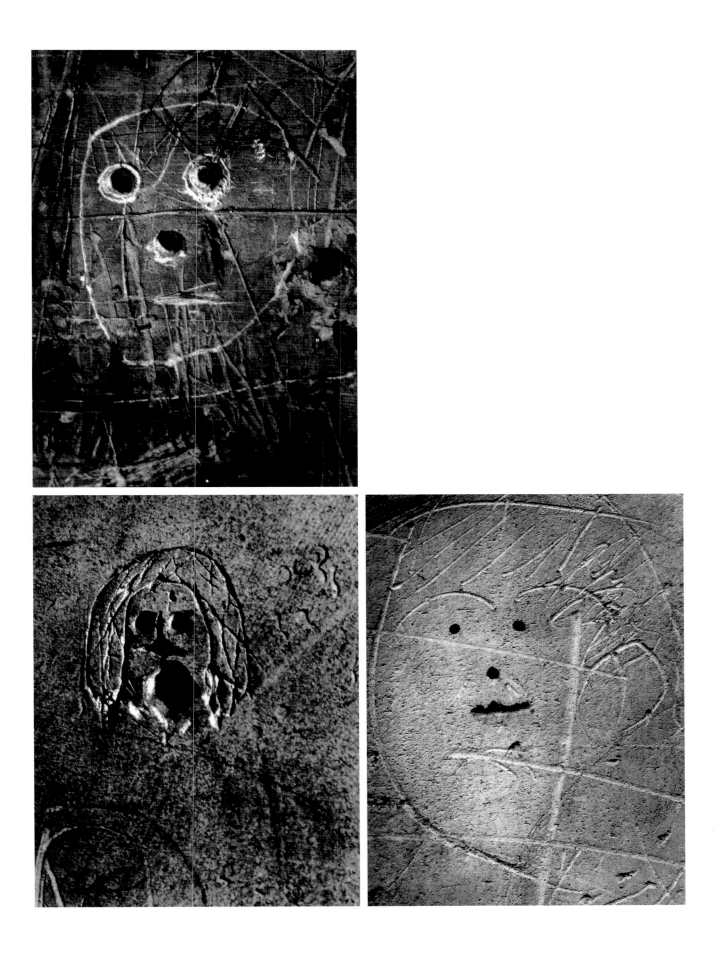

Graffiti from Series IV, 'Masks and Faces', 1933–56

'From Cave Wall to Factory Wall'* Brassaï

It is all a matter of perspective. If you simply eliminate the time factor, living analogies appear, establishing breathtaking parallels down the ages. Viewed in the light of ethnography, antiquity becomes first youth, the stone age a state of mind, and it is infantile understanding that adds the sparkle of life to the splintering of flints.

The following graffiti were recorded in the course of a few walks around Paris itself. In 1933, within spitting distance of the Opéra, the same signs appear on the walls as you see in the caves of the Dordogne or in the Nile and Euphrates valleys. The same sense of foreboding that once gouged out a tangled world of incisions on the walls of cave dwellings today traces drawings around the word 'prohibited', the first word children learn to decipher on a wall.

If you are curious enough to examine this early-blooming flora, you will look in vain to find in it the capriciousness of children's drawings. From paper to wall, from the supervised to the anonymous, the character of the expression changes. Quivering imagination yields to bewitchment. Here the word 'charming' is apt, restored to its original sense.

How hard the stone is! How primitive the tools! But what does that matter? This is not about playing, it is about mastering the frenzy of the unconscious. These abbreviated signs are none other than the origins of writing – these animals, monsters, demons, heroes, phallic deities are the elements of mythology, no less. Rising to the lofty heights of poetry or plunging to the depths of triviality ceases to make any sense in this region where the laws of gravity no longer apply. The strange region of the 'mothers' that Faust loved, where everything is in the process of being formed, transformed, deformed, while remaining quite still, where existing and potential creatures lie inert, containing within themselves all the subversive energy of the atom. It is just because it is thrown up to the surface by a violent groundswell that the graffito offers us such a valuable investigative tool in the artistic sphere.

Masterpieces are weighty and mature fruits of the mind, accumulating within them so much sap that the branch bearing them withers and cracks. Only the creative imagination can detect the scar that marks the secret of their birth. Graffiti allow us to experience, with all the sensual joy of the voyeur, the unfurling and fertilization of the flower before the fruit bursts forth, a tiny wild fruit that still bears the gold of the pollen amid the petals.

Beneath the crystalline transparency of spontaneity, what one observes here is a function of life, as insistent and instinctive as breathing and sleeping. With works of art, whatever the differences between them, it is the mark of this function within that is the proof of their authenticity, and the sole determinant of it.

The bastard art of the streets of ill repute that does not even arouse our curiosity, so ephemeral that it is easily obliterated by bad weather or a coat of paint, nevertheless offers a criterion of worth. Its authority is absolute, overturning all the laboriously established canons of aesthetics.

Beauty is not the purpose of creation, it is its reward. Its appearance, often late in the day, is no more than an indication that the disrupted equilibrium between man and nature has once again been restored by art. Submitted to this test, what remains of contemporary works of art?

If something is deceptive in appearance and does not contain the same truth, is not in the same way a physiological necessity, is not obedient to the constraints of such a strict discipline as graffiti, then let it be rejected as worthless.

* Article by Brassaï first published under the title 'Du mur des cavernes au mur d'usine' in *Minotaure*, no. 3–4, December, 1933.

Graffiti from Series VI, 'Love', 1933–56

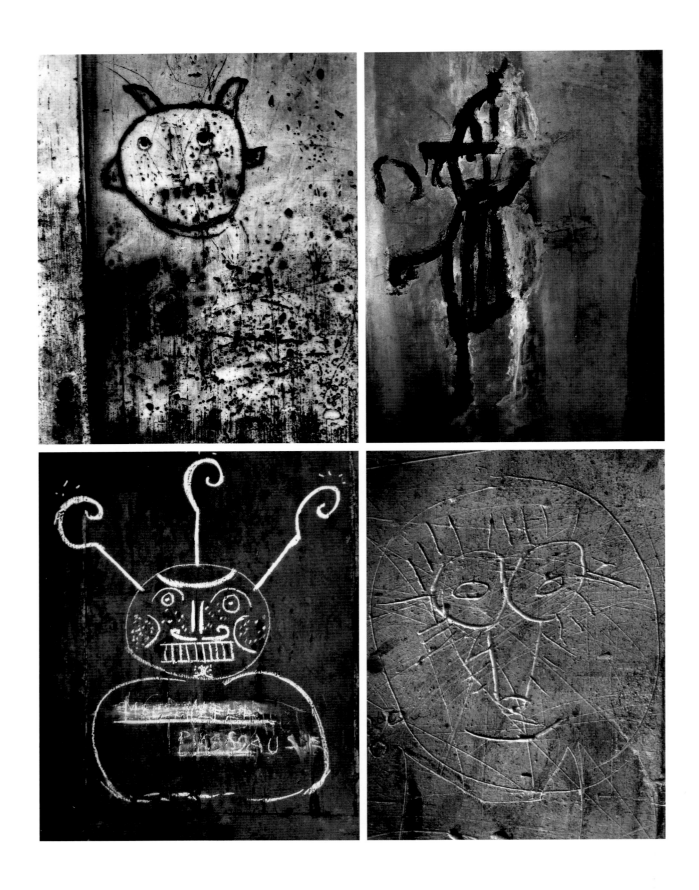

Graffiti from Series VIII, 'Magic', 1933–56

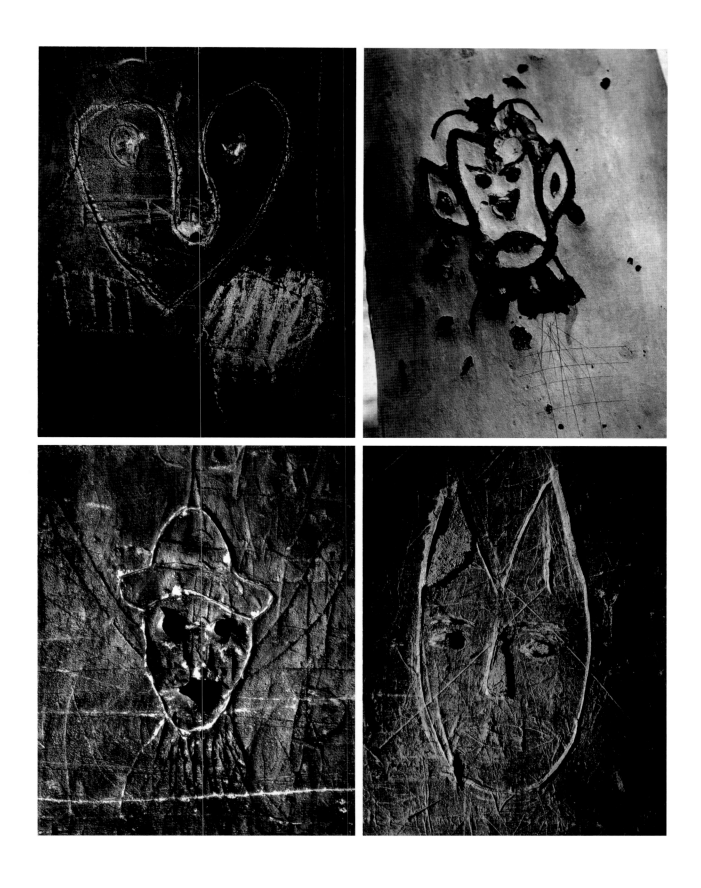

Transmutation, 1958–70

Arborescent Wall, 1958–70 *Red Manifesto*, 1958–70

Pas de Deux, 1958–70

Apocalypse I, 1958–70

Biography*

1899

Birth of Gyula Halász on 9 September 1899, under the sign of Mercury, at Brassó (Brașov) in Transylvania, now part of Romania. His mother is of Armenian origin, his father a university professor of French literature who had studied at the Sorbonne.

1903–4

First visit to Paris as a child, where he lives with his parents and younger brother in the Rue Monge, near the Luxembourg gardens.

1905

Begins his schooling in Brassó, and later Budapest.

1917–18

Serves in the cavalry of the Austro-Hungarian army. On leave, meets Béla Bartók and proposes an idea for a ballet.

1918–19

Studies at the Academy of Fine Arts, Budapest.

1921–22

Moves to Berlin in late December 1920. Intellectual life is vibrant.

Brassaï moves in artistic circles, his companions including László Moholy-Nagy, Vassily Kandinsky, Oskar Kokoschka and Edgar Varèse. Attends the Akademische Hochschule in Berlin-Charlottenburg and earns a diploma. Frequents also the free schools, where he practises drawing. His intellectual mentor is Goethe, whose scientific and artistic theories and philosophy remain a lifelong influence. Adopts as his own Goethe's aphorism: 'Little by little, objects have raised me to their own level.'

1924

Realizing at last his desire to live in France, arrives in Paris in January, never again to return to his native country.

* This biography, compiled by Gilberte Brassaï, was first published in the exhibition catalogue *Paris le jour, Paris la nuit*, Musée Carnavalet, Paris, 1988.

Bilingual in Hungarian and German, his first concern is to master the French language. To that end, he pores over works on linguistics and the latest publications of the grammarians; it is an obsession that remains with him for the rest of his life. Decides to live on the Left Bank. Earns a living by writing articles for a Hungarian sports paper and German magazines, and acquires old photographs and postcards eventually destined to figure in the collections of, among others, Tériade, Georges Ribemont-Dessaignes, Julien Levy, André Breton, Paul Éluard, Salvador Dalí, etc.

1925

Meets the young Belgian poet Henri Michaux, who becomes a close friend. Both are hard up, but share a love of poetry and German philosophy. Introduced by the dealer Léopold Zborowski to Eugène Atget. Brassaï is captivated by Atget's photographs and views him henceforth as a model.

1926

In Montparnasse, meets the Hungarian photographer André Kertész, whom he accompanies occasionally on assignments. First visit to Nice, where he experiences for the first time the dazzling Mediterranean light.

1928

Moves to a hotel on the corner of the Rue de la Glacière and the Boulevard Auguste-Blanqui. Other residents include artist friends such as Hans Reichel, Lajos Tihanyi and Vincent Korda. It is from this vantage point that, from 1930 onwards, he takes such photographs as *A Man Dies in the Street, Public Urinal in Winter, View towards the Place d'Italie, The Elevated Railway,* etc.

1929

Continues to contribute to leading German magazines, using photographs by a variety of different photographers to accompany his own articles. Now writes under his own name. In the autumn, a friend lends him an amateur camera with which he takes his first photographs.

Decides at this point to buy a professional Voigtländer camera and use it to attempt to capture his vision of the world and the overwhelming atmosphere of the labyrinthine Parisian streets.

1930–31

Brassaï becomes friendly with Alexander Calder and William Hayter. Trip to Brittany. His parents visit Paris for a few months. Starts to take photographs that express the nobility of ordinary objects, in *Objets à grandes échelles* (Large-scale Objects). In the course of his wanderings about Paris, executes his first nocturnal landscapes of the deserted city. Installs a darkroom in his hotel to develop his glass negatives and make his own prints, a practice he maintains all his life. Explicitly regards himself as a craftsman. It is at night, removed from time, that he takes his photographs, sometimes accompanied by such other indefatigable noctambulists as Léon-Paul Fargue, the 'Pedestrian of Paris', or Raymond Queneau, a fellow resident at his hotel. Mostly he is alone. Because of their weight, he can take no more than twenty-four plates with him on any one night: he has no special equipment. Arrival in Paris of Henry Miller, who visits him frequently at his hotel.

1932

Gyula Halász adopts the pseudonym Brassaï, which means literally 'of Brassó' (his native town). Henry Miller writes his first article about Brassaï, not published until 1938 when it appears under the title 'The Eye of Paris' in *Max and the White Phagocytes* (The Obelisk Press, Paris). Miller is another passionate walker, and Brassaï takes him out at all hours of the day and night to show him the out-of-the-way *quartiers* of Paris rarely seen by tourists. The result of these nocturnal meanderings is *Paris de nuit*, published on 2 December 1932 by Charles Peignot's Arts et Métiers Graphiques, with a foreword by Paul Morand. Brassaï's passion for alternative forms of art, and for Art Brut in particular, leads him to take an interest in graffiti, which he begins to seek out systematically on the walls of Paris. The collection is finally published in 1960, and includes examples rephotographed after an interval of ten years 'to show how they have deteriorated over time'. Georges Braque, Joan Miró, Pablo Picasso, Jean Dubuffet, Jacques Prévert, Henri Michaux, René Bertelé, Wols and Camille Bryen are enthusiastic collectors of these photographs. In parallel, he embarks on a series of studies of 'the city and the eccentricities of human behaviour', eventually published in 1976 in

The Secret Paris of the 30's. Through Georges Ribemont-Dessaignes, he meets the Prévert brothers, Jacques and Pierre, also Marcel Duhamel, Henri Langlois and Mary Meerson. Another friend is Maurice Raynal, art critic of *L'Intransigeant* and supporter of the Cubists, at whose home he meets Fernand Léger, Le Corbusier and Max Jacob. Raynal introduces him to Tériade, and he in turn introduces him to Picasso. Picasso likes the atmosphere of his night photographs and asks him to photograph his sculptures, as yet unknown to the public, at the Château de Boisgeloup where he lives in Normandy and at his Paris studio in the Rue La Boétie. The photographs are published the following year in the first issue of *Minotaure*.

1933

Through *Minotaure* and Albert Skira, he meets the Surrealist writers and poets who are his fellow contributors: André Breton, Paul Éluard, Robert Desnos, Benjamin Péret and Man Ray. At Picasso's, he meets Salvador Dalí and Gala, also the poet Pierre Reverdy, who becomes a good friend and whose portrait he takes in 1933 and again, almost twenty years later, in 1950. For *Minotaure*, Brassaï provides the photographs used to illustrate a long article on '*modern style*' (Art Nouveau), as well as those for a piece on 'Involuntary Sculptures' (such everyday items as soap, bus tickets, glassware and potatoes). Asked by André Breton and Paul Éluard, 'What was the most important encounter in your life?' he replies 'Goethe', thus making clear his reservations about Surrealism. In the same magazine, publishes the first of his articles on graffiti, 'Du mur des cavernes au mur d'usine' (From Cave Wall to Factory Wall). Publishes photographs of nudes for the first time in 'Variétés du corps humain' (Variations on the Human Body) and invites the public inside the 'artists' studios' of Picasso, Henri Laurens, Aristide Maillol, Jacques Lipchitz, Alberto Giacometti and Charles Despiau. Contributes to the issue of *Dakar-Djibouti* devoted to African art. Some of his female faces appear in Dalí's collage *The Phenomenon of Ecstasy*. Pictures of nocturnal landscapes and moths figure in the work of André Breton and Edward Young. Brassaï becomes friendly with the two Giacometti brothers, Diego and Alberto, taking a number of portrait photographs of the

latter at intervals of a few years – part of his fascination with the way faces, as well as walls, age. First one-man show at the Batsford Gallery in London, featuring his photographs of Paris by night. Trip to the Riviera with his parents and youngest brother. Intrigued by the Exotic Gardens in Monte Carlo: also starts to photograph the mineral kingdom.

1934

Continues his studies of human behaviour, meanwhile supporting himself with assignments for the magazines *Détective* and *Paris-Soir*. In London, he is awarded a medal by the scientist and photographer P. H. Emerson for the English edition of *Paris de nuit* (*Paris after Dark*). Becomes friendly with the English photographer Bill Brandt, with whom he discovers much in common. They maintain a lifelong association, meeting either in London or the South of France.

1935

Brassaï moves the short distance from his hotel to the rooms in the 14th arrondissement where he is to spend the rest of his life, close to the psychiatric hospital of Sainte-Anne, the Catacombs and the prison of La Santé. Blaise Cendrars becomes his neighbour, and later Samuel Beckett. Several of Brassaï's photographs of 'lovers' and other now famous pictures are taken in the 13th and 14th arrondissements, where he finds much of his inspiration.

Works for the Rapho photographic agency founded by his Hungarian friend Charles Rado, who during the war years leaves Europe for New York. Émile Savitry becomes Brassaï's assistant. First use of a Rolleiflex.

In around 1935, Brassaï meets Henri Matisse and takes his first portraits of the artist at work on his sculpture, surrounded by birdcages; these appear in the first issue of *Verve* in December 1937.

1936

Becomes one of the founder members of Henri Langlois's Cinémathèque Française.

1937

In Budapest, wins a gold medal at the exhibition held to celebrate Daguerre's centenary (but does not attend in person). Approached by francophile Carmel Snow,

editor-in-chief of *Harper's Bazaar*, and its highly talented art director Alexey Brodovitch, and asked to become a regular contributor to the magazine, with absolute freedom to choose his own subjects. This association is to last some twenty-five years, right into the sixties. For Carmel Snow he takes portraits of a variety of writers and artists, photographed in their studios. The subjects include Aristide Maillol, Germaine Richier, Pierre Bonnard, Georges Braque, Georges Rouault, Bernard Buffet, Father Couturier, Samuel Beckett, Eugène Ionesco, René Char, Thomas Mann, Pierre Soulages, Marie-Hélène Vieira da Silva, Robert Graves and Olivier Messiaen. Brassaï also works for *Vu*, *Verve*, *Picture Post*, *Coronet*, *Réalités* and *Labyrinthe*, contributing articles and photographs.

1939

At the request of Matisse, executes a series of 'nudes in the studio' at the Villa des Plantes, near Giacometti's studio in Paris. Also a series of portraits of 'Picasso in His Studio' for *Life* magazine.

1940–42

12 June 1940: the exodus. At the deserted Café de Flore, the 'Prévert gang' assemble: Jacques Prévert, Claudie, Simone Chavance, Dr Boiffard and his wife, Joseph Kosma and his wife. Later they will all meet up again in Cannes – but Brassaï decides to take the last refugee train back to Paris because he has forgotten … his negatives. Although invited to take up residence in the United States, he does not want to leave France. When approached by the Germans, refuses to submit a request for a photography permit. As a result, is forbidden to publish or to practise his profession. Starts drawing again at the Académie de la Grande-Chaumière, where he frequently encounters Henri Michaux.

1943

Writes *Bistro-Tabac*, which expresses in down-to-earth language the fears and absurdities of life under the Occupation. In late September, at Picasso's request, photographs the artist's sculptures in his studio at 7, Rue des Grands-Augustins. This task occupies him until the end of 1946. Throughout his time with Picasso, makes a habit of jotting down what the painter says to friends, artists and writers who pass

through his studio. Jacques Lacan is a frequent visitor, to discuss the drawings of his psychiatric patients.

1944

Brassaï's youngest brother disappears during the Russian campaign.

Photographs the liberation of Paris.

1945

First exhibition of Brassaï's drawings at the Galerie Renou et Colle, Rue du Faubourg-Saint-Honoré. In nostalgic mood, photographs another series of landscapes in the mist. In June, uses giant photographs as part of his set designs for the ballet *Le Rendez-vous*, based on an idea by Jacques Prévert, with music by Joseph Kosma and choreography by Boris Kochno and Roland Petit, performed at the Théâtre Sarah-Bernhardt. The ballet is taken on a world tour and provides the inspiration for Marcel Carné's *Gates of the Night*.

1946

Indulges his passion for high peaks with long holidays in the Chamonix region, which reminds him of the Transylvanian mountains of his childhood. His many photographs taken during climbing expeditions in Les Bossons and Argentière include the portrait of Henri Michaux, 'exhilarated by this hostile world of crystal and ice'.

1947

Creates photographic set designs for Raymond Queneau's play *En passant*. Ends his association with the Rapho-Grosset agency.

1948

Marries Gilberte-Mercédès Boyer. While walking in the Pyrenees, discovers that the pebbles in the mountain streams provide an ideal material for sculpture. In future, spends part of the year in the hinterland of Nice, concentrating on meditation and writing, and following paths in the wilderness in imitation of Nietzsche. Writes a long poem *Histoire de Marie*, with a preface by Henry Miller, published by René Bertelé for Éditions du Point du Jour. Jean Paulhan and Francis Ponge are among the most enthusiastic admirers of the story of his housekeeper, the 'humble Marie'.

1949

Brassaï becomes a naturalized French citizen. Creates photographic set designs for the ballet *D'amour et d'eau fraîche* by Elsa Triolet.

1949–60

Travels for *Harper's Bazaar* in Greece, Ireland, Italy, Spain, Turkey, Brazil, Sweden, Morocco, the United States and elsewhere. Returns with an extensive archive, some of which is published in the magazine.

1950

Creates photographic set designs for *Phèdre*, the ballet by Jean Cocteau and Georges Auric, performed at the Paris Opéra.

1952

Death of Brassaï's mother. Robert Delpire launches his career as director of Éditions Neuf with the publication of *Brassaï* as his first book. A group of students from Nancy organize Brassaï's first one-man show in France, at the Musée Stanislas.

1956

At the zoo in Vincennes, shoots the film *Tant qu'il y aura des bêtes* (As Long as There Are Animals), which wins a special award for originality at the Cannes Film Festival. Enthusiastic reception for the exhibition of 'Graffiti' at The Museum of Modern Art in New York, organized by Edward Steichen.

1957

Wins the gold medal for photography at the Venice Biennale. His first trip to the United States lasts several months and includes a long stay in Louisiana. Brassaï uses a Leica for colour shots. Meets Walker Evans and Robert Frank.

1958

The Unesco architects Le Corbusier, Marcel Breuer, Pier Luigi Nervi and Bernard Zehrfuss, and Georges Salles, director of the Musées Nationaux, choose the panel 'Les roseaux' (The Reeds) by Brassaï to represent photography in the Unesco building in Paris.

1960

Exhibition of pebble sculptures and drawings at the Galerie du Pont-Royal, Rue du Bac, Paris. Completes the text and prints for *Graffiti*, the book he has been

planning since the thirties. It is published first in German for the German market, and appears the following year in France in a French-language edition.

1961

Seized once again by the 'rage to express himself', begins to write up his notes on Picasso.

1962

Exhibits his 'Graffiti' and sculptures at the Daniel Cordier gallery in the Rue de Miromesnil, Paris.

1963

At the suggestion of Julien Cain and Jean Adhémar, the Bibliothèque Nationale, Paris, mounts a retrospective of his work.

1964–65

Publishes *Conversations avec Picasso* [*Picasso & Co.*], one of his most important books, with a text illustrated by some fifty photographs. It is subsequently translated into several languages, and republished in France in 1987. According to Brassaï, the trick is to 'say profound things in the guise of a detective story', in order to reach the widest possible audience.

1966

With Ansel Adams, is made an honorary member of the American Society of Magazine Photographers, receiving the ASMP Memorial Award for his major contribution to photography.

1967

Exhibition of drawings, sculptures and engravings at the Galerie Les Contards, Lacoste, Provence. Embarks on a number of tapestries based on the theme of graffiti.

1968

Exhibition of sculpture, drawings and engravings at Lucie Weill's Galerie du Pont des Arts, Rue Bonaparte, Paris. A retrospective of his photographs is staged by John Szarkowski at The Museum of Modern Art in New York. The catalogue includes prefaces by his friend Lawrence Durrell and John Szarkowski. One-man show of his drawings, sculptures and tapestries at the La Boetie gallery, New York. Death of his father, aged ninety-seven, who at the time of his death was

working on a book about the revolutionary songwriter Pierre-Jean de Béranger. Brassaï devotes himself to sculpture, making frequent trips to Italy. At the same time, works on an essay about Henry Miller and the correspondence they conducted between them.

1970–71

One-man show 'Trente panneaux couleur' (Thirty Panels in Colour) at the Galerie Rencontre in Paris. Receives a commission from the French state for the tapestry *Graffiti II*, subsequently exhibited at the fifth Lausanne Biennale.

1972

One-man show of sculptures, tapestries and drawings at the Galerie Verrière, in Paris and Lyons.

1973

Brassaï travels to Washington for a one-man show at the Corcoran Gallery of Art. Subsequently, in California, is invited by Ansel and Virginia Adams to visit Yosemite Park in the Sierra Nevada, in the company of Nancy and Beaumont Newhall.

1974

Guest of honour, with Ansel Adams, at the International Days of Photography in Arles.

1975

Publication by Gallimard of *Henry Miller grandeur nature*, followed in 1978 by *Henry Miller rocher heureux*.

1976

Long-awaited publication by Gallimard of *Le Paris secret des années 30* [*The Secret Paris of the 30's*]: 'time regained', an exploration of the human comedy, a sort of panorama of French life as it is led by ordinary people and outcasts, a world on the point of vanishing that Brassaï holds in great affection. The book is published simultaneously in the United States, England, Germany and Japan (and is republished in 1988). A major exhibition of Brassaï's photographs is held at the Marlborough Gallery in New York, and subsequently in a number of European cities. Brassaï is made a Chevalier of the Legion of Honour.

1977

Invited to lecture at the Massachusetts Institute of Technology (Cambridge, Mass.) and Columbia University (New York). Publication of *Paroles en l'air*, containing a number of essays and articles dealing with the problems of transposing spoken into written language.

1978

Brassaï works on the texts and photographic plates for his last book *The Artists of My Life* (*Les Artistes de ma vie*). Becomes a member of the PEN Club. In December, in Paris, is awarded the first Grand Prix National for photography.

1979

To celebrate his eightieth birthday, retrospectives are held in New York and London.

1982

Publication of *The Artists of My Life* by Viking Press in the United States, Thames & Hudson in Great Britain, and Denoël in France.

1983

Awarded the Prix de la Société des Gens de Lettres for *The Artists of My Life*.

1984

Shortly after completing his manuscript on Proust, the culmination of many years' work, Brassaï dies on 7 July at Beaulieu-sur-Mer, in the Mediterranean light. He is laid to rest in the cemetery of Montparnasse in the heart of Paris, the city he has celebrated in fifty years of life and work.

Bibliography

Books by Brassaï

Paris de nuit. 60 [64] previously unpublished photos by Brassaï, in the collection 'Réalités', general editor J. Bernier, text by Paul Morand. Éditions Arts et Métiers Graphiques, Paris, 1933 [December 1932]. *Paris after Dark*, Batsford Gallery, London, 1933. Reprinted, Flammarion, Paris, 1987; Thames & Hudson, London, 1987. *Paris by Night*, Pantheon Books, New York, 1987; Misuzu Shobo, Tokyo, 1987.

Voluptés de Paris, Paris-Publications, Paris, 1934. (N.B., Brassaï does not include this book in the list of his works, as the title and the selection of images were chosen by the publisher against his wishes.)

Trente dessins, poem by Jacques Prévert, drawings by Brassaï, Éditions Pierre Tisné, Paris, 1946 (600 copies).

Camera in Paris, preface by Brassaï, The Focal Press, London, 1949.

Histoire de Marie, introduction by Henry Miller. Éditions du Pont du Jour, Paris, 1949. Reprinted, Actes Sud, Arles, 1997.

Les Sculptures de Picasso, text by Daniel Henry Kahnweiler, photographs by Brassaï. Éditions du Chêne, Paris, 1949. *The Sculptures of Picasso*. Rodney Phillips, London, 1949.

Brassaï, text by Henry Miller, 'The Eye of Paris'; texts by Brassaï, 'Memories of My Childhood' and 'Notes'. Paris, Éditions Neuf, 1952. (*Neuf*, no. 5, special issue, 'Brassaï', compiled by Robert Delpire and Pierre Faucheaux, December 1951.)

Séville en fête, preface by Henry de Montherlant, text by D. Aubier, notes by Brassaï. Paris, collection 'Neuf', edited by Robert Delpire, 1954. *Fest in Sevilla*, Buchheim-Verlag, Feldafing, 1954. *Fiesta in Seville*, Thames & Hudson, London, 1956; The Studio and Thomas Y. Crowell, New York, 1956.

Graffiti, text by Brassaï and Picasso, Belser Verlag, Stuttgart, 1960; Les Éditions du Temps, Paris, 1961; Reprinted, with preface by Gilberte Brassaï, Flammarion, Paris, 1993.

Conversations avec Picasso, Gallimard, Paris, 1964. Reprinted 1969, 1987, new edition 1997. *Conversaciones con Picasso*, Aguilar, Madrid, 1966. *Picasso and Company*, preface by Henry Miller, introduction by Roland Penrose. Doubleday, Garden City, New York, 1966; *Picasso & Co.*, Thames & Hudson, London, 1967. *Conversations with Picasso*, preface by Henry Miller, introduction by Pierre Daix. University of Chicago Press, Chicago, 1999.

Transmutations, 12 photogravure illustrations, text by Brassaï. Galerie Les Contards, Lacoste, 1967 (110 copies).

A Portfolio of Ten Photographs, text by A. D. Coleman and Brassaï. Witkin Berley Ltd, New York, 1973 (50 copies).

Henry Miller grandeur nature. Gallimard, Paris, 1975.

Le Paris secret des années 30, text by Brassaï, Gallimard, Paris, 1976. *The Secret Paris of the 30's*, Thames & Hudson, London, 1976; Pantheon Books, New York, 1976; S. Fischer, Frankfurt, 1976. Misuzu Shobo, Tokyo, 1977.

Paroles en l'air. Jean-Claude Simoën, Paris, 1977.

Henry Miller rocher heureux, Gallimard, Paris, 1978, 1997.

Elöhívás: Levelek (1920–1940), text by Andor Horváth. Kriterion Könyvkiadó, Bucharest, 1980. *Letters to My Parents*, postscript by Anne Wilkes Tucker, University of Chicago Press, Chicago, 1997. *Lettres à mes parents*, Gallimard, Paris, 2000.

The Artists of My Life, Viking Press, New York, 1982; Thames & Hudson, London, 1982. *Les Artistes de ma vie*, Denoël, Paris, 1982.

Marcel Proust sous l'emprise de la photographie, Gallimard, Paris, 1997.

Articles by Brassaï, or with photographs by Brassaï

'Images latentes', *L'Intransigeant* (Paris), 15 November 1932.

'Technique de la photographie de nuit', *Arts et Métiers graphiques* (Paris), no. 33, 15 January 1933; and *Photo-Ciné-Graphique* (Paris), January 1934.

'De la beauté terrifiante et comestible, de l'architecture modern style', text by Brassaï and Salvador Dalí, *Minotaure* (Paris), no. 3–4, December 1933.

'Du mur des cavernes au mur d'usine', *Minotaure* (Paris), no. 3–4, December 1933.

'Pouvez-vous dire quelle a été la rencontre capitale de votre vie?', 'Enquête' by André Breton and Paul Éluard, Brassaï's response, *Minotaure* (Paris), no. 3–4, December 1933.

'Sculptures involontaires', text and photographs compiled in collaboration with Salvador Dalí, *Minotaure* (Paris), no. 3–4, December 1933.

'Ciel postiche', *Minotaure* (Paris), no. 6, December 1934.

'L'enfer de Dante retrouvé aux Baux', *Labyrinthe* (Geneva), no. 6, 15 March 1945.

'La tourterelle et la poupée', *Labyrinthe* (Geneva), no. 8, 15 May 1945.

'L'agonie des anges', *Labyrinthe* (Geneva), no. 13, 15 October 1945.

'Le sommeil', *Labyrinthe* (Geneva), no. 14, 15 November 1945.

'Un homme meurt dans la rue', *Labyrinthe* (Geneva), no. 20, 1 June 1946.

'Louis Stettner', *Camera* (Lucerne), December 1949. Revised introduction by Brassaï for *10 Photographs by Louis Stettner*, Two Cities Publications, Paris & New York, 1949.

'Le procès de Marie' (extracts from *Histoire de Marie*) *Labyrinthe* (Geneva), no. 22, 23 December 1950.

'La photographie n'est pas un art?', *Le Figaro littéraire* (Paris), 21 October 1959.

'Walls of Paris by Brassaï', *Harper's Bazaar* (New York), no. 2900, July 1953.

'Zinc en bois' or 'Le bistro-tabac', *Arts* (Paris), 17 November 1954.

'Le chauffeur de taxi', *Les Lettres nouvelles* (Paris), no. 34, January 1956.

'Tant qu'il y aura des bêtes', *Arts* (Paris), 2 May 1956.

'Language of the Wall', text by Edward Steichen and Brassaï, *US Camera* (New York), 1957.

'Brassaï Makes a Movie', *Popular Photography* (New York), April 1957.

'Graffiti parisiens', XX^{ème} siècle (Paris), no. 10, March 1958.

'Paris insolite', *Réalités* (Paris), December 1960.

'Un surréalisme baroque en Sicile au XVII^{ème} siècle: les folies du prince Palagonia', *Le Figaro littéraire* (Paris), no. 773, 11 February 1961.

'Le langage du mur', *Mercure de France* (Paris), no. 1180, December 1961.

'Reverdy dans son labyrinthe', *Mercure de France* (Paris), no. 1181, January 1962.

'Les saints guérisseurs, les saints et la médecine magique', *Planète* (Paris), no. 4, April/May 1962.

'Le XVIII^e siècle dans les caves du Louvre', *Connaissance des arts* (Paris), April 1962.

'La villa Palagonia, une curiosité du baroque sicilien', *La Gazette des beaux-arts* (Paris), September 1962.

'Mon ami Hans Reichel', *Hans Reichel 1892–1958*, Jeanne Bucher, Paris, 1962.

'Paris la nuit', text by Brassaï and Henry Miller, *Evergreen Review* (New York), 1962.

'My Friend André Kertész' (in English, French and German), *Camera* (Lucerne), no. 4, April 1963.

'Brassaï présente images de *Caméra*', foreword to *Caméra*, Hachette, Paris, 1964.

'Les souvenirs d'un grand photographe, Brassaï: Picasso s'explique enfin' (I), *Le Figaro littéraire* (Paris), 15 October 1964.

'Trente ans dans l'amitié des peintres et des écrivains: Brassaï raconte' (II), *Le Figaro littéraire* (Paris), 22 October 1964.

'Trente ans dans l'amitié des peintres et des écrivains: Brassaï raconte' (III), *Le Figaro littéraire* (Paris), 29 October 1964.

'Les choses parlent', *Les Nouvelles littéraires* (Paris), 18 March 1965.

'Mon ami Hans Reichel', *Jardin des arts* (Paris), no. 122, January 1965.

'Ma dernière visite à Giacometti', *Le Figaro littéraire* (Paris), 20 January 1966.

'Brassaï raconte la naissance difficile des *Métamorphoses* d'Ovide', *Bulletin trimestriel d'Albert Skira* (Geneva), no. 3, September 1966.

'Extraits de mes conversations avec H. Miller', *Synthèses* (Brussels), no. 249–50, March 1967.

'Picasso and Photography', *Popular Photography* (Chicago), vol. 60, no. 5, May 1967.

'Mes souvenirs de E. Atget, P. H. Emerson et Alfred Stieglitz', *Camera* (Lucerne), vol. 48, no. 1, January 1969.

'Louis Tihanyi', *Les Lettres françaises* (Paris), 8 April 1970.

'Elsa et la danse', *Les Lettres françaises* (Paris), 24 June 1970.

'Choses et autres de Jacques Prévert', *Vogue* (Paris), no. 512, December 1970–January 1971.

'Lewis Carroll photographe ou l'autre côté du miroir', *Cahier de l'Herne* (Paris), no. 17, September 1971.

'Les antipodes de la photographie', *Les Nouvelles littéraires* (Paris), 25 November 1976.

Works on Brassaï

MONOGRAPHS

'Brassaï', *Formes, le magazine des artistes, peintres et sculpteurs* (Paris), no. 1, special edition, 1950.

Brassaï, Éditions Neuf (no. 5), Robert Delpire ed., Paris, 1952.

Brassaï, preface by Peter Pollack. The Art Institute of Chicago, 1954.

Brassaï, preface by John Szarkowski, text by Lawrence Durrell. The Museum of Modern Art, New York, 1968.

Brassaï, introduction by Roger Grenier. Photo-poche, no. 28, Centre national de la photographie, Paris, 1987. Photofile, Thames & Hudson, London, 1987; Pantheon Books, New York, 1998.

Paris le jour, Paris la nuit, text by Kim Sichel. Musée Carnavalet, Paris, 1988.

Brassaï: The Eye of Paris, preface by Edwynn Houk, texts by Gilberte Brassaï and David Travis. Houk Friedman Gallery, New York, 1993.

Brassaï: From Surrealism to Art Informel, text by Manuel J. Borja-Villel, Dawn Ades, Jean-François Chevrier, Édouard Jaguer. Fundació Antoni Tàpies, Barcelona, 1993.

Modiano, Patrick, *Paris tendresse*. Éditions Hoëbeke, Paris, 1990.

Soucék, Ludwig, *Brassaï*. Státní Nakladatelsví Krásné Literatury a Uméní, Prague, 1962.

Tucker, Anne Wilkes, *Brassaï: The Eye of Paris*. The Museum of Fine Arts, Houston, 1999.

Warehime, Marja, *Brassaï. Images of Culture and the Surrealist Observer*. Louisiana State University Press, Baton Rouge, 1996.

GENERAL WORKS

Hill, Paul, and Cooper, Thomas, 'Brassaï', *Dialogue with Photography*. Thames & Hudson, London, 1979.

Lionel-Marie, Annick, and Sayag, Alain, 'Brassaï', *Collection de photographies du Musée national d'art moderne 1905–1948*. Centre Pompidou, Paris, 1996.

Miller, Henry, 'The Eye of Paris', *Max and the White Phagocytes*. The Obelisk Press, Paris, 1938.

Newhall, Nancy, *Photography, Essays and Images*. Beaumont Newhall, Museum of Modern Art & New York Graphic Society, New York, 1980.

Sichel, Kim, *Photographs of Paris, 1928–1934: Brassaï, André Kertész, Germaine Krull and Man Ray*. Yale University Press, Ann Arbor, Massachusetts, 1986.

ARTICLES ON BRASSAÏ

'Paris de nuit', *Nieuwe Rotterdamsche Courant* (Rotterdam), 29 December 1932.

'Brassaï Makes Photo Record of Nocturnal Paris', *The Chicago Herald Tribune*, 13 March 1933.

'Paris by Night', *The Listener* (London), 28 June 1933.

'Paris by Night', *The British Journal of Photography* (London), 7 July 1933.

'Paris de nuit', *The Times* (London), 1 July 1933.

'Brassaï, Paris by Night', *Picture Post* (London), 21 January 1939.

'Brassaï', *Popular Photography* (Chicago), December 1944.

'Brassaï, Famous Photographer', *Vogue* (New York), November 1945.

'Brassaï', *Neue Zürcher Zeitung* (Zurich), 25 September 1949.

'Brassaï', *The British Journal of Photography* (London), November 1949.

'Brassaï, Camera in Paris', *New London Statesman* (London), December 1949.

'Brassaï', *The Record* (London), December 1949.

'Les décors de théâtre de photos géantes de Brassaï', *Bauzeitschrift* (Saarbrücken), no. 2, 1949.

'Fem Franska Fotografer Brassaï', *Foto* (Stockholm), no. 7, September 1949.

'The Photographs of Brassaï', *Harper's Bazaar* (New York), November 1951.

'Brassaï', *L'Information* (Paris), 17 January 1952.

'Brassaï', *Point de vue* (Paris), 27 March 1952.

'Brassaï', *Le Photographe* (Paris), 5 July 1952.

'Brassaï', *US Camera* (New York), 1953.

'L'éminente œuvre de Brassaï (I)', *Asahi Camera* (Tokyo), no. 1, January 1953.

'L'éminente œuvre de Brassaï (II)', *Asahi Camera* (Tokyo), no. 2, January 1953.

'Brassaï: One-Man Photo Show', *Chicago Sunday Times*, 15 November 1954.

'Brassaï Makes a Movie', *Popular Photography* (New York), April 1957.

'Brassaï', *Cimaise* (Paris), April/June 1960.

'Il n'a pas de prénom, on l'appelle Brassaï', *Télérama* (Paris), 30 October 1960.

'Le Paris insolite du poète photographe Brassaï', *Asahi Camera* (Tokyo), 1961.

'Brassaï', *Réalités* (Paris), December 1960.

'Walls of Paris by Brassaï', 'Brassaï', *Photography* (London), vol. 17, no. 2, February 1962.

'Brassaï sculpteur', *Asahi Journal* (Tokyo), 12 March 1962.

'Brassaï', *Il Messaggero* (Rome), 12 April 1962.

'Les graffiti de Brassaï', *L'Express* (Paris), 16 November 1962.

'À 85 ans il continue de nous étonner. Quoi de neuf, Monsieur Picasso?', *Le Figaro littéraire* (Paris), 13 and 20 October 1966.

'Brassaï, Early Master of the Underground', *Modern Photography* (New York), December 1968.

'Graffiti de Brassaï', *Chroniques de l'art vivant* (Paris), no. 7, January 1970.

'Brassaï in the 30's', *The Photo Reporter* (New York), July 1972.

'Brassaï', *The New Yorker*, October 1976.

'Paris by Night Captured by One of France's Greatest Photographers', *The New York Times Book Review*, October 1976.

'Brassaï, grand prix des Arts et lettres', *Le Photographe* (Paris), no. 1357, February 1979.

'Brassaï. Les photos inédites et les souvenirs du lauréat du Grand Prix national', *Photo*, (Paris), no. 137, February 1979.

'The Eye of Brassaï', *The Observer Magazine* (London), 11 November 1979.

'Brassaï und seine Künstler', *Das Kunstmagazin* (Hamburg), no. 6, June 1983.

'Brassaï, the Three Faces of Paris', *Architectural Digest* (New York), July 1984.

Banier, François-Marie, 'Objets à grande échelle par Brassaï', *L'Égoïste* (Paris), no. 10, June 1987.

Barcillon, Edmond, 'Brassaï, l'œil de Paris', *Lecture pour tous* (Paris), no. 88, April 1961.

Barotte, René, 'Brassaï qui transforma un galet en Picasso', *Paris-Presse*, 2 April 1968.

Bequette, France, 'Rencontre avec Brassaï', *Culture et Communication* (Paris), no. 27, 1980.

Berger, Viviane, 'Brassaï par Brassaï', *Jardin des arts* (Paris), no. 209, 27 March 1972.

Berman, Avis, 'Guest Speaker Brassaï', *Architectural Digest* (Los Angeles), vol. 41, no. 7, July 1984.

Bernier, Jean, 'Paris de nuit', *Vu* (Paris), 1 February 1933.

Blume, Mary, 'Brassaï's Secret Paris: Incisive, Funny, Humane', *International Herald Tribune* (Paris), 23–24 October 1976.

— 'Brassaï among Friends', *International Herald Tribune* (Paris), 29 October 1982.

Bomy, Jean, 'Brassaï à la Résidence du Louvre à Menton', *Nice-Matin*, 10 August 1963.

Bonnefoy, Claude, 'Chez les voyous et dans le beau monde', *Les Nouvelles littéraires* (Paris), 17 October 1976.

Borhan, Pierre, 'Brassaï, les affinités immuables', *Clichés* (Brussels), no. 14, March 1985.

— 'Les mystères de la chambre noire', *Beaux-Arts magazine* (Paris), no. 35, May 1986.

Bott, François, 'Le Paris nocturne de Brassaï', *Le Monde des livres* (Paris), 18 December 1987.

Boujut, Michel, 'Brassaï, l'œil de maître', *Le Nouveau Photocinéma* (Paris), no. 67, April 1978.

Bouret, Jean, 'Brassaï', *Les Lettres françaises* (Paris), 1 March 1968.

— 'Brassaï', *Les Lettres françaises* (Paris), 21 October 1970.

Braive, Michel, 'Graffiti de Brassaï', *Beaux-Arts* (Brussels), January 1962.

Broodthaers, Marcel, 'Piéton des nuits de Paris, Brassaï a découvert le langage photographique', *L'Oise-Matin* (Beauvais), 28 May 1963.

Bunnell, Peter, 'The Secret Paris of the 30's', *The New Republic* (New York), 6 November 1976.

Butcher, George, 'Brassaï and the Image', *Art News* (London), 11 October 1958.

Cabanne, Pierre, 'Brassaï: "j'imagine tout"', *Arts* (Paris), no. 917, 22 May 1963.

— 'Brassaï, l'œil d'un poète', *Lecture pour tous* (Paris), no. 205, February 1971.

Calles, André, 'Brassaï, magicien, a mis pour nous le monde dans des boîtes', *Combat* (Paris), 18 July 1949.

— 'Portraitiste de Picasso, de Prévert et de Miller, Brassaï a préféré au pinceau un appareil photographique', *Samedi-Soir* (Paris), 25 April 1952.

Carné, Marcel, 'Descendra-t-il dans la rue?', *Photo-Magazine* (Paris), November 1933.

Caujolle, Christian, 'L'œil de Brassaï s'est fermé', *Libération* (Paris), 12 July 1984.

— 'Brassaï', *Beaux-Arts magazine* (Paris), vol. 7, October 1984.

Chapelin, Maurice, interview with Brassaï, 'La photographie n'est pas un art, Baudelaire avait raison', *Le Figaro littéraire* (Paris), 14 October 1950.

Chevrier (Jean-François), 'Degas, Brassaï et Picasso', *Photographies* (Paris), no. 7, May 1985.

— 'Brassaï à l'écrit', *Le Monde* (Paris), 21 November 1997.

Chollet, Roland, 'Picasso dans l'œil d'un photographe', *La Nouvelle Revue française* (Paris), 1 April 1965.

Chonez, Claudine, 'Brassaï', *Les Nouvelles littéraires* (Paris), 9 October 1952.

Cogniat, Raymond, 'Graffiti', *Le Figaro* (Paris), 28 December 1961.

— 'Transmutations de Brassaï', *Le Figaro* (Paris), 24 April 1968.

Coleman, A. D., 'Latent Images', *The Village Voice* (New York), 14 November 1968.

Cordier, Daniel, 'Photos Rival Paintings in Paris Shows', *International Herald Tribune* (New York), 24 January 1962.

Crespelle, Jean-Paul, 'Un œil fertile', *France-Dimanche* (Paris), 24 March 1968.

De Angelis, R. M., 'I graffiti di Brassaï', *La Fiera Litteraria* (Rome), 6 May 1962.

Delinée, Robert, 'Paris du troisième œil', *La Gazette des lettres* (Paris), 15 April 1952.

Denoyelle, Françoise, 'Arts et Métiers Graphiques: Histoire d'images d'une revue de caractères', *La Recherche photographique* (Paris), no. 3, December 1987.

Descargues, Pierre, 'Brassaï, photographe d'avant-garde, sculpteur préhistorique', *Tribune de Lausanne*, 20 March 1960.

— 'Brassaï célébré à la Nationale', *Tribune de Lausanne*, 5 May 1963.

— 'Brassaï chez Picasso', *Les Lettres françaises* (Paris), 19–20, November 1964.

Deschaumes, Jacques, 'De Boticelli à Brassaï', *Revue des Deux-Mondes* (Paris), November 1970.

Deschin, Jacob, 'Graffiti Photographed by Brassaï', *The New York Times*, 29 April 1956.

— 'Brassaï Pictures. Scribbling on Walls Subject of New Show', *The New York Times*, 28 October 1956.

— 'The Eye of Paris', *The New York Times*, 25 October 1959.

— 'Brassaï Looks Back to the 1930's', *The New York Times*, 3 November 1968.

Diehl, Gaston, 'Brassaï', *XXème siècle* (Paris), no. 36, June 1972.

Drahos, Tom, 'Paris 1930 vu par le maître Brassaï', *Photo* (Paris), no. 22, July 1969.

Dunoyer, Jean-Marie, 'Les Grands Prix nationaux des arts et lettres: photographie, Brassaï', *Le Monde* (Paris), 14 December 1978.

Eisner, Maria Giovanni, 'Brassaï', *Minicam Photography* (Cincinnati), April 1944.

Elliott, David, 'Abbott, Brandt and Brassaï, a City Vision', *Chicago Daily News*, 8 March 1977

Ellis, Ainslie, 'A Bronze for Brassaï, Should It Have Been Gold?', *British Journal of Photography* (London), no. 131, 24 August 1984.

Esnault, A., 'Brassaï, un poète de la photo', *Pour tous* (Lausanne), December 1952.

— 'La photographie est-elle un art?', *La Gazette de Lausanne*, 18–19, December 1954.

Ferney, Frédéric, 'Un sociologue de la nuit', *Le Nouvel Observateur* (Paris), 20 July 1984.

Fleury, Jean-Christian, 'Le Paris de Brassaï', *Photographies* (Paris), no. 56, March 1994.

Foresta, Merry, 'Art and Photography in the Age of Contact', *Aperture* (New York), no. 125, Autumn 1991.

Foster, Hal, 'L'amour faux', *Art in America* (New York), vol. 74, no. 1, January 1986.

Gallian, Jean, 'Brassaï (III)', *Photo-Monde* (Paris), no. 29, October 1953.

Gauthier, Maximilien, 'Brassaï au pied du mur', *Les Nouvelles littéraires* (Paris), 15 October 1970.

Gautrand, Jean-Claude, 'Brassaï l'universel', *Photo-Revue* (Paris), July 1974

— 'Brassaï the Universal', *Afterimage* (Rochester, New York), vol. 3, no. 3, September 1975.

— 'Brassaï, Grand Prix national', *Images du monde* (Paris), no. 1589 and 1590, 5 and 12 January 1979.

Georges, Waldemar, 'Brassaï porte témoignage', *Art et Industrie* (Paris), no. 21, September–November 1951.

Gindertael, R. V., 'La conscience au pied du mur', *XXème siècle* (Paris), no. 20, December 1962.

Gingrich, B., 'About Brassaï, Who Tells the Truth and Nothing But the Truth – and Makes It Sing', *Coronet* (Chicago), vol. 3, no. 2, December 1937.

Girod de l'Ain, 'Brassaï et *Paris de nuit*', *Le Monde* (Paris), 10 May 1963.

Goldberg, Vicky, 'Brassaï, Pushed-Back Hat, Spit-Curl, and Cigarette-in-Mouth', *Art News* (New York), vol. 91, no. 4, April 1992.

— 'Paris Belongs to Brassaï', *Vanity Fair* (New York), December 1998.

Goodheart, Adam, 'Night Visionary', *Art News* (New York), September 1998.

Gosling, Nigel, 'Walls', *The Observer* (London), 9 October 1960.

Grégory, Claude, and Deharme, Lise, 'Deux hommes et leurs images: Brassaï, Man Ray', *Arts* (Paris), no. 349, 7 March 1952.

Grenier, Roger, 'Brassaï écrivain', *Bulletin NRF* (Paris), November 1964.

— 'Hommes: avec Brassaï', *Le Nouvel Observateur* (Paris), 19 November 1964.

— 'Brassaï, les murs de Paris', *La Quinzaine littéraire* (Paris), 1 November 1970.

— 'Brassaï', *Le Club français de la médaille* (Paris), no. 45, 4th quarter, 1974.

— 'Un Gigante della fotografia, Brassaï, "L'Occhio di Parigi" compie 80 anni: la grande occasione mancata di Venezia 1979', *Bolaffiarte* (Turin), vol. 10, no. 190, July 1979.

Groebli, René, 'Begegnung mit Brassaï', *Der Schweizer Journal* (Zurich), no. 9–10, September–October 1949.

Gruen, John, 'Brassaï, Paris in the Shadows', *New York Magazine*, 18 November 1968.

Guerrin, Michel, 'Brassaï, l'œil vivant', *Le Monde* (Paris), 24 February 1994.

Guibert, Hervé, 'Un grand reportage sur la vie humaine', *Le Monde* (Paris), 2 December 1982.

— 'Le photographe Brassaï est mort', *Le Monde* (Paris), 12 July 1984.

Gullers, K. W., 'Den Fotografiske Brassaï', *Foto* (Stockholm), no. 3, 1950.

Guth, Paul, 'Interview avec Brassaï', *Le Figaro littéraire* (Paris), 9 April 1949.

Haden-Guest, Anthony, 'The Night and the City', *Vanity Fair* (New York), vol. 56, no. 3, March 1993.

Hall, Norman, 'Opinions: Giants and Others', *Photography* (London), vol. 17, no. 2, February 1962.

Halpert, Peter Hay, 'The World of Brassaï', *American Photo* (New York), vol. 10, no. 1, January–February 1999.

Hannon, Brent, 'Les roseaux', *Courrier de l'Unesco* (Paris), no. 2, November 1958.

Henriot, Émile, 'Photos de Paris', *Le Temps* (Paris), 30 January 1933.

Heron, Liz, 'The Real Paris of the Thirties?', *Camerawork* (London), no. 7, July 1977.

Holborn, Mark, 'Brassaï, 1899–1984', *Aperture* (New York), no. 97, Winter 1984.

Holliday, Taylor, 'Brassaï, Seeing Paris His Way', *The Wall Street Journal* (New York), 15 January 1999.

Hopkinson, Amanda, 'Just Celebrating: Paris Shows Brassaï, Cartier-Bresson and Lartigue', *Creative Camera* (Manchester), no. 6, 1989.

Hughes, George, 'Brassaï', *L'Amateur photographique* (Paris), 18 June 1969.

Huser, France, 'Les minuits de Brassaï', *Le Nouvel Observateur* (Paris), 25 October 1976.

Izawa, Kohtaro, ['Brassaï, Parisian Graffiti'], *Nippon Camera* (Tokyo), January 1988.

Jaloux, Edmond, 'Le Minotaure et la nuit', *Le Jour* (Paris), 27 July 1935.

Kalil, Susie, 'Nuit Prowler', *Houston Press*, 31 December 1998, 6 January 1999.

Kasser, Hans, 'Brassaï', *Camera* (Lucerne), no. 9, September 1944.

— 'Brassaï, Paris as Seen by the Camera' (in English, French and German), *Camera* (Lucerne), September 1949.

Kertész, André, 'Brassaï', *Infinity* (New York), vol. 15, no. 7, July 1966.

Klein, Roger, 'Brassaï. Eye of Paris', *Photography* (Chicago), vol. 1, no. 1, 1947.

Kovács, János, 'Párizsi Látogatás Brassaïnál', *Korunk* (Kolozsvár, Romania), March 1968.

Kramer, Hilton, 'Brassaï: the High Art of Photographing Low Life in Paris', *New York Sunday Times*, 19 September 1976.

Krauss, Rosalind, 'Nightwalkers', *Art Journal* (New York), vol. 41, no. 1, Summer 1981.

— 'The Photographic Conditions of Surrealism', *October* (Cambridge, Massachusetts), no. 19, Autumn 1981.

Lacayo, Richard, 'The Night Watchman', *Time* (New York), 18 January 1999.

Lepage, Jacques, 'Brassaï', *Les Lettres françaises* (Paris), 10 October 1963.

— 'Brassaï ou l'œil insatiable', *Aujourd'hui, art et architecture* (Paris), no. 49, April 1965.

Levy, René, 'Quelques visions en photographie', *Le Monde* (Paris), 4 February 1933.

Loehwing, David, 'Brassaï, Eternal Amateur', *Popular Photography* (New York), 1952.

Loengard, John, 'Brassaï', *Life* (New York), May 1982.

Mac Orlan, Pierre, 'La photographie et la poésie du monde', *Mercure de France* (Paris), 1 February 1952.

Mallet, Robert, 'Brassaï', *Le Figaro littéraire* (Paris), 8 March 1952.

Maraï, Sandor, 'A Parisi ejsaka', *Az Ujsag* (Hungary), 26 February 1933.

Masclet, Daniel, 'Brassaï, l'homme de la foule', *Le Photographe* (Paris), no. 763, 5 March 1952.

— 'Brassaï, l'homme de la foule', *Photocinéma* (Paris), no. 605, 20 March 1952.

— 'Le cas Brassaï', *Le Photographe* (Paris), 20 June 1963.

Mauriac, Claude, 'Picasso écouté et vu par Brassaï', *Le Figaro* (Paris), 13 January 1965.

Mauriac, François, 'Brassaï: il chasse l'homme avec amour', *L'Express* (Paris), 10 November 1960.

Mazard, Pierre, 'Brassaï sculpteur', *Le Figaro littéraire* (Paris), 19 March 1960.

Merester, Guy, 'Les photographies de Brassaï', *Combat* (Paris), 4 March 1952.

Michaud, Paul, 'Brassaï at 80', *Paris métro*, 11 September 1976.

Miller, Henry, 'The Eye of Paris' [1933], *Globe* (Chicago), November 1937.

Mithois, Marcel, 'Brassaï joue avec les cailloux', *Jours de France* (Paris), March 1960.

Moorman, Margaret, 'Brassaï 1899–1984', *Art News* (New York), vol. 83, October 1984.

Mora, Édith, 'Brassaï, l'œil et la main', *Les Nouvelles littéraires* (Paris), 20 May 1965.

Morand, Paul, 'Paris de nuit', *Les Nouvelles littéraires* (Paris), 31 January 1933.

Moulin, Raoul-Jean, 'Brassaï', *Les Lettres françaises* (Paris), 17 March 1960.

Mourgeon, Jacques, 'Brassaï, poète de la photo', *Combat* (Paris), 15 November 1960.

Neugass, Fritz, 'Graffiti Parigini', *Photo-Magazin* (Milan), no. 7, July 1959.

Newhall, Nancy, 'Brassaï: "je n'invente rien, j'imagine tout"', *Camera* (Lucerne), vol. 35, no. 5, May 1956.

— 'Brassaï', *Quarterly of the Friends of Photography* (Carmel, California), no. 10, 1976.

Nieting, Valentin [pseudonym of Henry Miller], 'L'œil de Paris', *The Booster* (Paris), no. 7, September 1937.

Nourissier, François, 'Le livre de la semaine: *Conversations avec Picasso*', *Les Nouvelles littéraires* (Paris), 26 November 1964.

Nuridsany, Michel, 'Brassaï à l'œil de Paris', *Le Figaro* (Paris), 9 October 1976.

— 'Brassaï: le Toulouse-Lautrec de la photo', *Le Figaro* (Paris), 28 November 1979.

— 'Brassaï, photographe et écrivain', *Le Figaro* (Paris), 17 December 1982.

Owens, Craig, 'Photography "en abyme"', *October* (Cambridge, Massachusetts) no. 5, Summer 1978.

Parella, Lew, 'Brassaï: Faithful Chronicler of Life', *US Camera* (New York), February 1955.

Petkanas, Christopher, 'Brassaï at 83: I have Things to Do', *Women's Wear Daily* (New York), 8–15 October 1982.

Pieyre de Mandiargues, André, 'Le mur', *XXème siècle* (Paris), no. 10, March 1958.

Pittolo, Véronique, 'Picasso sous l'œil de Brassaï', *Beaux-Arts magazine* (Paris), no. 49, September 1987.

Plécy, Albert, 'Homme d'images: Brassaï', *Point de vue, Images du monde* (Paris), 11 December 1954.

— 'Brassaï', *Point de vue, Images du monde* (Paris), 17 May 1963.

Plécy, Albert, and Gautrand, Jean-Claude, 'Les grands maîtres de l'art photographique: Brassaï (I), (II), (III)', *Point de vue, Images du monde* (Paris), 6, 13 and 20 September 1974.

Pluchart, François, 'Brassaï et Georges Noël: l'humain seul les sépare', *Combat* (Paris), 17 January 1962.

Pollack, Peter, 'The Parisian Scene by Brassaï', *Art Photography* (Chicago), October 1956.

Putnam, Jacques, 'Graffiti vus par Brassaï', *XXème siècle* (Paris), no. 18, February 1962.

Rado, Charles, 'Paris Photographers', *Modern Photography* (Chicago), February 1950.

Ray-Jones, Tony, 'Brassaï Talking about Photography', *Creative Camera* (London), no. 70, 15 November 1954.

Reismann, János, 'Brassaï, Photographer of Night', *Miniature Camera World* (London), vol. 3, no. 4, April 1939.

Renoir, Jean, 'Picasso and Brassaï', *The New York Times*, 9 October 1966.

Ribemont-Dessaignes, Georges, 'Tableaux en liberté', *L'Intransigeant* (Paris), 10 April 1933.

Rinaldi, Angelo, 'I graffiti di Brassaï', *Il Mondo* (Rome), 12 May 1962.

Rivière, Claude, 'Les graffiti de Brassaï', *Combat* (Paris), 15 January 1962.

Roche, Denis, 'Paris de nuit de Brassaï', *Télérama* (Paris), 25 November 1987.

Rogiers, Patrick, 'Brassaï et la puissance des ténèbres', *Le Monde* (Paris), 27 October 1988.

Root, Waverley Lewis, 'Brassaï Makes Photo Record of Nocturnal Paris', *Chicago Daily Tribune*, 13 March 1933.

Rousseau, François-Olivier, 'Je n'éprouvais que du mépris pour la photographie', *L'Égoïste* (Paris), May 1983.

Roy, Claude, 'Brassaï, les yeux fertiles', *Libération* (Paris), 2 December 1952.

Russell, John, 'Memories of Paris and of One Who Saw It As It Was', *The New York Times*, 29 November 1999.

Saucet, Jean, 'Il y a trente ans sur le pont des Arts ... Brassaï', *Télé 7 jours* (Paris), 3 November 1960.

Seaver, Richard, 'Brassaï: Four Wall Faces', *Merlin* (Paris), Autumn 1953.

Shapiro, Karl, 'Brassaï: Poetic Focus on France', *Art News* (New York), no. 53, February 1955.

Sichel, Kim, 'Brassaï Revisited', *Views* (Boston), Summer 1988.

Siclier, Jacques, 'À la télévision, Brassaï', *Le Monde* (Paris), 5 November 1960.

Skogholm, Carl Werner, 'Cave Art in the Street', *Politiken* (Copenhagen), 14 December 1957.

Solier, René de, 'Cartier-Bresson, Brassaï et autres gens d'images', *La Nouvelle Revue française* (Paris), no. 39, 1 March 1956.

Sonthonnax, P., 'Brassaï (I)', *Photo-Monde* (Paris), July–August 1953.

— 'Brassaï (II)', *Photo-Monde* (Paris), September 1953.

Soucek, Ludwig, 'Brassaï aneb cesta od slozitosti k. Prostote', *Suétova Literature* (Czechoslovakia), no. 1, 1962.

Steichen, Edward, 'Brassaï and the Language of the Wall', *Bulletin of The Museum of Modern Art* (New York), no. 100, 23 October 1956.

— 'Brassaï', *US Camera* (New York), 1958.

Stettner, Irving, 'A Visit to Brassaï', *Photo-Notes* (New York), Autumn 1948.

Stevens, Nancy, 'Brassaï', *The Village Voice* (New York), 27 September 1976.

Stoecker, Karl, 'Brassaï', *Arts Review* (London), 16 January 1971.

Szarkowski, John, 'Brassaï', *Bulletin of the Museum of Modern Art* (New York), no. 109, 15 October 1968.

Szilágyi, Júlia, 'Párizs Szeme-Brassaï' [L'œil de Paris/The Eye of Paris], *Korunk* (Kolozsvár, Romania), no. 12, 1962.

Tériade, 'Le point de vue de la nature', *Arts et Métiers Graphiques* (Paris), 15 August 1936.

Valogne, Catherine, 'Un photographe à la Nationale: Brassaï', *Les Lettres françaises* (Paris), 30 May 1963.

Varia, Radu, 'De Vorba cu Picasso', *Secolul 20* (Bucharest), January 1967.

Vilaine, Anne-Marie de, 'L'école du graffiti', *France-Soir* (Paris), 9 December 1961.

Walzer, P. O., 'Picasso et Brassaï', *Journal de Genève* (Geneva), 13 December 1964.

Watterson, Zdenke, 'Der grosse Photo-Reporter von Paris: Ein Besuch im Atelier Brassaï', *Prager Presse* (Prague), 21 September 1932.

Westerbeck, Colin J., 'Night Light: Brassaï and Weegee', *Artforum* (New York), vol. XVI, December 1976.

Film by Brassaï

1956: *Tant qu'il y aura des bêtes*, A 'Franco-Britanniques' production (21 minutes). Prizewinner at the 9th Cannes Film Festival.

Stage sets by Brassaï
(created from photographs)

1945: *Le Rendez-vous*, ballet by Jacques Prévert. Choreography by Roland Petit, music by Joseph Kosma. Théâtre Sarah Bernhardt, Paris, 15 March 1945.

1947: *En passant*, a one-act play by Raymond Queneau. Théâtre Agnès-Capri, Paris, 1947.

1949: *D'amour et d'eau fraîche*, ballet by Elsa Triolet. Music by Jean Rivier. Ballets des Champs-Elysées, Paris, 1949.

1950: *Phèdre*, ballet by Jean Cocteau. Music by Georges Auric, choreography by Serge Lifar. Théâtre national de l'Opéra, Paris.

Films and television programmes

1958: *Brassaï*, Télé-Luxembourg (30 minutes).

3 November 1960: 'Brassaï ou les yeux d'un homme', by Jean-Marie Drot, for the programme *L'art et les hommes*, RTF, 1re chaîne [Channel 1] (45 minutes).

5 May 1964: *La Chambre noire*, by Claude Fayard, Michel Tournier and Albert Plécy.

1965: *Brassaï*, Pathé-Cinéma (6 minutes).

1967: *Paris-Brassaï*, a short film compiled from photos of Paris by Brassaï taken between 1930 and 1932. By Francis Warin, Productions Coty & Co, Paris.

March 1968: 'Un certain Brassaï', France-Actualité, for the series *Regards sur le monde*, no. 33 (6 minutes).

1968: *Brassaï*, directed by Rune Hassner, for Swedish television (60 minutes).

1969: 'Brassaï ou le regard en liberté', by Robert Valey, Pierre Schneider and Michel Chapuis, for the programme *Champ visuel*.

28 September 1971: 'Spécial Brassaï' by Claude Gallot, for the programme *Variances* by Michèle Arnaud, TF1.

Radio interviews

June 1945: *Paris vous parle*, by Jean-José Marchand (relating to an exhibition of Brassaï's drawings at the Galerie Renou et Colle, Paris).

January 1951: *L'Art et la vie*, by Georges Charensol (programme with Robert Doisneau on the 'Five French Photographers' exhibition at The Museum of Modern Art, New York).

10 March 1960: *L'Art et la vie*, by Georges Charensol (Florent Fels discusses the sculptures by Brassaï exhibited in the Galerie Au Pont des Arts, Paris).

16, 23 and 30 September, 7 and 14 October 1964: 'Brassaï, l'œil vivant', by Roger Grenier, for the *Entretiens* series, France-Culture.

25 December 1966: *Lewis Carroll photographe*, by Jacques Brunius and Paul Chavasse.

19 December 1969: *Champ visuel*, by Robert Valey, Pierre Schneider and Michel Chapuis.

January 1978: *Radioscopie*, by Jacques Chancel, France Inter.

10 November 1980: *Entretien*, with Michel Nuridsany, France-Culture.

1982: *Nuits magnétiques*, with Jean-François Chevrier, France-Culture.

Exhibitions

Solo exhibitions

1933
'Brassaï, Paris de nuit', Galerie Arts et Métiers Graphiques, Paris.

'Brassaï, Paris after Dark', Batsford Gallery, London.

1945
'Brassaï, dessins', Galerie Renou et Colle, Paris.

1946
'Photographies parisiennes de Brassaï', Palais des Beaux-Arts, Brussels

1952
'Cent photographies de Brassaï', Musée des Beaux-Arts, Nancy.

1954
'Cent photographies de Brassaï', Interclub, Toulouse.

'Brassaï', The Art Institute of Chicago. Catalogue: foreword by Peter Pollack. Travelling: 1955, Walker Art Center, Minneapolis; George Eastman House, Rochester, New York; Institute of Art, New Orleans.

1956
'Language of the Wall: Parisian Graffiti Photographed by Brassaï', The Museum of Modern Art, New York.

'Brassaï', Hansa Gallery, New York.

1958
'Language of the Wall: Parisian Graffiti Photographed by Brassaï', Institute of Contemporary Arts (ICA), London. Catalogue: foreword by Roland Penrose, main text by Brassaï.

1959
'Brassaï', Limelight Gallery, New York.

1960
'Brassaï, sculptures-galets, dessins, gravures', Galerie du Pont-Royal, Paris.

1961
'Brassaï, graffiti', Institut d'Études Françaises, Saarbrücken.

1962
'Brassaï, photographies de graffiti', Galerie Daniel Cordier, Paris.

'Brassaï, graffiti', L'Obelisco, Rome.

1963
'Brassaï, photographies, sculptures, gravures', Bibliothèque Nationale, Paris. Catalogue: foreword by Julien Cain, texts by Jean Adhémar and Alix Gambier. Travelling: Résidence du Louvre, Menton.

'Brassaï, graffiti', Maison de la Culture, Caen.

'Brassaï, sculptures', Musée du Havre, Le Havre.

'Photographs by Brassaï', Worcester Art Museum, Worcester, Massachusetts.

1964
'Brassaï, Graffiti', Staatliche Kunsthalle, Baden-Baden.

'Photographies de graffiti de Brassaï', Musée du Vieux-Château, Dieppe.

'Les sculptures de Picasso et les photographies de Brassaï', Galerie Madoura, Cannes.

1965
'Les sculptures de Picasso et les photographies de Brassaï', Librairie-Galerie Peron, Paris.

1966
'Brassaï', Kölnischer Kunstverein, Cologne.

1967
'Cet homme, Brassaï. Sculptures, dessins, gravures', Galerie Les Contards, Lacoste, Haute-Provence.

1968
'Brassaï, sculptures, dessins, gravures', Galerie Lucie Weill, Au Pont des Arts, Paris.

'Brassaï' [retrospective exhibition], The Museum of Modern Art, New York. Catalogue: foreword by John Szarkowski, main text by Lawrence Durrell. Travelling: 1969: St. Louis Art Museum, Missouri; 1971: National Gallery of Victoria, Melbourne; Farmer's Blaxland Gallery, Sidney; Auckland City Art Gallery, Auckland; National Art Gallery, Wellington; Govett-Brewster Art Gallery, New Plymouth, New Zealand; 1972: Centro Venezolano Americano, Caracas, Venezuela; 1973: Museo de Arte Moderno 'La Tertulia', Cali, Colombia; Museo de Arte Moderno de Bogotá, Colombia; Museo de Zea, Medellín, Colombia; Instituto Nacional de Cultura, Lima, Peru; 1974: Museo de Arte Contemporanea, São Paulo, Brazil; Fundaçao Cultural de Brasilia, Brazil; Museo de Arte Moderna da Bahia, Salvador; Hayden Gallery, Boston.

'Brassaï', Staatliche Landesbildstelle, Hamburg.

'Brassaï, sculptures, dessins, gravures', La Boetie Gallery, New York.

1970
'Brassaï, art mural', 30 colour photographs, Galerie Rencontre, Paris.

1971
'Brassaï', Robert Schoelkopf Gallery, New York.

'Brassaï', 30 colour photographs, 'Not Bend' Gallery, London.

1972
'Brassaï', Harry Lunn Gallery, Washington D.C.

'Brassaï: sculptures, tapisseries, dessins', Galerie Verrière, Paris. Catalogue: foreword by Gaston Diehl.

1973
'Brassaï', Witkin Gallery, New York. Travelling: Santa Barbara Museum of Art, California.

'Brassaï', Dartmouth College of Art. Travelling, supported by the International Exhibition Foundation: 1973: The Corcoran Gallery of Art, Washington D.C.; 1974: University of Iowa Museum of Art, Iowa;

University of California, Berkeley; Winnipeg Art Gallery, Winnipeg; 1975: Munson-Williams-Proctor Institute, Museum of Art, Utica; Everson Museum, Syracuse.

'Brassaï: sculptures, tapisseries, dessins', Galerie Verrière, Lyons.

1974
'Brassaï', Musée Réattu, Arles.

'Brassaï', Wolfgang Wittrock Kunsthandel, Düsseldorf.

1975
'Brassaï', Gemini Gallery, Palm Beach.

'Brassaï', French Institute/Alliance Française, New York.

1976
'The Secret Paris of the 30's/Le Paris secret des années trente', Marlborough Gallery, New York. Travelling: 1976: Cronblatt Gallery, Baltimore; 1977: Marlborough Gallery, Zurich; Neue Galerie der Stadt, Linz; Galerie Levy, Hamburg; Massachusetts Institute of Technology, Cambridge; Halsted 831 Gallery, Birmingham; Galerie Arta, The Hague; The Image Gallery, Sarasota; Miami Dade Community College, Florida; 1978: Banque Lambert, Brussels; Galerij Paula Pia, Antwerp.

1979
'Brassaï, Artists and Studios', Marlborough Gallery, New York. Travelling: Lowinsky and Araï Gallery, San Francisco; Gallery 700, Milwaukee.

'Brassaï', The Photographer's Gallery, London. Catalogue: introduction by Sue Davies, text by Bill Brandt. Travelling: 1979: Brewery Arts Centre, Kendal; The Scottish Photography Group Gallery, Edinburgh; Tolarno Galleries, Melbourne; Salford University, Salford, Australia.

1980
'The Eye of Paris. Brassaï's Photographs', Edwynn Houk Gallery, Chicago.

1982
'Brassaï, The Artists of My Life', Marlborough Gallery, London.

1984
'Hommage à Brassaï', Marlborough Gallery, New York.

'Brassaï', Yurakucho Asahi Gallery, Tokyo. Catalogue: texts by Taro Okamoto and Ryuichi Kaneko.

1986
'Brassaï, Artistes de ma vie', Galerie Municipale du Château d'Eau, Toulouse. Catalogue: text by Jean Dieuzaide.

1987
'Picasso vu par Brassaï', Musée Picasso, Paris. Catalogue: texts by Marie-Laure Bernadac and Jean-François Chevrier.

1988
'Brassaï, Paris le jour, Paris la nuit', Musée Carnavalet, Paris (8 November 1988–8 January 1989). Catalogue: text by Kim Sichel, biography and bibliography compiled by Gilberte Brassaï.

'Paris tendresse', Galerie de la FNAC, Paris. Catalogue: text by Patrick Modiano, Editions Hoëbeke, Paris.

1990
'Brassaï', Printemps Ginza, Tokyo. Catalogue: texts by Taro Okamoto, Koji Shirai and Ryuichi Kaneko.

1993
'Brassaï: The Eye of Paris', Houk Friedman Gallery, New York. Catalogue: foreword by Edwynn Houk, texts by Gilberte Brassaï and David Travis.

'Brassaï', Centre National de la Photographie, Paris.

'Brassaï: del Surrealismo al informalismo', Fundació Antoni Tàpies, Barcelona. Catalogue: texts by Dawn Ades, Manuel J. Borja-Villel, Jean-François Chevrier and Édouard Jaguer.

1995
'Photographies de Brassaï présentées à l'exposition "Five French photographers" (Brassaï, Henri Cartier-Bresson, Robert Doisneau, Izis, Willy Ronis) au Museum of Modern Art, New York, 1951' [re-hang of the Brassaï component of the 1951 'Five French Photographers' exhibition], Centre Pompidou, Paris.

1998
'Brassaï and Company', The Art Institute of Chicago.

'Brassaï: The Eye of Paris', The Museum of Fine Arts, Houston (6 December 1998–28 February 1999). Catalogue: text by Anne Wilkes Tucker, including an essay by Richard Howard. Travelling: The J. Paul Getty Museum, Los Angeles (13 April 1999–4 July 1999); The National Gallery of Art, Washington D.C. (17 October 1999–16 January 2000).

Group exhibitions

1931
'Photographes d'aujourd'hui', Librairie-Galerie de la Plume d'Or, Paris.

1932
'Modern European Photography', Julien Levy Gallery, New York.

1933
'Groupe annuel des photographes', Galerie de la Pléiade, Paris.

'Exposition internationale de photographie', Palais des Beaux-Arts, Brussels.

1934
'Groupe annuel des photographes', Galerie de la Pléiade, Paris.

1935
'La photographie contemporaine internationale', Musée Rath, Geneva.

'L'humour et le fantastique par la photographie', Galerie de la Pléiade, Paris.

'Exposition internationale photographique du nu esthétique', France-Diffusion, Paris.

'Documents de la vie sociale', Galerie de la Pléiade, Paris.

1936
'Exposition internationale de la photographie', Musée des Arts Décoratifs, Pavillon de Marsan, Paris.

'Les Dix ou la photographie vivante', Galerie Leleu, Paris.

1937
'Photography 1839–1937', The Museum of Modern Art, New York.

'L'envers des grandes villes', Galerie de la Pléiade, Paris.

1939
'Straalende Franske Foto-Udstilling', Kunstindustri Museet, Copenhagen.

'Exposition photographique des maîtres photographes contemporains', Palais des Beaux-Arts, Brussels.

1948
'French Photographers', The Photo-League, New York.

'Troisième Salon national de la photographie', Bibliothèque Nationale, Paris.

1950
'Brassaï et Paul Grimault', Librairie du Cheval Blanc, Paris.

'Internationale Foto Tentoonstelling', Stedelijk van Abbe Museum, Eindhoven.

1951
'Subjektive Fotografie', Staatliche Schule für Kunst und Handwerk, Saarbrücken.

'Five French Photographers', The Museum of Modern Art, New York.

'Cinq photographes', Librairie-Galerie La Hune, Paris.

1952
'Welt-Ausstellung der Photographie', Luzerner Kunsthaus, Lucerne.

1953
'Post-war European Photography', The Museum of Modern Art, New York.

'Vingt hommes d'images', Galerie Craven, Paris.

'Meister Photographien aus Frankreich', Institut Français, Innsbruck.

1955
'The Family of Man', The Museum of Modern Art, New York.

1957
'Mostra Internazionale biennale della fotografia', Sala Napoleonica, Palazzo Reale, Venice.

1959
'Photography at Mid-century', George Eastman House, Rochester, New York.

1960
'Brassaï, graffiti', Milan Triennale.

1963
'Grosse Photographen unseres Jahrhunderts', Photokina 2, Cologne.

1964
'The Photographer's Eye', The Museum of Modern Art, New York.

1968
'Photography as Printmaking', The Museum of Modern Art, New York.

1971
'5ᵉ Biennale internationale de la tapisserie', Musée Cantonal des Beaux-Arts, Lausanne.

1972
'Alexei Brodovitch and His Influence', Philadelphia College of Art.

1975
'Three Cities: Bill Brandt, Brassaï, Berenice Abbott', Marlborough Gallery, New York. Travelling: David Mirvish Gallery, Toronto.

'Brassaï, Man Ray', Janet Fleischer Gallery, Philadelphia.

'Brassaï, Kertész', Phoenix Gallery, San Francisco.

1976
'One Hundred Master Photographs', The Museum of Modern Art, New York.

'Photographs from the Julien Levy Collection', The Art Institute of Chicago.

'Brassaï, art fantastique', Menton Biennale.

1977
'Documenta 6', Museum Fridericianum, Kassel.

1979
'Livres rares et photographies', Galerie Zabriskie, Paris.

1980
'Photographic Surrealism', Brooklyn Museum, New York.

'Les réalismes 1919–1939', Centre Pompidou, Paris.

1981
'Paris-Paris: création en France 1937–1957', Centre Pompidou, Paris.

1982
'Counterparts. Form and Emotion in Photography', The Metropolitan Museum of Art, New York.

1984
'Celebrations', Zabriskie Gallery, New York.

1985
'L'amour fou. Photography and Surrealism', The Corcoran Gallery of Art, Washington D.C. Travelling: Centre Pompidou, Paris.

'Das Aktfoto: Ansichten vom Körper im fotografischen Zeitalter, Aesthetik, Geschichte, Ideologie', Stadtmuseum, Munich.

'Elementarzeichen: Urformen visueller Information', Staatliche Kunsthalle, Berlin.

1987
'Regards sur *Minotaure*', Musée Rath, Geneva.

'L'œil du *Minotaure*, Ubac, Brassaï, Alvarez-Bravo, Bellmer, Man Ray', Galerie Sonia Zanettacci, Geneva.

1988
'Une exposition de photographie française à New York', Centre Pompidou, Paris.

1989
'The New Vision: Photography between the World Wars', The Metropolitan Museum of Art, New York.

'Das Innere der Sicht: surrealistische Fotografie der 30er und 40er Jahre', Museum des 20 Jahrhunderts, Vienna.

1993
'Espais existencials: la mirada apassionada de Daniel Cordier', Centre Cultural de la Fundacio 'La Caixa', Barcelona.

1997
'Le Paris des photographes', September–October: Bunkamura, Tokyo November–December: Suntory Museum Osaka.

1998
'Le jour est trop court', Musée Nicéphore Niépce, Châlons-sur-Saône.

1999
'Les abstractions et la photographie', XXXᵉᵐᵉ Rencontres Internationales de la Photographie d'Arles.

List of illustrations

The source of the works reproduced is indicated either by the reference 'AM...', which is the inventory number in the collections of the Musée National d'Art Moderne, Paris; or by the letter '(D)', meaning that the work has been placed there on deposit; or, in a few cases, by the words 'Private Collection', when the work has been lent by an individual collector.

The dimensions are given as height × width.

The expression of authenticity

page

12 *Self-Portrait as Society Photographer for a Costume Ball*, c. 1932–34
Brassaï Archives

17 *'Juan-les-Pins' at the Folies-Bergère*, 1932
Two contact prints mounted on card, 16 × 8 cm
Brassaï Archives: Pl. 741 and 742 (D)

18 *The Canal de l'Ourcq, Seen from the Quai de l'Oise and from the Quai de la Marne*, undated
Twelve contact prints mounted on card, 23.5 × 32 cm
Brassaï Archives: N. 706A to N. 706F+1 (D)

20 *La Môme Bijou, Bar de la Lune*, 1932
Silver salt contact print, 8.3 × 6 cm
Brassaï Archives: Pl. 385 (D)

La Môme Bijou, Bar de la Lune, 1932
Silver salt print, 23.2 × 17.6 cm
Brassaï Archives: P. de N. 43
AM 1997–197

21 *La Môme Bijou, Bar de la Lune*, 1932
Silver salt print, 48 × 39 cm
Brassaï Archives: Pl. 384
AM 1995–220

22 *The Librairie de la Lune*, c. 1934
Silver salt contact print, 8.4 × 6.2 cm
Brassaï Archives: Pl. 408 (D)

23 *The Black Corset*, 1934
Silver salt print, 28.7 × 19.5 cm
Brassaï Archives: Nu Ré. 4 (D)

24 *Bonnard, Le Cannet*, October 1946
Silver salt print, 29.5 × 23.5 cm
Brassaï Archives: A. 379 (D)

25 *Braque*, 1946
Silver salt contact print, 8.3 × 4.5 cm
Brassaï Archives: A. 396 (D)

Giacometti, January 1948
Silver salt contact print, 8.3 × 5.8 cm
Brassaï Archives: A. 234E (D)

Matisse, 1939
Silver salt contact print, 8.3 × 5.6 cm
Brassaï Archives: A. 283 (D)

Bonnard's Studio, Le Cannet, October 1946
Silver salt contact print
Brassaï Archives (D)

26 *Intersection of the Boulevard Saint-Jacques and the Rue du Faubourg-Saint-Jacques, 25 August 1944, about six a.m.*
Silver salt print, 23.5 × 17.2 cm
Brassaï Archives: G. 116 (D)

The First Units of the Bilotte Group, 25 August 1944
Silver salt print, 23.5 × 29.7 cm
Brassaï Archives: G. 125 (D)

27 *The Bathroom Mirror, 25 August 1944*
Silver salt print, 17.2 × 23.5 cm
Brassaï Archives: G. 161 (D)

Paris after dark

30 *Notre-Dame*, c. 1930–32
Silver salt print, 23.1 × 17 cm
Brassaï Archives: P. de N. 7
AM 1997–166

32 *The Institut de France*, 1939
Silver salt contact print, 5.6 × 5.4 cm
Brassaï Archives: N. 444 (D)

Notre-Dame, 1939
Silver salt contact print, 5.7 × 5.4 cm
Brassaï Archives: N. 323 (D)

33 *The Arc de Triomphe*, 1939
Silver salt contact print, 4.9 × 5.5 cm
Brassaï Archives: N. 358 (D)

Saint-Germain-des-Prés, 1939
Silver salt contact print, 5 × 5.3 cm
Brassaï Archives: N. 445 (D)

34 *The Pont-Neuf*, c. 1932
Silver salt print, 30 × 22 cm
Brassaï Archives: N. 574 (D)

35 *The Quai de Conti*, c. 1930–32
Silver salt print, 23.2 × 17.8 cm
Brassaï Archives: P. de N. 9
AM 1997–167

36 *The Pont-Neuf*, c. 1930–32
Silver salt print, 22.8 × 17.3 cm
Brassaï Archives: P. de N. 18
AM 1997–173

37 *The Pont Marie*, c. 1931–32
Silver salt print, 20 × 28 cm
Brassaï Archives: N. 557 (D)

39 *The Pont-Neuf in the Fog*, c. 1934–35
Silver salt print, 24 × 18 cm
Brassaï Archives: N. 550 (D)

40 *The Edge of the Jardin du Luxembourg on the Rue Auguste-Comte*, c. 1931
Silver salt print, 30 × 24 cm
Brassaï Archives: N. 145 (D)

The Quai de Bercy, c. 1932
Silver salt print, 29 × 22 cm
Brassaï Archives: N. 629 (D)

41 *The Jardin du Luxembourg*, c. 1935–38
Silver salt print, 23 × 29 cm
Brassaï Archives: N. 601 (D)

42 *The Passage du Palais-Royal*, 1932
Silver salt print, 24 × 30 cm
Brassaï Archives: N. 80 (D)

43 *The Viaduc d'Auteuil*, 1932
Silver salt print, 30 × 24 cm
Brassaï Archives: N. 131 (D)

44 *The Gare Saint-Lazare*, c. 1932–33
Silver salt print, 24 × 30 cm
Brassaï Archives: N. 178 (D)

45 *Glacière Metro Station*, c. 1930–32
Silver salt print, 22.5 × 17.2 cm
Brassaï Archives: P. de N. 47
AM 1997–202

46 *The Grands Moulins de Paris, Quai de la Gare*, c. 1932–33
Silver salt print, 30 × 23 cm
Brassaï Archives: N. 710 (D)

47 *The Canal Saint-Denis*, c. 1930–32
Silver salt print, 22.5 × 16.3 cm
Brassaï Archives: P. de N. 16
AM 1997–220

48 *The Cesspool Cleaners and Their Pump, Rue Rambuteau*, 1931
Silver salt print, 22.5 × 17.5 cm
Brassaï Archives: N. 279
AM 1997–183

49 *Unemployed Workers at Les Halles*, c. 1932
Silver salt print, 17 × 23 cm
Brassaï Archives: N. 734 (D)

Market Porters at Les Halles, c. 1935
Silver salt print, 18 × 28 cm
Brassaï Archives: N. 734A (D)

50 *Building Site, Paris*, c. 1932
Silver salt contact print, 5.6 × 6.2 cm
Brassaï Archives: N. 767 (D)

Building Site, Paris, c. 1932
Silver salt contact print, 5.6 × 6.3 cm
Brassaï Archives: N. 768 (D)

51 *The Baker*, c. 1930–32
Silver salt print, 17.4 × 22.2 cm
Brassaï Archives: P. de N. 42 (D)

52 *Lamplighter at the Corner of the Rue Émile-Richard and the Boulevard Edgar-Quinet*, c. 1931
Silver salt contact print, 8 × 6 cm
Brassaï Archives: N. 267 (D)

53 *The Rag-picker*, c. 1931–32
Silver salt print, 29.5 × 20.3 cm
Brassaï Archives: N. 266
AM 1997–208

54 *Pigall's American Bar*, c. 1930–32
Silver salt print, 25.3 × 20 cm
Brassaï Archives: N. 91
AM 1997–181

55 *Bal du Moulin Rouge*, c. 1930–34
Silver salt print, 30 × 24 cm
Brassaï Archives: N. 234 (D)

56 *Public Urinal*, c. 1932
Silver salt contact print, 8.4 × 6 cm
Brassaï Archives: N. 212 (D)

Public Urinal, c. 1932
Silver salt contact print, 8.2 × 5.9 cm
Brassaï Archives: N. 214 (D)

Public Urinal, c. 1932
Silver salt contact print, 8.1 × 6 cm
Brassaï Archives: N. 213 (D)

57 *Public Urinal*, c. 1932
Silver salt contact print, 8.5 × 6 cm
Brassaï Archives: N. 218 (D)

Public Urinal, c. 1932
Silver salt contact print, 8 × 5.5 cm
Brassaï Archives: N. 219 (D)

Public Urinal, c. 1932
Silver salt contact print, 8.5 × 6 cm
Brassaï Archives: N. 221 (D)

58 *On the Grands Boulevards*, c. 1934
Silver salt print, 29 × 22 cm
Brassaï Archives: N. 515 (D)

59 *Tom's Childrenswear*, c. 1934
Silver salt print, 19 × 14 cm
Brassaï Archives: N. 496 (D)

60 *The Pick-up, near Les Halles*, c. 1932
Silver salt print, 29 × 23 cm
Brassaï Archives: Pl. 337 (D)

61 *The Pick-up, near Les Halles*, c. 1932
Silver salt print, 30 × 23 cm
Brassaï Archives: Pl. 336 (D)

62 *Near the Place d'Italie*, c. 1932
Silver salt print, 29 × 22 cm
Brassaï Archives: Pl. 69 (D)

63 *Boulevard Saint-Jacques*, c. 1932
Silver salt contact print, 8.2 × 6 cm
Brassaï Archives: Pl. 73 (D)

Passageway in the Metro, c. 1932–34
Silver salt print, 29 × 23 cm
Brassaï Archives: Pl. 75 (D)

64 *For a Detective Story*, 1931–32
Silver salt print, 23 × 18 cm
Brassaï Archives: Pl. 164 (D)

65 *Big Albert's Gang, near the Place d'Italie*, c. 1931–32
Silver salt print, 26 × 21 cm
Brassaï Archives: Pl. 156 (D)

66 *Toughs in Big Albert's Gang*, c. 1931–32
Silver salt print, 26 × 20 cm
Brassaï Archives: Pl. 172 (detail) (D)

Toughs in Big Albert's Gang, c. 1931–32
Silver salt print, 49.5 × 37.8 cm
Brassaï Archives: Pl. 172
AM 1995–222

67 *Toughs in Big Albert's Gang*, c. 1931–32
Silver salt contact print,
8.2 × 6.2 cm
Brassaï Archives: Pl. 172 (D)

69 *Rue de Lappe*, c. 1932
Silver salt print, 29 × 23 cm
Brassaï Archives: Pl. 328 (D)

70 *Streetwalker, near the Place d'Italie*, 1932
Silver salt print, 49.8 × 40 cm
Brassaï Archives: Pl. 332
AM 1995–221

71 *Streetwalker, near the Place d'Italie*, 1932
Silver salt contact print,
8.5 × 6 cm
Brassaï Archives: Pl. 333 (D)

72 *At Suzy's, Rue Grégoire-de-Tours*, c. 1932
Silver salt print, 23.1 × 17.1 cm
Brassaï Archives: Pl. 360
AM 1997–222

73 *The Introduction, at Suzy's, Rue Grégoire-de-Tours*, c. 1932
Silver salt print, 30 × 22 cm
Brassaï Archives: Pl. 362 (D)

74 *In a Brothel, Rue Quincampoix*, c. 1932
Silver salt contact print,
8.4 × 6.1 cm
Brassaï Archives: Pl. 352 (D)

In a Brothel, Rue Quincampoix, c. 1932
Silver salt contact print,
8.9 × 6.3 cm
Brassaï Archives: Pl. 354 (D)

In a Brothel, Rue Quincampoix, c. 1932
Silver salt contact print,
8.2 × 6.1 cm
Brassaï Archives: Pl. 351 (D)

75 *In a Brothel, Rue Quincampoix*, c. 1932
Silver salt print, 35 × 27.5 cm
Brassaï Archives: Pl. 352
AM 1988–1002

76 *At Suzy's*, c. 1932
Silver salt print, 18 × 25 cm
Brassaï Archives: Pl. 393 (D)

At Suzy's, c. 1932
Silver salt print, 24 × 28 cm
Brassaï Archives: Pl. 392 (D)

77 *At Suzy's*, c. 1932
Silver salt print, 29.8 × 22.5 cm
Brassaï Archives: Pl. 382 (D)

78 *Prostitutes in a Bar, Boulevard Rochechouart*, c. 1932
Silver salt print, 30 × 22 cm
Brassaï Archives: Pl. 343 (D)

79 *In a Bar, Boulevard Rochechouart*, c. 1932
Silver salt print, 29 × 21 cm
Brassaï Archives: Pl. 343 (detail) (D)

80 *Kiki at the Cabaret des Fleurs, Montparnasse*, c. 1932
Silver salt contact print,
8.4 × 5.2 cm
Brassaï Archives: Pl. 495 (D)

81 *Kiki, Thérèse Treize and Lily*, c. 1932
Silver salt print, 6 × 8.4 cm
Brassaï Archives: F. 85 (D)

82 *Bal Musette des Quatre-Saisons, Rue de Lappe*, c. 1932
Silver salt print, 18 × 24 cm
Brassaï Archives: Pl. 2 (detail) (D)

83 *Bal Musette des Quatre-Saisons, Rue de Lappe*, c. 1932
Silver salt print, 30 × 24 cm
Brassaï Archives: Pl. 9 (D)

Bal Musette des Quatre-Saisons, Rue de Lappe, c. 1932
Silver salt print, 30 × 24 cm
Brassaï Archives: Pl. 10 (D)

85 *Lovers in a Small Café, near the Place d'Italie*, c. 1932
Silver salt print, 25 × 19.5 cm
Brassaï Archives: Pl. 78
AM 1988–1004

86 *The Lovers' Tiff, Rue Saint-Denis*, c. 1931
Silver salt print, 24 × 18 cm
Brassaï Archives: Pl. 16 (D)

The Lovers' Tiff, Rue Saint-Denis, c. 1931
Silver salt print, 24 × 18 cm
Brassaï Archives: Pl. 17 (D)

87 *The Lovers' Tiff, Rue Saint-Denis*, c. 1931
Silver salt print, 24 × 18 cm
Brassaï Archives: Pl. 18 (D)

The Lovers' Tiff, Rue Saint-Denis, c. 1931
Silver salt print, 24 × 18 cm
Brassaï Archives: Pl. 19 (D)

88 *Lulu, at Le Monocle*, c. 1932
Silver salt contact print,
8.4 × 6.2 cm
Brassaï Archives: Pl. 431 (D)

89 *Fat Claude and Her Girlfriend, at Le Monocle*, c. 1932
Silver salt print, 40 × 30.3 cm
Brassaï Archives: Pl. 437A
Private Collection

90 *One Suit for Two, at the Magic City*, c. 1931
Silver salt print, 29.6 × 27.7 cm
Brassaï Archives: Pl. 444
Private collection

91 *Prostitute Playing Russian Billiards, Boulevard Rochechouart*, 1932–33
Silver salt contact print,
8.4 × 6 cm
Brassaï Archives: Pl. 400 (D)

92 *'The Regent's Orgy' at the Folies-Bergère*, 1932
Silver salt print, 23.3 × 17.5 cm
Brassaï Archives: P. de N. 50
AM 1997–201

93 *Duty Fireman, in the Wings at the Folies-Bergère*, 1932
Silver salt contact print,
8.5 × 6.2 cm
Brassaï Archives: Pl. 730 (D)

94 *An Evening at Maxim's*, 1949
Silver salt print, 49 × 37.5 cm
Brassaï Archives: So. 737
AM 1995–250

95 *Masked Ball, Pré Catelan*, 1947
Silver salt contact print,
7.8 × 5.6 cm
Brassaï Archives: So. 625 (D)

96 *The 'Big Night' at Longchamp*, July 1937
Silver salt contact print,
5.8 × 5.3 cm
Brassaï Archives: N. 788 (D)

97 *Tea Dance*, July 1939
Silver salt contact print,
5.5 × 8.2 cm
Brassaï Archives: N. 158 (D)

98 *Caravans, Boulevard Arago*, c. 1935–38
Silver salt print, 30 × 23 cm
Brassaï Archives: N. 604 (D)

99 *The Show's Over, Cirque Fanni*, 1930–32
Silver salt print, 23.2 × 17.8 cm
Brassaï Archives: P. de N. 21
AM 1997–176

Street Fair, Place Saint-Jacques, 1945
Silver salt print, 50 × 40.5 cm
Brassaï Archives: N. 815
AM 1994–38

100 *Six-Day Cycle Race at the Vélodrome d'Hiver*, c. 1931–33
Silver salt contact print,
8.7 × 6.2 cm
Brassaï Archives: Pl. 792 (D)

101 *Six-Day Cycle Race at the Vélodrome d'Hiver*, c. 1931–33
Silver salt contact print,
8.1 × 6.1 cm
Brassaï Archives: Pl. 795 (D)

102 *The Cirque Medrano*, c. 1932
Silver salt contact print,
8.9 × 6.4 cm
Brassaï Archives: Pl. 1131 (D)

The Cirque Medrano, c. 1932
Silver salt contact print,
8.7 × 6.2 cm
Brassaï Archives: Pl. 1132 (D)

103 *The Cirque Medrano*, c. 1932
Silver salt contact print,
8.5 × 6.2 cm
Brassaï Archives: Pl. 1130 (D)

Tightrope Walker, Cirque Medrano, c. 1932
Silver salt contact print,
8.2 × 6 cm
Brassaï Archives: Pl. 1137 (D)

Acrobat, Cirque Medrano, c. 1932
Silver salt contact print,
4.8 × 3.6 cm
Brassaï Archives: Pl. 1169 (D)

Minotaure

104 *False Sky*
Minotaure, no. 6, winter 1934–35, p. 5

106 *Nude*, 1934
Silver salt print, 22.4 × 15.5 cm
Brassaï Archives: Nu 58 (D)

107 *Nude*, 1934
Silver salt print, 22.6 × 17.5 cm
Brassaï Archives: Nu 80 (D)

108 *Nude*, 1934
Silver salt print, 17.5 × 23 cm
Brassaï Archives: Nu 98 (D)

109 *Nude*, 1934
Silver salt print, 23 × 16.5 cm
Brassaï Archives: Nu 101 (D)

110 *Nude*, 1934
Silver salt print, 17.5 × 29.6 cm
Brassaï Archives: Nu 115 (D)

Nude, 1934
Silver salt print, 24 × 30.4 cm
Brassaï Archives: Nu 4 (D)

111 *Nude*, 1934
Silver salt print, 29.7 × 22.7 cm
Brassaï Archives: Nu 8 (D)

113 *The Canal de l'Ourcq*, c. 1932
Silver salt print, 23.5 × 17.5 cm
Brassaï Archives: N. 195
CNAC GP purchase, with help from the Commission Nationale de la Photographie
AM 1994–34

114 *Statue of Marshal Ney in the Fog*, 1932
Silver salt print, 56.7 × 40.5 cm
Brassaï Archives: N. 165
AM 1987–624

115 *The Tour Saint-Jacques*, c. 1932–33
Silver salt print, 29 × 22 cm
Brassaï Archives: N. 446
CNAC GP purchase, with help from the Commission Nationale de la Photographie
AM 1994–36

116 *The Drawbridge on the Rue de Crimée between the Bassin de la Villette and the Canal de l'Ourcq*, c. 1933–34
Silver salt print, 22 × 16.5 cm
Brassaï Archives: N. 204
CNAC GP purchase, with help from the Commission Nationale de la Photographie
AM 1994–35

117 *The Canal de l'Ourcq*, c. 1932
Silver salt print, 27.5 × 21 cm
Brassaï Archives: N. 685
CNAC GP purchase, with help from the Commission Nationale de la Photographie
AM 1994–37

119 *Troglodyte*, c. 1935
Silver salt print, 17 × 23.5 cm
Brassaï Archives: Co. 710 (D)

120 *The Phenomenon of Ecstasy*, c. 1933
Silver salt print, 29.5 × 23 cm
Brassaï Archives: F. 110 (D)

121 *The Phenomenon of Ecstasy*, c. 1933
Silver salt contact print,
5.6 × 8.2 cm
Brassaï Archives: F. 111 (D)

122 *Moth and Candle*, c. 1934
Silver salt print, 22.8 × 17.5 cm
Brassaï Archives: An. Pap. X3 (D)

199 *Nude*, Paris, September 1944
Pencil drawing on paper,
15 × 12.5 cm
Brassaï Archives: 44/45/21
(D)

Nude, Paris, 1 January 1944
Pencil drawing on paper,
27 × 35 cm
Brassaï Archives: 44/45/69
(D)

201 *Squatting Woman*, undated
Silver salt contact print of the
stone sculpture
Brassaï Archives: A242Z+135

202 *Venus of the Adour*, 1946
Silver salt contact print of the
pebble sculpture
Brassaï Archives: A 242Z+115

Venus of the Adour, 1946
Silver salt print of the pebble
sculpture, 12.5 × 5.5 × 3 cm
Brassaï Archives (no. 2)
A242Z+122

203 *Venus of the Adour*, 1946
Silver salt contact print of the
pebble sculpture
Brassaï Archives: A242Z+116

204 *Black Bird I*, 1948
Silver salt print of the marble
sculpture, 8.5 × 5.5 × 3 cm
Brassaï Archives (no. 11)
A242Z+100

205 *Black Bird II*, 1960
Silver salt print of the black
marble sculpture,
11 × 5.5 × 1.5 cm
Brassaï Archives (no. 35)
A242Z+143Z+6

Brassaï and literature

209 *Portrait of Jean Genet*, 1955
Silver salt contact print,
8.4 × 5.7 cm
Brassaï Archives: A787F

Transmutations

Portfolio *Transmutations*,
1934/1967
40 × 30.4 × 3.8 cm
12 silver salt prints mounted on
paper, 23.8 × 17.8 cm each, made
from photographic plates exposed
and processed *c.* 1934–35
and printed in 1967
Galerie Les Contards, Lacoste
(Vaucluse) 1967
Text and titles by the artist, 100
copies, plus 10 not for sale
FNAC award, 1988
AM 1988 (1 to 12)

212 *Odalisque*, 1934/1967
Silver salt print, 23.8 × 17.8 cm
AM 1988-986(3)

214 *Mineral Face*, 1934/1967
Silver salt print, 17.8 × 23.8 cm
AM 1988-986(7)

215 *Woman of Seville Stripped Bare*,
1934/1967
Silver salt print, 23.8 × 17.8 cm
AM 1988-986(2)

216 *Fruit Woman*, 1934/1967
Silver salt print, 23.8 × 17.8 cm
AM 1988-986(1)

217 *Fruit Woman*, 1934, 1st state
Silver salt print
Private collection

Fruit Woman, 1934, 2nd state
Silver salt print
Private collection

Fruit Woman, 1934, 3rd state
Silver salt print
Private collection

Fruit Woman, 1934, 4th state
Silver salt print
Private collection

Fruit Woman, 1934, 5th state
Silver salt print
Private collection

Fruit Woman, 1934, 6th state
Silver salt print
Private collection

218 *Offering*, 1934/1967
Silver salt print, 23.8 × 17.8 cm
AM 1988-986(10)

219 *Girl Dreaming*, 1934/1967
Silver salt print, 23.8 × 17.8 cm
AM 1988-986(9)

Camera in Paris

220 *The Devil of Notre-Dame and the Tour
Saint-Jacques*, 1933
Silver salt print, 30 × 24 cm
Brassaï Archives: P. 2
(D)

222 *A Man Dies in the Street*,
223 *Boulevard de la Glacière*, 1932
8 silver salt prints,
24 × 18 cm each
Brassaï Archives: P. 522, 523, 524,
525, 526, 529, 530, 531
(D)

224 *Wall of La Santé Prison at the Corner of
225 the Boulevard Arago and the Rue de la
Santé*, *c.* 1930
Silver salt print, 17 × 20 cm
Brassaï Archives: P. 362A
(D)

226 *Steps of the Butte Montmartre with a
White Dog*, *c.* 1932–33
Silver salt print, 24 × 18 cm
Brassaï Archives: P. 363 (D)

*Steps of the Butte Montmartre with a
White Dog*, *c.* 1932–33
Silver salt contact print,
8.3 × 6 cm
Brassaï Archives: P. 363 (D)

227 *Steps of the Butte Montmartre with a
White Dog*, *c.* 1932–34
Silver salt print, 35.2 × 48 cm
Brassaï Archives: P. 364
AM 1988–1013

228 *Round Mirror*, *c.* 1932–34
Silver salt print, 23.5 × 18 cm
Brassaï Archives: P. 428 (D)

229 *The Madeleine*, undated
Silver salt contact print,
7.7 × 3.8 cm
Brassaï Archives: P. 346C (D)

230 *Rue de l'Hôtel-de-Ville*, *c.* 1936
Silver salt print, 39.3 × 29.7 cm
Brassaï Archives: P. 712
FNAC award 1988
AM 1988-998

231 *Courtyard of a Building in the Suburbs
of Paris* or *Slums*, 1939
Silver salt print, 30 × 24 cm
Brassaï Archives: P. 720 (D)

232 *Near the Panthéon*, undated
Silver salt print, 30 × 24 cm
Brassaï Archives: P. 654D+4 (D)

Mannequin, undated
Silver salt print, 30 × 21.3 cm
Brassaï Archives: N. 520A+4 (D)

233 *Secondhand Dealer in the Rue Galande*,
c. 1931–32
Silver salt print, 30 × 23.7 cm
Brassaï Archives: P. 419 (D)

234 *Frenchmen! Wake Up! Municipal
Elections*, May 1935
Silver salt print, 30 × 24 cm
Brassaï Archives: P. 509O (D)

235 *Flea Circus*, undated
Silver salt contact print,
5.8 × 5.2 cm
Brassaï Archives: Pl. 847S (D)

236 *Parc Montsouris, the Strolling
Photographer*, 1930
Silver salt print, 13 × 23 cm
Brassaï Archives: P. 498 (D)

237 *Wet Paint*, 1946
Silver salt print, 40 × 49 cm
Brassaï Archives: P. 509M
AM 1995–245

238 *Marlene*, 1937
Silver salt print, 30 × 24 cm
Brassaï Archives: P. 448A
(D)

239 *Billsticker*, 1948
Silver salt contact print,
5.9 × 5.1 cm
Brassaï Archives: P. 451D+2
(D)

240 *The Balloon Seller*, 1931
241 5 silver salt prints,
24 × 18 cm each
Brassaï Archives: P. 485 to 489
(D)

242 *Picnic on the Banks of the Marne*,
c. 1936–37
Silver salt print, 39.5 × 49 cm
Brassaï Archives: Déj. 155
AM 1995–214

243 *Square Viviani*, 1947
Silver salt print, 49 × 37.3 cm
Brassaï Archives: P. 328V+3
AM 1995–247

244 *At the Café de Flore*, 1944
Silver salt contact print,
5.5 × 7 cm
Brassaï Archives: A. 728 (D)

245 *Sartre, Café de Flore*, 1944
Silver salt contact print,
8 × 5.8 cm
Brassaï Archives: A. 739 (D)

Simone de Beauvoir, Café de Flore, 1944
Silver salt contact print,
8.5 × 5.9 cm
Brassaï Archives: A. 736 (D)

246 *The Café de Flore's Cat*, 1944
Silver salt contact print,
5.3 × 6.2 cm
Brassaï Archives: A. 742 (D)

247 *Outside 'Le Chat qui Pelote'*, 1939
Silver salt print, 30 × 22.5 cm
Brassaï Archives: P. 375G (D)

248 *Conchita on Display in Front of the
Booth of 'Her Majesty, Woman',
Boulevard Auguste-Blanqui*, *c.* 1931
Silver salt contact print,
5.2 × 8.1 cm
Brassaï Archives: Pl. 845 (D)

249 *Conchita on Display in Front of the
Booth of 'Her Majesty, Woman',
Boulevard Auguste-Blanqui*, *c.* 1931
Silver salt contact print,
5.2 × 8.1 cm
Brassaï Archives: Pl. 845 (D)

250 *The Three Masked Women and Their
Barker, Street Fair*, *c.* 1931
Silver salt contact print,
6.1 × 8.3 cm
Brassaï Archives: Pl. 833 (D)

251 *Conchita's Dance, Boulevard Auguste-
Blanqui*, *c.* 1931
Silver salt contact print,
7.5 × 5.5 cm
Brassaï Archives: Pl. 834 (D)

*The Wife of the Human Gorilla in her
Loïe Fuller Dance, Place d'Italie*, *c.* 1933
Silver salt contact print,
7 × 5.1 cm
Brassaï Archives: Pl. 838 (D)

*The Wife of the Human Gorilla in her
Loïe Fuller Dance, Place d'Italie*, *c.* 1933
Silver salt contact print,
5.5 × 7.4 cm
Brassaï Archives: Pl. 837 (D)

252 *Fairground Boxer*, *c.* 1930
Silver salt contact print,
8 × 5.5 cm
Brassaï Archives: Pl. 860 (D)

253 *Market Porter at Les Halles*, 1939
Silver salt print, 29.5 × 23.9 cm
Brassaï Archives: P. 375 (D)

254 *Fruit and Vegetable Seller*, *c.* 1932
255 Four silver salt prints,
16 × 18 cm each
Brassaï Archives: P. 466 to 469 (D)

256 *Sleeping Man Wearing a Boater*, *c.* 1934
Silver salt print, 24 × 30 cm
Brassaï Archives: P. 471B (D)

257 *Sleeping Man, Montmartre, c.* 1930–31
Silver salt print, 24 × 18 cm
Brassaï Archives: P. 472C (D)

258 *Tramp, Marseilles,* 1935
Silver salt print, 49.5 × 35.5 cm
Brassaï Archives: Mi. 7E
AM 1995–227

259 *Rome Metro Station, c.* 1933–34
Silver salt print, 24 × 18.5 cm
Brassaï Archives: N. 679D (D)

*Down-and-Outs, Boulevard
Rochechouart, c.* 1932–35
Silver salt print, 33 × 27 cm
Brassaï Archives: P. 472B
AM 1989–17

260 *Belote Players,* 1933
Silver salt print, 22.3 × 16.5 cm
Brassaï Archives: Pl. 66 (D)

261 *Belote Players,* 1933
Silver salt print, 29.5 × 22 cm
Brassaï Archives: P. 509N (D)

262 *Concierge,* 1946
Silver salt print, 49 × 37 cm
Brassaï Archives: P. 435J
AM 1995–244

263 *Window,* undated
Silver salt contact print,
5.9 × 5.7 cm
Brassaï Archives: P. 435W (D)

Window, Grasse, 1947
Silver salt print, 35.3 × 28.1 cm
Brassaï Archives: Mi. 414B
AM 1989–22

Window with White Flowers, 1946
Silver salt contact print,
5.7 × 5.2 cm
Brassaï Archives: P. 435M (D)

264 *Walkers in the Rain,* 1935
Silver salt print, 24 × 18 cm
Brassaï Archives: P. 552 (D)

265 *Rue de Rivoli,* 1937
Silver salt print, 23.8 × 17.7 cm
Brassaï Archives: P. 564 (D)

267 *Walkers in the Rain,* 1935
Silver salt print, 20.1 × 15.2 cm
Brassaï Archives: P. 551 (D)

268 *Dead Man on the Embankment,* 1931
Silver salt print, 23.5 × 17.2 cm
Brassaï Archives: P. 274 (D)

269 *Dead Man on the Embankment,* 1931
Silver salt contact print,
5.8 × 8 cm
Brassaï Archives: P. 273 (D)

Dead Man on the Embankment, 1931
Silver salt print, 23.5 × 30.3 cm
Brassaï Archives: P. 275 (D)

270 *The Riviera,* 1936
Silver salt contact print,
5.5 × 4.8 cm
Brassaï Archives: Mi. 820 (D)

The Riviera, 1936
Silver salt contact print,
5 × 4.2 cm
Brassaï Archives: Mi. 821 (D)

271 *The Riviera,* 1936
Silver salt print, 50 × 40 cm
Brassaï Archives: Mi. 1151
AM 1995–226

272 *The White Cat and the 'Black Lion',
c.* 1938
Silver salt print, 50 × 37.8 cm
Brassaï Archives: An. 207
AM 1995–235

Colette Cat, c. 1938
Silver salt print, 38.3 × 29.9 cm
Brassaï Archives: An. 214
AM 1988–996

273 *Stray Cat,* 1946
Silver salt print, 50 × 37.8 cm
Brassaï Archives: An. 255
AM 1995–217

The Black Cat on the Steps, c. 1945
Silver salt print, 49.2 × 38 cm
Brassaï Archives: An. 266
AM 1995–241

274 *The Kiss, c.* 1935–37
10 silver salt contact prints
mounted on green card,
23.5 × 32 cm
Brassaï Archives: P. 123
(D)

275 *The Kiss, c.* 1935–37
Silver salt print, 49.5 × 39 cm
Brassaï Archives: Pl. 872
AM 1995–234

276 *London,* undated
Silver salt contact print,
5.9 × 5.7 cm
Brassaï Archives: Et. 98Z+11
(D)

277 *Maundy Thursday, Church of San
Lorenzo, Seville,* 1950
Silver salt contact print,
5.5 × 5 cm
Brassaï Archives: Et. 561 (D)

278 *Hospices de Beaune,* 1951
Silver salt contact print,
7.8 × 5.6 cm
Brassaï Archives: Co. 561Z+36
(D)

Hospices de Beaune, 1951
Silver salt contact print,
8.1 × 5.9 cm
Brassaï Archives: Co. 561Z+26
(D)

279 *Hospices de Beaune, the Pharmacy,* 1951
Silver salt print, 50 × 35.7 cm
Brassaï Archives: Co. 561Z+45
AM 1995–257

Preface to *Camera in Paris*

284 Untitled (in *Anthologie de la poésie
naturelle,* 1949)

Interview with Gilberte Brassaï

287 *Brassaï and Gilberte Brassaï at Genoa,*
spring 1956
Brassaï Archives

Graffiti

288 Graffiti from Series VII, 'Death',
1933–56
Silver salt print, 49.4 × 39.4 cm
Brassaï Archives: A 1868C
AM 1996–173

290 Graffiti from Series III, 'The Birth of
the Face', 1933–56
Silver salt print, 49.5 × 39.4 cm
Brassaï Archives: A 1518
AM 1996–31

Graffiti from Series III, 'The Birth of
the Face', 1933–56
Silver salt print, 49.6 × 39.3 cm
Brassaï Archives: A 1499
AM 1996–134

Graffiti from Series III, 'The Birth of
the Face', 1933–56
Silver salt print, 47 × 39.9 cm
Brassaï Archives: A 1500R+2
AM 1996–142

291 Graffiti from Series IV, 'Masks and
Faces', 1933–56
Silver salt print, 38.8 × 27.8 cm
Brassaï Archives: A 1574C
AM 1996–151

Graffiti from Series IV, 'Masks and
Faces', 1933–56
Silver salt print, 37.5 × 29 cm
Brassaï Archives: A 1557
AM 1996–161

Graffiti from Series IV, 'Masks and
Faces', 1933–56
Silver salt print, 39.5 × 29.1 cm
Brassaï Archives: A 1615
AM 1996–162

293 Graffiti from Series VI, 'Love',
1933–56
Silver salt print, 29 × 22.7 cm
Brassaï Archives: A 1404Z+16
AM 1996–199

294 Graffiti from Series VIII, 'Magic',
1933–56
Silver salt print, 49.5 × 39.4 cm
Brassaï Archives: A 1731
AM 1996–117

Graffiti from Series VIII, 'Magic',
1933–56
Silver salt print, 49.5 × 36.9 cm
Brassaï Archives: A 1770
AM 1996–115

Graffiti from Series VIII, 'Magic',
1933–56
Silver salt print, 49.5 × 39.4 cm
Brassaï Archives: A 1625
AM 1996–120

Graffiti from Series VIII, 'Magic',
1933–56
Silver salt print, 39.4 × 29.2 cm
Brassaï Archives: A 1954
AM 1996–116

295 Graffiti from Series VIII, 'Magic',
1933–56
Silver salt print, 29.3 × 23.1 cm
Brassaï Archives: A 1424C
AM 1996–113

Graffiti from Series VIII, 'Magic',
1933–56
Silver salt print, 38 × 29.1 cm
Brassaï Archives: A 1702
AM 1996–106

Graffiti from Series VIII, 'Magic',
1933–56
Silver salt print, 47.5 × 39.3 cm
Brassaï Archives: A 1724
AM 1996–108

Graffiti from Series VIII, 'Magic',
1933–56
Silver salt print, 49.4 × 39.2 cm
Brassaï Archives: A 1624Z+1
AM 1996–109

297 *Transmutation,* 1958–70
Colour print mounted on
aluminium, 80 × 60 cm
Brassaï Archives: no. 483 (D)

298 *Arborescent Wall,* 1958–70
Colour print mounted on
aluminium, 80 × 60 cm
Brassaï Archives: no. 448 (D)

299 *Red Manifesto,* 1958–70
Colour print mounted on
aluminium, 60 × 40 cm
Brassaï Archives: no. 379 (D)

300 *Pas de Deux,* 1958–70
Colour print mounted on
aluminium, 40 × 60 cm
Brassaï Archives: no. 457 (D)

301 *Apocalypse I,* 1958–70
Colour print mounted on
aluminium, 60 × 80 cm
Brassaï Archives: no. 471 (D)